Saul Bass

A Life in Film & Design

Jennifer Bass & Pat Kirkham

Laurence King Publishing

For Amanda, Sylvie & Anderson

Contents

Foreword Martin Scorsese — vi

Preface Pat Kirkham — viii

Preface Jennifer Bass — x

Introducing Saul Bass… — xii

1. **From the Beginning** — 1
2. **Renaissance Designer** — 27
3. **Reinventing Movie Titles** — 105
4. **Beginnings, Middles & Ends** — 229
5. **The Wheel Comes Full Circle** — 263
6. **Corporate Identity** — 281
7. **Personal Handwriting** — 359

Notes — 392
Bibliography — 411
Selected Client / Project List — 414
Selected Chronology — 421
Index — 422
Picture Credits — 424

Foreword **Martin Scorsese**

Saul Bass. Before I ever met him, before we worked together, he was a legend in my eyes. His designs, for film titles and company logos and record albums and posters, defined an era. In essence, they found and distilled the poetry of the modern, industrialized world. They gave us a series of crystallized images, expressions of who and where we were and of the future ahead of us. They were images you could dream on. They still are.

For instance, I look at Saul's design for the album *Frank Sinatra Conducts Tone Poems of Color*, and I'm immediately drawn into a shared sense of the world at that moment, 1956. There was a vision of progress then, of hope, of a newer, better world. And there was an idea that everything could be streamlined, and that we would all benefit. Now, how is the future as we imagined it in 1956 contained in this beautiful album cover design? It's a series of rectangular color bars (resembling the Cuisenaire rods they used to use to teach math to children), in hues suggesting an array of moods, from warm to cool, from contentment to thoughtful melancholy. It has something to do with the economical beauty and elegance of the design, and the range of feeling it contains. In a way, it describes a mental space we all share. I'm speaking in the present tense here because Saul's designs, the ones he executed on his own and then with his wife and creative partner Elaine, speak so eloquently that they address all of us, no matter when or where you were born. When I was leafing through the section of this book devoted to the trademarks Saul designed (for Alcoa, Fuller Paints, Continental and United Airlines, the updates of Bell Telephone and Quaker Oats, and Getty and AT&T and Minolta…it boggles the mind), I came across this quote below the chapter heading: "The ideal trademark is one that is pushed to its utmost limits in terms of abstraction and ambiguity, yet is still readable. Trademarks are usually metaphors of one kind or another. And are, in a certain sense, thinking made visible." To me, that encompasses Saul's genius, because that's the way we take in reality a lot of the time: feelings push perceptions to the limits of abstraction and ambiguity, but the world around us stays readable, somehow. Thinking made visible.

and filmmaking are collaborative activities and, when known, credits are given (either in the text or notes) for those who worked with Saul on particular projects.

A huge amount of archive material was made available to me, including the Saul Bass Collection at the Academy of Motion Picture Arts and Sciences' Fairbanks Center for Motion Picture Study, Margaret Herrick Library, donated by the Bass family after Saul's death. Mostly visual, it is augmented by that institution's collection of press books, Special Collections materials, and an oral history conducted just before Saul died, the Bass Archive (including copies of talks, articles, presentations and interviews, some correspondence and tributes to Saul) of which Jennifer Bass is currently the custodian, and some material supplied by Elaine. What remains is only the tip of an iceberg: Saul sometimes produced as many as 300 idea sketches for a single logo. When asked by his friend the designer Lou Dorfsman why he did so many, he replied that he simply could not stop once he had started. Unfortunately, like most prolific designers with long careers, little instinct for hoarding and finite office space, Saul threw away a vast amount of work.

One of the joys of my research was reading or listening to, and in some cases watching, interviews with Saul. Listening to my own tapes and deciphering notes scribbled during lunches, telephone calls, or when Saul or Elaine would resume speaking after my tape recorder was packed away, brought back many memories and more than a few tears. More than any other of my books, this has been a labor of love.

My thanks to Elaine go beyond the scope of this book. A talented artist, musician and filmmaker, she has many wonderful gifts and the goodness that surrounds her inspires me to be a better human being. She has joined my panoply of role models for all manner of things, not least a working woman and grandmother. Jennifer Bass has put a huge amount of work and thought into this project. Quite simply it would never have come to fruition without her. She designed the book, selected the images, sifted through masses of archive material, suggested people for me to contact, worked closely with me to shape the text, and supervised production. I am extremely grateful for all those things as well as her valuable insights, thoughtful commentaries and friendship. Brad Roberts, formerly of Bass/Yager & Associates and now at the Margaret Herrick Library, has been unfailingly helpful and generous. Brad, Jennifer and I have often felt Saul looking down upon us during this project. Saul, we have tried our best and hope you will approve.

Huge and heartfelt thanks to Laurence King, the most generous, gentlemanly and patient of publishers and to Lesley Henderson and Clare Double at LKP for all their support. Stacey Sloboda, Scott Perkins and Kate Fox were resourceful research assistants and Anne Coco and Barbara Hall at the Margaret Herrick Library were helpful beyond the call of duty, as were librarians at the Getty Research Institute and the Bard Graduate Center. My thanks to Susan Weber, Director of the Bard Graduate Center, Deans Miller and Simon, my colleagues and students for making the BGC such a stimulating place to work. Thanks also to Tom Crow, Charles Salas, Gail Feigenbaum, Rani Singh, Andrew Perchuk of the Getty Research Institute and to my fellow Getty Scholars in the "Biography Seminar" (2002–2003) for creating such an intellectually sympathetic environment in which to conduct research into the person who created the Getty's corporate identity design.

Many thanks to Deborah Sussman for introducing me to Saul, Beverley Skeggs for driving me to my first interview with him, Shirley and Charlie Watts for a beautiful place in which to write, and Marcella Ruble, Alan Harris, Wendy Kaplan and Mimi Martell for warm hospitality. Victor Margolin, Paul Stirton, Lance Glover, Elaine Bass and Andy Hoogenboom read the manuscript and I thank them all for their comments. I am also grateful to Al Kallis, Lou Danziger, Lella and Massimo Vignelli, Ralph and Judith Caplan, Robert Redford, Martin Scorsese and Harold Williams for talking to me about Saul and/or Saul and Elaine. Some of those who helped me are sadly no longer alive but I want particularly to acknowledge Art Goodman, Billy Wilder and Lou Dorfsman. Others to be thanked include Jeremy Aynsley, Ruth Barolsky, Archie Boston, Neil Brand, Barbara Brooks, Dympna Callaghan, Stephanie Cassidy, David Crowley, Tony Cuchiara, David Coates, Jim Cook, Philip Dodd, Stuart Dorrian, Michael Eaton, Michael Friend, Bob Gill, Steve Heller, Neil Jaworski, Donna Loveday, Michele Majer, Alex Millar, Amy Ogata, Michael O'Shaunessy, David Peters, Kate Roberts, Robert Rosenstone, Walter Rueben, Markku Salmi, Douglas Sandberg, Jake Siewert, Sally Stein, Neil Symington, Lisa Tesei, Dieter Thomae, Tise Vahimagi, Sarah Warren, Jonathan Weinberg, Paul Wells, David Wexler, Catherine Whalen and Yumiko Yamamori.

My family members, whose love and support I cherish, have to forgo a dedication in this instance. Saul had this one earmarked long ago for his granddaughter Amanda, and that is how it should be. That dedication remains as powerful and appropriate as it was when Saul was alive (he would be so proud of the talented young woman she now is), but I cannot help feeling that this is for him too, and for Elaine and their two new grandchildren, Sylvie and Anderson.

Preface **Jennifer Bass**

When I was very young, my father would often go into the office on the weekends, and I always loved to go with him. We had our ritual – he would sit down at his desk to work, and I would head off to explore and embark on one of my own projects. After several hours he would find me and ask, "How are you doing…?" and, "When do you think you might be coming to a stopping point?," as though my projects, and work process, were just as important as his. Then we would head home, often swinging by a small shop on La Brea Avenue to buy flowers for my mom. We would begin by picking out a few stems. But then we'd get carried away, and by the time we left it felt like we had emptied the entire store! My mom would always be surprised and delighted by the one or two bouquets we gave her. Then we'd say, "But wait, there's more!" and return to the car again and again and again. Even though she knew what to expect, we all played along, as she enthusiastically greeted each new bouquet we presented. Then she and I would carefully trim and arrange the flowers and distribute them throughout the house. It was all great fun, and was typical of my parents. There was a magic in even the simplest things they did together.

There were always fascinating things for my brother Jeff and I to play with on my father's desk, and in his office, from dozens of Native American bear fetishes, all lined up in rows, to hourglasses filled with colored liquid that would rise to the top chamber from the warmth of your hand. On the floor were several printers' trays that originally held lead type, but instead were filled with small treasures from around the world that we could explore and arrange however we wanted. And on his desk at home there was a wooden taboret that had little drawers with dividers, each with neatly organized pens, pencils, a stop watch and one with colored pencils arranged by hue, all perfectly sharpened.

One day, when I was eight years old, I remember running down the stairs and hearing my parents' voices in the kitchen. Something my dad said made me sit down on the stairs to listen. He was talking about a book he wanted to do someday about his life and work. His vision was that it would be full of stories and would share the creative process, through sketches and storyboards, as well as the finished work. I was immediately struck by a mixture of excitement and a strange fear. How could my dad, with his huge presence, humor, warmth and energy, ever be captured in a book? And right then, I knew, that no matter how impossible the idea seemed, if my father didn't do this book, someday I would have to try my best to make it happen, not because of the work, but because of the human being he was and how much I loved him.

Throughout the years, the idea of a book was always in the background, but my father's creative energy was like a force of nature, always moving forward. So, the book project remained undone until 1993, when my parents' first grandchild, my daughter Amanda, was born and he decided that now was the time. He chose film critic Joe Morgenstern to work with him on the text and my dad began to organize and design the book. But then he became ill and couldn't continue. And so, together with my husband Lance, I promised him we would see it through.

Saul with Jennifer
c. 1967

Soon afterward, while reflecting on his life, he said to me, "You know, over the years, whenever I was presented with a challenge that brought up feelings of fear or self doubt, I almost always immediately said, 'Yes.'" He was speaking about a certain kind of fear that is a special marker for what we must do to be true to ourselves. I have often remembered these words and have drawn upon them repeatedly in living my life and in the process of completing a book that would be worthy of my father.

After his death, as I began to research and design, it became very clear that the scope of the book had to be enlarged. There was such a huge body of work that, rather than a selective look back by a living designer, it needed to become a truly comprehensive retrospective. That's when I asked design historian, Pat Kirkham, to collaborate with me on a book that would honor my father's original vision, but within a new, more complete context. The sidebars in the book are those he originally prepared, and we made a decision, early on, to weave his voice throughout the text. As designer, I have tried to carefully and thoughtfully 'stay out of the way.' My dream for the book is for the reader to feel as though they have just had a visit with Saul Bass. I hope that something of the man can be sensed within these pages.

I can't go any further without acknowledging my truly remarkable mother, who by nature, has always preferred to stay out of the spotlight. This book is as much for her as it is for my dad. A talented artist, filmmaker and composer in her own right, together they were an amazing team, always engaged in a dynamic, creative dialog, and Jeff and I were so lucky to have been surrounded by that energy and excitement. I am so grateful for our closeness and for her exceptional goodness, grace, strength and wisdom.

One cannot complete such an undertaking alone and I have been blessed with the opportunity to collaborate with extraordinary people. I am enormously grateful to Laurence King whose generosity, patience, kindness and encouragement have been boundless.

Sincere thanks also go to Felicity Awdry, Clare Double, Lesley Henderson, Ida Riveros and Simon Walsh at Laurence King Publishing for all their support.

Pat Kirkham has put a monumental amount of time, thought, energy, and love into this project – artfully weaving together mountains of material. I am deeply grateful to her for her dedication, skill, kindness and friendship as well as our rich process of collaboration.

I could never have finished the book without Vickie Sawyer Karten, my devoted co-designer and loyal friend, week-in and week-out, for more than four years. Her generosity of spirit, expert eye and meticulous care have made an enormous contribution to the book. And I am grateful beyond words to Anita Keys for her clarity, thoughtfulness and always valuable input in the editing of the text.

Special thanks go to many at the Academy of Motion Picture Arts and Sciences, Margaret Herrick Library, including Linda Mehr for her support and Anne Coco for her unwavering assistance and friendship through these many years. It has been a gift to work with Brad Roberts, whom I have known since he began working at my father's office thirty years ago, and who is now part of the library's archival staff. When he and I began sorting through boxes fifteen years ago, my father's archive was the largest single collection the Academy had ever received and had not yet been cataloged. Brad's knowledge, devotion, and positive energy have been invaluable, as we spent literally thousands of hours shoulder to shoulder discovering wonderful things. Others at the Library I wish to thank are Val Almendarez, Lucia Bay, Stacey Behlmer, Jane Glicksman, Jessica Holada, Jennifer Kim, Howard Prouty, Corlis Rauls, Jenny Romero and Michael Tyler. A heartfelt thank you to Mike Pogorzelski and Fritz Herzog at the Academy Film Archive for their generous help and for connecting me with Brian Meacham, whose dedication, friendship, and sharp eye were indispensable as we located each individual film frame. Thanks also to Brian Drischell, Joe Lindner and Mark Toscano.

Martin Scorsese has been a generous advocate and supporter of this book, and I want to thank him, along with Ralph Caplan, Thelma Schoonmaker and Joe Morgenstern. Sadly, two warm and wonderful men, who were like uncles to me, passed away before they could see this book: Art Goodman, who was so instrumental to and involved in my father's work, and Lou Dorfsman, who had planned to write a preface to accompany Martin Scorsese's.

I also want to thank Jennifer Chambliss, Mary Ellen Krieger, River Jukes-Hudson, Matt Boyd, Jessica Fleischman and Leah Hoffmitz for thoughtful design assistance; Theresa Schwartzman for dedicated editing and research; Alan Silvers, Janice Simpson, and Laura Sokolovsky at Cinetech for beautiful film scans; Tony Manzella, Rusty Sena and Hector Murillo at Echelon Color for passionate dedication to every detail; and my brother Jeff, whose perspective and insights have been of great value. I am also grateful for the contributions of Andrea Bass, Robert Bass, Shirley Chan (at C&C Printing), Brian Forrest, Juliana Friedman, Scott Hanna, Gina Henschen, Janice Lee, David Morgenstern, Diego Padilla, Lowell Peterson, Richard Rayner, Natalie Trevino, Todd Wiener (at the UCLA Film and Television Archive) and the many people who worked with my father over the years, especially Herb Yager, Nancy Von Lauderbach and George Arakaki.

My husband Lance and daughter Amanda have traveled this journey with me. Lance was intimately involved at each stage and always gave freely of his time, advice, love, and support, and Amanda has never known a mom who wasn't working on "the book." My gratitude to both of them is immeasurable. My father began this book in 1993, when Amanda was born, and it will be launched into the world at the same moment that she sets off for college. And so this book is for her; Sylvie and Anderson, my brother's two children who were born after my father's death; and especially for my Mom and Dad, who together taught me about courage and wonder, hard work and love, and to believe in the miraculous.

Introducing Saul Bass ...

I believe that there are very few artists in our time who have created as memorable a series of designs and objects. Saul truly shaped the vision of our time.

Milton Glaser

Saul Bass wasn't just an artist who contributed to the first several minutes of some of the greatest movies in history, in my opinion his body of work qualifies him as one of the best filmmakers of this, or any other time.

Steven Spielberg

Saul understood and harnessed the power of images, and his energy and ideas transcended the boundaries that have traditionally separated design, film, architecture, and art. He helped transform our visual landscape and shaped our sense of it and was irrepressible in his search for the best solution.

Harold M. Williams

Saul Bass practiced his craft and magic for more than fifty years. Throughout that time his designs and films remained provocative and challenging. They remain relevant because they continue to touch people. His combination of intellect and emotion – the Yin and Yang of design – comes through in everything he created.

Louis Dorfsman

Saul could find the precise words to express the most complex visual ideas and he could create images to express any verbal concept.

Irving Kershner

The great thing in working with Saul, if you were composing music for main titles, is that your music never got a better break.

Elmer Bernstein

If Saul Bass can die, none of us are safe.

Ray Bradbury[1]

Saul Bass was one of the great figures of twentieth century design and filmmaking. This talented, influential and versatile visual communicator enjoyed a sixty-year professional career (1936–1996) during which he produced a body of work that is as diverse as it is powerful. In the mid to late 1950s he expanded the boundaries of graphic design to include film title sequences – a genre that he transformed. He is best known for a series of title sequences, posters and trademarks, featuring impossibly compressed and highly evocative images of intense clarity and subtle ambiguities, created for films such as Otto Preminger's *The Man with the Golden Arm* (1955) and *Anatomy of a Murder* (1959) and Alfred Hitchcock's *Vertigo* (1958). Circulated worldwide, they provided some of the most compelling images of American postwar visual culture, and by the late 1950s Saul was probably the best-known graphic designer in the world.

Thereafter, in collaboration with his wife Elaine who joined the Bass office in 1956, he continued to create stunning openings for a wide range of films, from *Spartacus* (1960, Stanley Kubrick and Anthony Mann) to *Casino* (1995, Martin Scorsese). If there had been an Academy Award for such work, he – and they – would have been record holders. Less well known is the impressive series of award-winning short films created by Saul and Elaine, including the Oscar-winning *Why Man Creates* (1968) and two Oscar-nominated films – *Notes on the Popular Arts* (1977) and *The Solar Film* (1981). Saul also served as visual consultant on five feature films (*Spartacus*, 1960; *Psycho*, 1960; *West Side Story*, 1961; *Grand Prix*, 1966; *Not with My Wife You Don't*, 1966), creating sequences within the films as well as the titles, and went on to direct the now-cult feature film, *Phase IV* (1974).

Saul was one of the most influential graphic designers of postwar America. Indeed he was a graphic designer before he became involved in filmmaking. He established his own design office in 1952 so that he could work across a broad range of graphics, and later became known as a leading designer of trade symbols and corporate identity programs. Many of the more than eighty logos and identity programs created between 1952 and his death in 1996 are still in use as I write this. My breakfast cereal (Quaker Oats), camera (Minolta), phone bill (AT&T), airline ticket (United Airlines), packing labels (Avery), charity envelope on my desk (United Way), cheese (Real California Cheese), spices (Lawry's), temporary office (the Getty Research Institute) and the video I rented last night (Warner Brothers) all bear his symbols. The enormous circulation of these logos, repeated television screenings of old movies and the constant reworking of all manner of Bass images, ensures that Saul's work, including that undertaken in collaboration with Elaine, continues to impact the visual cultures of many countries on an everyday basis.

Besides those areas of work already mentioned, Saul also created commercials, sponsor tags and show openers for television, and designed a wide range of advertisements, as well as packaging, retail displays, album covers, book covers, sculpture, lettering, typefaces, ceramic tiles, toys, exhibitions, a modular hi-fi cabinet system and a postage stamp. He illustrated short stories and a children's book and, in collaboration with others, designed buildings and play environments, including a proposed pavilion for the 1964 World's Fair, an installation at the XIV Milan Triennale (1968) and a series of service stations.

His versatility was often remarked upon, as was his problem-solving approach to design. In 1954 *American Artist* attributed the "underlying logic" of his work to a "searching mind…always inquiring into the reason for things."[2] He also had a searching eye and it is no coincidence that one of the first films he and Elaine made was, in fact, called *The Searching Eye* (1964). It was also an eye that saw with great clarity: Martin Scorsese likened it to a jeweler's eye – patient and precise.[3] Both mind and eye are central to an understanding of this versatile designer, filmmaker and communicator who was an acute observer and articulate writer and speaker.

Saul received many prestigious awards and honorary degrees over the years, including Art Director of the Year (1957), Honorary Royal Designer for Industry (1965, bestowed by the Royal Society of Arts, London), the New York Art Directors Club Hall of Fame (1977) and the Gold Medal of the American Institute of Graphic Arts (AIGA, 1981). He took pride in recognition by his peers and gave back a great deal to the professions and institutions with which he was associated, engaging in them at local as well as national and international levels. He was particularly active in the AIGA, the Art Directors Clubs of both Los Angeles and New York, and the Alliance Graphique Internationale (AGI). He poured his prodigious energies into the International Design Conferences held annually in Aspen (IDCA), serving on the Board of Directors, and helped Robert Redford establish the Sundance Institute, serving on the Board of Trustees. Among the many other boards and panels on which he sat were the Board of Governors of the Academy of Motion Picture Arts and Sciences, the International Documentary Association and the Design Arts Policy Panel, National Endowment for the Humanities.

Described by film director Daniel Taradash as "a man who speaks up to the world, an artist with a soul; a person with a conscience," Saul was liberal in outlook and disposition.[4] He wore his integrity lightly but one was always aware of a strong moral backbone. He disapproved of advertising that used snobbery, social status or gratuitous sex to sell goods and refused assignments that offended his conscience or sense of fairness. He cared enormously – about people, about work, about issues and events, about life – and gave his services free when asked to design posters, logos and invitations for not-for-profit causes in which he believed. Fellow board members of the Academy of Motion Picture Arts and Sciences recalled him in the mid-1990s campaigning to retain the Academy Award category for Documentary Short Subject, when it was under threat, with an ardor and determination that expressed itself in "forensic brilliance."[5]

Most people who knew Saul also commented upon his warmth, generosity, enthusiasm, sense of humor (he was always ready to laugh – even at himself), love of telling stories and his special qualities as a human being. When Robert Redford describes what made Saul a special person, he points to "an indefinable spiritual energy. One that comes from the soul … an energy born out of talent, generosity, curiosity, wisdom, experience, joy; a joy that comes from such excitement and enthusiasm for art. It is a child's enthusiasm which is, of course, contagious."[6] Harold Williams, now President Emeritus of the J. Paul Getty Trust, also touched upon the infectious quality of Saul's zest for whatever it was he was involved in, commenting, "a relaxed exhilaration characterized his aura: it touched us all."[7]

Saul taught from time to time, mentoring many would-be designers and filmmakers including University of Southern California (USC) film student George Lucas, for whom he was hero and father figure rolled into one. Lucas stated: "One of my first mentors, Saul believed in me when I was a student, pushing my work when others were not interested. His extraordinary vision and creative talents left their unique imprint on me."[8]

Saul was also teacher to those who worked in his office. Former assistant, Michael Lonzo, described his learning process thus: "When he discusses a piece of work there is no wasted effort. He starts in where your thinking left off and gets you digging deeper into yourself. He has a kind of probing curiosity that immediately opens doors and explores new possibilities. First thing you know, you are turning out work that is way over your head. It's a wonderful experience. You don't know how it happens but you are thankful for it."[9]

The number of people with whom Saul kept in touch after first meeting them when they were fledglings in their field is remarkable. It can be explained in part by his sociability, but he was also conscious of the importance of mentors in his own life. Designer Arnold Schwartzman subtitled an article about Saul "Anatomy of a Mentor," and there are countless other examples of Saul's generosity to young people, including Ivan Chermayeff, Rudolph de Harak and Bob Gill.[10] When the latter was asked to design a film title in 1957, he contacted Saul, "thinking I might as well go straight to the King of Titles himself. I had never met him but I cannot tell you how gracious he was. He encouraged me to visit him in Los Angeles and insisted I stay at his home."[11]

Never happier than with an audience of young people, his last public appearance in March 1996 (a month before his death) was a master class presentation and discussion at the School of Visual Arts, New York, where a retrospective exhibition of his work had just opened. Those lucky enough to get a seat, squeeze into the aisles or stand in the stage wings, will never forget that tour de force, his humor or his humanity. Visibly ill, and present against doctor's orders, he gave his all (as always), insisting on the primacy of integrity and curiosity and conveying his love of process in design and filmmaking. He made the audience laugh while he made them think. Afterwards he showed infinite patience with each and every question and remained behind with students until the janitors closed the hall around him.

Saul was a born communicator whose large expressive hands painted pictures as he talked. He loved to tell stories to amplify or make more concrete a particular point, or simply to make one laugh. His expansive, anecdotal patterns of address stood in opposition to the reductive, minimalist aspects of his design work – though not to the layering, overlay and montage aspects of it – as well as to the directness and linear progression evident in his highly ordered presentations to clients. In each mode, however, the point was made as effectively as possible. He had a remarkable ability to get to the kernel of a design problem and translate it into compelling visual icons. He drew fluently and with great ease; ideas and observations seemed to flow effortlessly from the pen or pencil, be it a tiny doodle or a fully worked sketch. There is a vitality to his abstraction as well as his illustration, lettering and type that comes in part, I think, from his facility with drawing.[12]

Saul and Elaine Bass
Shooting *The Searching Eye*.
1963

It is difficult to pinpoint a definitive "Bass aesthetic" because he drew on a wide range of visual and cultural references in his quest to solve the individual problems of particular commissions. But there are recurrent elements. They include a strong tendency toward reduction, distillation, economy and minimalism – all features associated with Modernism – and an interest in fragmentation, addition, ambiguity and metaphor – features more associated with post-Modernism, but which were much in evidence in the 1950s.[13] Wit and seeing things in new ways are also often present, as are finely honed hand-lettering and typography, always appropriate to the visual and emotional loads they carry.

He had a tendency to use single strong graphic images but even when used symbolically an image such as a flame represented different things: passion (*Carmen Jones*), eternal light and freedom (*Exodus*) or evil and destruction (*Storm Center*). Human bodies, or parts of them, are evident throughout Saul's work, particularly hands and eyes. Eyes (which in many cultures stand as the most immediate testimony of life) and hands recall powerful parts of Saul himself – the keen all-seeing eye and the capable ambidextrous hands of a talent that was at once hands-on, cerebral and intuitive.

Saul was fearless with color. If one looks at the body of work as a whole, a wide range of palettes is evident. Sometimes color is dense and bold, at other times light or lightly washed over another. The human hand that created the image is sometimes suggested in the image itself, as for example the tearing away of a piece of paper to reveal the underlying credits in *Bunny Lake is Missing* (1965, dir. Otto Preminger). Masculine terms such as bold, strong and powerful are often used to describe the work, but there is also a lot of softer, delicate imagery as well as great warmth of image and color. Saul was a master of the dialectic of content and form.

Looking back in the mid-1990s on all the many areas of his work, including that created in collaboration with Elaine, he stated, "In the final analysis, content is the key and I've always looked for the simple idea. That is what I did in the 1950s and that is what Elaine and I do now. We have a very reductive point of view when it comes to visual matters. We see the challenge in getting things down to something totally simple, and yet doing something with it, which provokes; to achieve a simplicity, which also has a certain ambiguity and a certain metaphysical implication that makes that simplicity vital. If it's simple simple, it's boring. We try for the idea that is so simple that it will make you think – and rethink. What we do is reach for some way to make people sit up and pay attention to what we want to say. It's a risky business: we're improvising and never know if it will work out."[14]

The birth of their granddaughter Amanda in 1993, when Saul was aged seventy-three, focused Saul and Elaine's priorities, and they decided to streamline the graphic side of the office, bringing it more in line with the smaller film side. In personal terms, however, Saul remained as busy as ever, even when battling the illness that only those closest to him knew about. He bore it with such a wonderful mix of acceptance, disavowal, dignity and good humor that even those of us who suspected something might be seriously wrong thought we must be mistaken in the face of such a seemingly unstoppable talent and life-force. His interests remained as diverse as ever. No one loved what they did more than Saul. He could never envisage himself retired or even contemplating retirement – as not fully engaged with the next problem and the next solution. Brimming over with ideas, his work remained central to his existence. He joked about dying with his boots on and did so, remaining as enthusiastic about each and every project at the end of his sixty-year career as he had at the beginning.

Introducing Saul Bass… xv

1

From the Beginning

... a Bronx tale

He was so talented that he could have been many things. I believe he would have made an impact in any field he entered. Yet, amazingly, as a teenager he had wanted to be a graphic designer and that dream came true – as did his later dream of making films.[1]

Art Goodman

Skyline of Manhattan
Looking south from the Bronx.
1949

Saul as a teenager
Having fun with a friend.
c. 1938

2 Saul Bass

Saul and his sister Sylvia
Six years apart, they
were always very close.
1921

A family outing
Saul with his parents,
Pauline and Aaron.
1925

Saul Bass was born on May 8, 1920 in the East Bronx, New York City, the second child of Jewish immigrants from Eastern Europe. His parents, Aaron and Pauline (née Feldman), were born in 1887 and 1889 respectively in the town of Satanov, Russia (a Jewish shtetl on the Zbruck River in the Danube Delta) about 300 miles northwest of Odessa. They arrived in America in 1907 at the height of immigration from Eastern Europe.[2] In the 1920 census Aaron is recorded as a furrier working in a factory, but soon after he opened a small shop and became known not only for his skill at matching and arranging pelts, but also for his generosity and many kindnesses. Pauline, a homemaker, had a gift for storytelling and for infusing ordinary occasions with a spirit of laughter and creative mischief.[3] Saul, like his older sister Sylvia, inherited his parents' warmth, sense of fun and love of storytelling.

In the 1920s and 1930s, New York City had the largest concentration of Jews in the world. Thirty-two percent of these lived in the Bronx, a multi-ethnic borough of a million people, mostly in neighborhoods defined by cultural and ethnic ties.[4]

When describing his neighborhood, Saul said, "We lived on the 'other side of the railroad tracks.' In this case, the dividing line was a little park, called Crotona Park. On one side was the Grand Concourse, with substantial residences and fairly well-to-do people, and on the other side of the park were we."[5] This said, until the early 1930s, his family fared better than many.

Saul showed an early flair for art, and his parents encouraged his talents. "My earliest memory of artwork was my father giving me a Crayola box. There were forty-nine different colors in that box. And I used them and drew until I'd worn them down to the nub, and then he gave me another box and I kept going."[6] He wondered in later years whether his visual sensibilities and love of working with his hands was inherited from his father, whom he described as an artist as well as a furrier.[7]

"What he did that was quite extraordinary was draw flowers and birds. He did decorative paper cut-outs too. He would take paper, fold it eight, ten, twelve times and then do his little thing with scissors. Then we'd have that grand moment where we unfolded the whole thing and it was just flowers and birds and trees, it was a whole world!"[8] Saul also wondered whether his passion for lettering and a desire to make art out of letters came from his father's brother, a gravestone cutter who stayed in the old country.[9]

The young Saul was passionate about sports, especially basketball.[10] He also loved movies, science fiction and archaeology. "I was attracted by the mystery of ancient civilizations – the more ancient and unknown the more alluring, because it allowed me to speculate and dream. I was an avid reader of science fiction, and my favorite theme was lost civilizations, such as Atlantis."

Saul spent a great deal of time looking at the collections and special exhibitions in the Metropolitan Museum of Art and the Museum of Natural History. His favorite pieces were artifacts from Egypt and other ancient civilizations. In later years, he remembered his days wandering these museum galleries as "some of the most delicious, indelible memories of my childhood."[11]

A family celebration
Standing at the head of the table are Sylvia, Pauline, Aaron and Saul. Behind them is a painting of David and Goliath that Saul made when he was twelve.
c.1936

Saul as a boy
Studio portrait, the Bronx.
c.1931

Only Yiddish was spoken at home, and Saul did not learn English until he started school. Like many children of Jewish immigrants, he grew up within a strongly Jewish culture in a city that epitomized American modernity. He enjoyed the rituals of temple, and was asked to sing occasionally when the cantor was away.[12]

Saul and his mother stayed with relatives in Chicago for the summer of 1934, the year the city was hosting the "Century of Progress" World's Fair (1933–34). There was much to delight a fourteen-year-old boy at the fair, from fantastical light shows and the famous sky ride to "eat as many pancakes as you like for a dime" at the Quaker Oats pavilion.[13] Little did Saul realize then that, thirty-five years later, he would redesign the Quaker logo. Also visiting was eighteen-year-old Esther Kraines, who stated: "I recall how he looked when he ran out of the house to ride Shirley's bike… he was adorable with flashing eyes and dark, dark hair. He was like the little brother I never had."[14] Two or three years later, Saul created what may have been his first foray into title design – a "sheet on construction paper and decorated with lovely designs and wonderful lettering" for her paperback copy of *The Rubaiyat* by Omar Khayyam.[15]

4 Saul Bass

Saul graduated from James Monroe High School, where he excelled at art, sometime before his sixteenth birthday. He was arts editor of the school's literary and arts publication *The Monroe Doctrine*, and also of the yearbook. While at school he won two awards given by the School Art League of New York City – the Art in Trades Club medal for excellence in design and the Saint-Gaudens medal for excellence in draftsmanship – and when he was seventeen he won the John Wanamaker annual drawing competition. Outside school hours he worked as a delivery boy for Bucknoff's delicatessen and painted signs for local fruit stalls and store windows.[16]

Fortunately for Saul, a scout for the Art Students League in Manhattan happened upon a storefront displaying some of his signs, inquired as to their source, and offered him a scholarship.[17] Any vague hope his parents had of Saul following his father's trade was set aside as his artistic talents blossomed and he made clear his desire to pursue a career related to art. Saul recalled, "I worked with my father one summer but I already knew what I wanted to do. A high school friend had an uncle who painted those massive fronts that went up whenever a new movie opened at the Capitol, the Strand, or the Loew's State… I couldn't believe you could make a living at art. I decided that was what I would like to do and remember thinking how lucky this kid was because he could have a job in art when he left school. I didn't make a big deal out of not going to college. In a way I was happy to go out into the world of work. In those times you did what you had to do. You only had to look around you or pick up a newspaper to realize there were many worse off."[18]

His parents had wanted Saul to have the college education his sister had enjoyed, but it was the Depression and times were hard. Saul's earnings were needed to supplement the family income, and soon became essential when Aaron became ill with leukemia, passing away when Saul was twenty-two years old.

Saul's poster for his high school's open house
c.1936

Howard Trafton (front row, second from left) teaching at the Art Students League
Saul is standing behind Trafton in a white shirt and dark tie.
1937

Figure drawing
Trafton asked students to study the work of a great painter (Saul chose Rubens), and to apply that style to their own work.
c. 1937

Art Students League

Saul's scholarship entitled him to one class per week for six months at the Art Students League. He worked in the day and therefore, in September 1936, enrolled in an evening class, "Layout and Design for Industry." It was taught by Howard Trafton, a well-known commercial artist highly skilled in illustration, lettering and typography whose work was influenced by European Modernism. During the three-and-a-half years Saul studied with Trafton, he learned a great deal not only about modern art and design but also about the artists of the past. The influence of Trafton's freely brushed letters and crisp modern typography can be seen in Saul's later work, but Saul mainly recalled Trafton's ability to explain the formal qualities of art and his insistence on honing drawing skills.[19] Whenever student designers asked Saul how best to prepare for their future careers, he always said, "learn to draw."

The layout class had a high fine-art content, but Saul was happy with the approach, realizing that to be any good at commercial art he had to learn about such things as form, color, perspective and composition. "Intuitively I understood that if I wanted to come to grips with design … I really had to understand the principles that made fine art work and Trafton gave me that. He believed that the fundamentals of color, composition and arrangement were the same for easel painting as for advertising. I learned about Cezanne, Picasso and African sculpture as well as the Renaissance masters and grappled with perspective, form and negative space. He revealed to me the rhythmic patterns that carry the eye from one area of a drawing to another by the arc of a hand, the curve of a cloud. In short, Trafton's class was exactly what I needed at that time."[20]

Some of Trafton's projects, such as drawing in extreme, almost distorted, perspective or against the light of a naked bulb, sought to force students to see things in new ways – a point of view at the heart of some of Saul's most memorable images. A more orthodox project required students to immerse themselves in the work of a great painter, with the expectation that careful study might reveal the inner wheels of the master. Saul, who always aimed high, chose Rubens, and spent hours researching the artist in the Metropolitan Museum of Art and the Morgan Library.[21]

During this project, Saul realized that a mechanical imitation of form, texture and technique could only lead to superficial results. "It never looks right until you dig in and you begin to understand … how all those dynamic rhythms cause a painting to work … Thus you find you think you're getting into a mechanical exercise, but it turns out you're getting at the guts of what makes it work." Saul went on to develop a remarkable ability to get at the guts of a project.[22]

6 Saul Bass

Composition study
One of Saul's many sketches after exploring the form, color and composition of works by Rubens.
c.1937

Starting Work

When Saul finished high school, unemployment was at a record high. Half the young people in New York had no job.[23] Saul was luckier than most, but his first two jobs were only loosely related to commercial art. First he worked for a label designer, but there he mainly ran errands and sobered up his employer. His next job was at a photo-offset plant, where he covered up spots on negatives with black paint. About a year after leaving school, he prepared his portfolio and took it around town to advertising agencies.[24]

He set about the task in an extremely systematic way: "I took a very obsessive point of view, which, incidentally, I've learned is very characteristic of me. I divided a map of Manhattan into sections and used telephone and trade directories to locate likely firms. I started on 42nd Street because there were a lot of studios and art services there. I'd spend a day or two in some of those buildings. I worked my way from the East River to the Hudson. I turned around and went up 43rd, across town to the east, 44th Street, 45th Street and so on. After three months I had reached 47th Street. Between Fifth and Sixth Avenues, on the north side of the street, I got lucky. I showed my work at a small studio run by two brothers and continued on my way. A day or two later I got a call."[25]

Saul landed a job in a small commercial art studio that designed trade ads for United Artists. Film ads in those days were regarded as the dregs of the advertising business, but Saul was happy; he was exactly where he wanted to be. This job marked the proper beginning of his career, and he sometimes mused on how he almost missed it. Saul was out when the offer came. His mother answered the phone and, because of her poor English, did not pick up all the details but was fairly sure the conversation had something to do with a job. Saul's meticulous, immaculately handwritten list of names, addresses and telephone numbers of all the places he had visited saved the day. He telephoned each studio on his list until he found the right one.[26]

At the time Saul entered the labor market, graphic design, then still often referred to as "commercial art" or "advertising art," was emerging as a specialized area of design. It was in the process of becoming a profession in its own right with a more upmarket name, as were industrial design and interior design. Despite the strides taken since the Arts and Crafts Movement toward affording applied arts the same status as fine arts, there remained a hierarchy, with painting at the top and arts related to manufacture and commerce at the bottom. In the 1930s, it was possible to study commercial art/graphic design at college level, but, fortunately for Saul, entry to the field remained fluid, not least because within design, advertising came low in the pecking order.[27] Yet Saul never felt he was selling himself, or art, short by becoming a commercial artist: "I had no idea anyone looked down upon advertising. I looked up to it."[28]

Gyorgy Kepes
Self-portrait
1931

Saul described himself as a subway scholar, reading voraciously during the hour-long subway journeys to and from midtown Manhattan and soaking up a wide array of imagery, from comic books and films to magazine covers. James Montgomery Flagg, J.C. Leyendecker and Norman Rockwell were among the American illustrators he admired. He also recalled seeing wonderful posters by Lucian Bernhard, the famous German designer, in the subway.[29] The Bronx, a hotbed of radicalism in the 1930s, was his university.

Saul remembered, "The Bronx was very Left in those days. It was hard not to be in the 1930s. Times were desperate and there was a great deal of injustice at home and abroad. Everyone I knew supported Roosevelt's New Deal. We admired those who went to fight in Spain, and we opposed fascism in Italy and Germany. We all read Marx and Freud and voted for Roosevelt. We were searching for keys – keys to full employment, keys to understanding fascism, keys to understanding racial discrimination, keys to understanding the human psyche."[30]

Saul desperately wanted to produce art, but there was little room for creativity in movie trade advertising, which was dominated by what Saul called the "See, See, See" approach to design – "See the missionaries boiled alive! See the virgins dance in the Temple of Doom! See Krakatoa blow its top!"[31] Nevertheless, Saul gained valuable experience in rendering and tidying up roughs. His aptitude for lettering stood him in good stead, and he learned a lot about typography from a typeface designer who rented a desk in the same studio.[32] Endlessly curious and extremely personable, Saul had a remarkable capacity for listening and learning. That typographer was just one of many people who, throughout Saul's life, took a liking to him and enjoyed sharing their knowledge and skills.

Saul's wages of twenty dollars a week placed him among the higher-paid young workers in the city, on a par with many skilled workers and foremen.[33] In about 1938, he was offered twice as much to work for Warner Brothers as a "lettering and paste-up man."[34] The film industry was thriving, and in 1940, assured of steady work and good wages, Saul married a neighborhood girl, Ruth Cooper, and they set up home in Parkchester, a smarter part of the Bronx.[35] Their son Robert was born in 1942 and their daughter Andrea followed in 1946.

In about 1941, ad executive Jonas Rosenfield (who was later to engage Saul to work on the advertising campaign for *No Way Out*, 1950) recommended Saul to Twentieth Century-Fox as a "layout man." "I was struck by his intelligence, and by a willingness to experiment," Rosenfield recalled.[36] It was a big step up, and Saul now earned 100 dollars a week working in the "bullpen," as the large studio packed with (male) designers was known.

Saul set himself extraordinarily high goals. He wanted to introduce to film advertising the high standards set by the art directors of glossy magazines. He recalled, "I could see all around me exciting stuff by Cassandre, Paul Rand, just a few years older than me, Alexey Brodovitch and others, but I was in the ass-end of the industry. I was young enough, naive enough, and sufficiently cocky to believe I could elevate movie advertising to the standards set by Man Ray's Rayographs and Jean Cocteau's films and illustrations."[37]

Although Saul did have a greater say in advertising campaigns, conventions within the industry continued to favor fixed formulae and "cramming as much illustration, type and hype as you possibly could into ads."[38] His frustrations mounted as his more stylish efforts were continually knocked back. He found producing "potpourri" ads or ones featuring Betty Grable's famous legs (insured for a million dollars) profoundly depressing. Some time before 1944, Saul left the studio, vowing never again to work in film advertising.[39] So keen was he to be a "proper" art director that he took a fifty percent wage cut and joined the Blaine Thompson Company, a prominent New York agency, with the proviso that he would not work on movie ads. He designed ads for a range of products and Broadway shows and, for the first time in a few years, was happy with the type of work he was doing.[40]

Gyorgy Kepes & European Modernism

It was while he was working at Blaine Thompson that Saul met Gyorgy Kepes, the Hungarian-born artist, designer and teacher, who was to have an enormous influence upon him. Saul often told the story of how, casually browsing in a bookshop, he discovered Kepes's *Language of Vision* (1944), a seminal publication that featured contemporary American advertising and student exercises – all heavily influenced by the Bauhaus and other European Modern Movement design. To Saul's astonishment, the blurb on the book's cover noted that Kepes, who had worked in Germany with his compatriot and former Bauhaus teacher, László Moholy-Nagy, and had headed the Light and Color Department at the New Bauhaus in Chicago, taught advertising design, and was now teaching at Brooklyn College. Saul enrolled immediately.[41]

Kepes helped transform the ways in which Saul thought about design, helping him make the transition from a talented designer with a burgeoning interest in Modernist graphics to a major player. It is difficult to know exactly how well acquainted with Modern Movement design Saul was before he met Kepes. He was familiar with some modern art and design through Trafton's classes, with "modern" expression in French, German and Soviet cinema, loved surrealism – especially Magritte – and greatly admired Man Ray, Cassandre, Paul Rand and others whose designs appeared in Kepes's book. He had read Moholy-Nagy's *The New Vision: From Material to Architecture* (first published in English in 1932), but his knowledge was piecemeal and mainly visual.[42] That would change with Kepes's class. Kepes took a highly intellectual approach to design. He believed that visual tensions produced by certain combinations of visual elements form the basis of a universal language of vision, and that graphic design and motion pictures could play a major role in changing the world because they were less hidebound by tradition. Such ideas resonated with Saul's political beliefs and artistic sensibilities, while the elevation of graphics and moving images to the top of the artistic hierarchy validated Saul's own area of work in ways that no one else had done.

Many graphic designers besides Saul have testified to the excitement of studying with this most gifted and evangelical of teachers.[43] Reminiscing about the fast learning curve he experienced, Saul said that he felt as if he had discovered "The Word" and described Kepes as opening up a new world for him.

"Trafton brought me into the room and led me to the door. I tried it. But it wouldn't open. And Kepes said, 'To the left.' I turned it. The door opened.

"He really just set me on fire...I felt...like my pores were palpitating, you know? I was so excited and so upset – in a good way – that it would take me hours to settle down after each class. And indeed I had plenty of time. It was a two-hour subway ride from Brooklyn College to where I lived...but it was well worth it."[44]

Although the basis of his training with Kepes was in Bauhaus-style graphics and the "New Typography," Saul increased his familiarity with other aspects of European Modernism, from Cubism and Constructivism to De Stijl and Surrealism. Saul's fascination with psychology ensured that he soaked up Kepes's views on the importance of the psychological responses to design.

OKAY, YOU CAN GET DOWN NOW, GERTRUDE...

We were thinking how to show you the kind of absolute control you get with Tylon, and in walked Gertrude. We'd forgotten the appointment. She hadn't, of course. You know how it is with elephants. We persuaded her to demonstrate what we mean. Cost us a few bales of hay, but it seems worth it. • Absolute control and perfect balance in all Tylon cold wave solutions—that's gospel. (Okay, you can get down now, Gertrude.) That's what keeps its popularity soaring. • That, plus the fact that you can give three Tylon cold waves in the time it takes for two others. Makes it nice for everybody. Speed . . . simplicity . . . absolute control. Just what you're looking for, isn't it? (Okay, you can get *down* now Gertrude!) • And that reminds us, big things are happening at Tylon. More excitement than a circus! George Barrie came over as vice-president and general manager, and John Zerbo joined us as technical director in charge of product development. (Gertrude, get *down* will you—the performance is over!)

Tylon COLD WAVE • contains genuine TYO

Tylon Products, Inc., 251 E. 139th St., N. Y. 51, N. Y.

Tylon Cold Wave
Saul's first design award from the New York Art Directors Club was for this Bauhaus-influenced print ad stressing the perfect balance achieved by using Tylon Cold Wave. This black and white version was published in a design journal. The original had touches of red, probably the circle, ball and triangle.
1945

Kepes's student exercises in *Language of Vision* remain instructive models. "The basis of every living process is an inner contradiction," wrote Kepes, "The living-quality of an image is generated by the tension between the spatial forces; that is, by the struggle between the attraction and repulsion of these forces."[45] Similar exercises at Brooklyn College led Saul to a greater understanding of this and other things such as dynamic equilibrium, compression, the unity of opposites, the interpenetration of lines and planes and the physical modulation of light.

Saul's work changed dramatically, becoming more dynamic and abstract. The Modernist concern with paring away the extraneous and the decorative marked Saul's work thereafter, and he developed greater facility with, among other things, montage and the expressive possibilities of lettering and typography.

Kepes recognized Saul's talents and invited him to collaborate on several projects, including an exhibition for the Office of War Information and the French Government about American public housing during World War II (1945).[46] At the age of twenty-five, Saul was playing in the major league. Through Kepes and the New York Art Directors Club, Saul came to know as colleagues and friends the most progressive graphic designers working in New York, including Herbert Bayer, Alexey Brodovitch, Will Burtin, Herbert Matter and Paul Rand.[47]

Saul applied what he learned in Kepes's class to his work. His advertisement for a hair product (Tylon Cold Wave), which resulted from one of Kepes's exercises based on spatial tensions, won Saul his first award from the New York Art Directors Club. It broke generic conventions by not referring to beautiful hair or glamorous transformations, instead using the idea of balance to link the written and visual messages.[48]

Just as he was establishing a reputation in product advertising and collaborating with Kepes, however, Saul was recalled to movie ads. Blaine Thompson was having trouble with the Warner Brothers account and Saul was needed to rescue the situation. Remaining on the company payroll, he was housed at Warner Brothers' New York offices.[49]

While there, Saul's colleague, Paul Radin, was asked to head the new Los Angeles office of Buchanan and Company, the fifth-largest advertising agency in the United States, which undertook work for TWA (Trans World Airlines) and Paramount Pictures. On Radin's recommendation, in 1946 Saul was offered a huge salary increase to work as art director/pitchman in Hollywood.[50]

Saul recognized that, although New York remained the center of the film advertising industry, changes were afoot that promised new opportunities for designers. In New York there was a gentleman's agreement that a studio did not renege on an advertising contract even if it disliked the campaign. Buchanan and Company, however, felt that the new independent producers and directors could not be relied upon to adhere to this agreement and that someone was needed to deal with them directly on their home turf.[51] Saul's contract was only for two years, but he felt he had to seize the moment.[52]

Saul at the Garden of Allah
1946

Love Affair with Los Angeles

With a booming postwar economy, the glamour of Hollywood and a garden-like landscape nestled between pristine mountains and the blue Pacific, Los Angeles in 1946 was a vision of splendor to a young art director from the East Coast. "You can't imagine how beautiful it was then – clean beaches, not much traffic and endless sunshine. The Garden of Allah, the legendary hotel on the Sunset Strip where the agency had rented accommodation for me, was as exotic as any film set."[53]

Built in the 1920s for the equally exotic Russian actress and film director Alla Nazimova, the Garden of Allah was home to glamorous stars and literary figures such as F. Scott Fitzgerald, Robert Benchley and Dorothy Parker. There, and at work, Saul rubbed shoulders with all manner of fascinating people. A film fan since his youth, the first few years proved "pretty heady stuff."[54] Saul supervised photo sessions with Paramount stars like Charlton Heston, Veronica Lake and Brian Donlevy, and dined at Romanov's with one of his favorite stars, Olivia de Havilland. By 1950 he was enjoying working lunches with one of his most admired directors, Preston Sturges – yet another person who took a particular liking to Saul.[55]

There were, of course, a few surprises. Saul had assumed that a decade of working in New York advertising meant that he could cope with anything dished out in Hollywood, but, as he later remarked: "You don't know how wrong I was about that! But I can be abrasive when I need to be. It was the knowledge that I could be tough if necessary that enabled me to survive in Hollywood."[56]

Saul was fortunate to find kindred spirits. After a particularly inspiring lecture by Kepes in Los Angeles, he and a few friends, including Alvin Lustig, Lou Danziger, John Follis and Rudolph de Harak, founded the Society of Contemporary Designers. Lustig designed the announcement graphics in 1950 and Saul the catalog cover for the group's first annual exhibition.[57] That group was fairly short-lived, but more important in terms of long-term support networks was the Art Directors Club. Membership was small but meetings, held in the bar of the Masquers Club in Hollywood, proved jolly affairs. Robert Guidi and Lou Danziger, both of whom occasionally freelanced for Saul, and Jack Roberts, whose agency put work Saul's way, were among the regulars.[58] Saul recalled: "Art directors were frequently seen

12 Saul Bass

Two views of the Garden of Allah
This legendary hotel on the Sunset Strip was Saul's first home in Los Angeles.
c. 1930

Saul with friends
Possibly at an early Society of Contemporary Designers or Art Directors Club meeting.
c. 1950

as oddballs or eccentrics, who didn't know about business and couldn't spell... sometimes we were treated like talented and adorable – but slightly dim – children... for a few of us, the Art Directors Club served variously as an emotional outlet, professional validation, group therapy and social club. We huddled together for warmth, and while in the huddle laughed a lot and learned a lot, as well."[59]

At the time of Saul's arrival in Los Angeles, the city was a Mecca for young artists and designers. The thriving progressive, creative and cultural life dated back to the 1920s when Aline Barnsdall, Louise and Walter Arensberg and others patronized modern art, architecture and design. Photographer Edward Weston, artist Rockwell Kent and the young Lloyd Wright congregated at Jacob Zeitlin's radical bookshop, while more politically focused artists, designers and intellectuals gravitated to the circle around the Viennese Modernist architect Rudolph Schindler. Other émigrés who lived there in the 1920s and 1930s included architect Richard Neutra, filmmakers Josef von Sternberg, Billy Wilder and Oskar Fischinger, weaver and designer Maria Kipp, composers Igor Stravinsky and Arnold Schoenberg and writers Aldous Huxley and Christopher Isherwood. Many figures in the film industry were known for their interest in and promotion of contemporary art and design, including Wilder, von Sternberg, Vincent Price and Edward G. Robinson.[60]

In 1940, Man Ray moved to Southern California and exhibited in the Sunset Boulevard gallery, then recently opened by Frank Perls, whom Saul remembered as one of the great showcasers of avant-garde art and design. Bertolt Brecht, Thomas Mann, Theodor Adorno and Ray and Charles Eames were among the new arrivals of 1941. In 1942, designer Margaret Harris and architect Griswold Raetze left MGM's art department to join the small team working with the Eameses to develop plywood and metal products. Architect Gregory Ain, sculptor Harry Bertoia and photographer Herbert Matter also joined the Eames office that year. In 1946, Alvin Lustig moved back to Los Angeles, where he designed interiors, furniture, textiles and buildings, as well as the graphics for which he is better known.[61]

Saul in Los Angeles
c. 1951

Arts & Architecture
Saul designed this cover
for the Los Angeles magazine
that published the work of
the most progressive
Modernist architects and
designers of the period.
1948

14 Saul Bass

Saul with students
Kahn Institute of Art,
Advanced Advertising
Class, Los Angeles
1949

Other designers contributing to what is now known as "L.A. Modernism" at the time of Saul's arrival included architect and product designer Greta Magnusson Grossman, landscape designer Garrett Eckbo, glass designer Dorothy Thorpe, textile designer Dorothy Liebes, fashion and film costume designer Bonnie Cashin, potters Otto and Gertrude Natzler, Edith Heath and Peter Voulkos and the group around *Arts & Architecture*.

The Los Angeles-based and internationally influential magazine *Arts & Architecture* had a considerable influence on many of Saul's generation: "It spoke of things I wanted to hear and was receptive to."[62] Edited by John Entenza and packed with Modernist images, it favored all things progressive, commenting on a wide range of activities, from art, architecture, design, photography and film to dance, music and politics. It featured individuals whose work Saul admired, from Kepes and Moholy-Nagy, to Hans Hoffman and Mies van der Rohe. Saul remembered particularly the freshness of the graphics of Matter and Lustig and the photographs of Julius Shulman.[63]

At first Saul did not feel able to approach the well-known people who put together the magazine; "I was one of the younger kids in town. Even Charlie Eames, whom I later knew to be extremely approachable, seemed 'way up there' – his exhibition at the Museum of Modern Art (1946) really put him on the map."[64]

By 1948, however, Saul was sufficiently well regarded to be asked to design the cover for the November issue. In the "functionalist" prose then popular with the *Arts & Architecture* crowd, he explained that the forms represented "man's conflict" and that the "natural machine" – the egg – was "a symbol not only of order but also of purposeful growth," while the "air machine" – a hot-air balloon – suggested "man's struggle … to pass on to new stages of development."[65]

From the Beginning 15

A New Mood in Hollywood

At Buchanan and Company, Saul continued to learn from working to short deadlines on a range of advertising for journals such as *Daily Variety*, *The Hollywood Reporter* and *Motion Picture Daily* as well as popular magazines. For the most part, his experience in Hollywood in the late 1940s and early 1950s confirmed his opinion that the abysmal state of film advertising lay in the inability of studio publicity executives to credit cinema-goers with intelligence or taste.[66] But the nature of films was changing, partly in terms of content but also because of competition from television – opening up new possibilities for designers like Saul.

As writer and filmmaker Ephraim Katz noted: "The films produced by Hollywood in the late forties and early fifties reflected both the great upheavals in the industry and the general social conditions of the postwar years. No sooner had the nation sobered up from the intoxication of victory, than a new mood and new realities surfaced in American life and on the American screen. The romanticism of the prewar era and the patriotism of the flag-waving days now gave way to a new naturalism and a willingness to face up to psychological and social issues in a realistic, often cynical way."[67]

The days of the studio system, wherein movie moguls ruled over huge empires of stars, directors, cinematographers, art directors, costume designers and other personnel, were numbered. Even before the major studios' monopolistic control over the distribution of films was ended in 1948, independent producers and directors were already planning and making new sorts of films in new sorts of ways. Saul found that more creative approaches to advertising usually went hand in hand with more creative filmmaking.[68] The modernity of the content of certain films helped the acceptance of modern forms in advertising, and it is no coincidence that Saul's most important work in the late 1940s and early 1950s was either for independent producers and directors or for films with topical subject matter – and often both.

The first independent with whom Saul worked was one of his all-time heroes, Charlie Chaplin. The campaign was for *Monsieur Verdoux* (1947). Unfortunately, Saul's designs were buried in the battles between the distributing company (United Artists) and Chaplin's company and ultimately were not used. Meeting Chaplin, however, was another highlight of Saul's early Hollywood years.[69]

"I may have been the young kid in the office but I was the creative person and that made a difference in Hollywood – at least with other creative people. I'll give you an example. Charlie Chaplin was making *Monsieur Verdoux* and our agency was doing the advertising. Chaplin was mega-famous by then and a great hero of mine. We – the account executive and me – went to his studio for him to talk us through the story. We ended up being there almost the whole day. There was a piano on the stage in his screening room but he didn't show us the film. He sat at the piano and played, sang and talked. He went through the entire film with music, voices, dialogue and sound effects.

"He'd say 'then he took out the bills – ffrrrrrrtt!!' You know, he really did the ffrrrrrtt of the bills. You remember the way Monsieur Verdoux was able to count those bills? What was as amazing to me was that he ignored the account executive and focused on me – the other creative guy, the person who was going to create the ad. It was director-creative director to creative director of advertising, which was remarkable in those days given the hierarchies… We didn't talk advertising. He was simply saying, 'That's the movie. Work from this'."[70]

The Men
(Opposite) Magazine ad
1950

Death of a Salesman
(Opposite) Magazine ad
1951

Champion
(Opposite) This breakthrough ad reversed convention by placing a tiny image of the stars "like a bullet" within an expanse of black.
1949

Champion
Alternate ad
1949

Although the bulk of the bread and butter motion picture advertising that Saul designed or art directed for Buchanan cannot be identified, several campaigns for Stanley Kramer are documented. Kramer was the independent producer/director who most furthered Saul's career during this period. Saul's bold trade advertisements for *Champion* (1949, dir. Mark Robson), a film about the seedy world of boxing and the tragedy of success, caused quite a stir when they appeared in *Life*, *Look* and other magazines.[71]

Champion was made by the "hot new creative team" of Stanley Kramer (producer), Carl Foreman (writer) and George Glass (advertising) that was responsible for a series of "social conscience" films, from racism in the U.S. Army (*Home of the Brave*, 1949, dir. Mark Robson) to paralyzed war veterans (*The Men*, 1950, dir. Fred Zinnemann) and a critical commentary on McCarthyism (*High Noon*, 1952, dir. Fred Zinnemann).[72] They were denounced for producing "Red-slanted, Red-starred films," but Saul admired what they were trying to do.[73] He created advertising for the three films mentioned above as well as six other Kramer productions: *Cyrano de Bergerac* (1950, dir. Michael Gordon); *Death of a Salesman* (1951, dir. Laszlo Benedek); *The Sniper* (1952, dir. Edward Dmytryk); *The Member of the Wedding* (1952, dir. Fred Zinnemann); *The Four-Poster* (1952, dir. Irving Reis); and *The Happy Time* (1952, dir. Richard Fleischer).[74]

From the Beginning 17

No Way Out
Magazine ad
1950

Decision Before Dawn
One in a series of large-format newspaper ads.
1951

Fast upon the success of the *Champion* campaign, Saul was involved in that for *No Way Out* (1950, dir. Joseph Mankiewicz), a controversial Twentieth Century-Fox film about racism in America. It was made in response to the popularity of "new wave," "adult-theme" and "issue" films in general, and to *Champion* in particular. Given the potentially explosive nature of the theme and the sympathetic foregrounding of a black man (played by Sidney Poitier), the studio decided that the advertising needed very careful handling. The pressure on the in-house design team not to get it wrong, however, meant that nothing suitable emerged. Jonas Rosenfield, head of advertising, brought in Paul Rand and Erik Nitsche. When they did not produce material with which he felt entirely confident, Rosenfield turned to Saul, whom he had admired since the early 1940s.

According to Rosenfield: "There were so many concerns about what you could and couldn't reveal that our office wasn't able to come up with a campaign. We commissioned work from Paul Rand and Erik Nitsche, which was quite good. But we were still concerned. Saul was in New York, and he came in to talk about it. I told him I needed the work Monday morning. He said he was staying over the weekend at the Algonquin, so we had a drawing board delivered to his hotel room. He worked all weekend at the hotel and on Monday morning he came up with the campaign."[75]

This campaign is extremely significant in the history of Modernist movie advertising. The press book referred to the "history-making new conceptions of graphic art" and, together with Erik Nitsche's campaign for *All About Eve* (1950, dir. Joseph Mankiewicz), it put Modernist graphics on the map in terms of film advertising. A trade ad by Nitsche was regarded as sufficiently arresting to feature on the cover of the *No Way Out* press book, while Rand's brilliant billboard design is on the back. Both men had their names on their designs but Saul's do not bear his, probably because he was not a freelance designer at the time. Indeed, Saul did not sign his film advertising designs until about 1954, and even then not consistently. The signature notwithstanding, Saul was on his way to becoming "Saul Bass."[76]

Rosenfield used Saul again for *Decision Before Dawn* (1951, dir. Anatole Litvak), about German prisoners of war spying for the Allies during World War II, for which Saul created yet another arresting Bauhaus-influenced campaign that captured the essence of the film. A contemporary journalist commented: "As simply as that it conveyed the time and locale, the mood of suspense that dominates the picture, and the idea of the chase on which the plot turns."[77]

Howard Hughes & RKO

In 1950 Saul changed job yet again. He had gone to Los Angeles as an art director and designer, but found he was spending much more time than he wanted on matters unrelated to design. "I found myself suddenly running that office. I was the designer, art director, account person and office head. I talked to the producers and to the directors. I found the business and I executed it. It was an extraordinarily valuable experience, but in the end I looked at it and said, 'This is not what I want my professional life to be about. I really just want to design.'"[78]

In order to return to being an art director, and with the prospect of more challenging work, Saul moved to Foote, Cone & Belding to work on the RKO account. This meant working directly with the owner of the studio, millionaire Howard Hughes, whom Saul described as "a genuine eccentric."[79]

"When I completed the layouts for a campaign, I'd call a special number.
The lady who answered was named Dora.
I would tell Dora I was ready.

"From then on I'd carry the new campaign in a portfolio in the trunk of my car. Everywhere I went (to restaurants, shops, theaters) I left phone numbers so I could always be reached.

"A few days … maybe a week later, I would receive 'the call.'

"It was Dora. She would typically say, 'meet Mr. Hughes at the northwest corner of Camden and Santa Monica Boulevard at 11:30 pm, Tuesday night.'

"So there I would be on Tuesday night, on the northwest corner of Camden and Santa Monica at 11:30 with my portfolio under my arm. Waiting.

"At precisely 11:30, the limo pulled up. The door opened.

"There was Hughes as advertised. Unshaven, tennis shoes, casual trousers, open-necked white shirt and blue blazer.

"I climbed in. Sat down.
Not too close.
The light would go on.
The limo would head off.

"The discussion might take five minutes, twenty minutes, a half hour. But the moment it ended, the limo would stop.

"The door would open.
I don't know how he did it.

"But there I was … back on the corner of Camden and Santa Monica Boulevard.

"That was communing with Hughes."[80]

While these unusual episodes enlivened Saul's life, it was soon apparent that, although he had more time to spend on design, he had little creative freedom. Recalling this period, Saul stated: "In terms of the advertising for his films, there were some special projects that Hughes personally wanted to do. I was hired mainly to work with him. I didn't know too much about Hughes but figured I could bring enlightenment to 'Darkest Africa.' It didn't turn out to be that way.

"A man of myopic obsessive temperament, his notion of a good film ad was to use pretty hard-boiled photographic kind of illustration. I was naive and really believed I could sway people by doing what I thought were wonderful designs. But I didn't understand just how rigid he was. In the end, it was very restrictive. I felt very claustrophobic and knew I had to escape from Hughes's myopic point of view. I'm a night bird so it didn't matter to me that he liked to meet at odd hours and in crazy places. That part was interesting and amusing. But I didn't count on the fact that he would be so totally rigid. I lasted just more than a year."[81]

Saul's first office
The garage at his home in Altadena (one of the Gregory Ain Park Planned Homes, with landscaping by Garret Eckbo) was converted into a studio and darkroom.
c.1953

An Office of His Own

In 1952, Saul decided to branch out on his own. The proposed sale of RKO, scheduled for September of that year, offered an appropriate moment to leave Foote, Cone & Belding. Anxious to retain some connection with this talented designer, the agency offered Saul free office space and facilities in return for his designing two or three campaigns a year. He ran his office from there for a while and had more than enough freelance work to keep him busy. Saul soon realized, however, that free office space was less important than professional maneuvering space.[82]

He worked from home for a while, before moving in 1954 to office space at the corner of Highland Avenue and Franklin Avenue that he shared with two other designers, and by 1956 he had his own premises at 1778 Highland Avenue in Hollywood.[83] Joe Youngstrom was Saul's production assistant, but the office was effectively a one-man concern. Saul typed his own letters and his lawyer handled contracts.[84] In December 1956, when Saul was immersed in several major commissions and the planning of that year's International Design Conference in Aspen, Elaine Makatura was hired as an assistant. This was the beginning of a collaboration that would last for forty years.

From the Beginning 21

Elaine Makatura Bass

Seven years younger than Saul, Elaine's route to working in design and film was even more circuitous than his. The youngest child of Hungarian immigrants, she came from a larger, poorer, but more musical New York family than Saul. Like him, she showed early promise at art and exercised her cinematic imagination by creating stories and drawing them, frame by frame, on the sidewalk to entertain the other children in the neighborhood. Her talents won her admission to the New York High School of Music and Art at the age of twelve, but she was unable to attend due to the difficulty of combining her school schedule with that of singing professionally with her sisters. Similar to the Andrews Sisters, they sang as the Belmont Sisters (their agent felt "Makatura" sounded too ethnic).[85]

The group began in vaudeville when Elaine was twelve. She was lead singer and soloist, and recordings made when she was fourteen to eighteen reveal a surprisingly mature voice singing swing with touches of Billie Holiday. During World War II, the group sang in service clubs and enjoyed a regular radio spot, but soon after the war ended the older sisters left to get married. Elaine recalled, "I was eighteen years old and I had lost what I had been doing professionally for six years. I would have loved to continue but was far too shy to sing on my own. I loved music and art but had no clear plan for my future."[86]

Elaine went to work in the New York ready-to-wear fashion industry, producing fashion renderings and sketches and working up design ideas for several fashion houses. She first moved to Los Angeles in 1947, settling there permanently in 1954. Soon thereafter she found a job in the design department at Capitol Records. She recalled: "After about a year I was looking for something more challenging when someone told me that Saul Bass was looking for an assistant. I had enjoyed the credits for *The Seven Year Itch* very much but the name 'Saul Bass' didn't mean anything to me."[87]

Elaine Makatura
1948

Sketch of a woman
c. 1960

Elaine and her sisters
In the early 1940s, the girls began singing professionally as the Belmont Sisters. Here they are having fun on the roof of their New York apartment building. Veronica on the violin, Lillian, Christine and Elaine in front.
1932

Once in the office, Elaine found herself developing skills and interests that had lain dormant as well as ones she didn't know she possessed: "I knew I could draw well but had never thought that I could contribute to making film titles or short films. The more my ideas were appreciated by Saul and others, and the more they worked out in practice, the more confident I became about putting them forward."[88]

By 1959 Saul was delegating important tasks to Elaine. When he attended the World Design Conference in Japan in 1960, for example, Elaine was left in charge of producing and directing the *Spartacus* title sequence.[89] The following year, she and Saul were married. After the birth of their children, Jennifer in 1964 and Jeffrey in 1967, she concentrated on motherhood and filmmaking – short films as well as title sequences.

Many people saw Saul and Elaine as soulmates. At first one noticed the differences between them, but the way they complemented each other and the balance of their personal and professional relationships soon became apparent. Their closeness was rooted in similarities and shared interests as well as the joining of yin and yang. She was soft-spoken, serene, more retiring and happiest out of the public arena; he was voluble, energetic and gregarious, with a strong, passionate voice and hugely expressive gestures. Yet when they first met they already shared an intellectual intensity, similar aesthetic sensibilities and views about art and design. Each was extremely disciplined, with a profound respect for hard work, and at the center was the excitement of creativity and the thrill of working together. Indeed, throughout and behind the work, theirs was a great love story.

Elaine, Saul and Joe Youngstrom
c. 1957

Ink and brush sketch of Tippi-Tu
Saul and Elaine's cat was featured in the roughs for *Walk on the Wild Side* (an 'actor' cat starred in the final sequence).
1961

Sketch of daughter Jennifer
1964

Saul Bass & Associates

Shortly after Elaine went to work for Saul, he hired a business manager, Morris Marsh, who was responsible for sales and workflow, and the office became known as Saul Bass & Associates (SB&A). Saul brought in freelancers – illustrators, photographers, calligraphers, designers and architects – as and when he needed them until 1960, when he hired his long-term freelancer, Art Goodman, as his first full-time designer to help with the realization of design concepts.[90] Art Goodman would go on to become Saul's right-hand man. Goodman's assistant, photographer George Arakaki, was also hired in 1960, as was production manager Nancy von Lauderbach. All three stayed for more than thirty years.[91]

In 1959, *Design Forecast* noted there were seven people in the office, but it grew steadily during the 1960s, reaching forty employees by 1969. In 1975, Saul brought in a new business partner. Herb Yager, an energetic marketing executive who had experience working in advertising agencies with large corporate accounts, enabled Saul to focus on design. Saul appreciated Yager's sharp analytical mind and enjoyed working with this younger man who also came from the Bronx, and in 1978 the office became known as Bass/Yager & Associates (BY&A). However, it remained centered around Saul even through the boom years of the 1980s, when as many as fifty people were employed.[92]

Saul always acknowledged the talents and support of his dedicated staff, without whom he could not have worked so effectively or prolifically, particularly Art Goodman. Reflecting on his dear friend, Saul described Art as "shy, funny and self-effacing, but undoubtedly one of the most gifted people I've ever known."[93] But it would be a mistake to think that Saul handed over control, especially on the design side. In 1968, *Communication Arts* emphasized that the graphic design work remained "primarily an individual creative effort."[94]

Goodman himself stated: "Many people simply couldn't believe that all the creativity stemmed from one person. They saw how prolific he was and thought it had to be coming from others. What they didn't realize was just how well organized he was; he had that office buttoned down so tight precisely so that he could concentrate on designing and making films. I always reported to him every day. Even after twenty years I'd feel guilty if I let a small thing through without his 'OK.' That business was Saul. Everything flowed from him and from his huge energy. He took on so much yet never saw himself as overworked."[95]

Goodman was central to Saul remaining the creative nerve center. In him Saul found what most major designers dream of: an extremely talented right-hand man who could work up sketches in ways Saul wanted and add to the existing creative mix. Goodman, who found in Saul a big brother, friend and mentor, recalled, "Saul was everything I'd always wanted in a colleague or a boss. He went for that extra percentage and, with him, you achieved things you never dreamed you were capable of. Saul knew exactly what he wanted to do and I would visually explore different ways of expressing his concept. If, in the process of that exploration, other more interesting ideas surfaced, we would develop those together as well. Any idea that answered the criteria was welcome."

"Sometimes," Goodman added, "we would exchange ideas ranging from absurd to brilliant to arrive eventually at appropriate solutions. Those meetings were the most exciting and fun. Saul, in the end, would always cut to the core of the problem and flush out the best solutions. He had a wild sense of humor and would invariably bring me to tears of laughter. Working with Saul was a joy. He was an extraordinary guy who changed my life. I grew as a designer and a person. It was thrilling to be part of his journey as a designer and filmmaker but, had I wanted to press my own point of view or go in directions Saul's work was not headed, then it would not have worked. That applied to the whole

Early Bass office
(Opposite) A house at 7758 Sunset Boulevard was home to the office from 1959–65. Amongst the staff at the time were (back row, far left) Morris Marsh, (center) Art Goodman, Dave Nagata, George Arakaki and accountant Al Rothman; (bottom row, left to right) Phyllis Tanner, secretary Judy Rose, Joe Youngstrom and Elaine.
c. 1961

Bass / Yager & Associates
The back patio at 7039 Sunset Boulevard, where the office was located from 1965–96. Saul and Herb Yager at far left, Art Goodman in front.
1978

Art Goodman in his office
1978

office. Some younger designers came in not understanding fully that Saul was the office. Those with strong egos or a determination to develop their own style and forge their own paths left fairly quickly – usually with Saul's blessing, because he understood their needs and ambitions."[96]

Those that stayed enjoyed the journey and learned along the way, recalling the camaraderie and the casual but highly professional atmosphere. Space does not permit a chronicle of the history of the office and the input of each employee but, where known, individual contributions are included in the notes.[97] The chapters that follow indicate the range, quality and sheer quantity of output from the Bass office, in both design and film, over a period of forty-four years.

From the Beginning 25

FRANK SINATRA CONDUCTS
TONE POEMS OF COLOR

Purple, The Schemer / Billy May
Yellow, The Laughter / Jeff Alexander
Brown, The Earthbound / Jeff Alexander
Orange, The Gay Deceiver / Nelson Riddle
White, The Young In Heart / Victor Young
Gold, The Greedy / Nelson Riddle
Gray, The Gaunt / Alec Wilder
Red, The Violent / Andre Previn
Silver, The Patrician / Elmer Bernstein
Green, The Lover / Gordon Jenkins
Blue, The Dreamer / Alec Wilder
Black, The Bottomless / Victor Young

DESIGNED BY SAUL BASS

Capitol Records
HIGH FIDELITY RECORDING

2

Renaissance Designer

… becoming Saul Bass

… Saul Bass disposes of a rich scale of forms of expression and an astoundingly vast artistic range … [that reveals] the wit and fertility of a felicitous imagination.[1]

Ludwig Ebenhöh, Gebrauchsgraphik, *1956*

Tone Poems of Color
Album cover
1956

Saul at his desk
late 1950s

Saul in his office
Hollywood, California
c. 1960

John Westley Associates
(Below) Folder for a New York
direct mail advertising firm.
c. 1953

Committee of Aluminum Producers
(Opposite, upper left) Logo
for a group representing three
industry leaders (Alcoa, Kaiser
and Reynolds).
1960

Oakbrook Shopping Center
(Opposite, center) Symbol for
a commercial development,
west of Chicago.
c. 1960

Joseph Eger Ensemble
(Opposite, right) Program cover
1953

Going independent in 1952 proved to be one of the most important career moves Saul ever made. In the decade after he established his own office, he undertook a greater variety of work than probably any other graphic designer in the United States at that time. The stretch from film advertising to product design, architecture, film title sequences, television commercials and visual consultancies in the film industry can be accounted for only partly by the need to sustain a fledgling business. One gets a strong sense of Saul constantly reaching out for new challenges. He considered the best designer to be one who had an open mind to life as well as to design: "The only way I work as a designer is to consciously avoid specialization. It happens to be my way and it suits my needs and attitudes very well. It may well be all wrong for some others."[2]

It is tempting to put Saul's work into neat compartments; first he did this, then he did that. In reality, he was juggling many different things at the same time. A 1950s article about advertising in Los Angeles noted that a few of the younger designers "point the future to a new kind of Renaissance designer... the man who not only tackles a flat graphic two-dimensional problem, but also solves the design of a building, packaging, a TV show, an exposition, or a film."[3] No designer in Los Angeles fitted this description more closely than Saul. New types of designers tended to be dependent on new types of clients. Saul's clients in the 1950s and 1960s included relatively young entrepreneurs seeking to market new ideas, and independent film directors and producers who also sought modern expression when advertising their products.[4]

Saul's work began to attract more attention in the design press; those who interviewed him were impressed by his versatility and fascinated by the combination of his ultra-serious intent and lighthearted spirit. Saul also began to be known as someone who could write and speak about design in engaging, informed and challenging ways. What stands out most, however, is the sheer variety and amount of work undertaken. Remarkably, in the same years Saul was making a name for himself in the design world, he was garnering equal attention in Hollywood for his pioneering work in the development of movie title sequences – the subject of the following chapter.

Renaissance Designer **29**

Saul as Program Chairman
Aspen, Colorado
"Design & Human Values"
1957

Relaxing in the Herbert Bayer Sculpture Garden
Aspen, Colorado
mid-1950s

Call to the Conference
Poster
1960

International Design Conferences

Encouraged by Gyorgy Kepes, Saul attended the first annual International Design Conference in Aspen, Colorado, in 1951 at which Charles Eames, George Nelson, Louis Kahn and Herbert Bayer were among the speakers. He was hooked from the start: the intensity of the debate spoke to the intellectual in him, while the relaxed sophistication and socializing with like-minded people appealed to his gregarious side. The conference, founded by Walter Paepcke, CEO of the Container Corporation of America (CCA), with the assistance of Egbert Jacobson and Herbert Bayer, grew out of a moment in the twentieth-century alliance between commerce and culture and helped frame design discourses in the United States. It brought together business executives, designers, architects, curators, educators and others around a loose agenda of design reform in conjunction with and through the transformation of corporate culture.[5]

In typical fashion, Saul threw himself wholeheartedly into the new venture. He spoke at several conferences, was active at organizational and policy-making levels, and helped establish a permanent organization, the IDCA (International Design Conference in Aspen) in 1955.

Aside from helping make it an "affection-based organization," his contributions included shifting the focus from design and management to issues such as creativity and the arts and human values, and attracting people from outside fields.[6] He chaired the planning committee for the 1954 conference, "Planning: Basis of Design," and was program chairman of the 1957 conference, "Design and Human Values." The title for the latter was taken from the book *Science and Human Values* (1956) by Jacob Bronowski, whom Saul persuaded to give the keynote address.

Saul recalled, "Aspen was an extraordinary experience at a time when 'designer' was a relatively new and somewhat uncomfortable designation. Once a year in the meadows and in the mountains of Aspen, a few 'advanced' designers (Will Burtin, Leo Lionni, Gyorgy Kepes, Herbert Bayer and others) and a few 'enlightened' businessmen (Walter Paepcke of CCA, Tom Watson of IBM, Frank Stanton of CBS and others) gathered to hold hands and assert that 'Good Design is Good Business.'

30 Saul Bass

Tenth International Design Conference in Aspen. June 19th through June 25th, 1960. The Corporation & the Designer: An inquiry into the opportunities and limits of action for innovators in the Twentieth Century Technological Society.

Bulletin No.1 / please post

call

The Corporation is society's principal way of bringing together its money, machines, materials, human skills, and energy, to produce the objects and services it needs. It is the system through which much of the designer's work reaches the public. For this reason, the present condition and the probable future of corporations is of critical importance to designers.

The dilemma of the corporation is that large and complex organizations induce pressures toward order, uniformity, and self-perpetuating systems; while the organic forces of technical, economic, and cultural change necessitate the creative adaptation and the active participation of corporations in social and technological progress.

The International Design Conference, realizing that design is but one of many factors of corporate concern, conscious of the fact that design is one corporate area within which the conflict is vividly apparent, will in its program this June inquire into the conditions for creative action as they exist — in design and other areas, now and in the future — within the corporate structure.

To deal with these questions the conference is calling to Aspen outstanding corporation heads, leading designers, theoretical thinkers — economists, sociologists, writers who have studied the problems of corporations — and you. The actual experiences of corporation executives will be the springboard from which the discussions will be launched. Ideas developed in the general sessions will be the basis for further discussions in seminars and informal meetings with the panelists.

Each year adds new and impressive names to the list of those who have taken part in the Aspen experience. The real innovators — the men whose contribution to the creative thought of our time has been recognized around the world — are your associates during this week of stimulating informal discussion. The conference has always set its sights high. It is a forum for ideas, where vital minds join together in the shared excitement of intellectual adventure.

There is something about Aspen that is unique. It may have to do with its remote and beautiful location. Or perhaps it is having time to think, to talk — and to listen. This is the call to Aspen. Come.

George Culler, program chairman

contact: James Cross, general membership chairman, 5712 West 75th Street, Los Angeles 45, California

"We believed that once all business embraced the notion of design as a function of management, all of us would be employed to produce beautiful products and communications for a hungry public who, in turn, would be transformed by this experience and create 'a new civilization.' There was an inspiring, passionate evangelism in the air each year which energized me and impelled me to make each project I worked on a solution and a statement at the same time.

"But it didn't turn out the way we thought. Sure enough, Big Business embraced design, and promptly turned it into a commodity. Looking back, it's curious that I at least didn't understand how it would work. I thought the millennium would consist of the pervasive spread of all this marvelous stuff. It was a naive point of view but very sweet. We lived through a wonderful moment."[7]

Will Burtin, Saul and Herb Pinzke
Aspen, Colorado
Enjoying Japanese kites at an IDCA conference.
mid-1950s

Saul in Kyoto, Japan
1960

World Design Conference
Tokyo, Japan
Herb Pinzke, Saul and Alberto Rosselli, from Italy.
1960

One of the many things Saul spoke about in Aspen, and elsewhere, was creativity, a hot topic in the 1950s. Academics devised numerous ways of measuring this elusive quality, and General Motors used creativity tests in the recruitment and placement of personnel. After October 1957, when the USSR's unmanned satellite *Sputnik* indicated that American know-how was no longer sufficient to guarantee world supremacy, interest in creativity exploded.[8] At a two-day think tank organized by the New York Art Directors Club in 1958, Saul noted the links between creativity and nonconformity, pointing to the fear of risk-taking and the stigma attached to failure in a success-oriented society.[9]

Saul, who went on to make a film about creativity for Kaiser Aluminum in 1968, spoke of the intensity of the creative process as both exhilarating and anxiety-producing. He would often tell young designers that he too experienced anxieties and uncertainties with each new brief — aware that his previous accomplishments would not necessarily provide a solution to the problem at hand. The only difference experience made, he believed, was the knowledge that since one had managed to come up with good ideas in the past, there was good reason to believe it would happen again.[10]

In 1960 Saul was co-chair with Herbert Bayer of the American delegation to the World Design Conference in Tokyo that included Isamu Noguchi, Louis Kahn, Paul Rudolph and Raphael Soriano. Other participants from the sixty nations represented at what some dubbed the "Japanese Aspen" included Jean Prouvé (France), Yusaku Kamekura and Kenzo Tange (Japan), Tomas Maldonado (Italy) and Balkrishna Doshi (India). Saul's contributions included a plea for "the insight to meet the demands of human beings" and an insistence that "we must have a warm humanity."[11] Such pronouncements differentiated him from the sincerely held but well-worn Bauhaus-style statements on the moral need for good design and somewhat smug jibes at any design that referenced "epochs long gone by." They aligned him more with newer voices such as that of Peter Smithson, the British architect and designer, who defined designers as interpreters of society to itself; as "mythmakers" who gave form to "the daily consumed myth" — something at which Saul excelled.[12]

32 Saul Bass

World Design Conference
Tokyo, Japan
Joella and Herbert Bayer, talking with Isamu Noguchi and Saul.
1960

Keio Department Store
Wrapping paper
1964

Keio Department Store
Newspaper ad
"These doves flew from America to decorate the wrapping paper of Keio Department Store… the doves symbolize happiness, richness, beauty and joy. They are the work of Saul Bass… already familiar to us with the film title credits… *Bonjour Tristesse*, *Around the World in Eighty Days* and *West Side Story*."
1964

Renaissance Designer 33

Becoming Saul Bass

In the early 1950s, Saul found new levels of confidence and his work increasingly gave way to a more distinct personal style. Placing an increasing emphasis on bolder and more symbolic forms, as well as narrative and emotional content, he searched less for universally applicable formulae and relied more on his own instincts. Traces of earlier influences resurfaced as his designs moved more to the dramatically simplified forms, flat color, single image and minimal text seen in the early twentieth-century German posters that he had admired in his youth.[13]

Problem-solving and a conscientious attitude toward content continued to underpin his work, but Saul allowed himself much greater freedom to draw upon his "inner well of intuition," his strong sense of humor and the human dimensions of projects. He loved to probe "the emotional heart of the problem," always trying to give form to feeling.[14]

Saul spoke of being inspired by other graphic designers such as Paul Rand, Lester Beall, Will Burtin, Herbert Bayer, William Golden, Alvin Lustig, Leo Lionni, Ladislav Sutnar, Herbert Matter and Alexey Brodovitch, who, like him, were forging new, more distinctly American modes of expresion.[15] Recalling the cool sophistication of Rand, Saul stated, "At that time there were really extraordinary designers around, first of all Paul Rand. You've got to understand, Paul is maybe only five years or so older than I am, but at that time, when I was at the Art Students League, Paul was already famous … he was so talented. I used to watch his work like a hawk."[16]

It was an exciting time to be a cultural producer. The United States was assuming leadership in several artistic fields, and it is no coincidence that Saul's more abstract images first made a huge impact on cinema screens across the world at a time when American Abstract Expressionist art was first exhibited internationally.[17] The more expressive and symbolic nature of Saul's work in the 1950s was also a response to the postwar American fascination with psychology, which nurtured his long-term interest in the human psyche and symbols.

But Saul no longer expected psychology, or anything else, to provide certainties. He understood more deeply than many Modernists of his generation, be they designer or scientist, that many things are not "knowable." This dates back to his adolescent interest in artifacts from cultures about which little is known except for evidence from physical remains.

Recalling this early period, from the late 1940s to the early 1950s, Saul commented, "At this point I was very analytical in my approach. I believed, or at least hoped, that if I could reach a rational understanding of what to do, then everything would work exceptionally well. And when something did work, I would be able to figure out how to replicate it.

"In many instances the process was logical and direct – presenting Jack Palance as a serious man in a promotional ad I did for him; using the element of a fraying cord as a reminder of the dynamic tension in his personality. Most of the

Saul Bass
c. 1953

…Tiger on a Frayed Leash
Trade ad for Jack Palance
1953

time, though, I was reaching for some theory of predictability that didn't exist, I kept trying to isolate principles, one after another. When they didn't lead to telling designs, I'd abandon them and hope for something else to happen.

"I slowly came to the conclusion that theory is terrific after you have done the work. But when I started on a new piece of work, I had to discard the theory. I looked at the problem. I muddled and mucked around and got through it. If it worked, I may have developed another wonderful theory about why it worked. But I had to dump it the minute I started the next project.

"Belief in predictability was comforting because it held out the hope that the anxieties and uncertainties of the creative process could be tamed and become susceptible to coherent methodology. But it didn't work that way.

"That's one of the things that dogs you in the beginning; whenever you produce something good, you assume it was accidental, something you just happened to stumble on. You haven't amassed a large enough body of work to understand your own process.

"You don't realize that the good stuff comes from a wellspring inside you, one that's available to you most of the time; so each success seems like an external event. It didn't come from within you, you just happened to flail your arm and hit a bull's-eye." [18]

Renaissance Designer 35

For several years Saul continued to design trade advertising for films, often for independent production companies and director/producers, such as Robert Aldrich, Stanley Kramer and Hecht-Lancaster, a company founded by Burt Lancaster and Harold Hecht. Saul also created promotional advertising for other areas within the film industry, including a 1954 trade ad for Panavision widescreen lenses as well as trade ads and press kits for individual actors such as Jack Palance, Neville Brand and Richard Conte.[19]

Commissions also came from the larger, more established studios that were more likely to interfere in terms of design than the smaller independents. In the mid-1950s Saul worked for Warner Brothers (*A Star is Born*, 1954 and *Mister Roberts*, 1955); Twentieth Century-Fox (*The Virgin Queen*, 1955 and *On the Threshold of Space*, 1956); Columbia Pictures Corporation (*My Sister Eileen*, 1955); Paramount Pictures (*The Rose Tattoo*, 1955); RKO (*The Conqueror*, 1956); MGM (*Somebody Up There Likes Me*, 1956) and Universal International (*Magnificent Obsession*, 1954).[20]

Panavision
Trade ad
1954

Gimmick
Trade ad for Neville Brand
1954

Bullet
Trade ad for Richard Conte
1955

Equation
Trade ad for the film
Return to Paradise
1953

Design for Stardom
Trade ad for Jack Palance
1953

No Voodoo
Trade ad for Dick Danner,
Saul's agent
1954

Vera Cruz
Two in a series of trade ads for a film about rival soldiers of fortune set during the Mexican revolution.
1954

A SHADOW OF **GREAT THINGS** TO COME

HAROLD HECHT and BURT LANCASTER
are proud to welcome
GARY COOPER
to
"VERA CRUZ"

THE WORLD'S GREATEST SHOWMEN ARE UNANIMOUS IN THEIR EXCITEMENT ABOUT THE CO-STARRING OF

GARY COOPER AND BURT LANCASTER IN "VERA CRUZ"

IN TECHNICOLOR

Production starts Monday in Mexico

"A dynamite combination for Texas and as Texas goes, so goes the nation."
Robert O'Donnell
Chairman of Board, Interstate Theatres

"When two such great stars as Cooper and Lancaster get together in a picture like 'Vera Cruz', it is important and happy news for every exhibitor."
Charles P. Skouras, President
National Theatre Corporation

"Congratulations on co-starring Gary Cooper with Burt Lancaster in 'Vera Cruz'. This is a sensational boxoffice combination."
Eugene Picker, Loews Theatres

"Teaming Gary Cooper with Burt Lancaster in 'Vera Cruz' plus Technicolor is great showmanship. Sounds like terrific moneymaker. Looks like when bigger pictures are made United Artists will release them."
Harry Brandt, Brandt Theatres

"Gary Cooper plus Lancaster in Technicolor in an outstanding western like 'Vera Cruz' is just what the doctor ordered as a champion motion picture package for our industry. Congratulations."
Sol Schwartz, President RKO Theatres

"Congratulations on the news about Gary Cooper joining Burt Lancaster in Technicolor spectacle 'Vera Cruz'. A boxoffice natural. These showmanship values are what industry needs most now." —Leonard Goldenson,
American Broadcasting Co.
United Paramount Theatres

Blitz Beer
Billboard
Saul also created a series
of print ads and television
commercials for Blitz.
1957

Pabco Paint
Billboard
1956

40 Saul Bass

Breaking Away

In the 1950s, Saul generated a virtual explosion of work in nearly every area of design from advertising, including billboards and illustration, to identity design, environments and architecture. He created trademarks for numerous companies and reshaped the images of others through distinctive advertising, packaging and television commercials. To clients willing to embark on the adventure with him, Saul brought his appetite for ideas, his playfulness and his delight in engaging viewers in spirited games of visual thinking.[21]

The Detroit News
Billboard
One in a witty series playing on the phrase "What in the World's Going On?"
1961

Speedway / Marathon
Billboard
Announcing the merger of two gasoline companies.
1959

Renaissance Designer 41

The Detroit News
Billboards
1961

Blitz Beer
Billboards
1957

42 Saul Bass

Pabco Paint
Magazine ads / billboards
In this series Saul took advantage of the high level of recognition of the rainbow color spectrum used in the company's advertising since the 1920s.
1956

Renaissance Designer

British European Airways
Billboards
1957

🇬🇧 BRITISH EUROPEAN AIRWAYS EUROPE'S FOREMOST AIRLINE

In the late 1950s, Saul was represented in Britain by the Artist Partners Ltd. Agency and worked for a variety of British companies, including British European Airways (BEA), Enfield Cables and Transparent Paper Limited. One of the advertisements for BEA featured stylized contrails dotted with flags to indicate the geographical spread that made the airline "Europe's Foremost," while another featured luggage adorned with national flags.[22]

Saul's 1957 designs for Shell Oil placed him among the ranks of the great and good of British advertising. The company had a long-established policy of engaging leading designers and artists to create its posters, the most famous being Edward McKnight Kauffer, whom Saul had admired since the 1930s.[23] Saul's advertisements followed the company's signature theme of "motoring": performance was implied through lines suggestive of speed, while type was used to fashion an undulating road.

Shell Oil
Billboards
1957

Timothy, age four, is curious. "Why," he wonders, "is a bug snug in a rug?" Curiosity like that is the beginning of research…which may someday make the bug snugger or the rug bug-resistant. At Speedway, research is responsible for creating the highest octane gasoline ever sold at regular price–new Speedway 79 Super-Regular, which satisfies more cars than any other regular price gasoline. Why not do some research yourself…at the sign of Speedway 79.

Speedway 79

"What ever happened to the nickel cup of coffee?"

Gone the way of the corner apple stand. And in a way, good riddance… because there's none of us who would trade his present standard of living for that bygone day when coffee cost a nickel—and nickels were mighty scarce! BUT in the midst of high prices on most commodities, here is one bargain that will surprise you. It's a really high-octane gasoline, it sells at regular price, and it's called Speedway 79 Super-Regular. It is nearly four octane points higher than the average regular… meaning you'll run quieter and farther on a gallon of Speedway 79 Super-Regular than any other regular …and you'll be paying 4 cents less than for premium gasoline.

Speedway 79

Speedway
Two from a series of a dozen strong graphic ads for a gasoline brand.[24]
1959

Manufacturers National Bank
A selection from a playful series of ads targeting a diverse group of potential customers.
1960–61

46 Saul Bass

Renaissance Designer 47

Container Corporation of America

This poster was part of a high-profile series for CCA, founded by Walter Paepcke, who favored advertising by inference over hard sell. The theme was "Great Ideas of Western Man." Other designers involved in the series included Paul Rand, Alvin Lustig and Herbert Matter. Saul represented John Stuart Mill only by a signature placed next to a statement from his well-known book *On Liberty*. This design earned Saul a Club Medal from the New York Art Directors Club the same year he won the prestigious Art Director of the Year award.[25]
1957

Great Ideas of Western Man | ONE OF A SERIES

John Stuart Mill ON THE PURSUIT OF TRUTH

Not the violent conflict between parts of the truth, but the quiet suppression of half of it, is the formidable evil; there is always hope when people are forced to listen to both sides; it is when they attend only to one that errors harden into prejudices, and truth itself ceases to have the effect of truth, by being exaggerated into falsehood. *(On Liberty, 1856)*

would put an end to the evils of religious or philosophical sectarianism. Every truth which men of narrow capacity are in earnest about, is sure to be asserted, inculcated, and in many ways even acted on, as if no other truth existed in the world, or at all events none that could limit or qualify the first. I acknowledge that the tendency of all opinions to become sectarian is not cured by the freest discussion, but is often heightened and exacerbated thereby; the truth which ought to have been, but was not, seen, being rejected all the more violently because proclaimed by persons regarded as opponents. But it is not on the impassioned partisan, it is on the calmer and more disinterested bystander, that this collision of opinions works its salutary effect. Not the violent conflict between parts of the truth, but the quiet suppression of half of it, is the formidable evil; there is always hope when people are forced to listen to both sides; it is when they attend only to one that errors harden into prejudices, and truth itself ceases to have the effect of truth, by being exaggerated into falsehood. And since there are few mental attributes more rare than that judicial faculty which can sit in intelligent judgment between two sides of a question, of which only one is represented by an advocate before it, truth has no chance but in proportion as every side of it, every opinion which embodies any fraction of the truth, not only finds advocates, but is so advanced as to be listened to. We have now recognised the necessity to the mental well-being of mankind (on which all their other well-being depends) of freedom of opinion, and freedom of the expression of opinion, on four distinct grounds; which we will now briefly recapitulate. First, if any opinion is compelled to silence, that opinion may, for aught we can certainly know, be true. To deny this is to assume our own infallibility. Secondly, though the silenced opinion be an error, it may, and very commonly does, contain a portion of truth; and since the general or prevailing opinion on any subject is rarely or never the whole truth, it is only by the collision of adverse opinions that the remainder of the truth has any chance of

ARTIST: SAUL BASS

CONTAINER CORPORATION OF AMERICA

48 Saul Bass

Westinghouse puts the future in your hands

A 'ROCKET ENGINE' MAY GENERATE TOMORROW'S ELECTRICITY

Today's electricity is produced in some of the biggest, most ingenious and precise equipment ever built. One part...the turbine...is as big as a locomotive, revolves at the speed of sound, is so hot it glows a cherry red, and its parts fit together like a fine watch. That's today's best method, and it's gone about as far as it can go. And so Westinghouse, which builds this equipment, is experimenting with completely new methods of producing electricity. Some of them are rather exotic. One method produces electricity by shooting a stream of gas between a set of magnets. Sounds simple, but this is like handling the roaring exhaust of a rocket. The gas travels 2,000 miles an hour at 5,000 degrees F. This method has a jawbreaker of a name...magnetohydrodynamics. Called MHD for short. It is a jawbreaker of a problem. But companies like Westinghouse are nearing a solution. A Westinghouse MHD generator has produced electricity for 52 minutes. That's five times as long as any other has ever run. If MHD "works," we will be in a new world of electric power. You can be sure...if it's **Westinghouse**

Westinghouse
An ad introducing new methods of producing electricity being pioneered by Westinghouse.
c. 1960

Renaissance Designer 49

NAME THE DAY

Planning great events or trivial appointments, we glance at the calendar and name the day, using a simple device on which scientists have labored for 5,000 years.
The calendar began with primitive man's discovery that his subsistence depended on the seasons. There were times for the best hunting and fishing, times for planting various crops. Some star-gazer made the epoch-making observation that the stars appear in the same relationship to sun and moon at specific times. Priests began keeping written records of astronomy, the first calendars.
Our present day calendar is only 200 years old—dating from an Act of the British Parliament, which corrected inaccuracies by jumping ahead eleven days.
No calendar records the time science has saved for humanity. But every time we jot down a date, we pay unconscious tribute to the method of science, always seeking more accurate, simpler, quicker ways of meeting human needs.

General Pharmacal Corporation, Los Angeles, California

General Pharmacal Corporation is the creator of Q-Test, the one-hour office screening test for pregnancy. Sold only to physicians through ethical channels.

Number 2 of a series on the human meaning of great discoveries

THE DIFFICULTY OF KNOWING NOTHING

We may say that early man knew almost nothing. But nothing is just what early man could not know. The knowledge of nothing came hard and late in the progress of civilization. Plato and Aristotle, and even the great mathematician Euclid, calculated without a zero. With all that they knew, they did not know nothing. Bagdad of the Arabian Nights was the birthplace of the zero. The brawling bazaars of a great commercial city demanded swift accurate accounting, and the Arabian mathematician, al-Kwarizimi, met the need. Humanity's long journey out of darkness begins anew for each child opening his eyes to the light, seeking and discovering, finding answers to living needs. Science serves these needs from the moment of birth, even before birth.

General Pharmacal Corporation, Los Angeles, California

General Pharmacal Corporation is the creator of Q-Test, the one-hour office screening test for pregnancy. Sold only to physicians through ethical channels.

General Pharmacal Corporation "Q-test" series
(Opposite and this page) The task was to advertise a pregnancy test at a time when pregnancy was something of a taboo topic. Saul announced the product by associating it with great inventions of the past.[26]
c. 1953

General Controls Company
(Bottom right) Manufacturers of temperature, pressure and flow controls for home and industry.
1956

Saul was one of the first freelance graphic designers to move into album cover design. The first long-playing album was issued in 1948. Within a year, Saul had designed two covers, including Columbia Records' *Barber Shop Harmony* by The Sportsmen Quartet, for which he created playful renditions of barbershop singers, complete with mustaches and flattened-down hair. For the 1950 *Cyrano de Bergerac* soundtrack, Saul used whimsical, light-hearted graphics to suggest similar qualities in the film.[27]

From 1954, Saul designed album covers as part of coordinated publicity campaigns for many films and, in addition, for Elmer Bernstein and Frank Sinatra, the composer and star of *The Man with the Golden Arm*. Sinatra felt that "An album's cover art is as important in setting the mood of a music recording as are lyrics and music," and admired Saul's ability to capture "entire films and albums in a few brush strokes."[28] For *Tone Poems of Color* (1956), which featured Sinatra as a conductor, Saul offered his own poem of color, line and pattern. The lyricism of the design for Bernstein's *Blues & Brass* (1956) lies in the harmonious yet dynamic relationship of free-floating forms.

Blues & Brass
Album cover
1956

Tone Poems of Color
Album cover
1956

Hollywood for SANE
Invitation/poster
Established in 1959 and
co-chaired by Steve Allen
and Robert Ryan, other
members included Harry
Belafonte, Marlon Brando,
Kirk Douglas, Henry Fonda,
Aldous Huxley, Groucho
Marx, Marilyn Monroe
and Gregory Peck.
1959

Hollywood for SANE
Invitation
The white and sky blue of the
invitation offers hope and
suggests that by standing
together the organization's
mission to "lead mankind
away from war and toward
justice and peace" might
be realized.
1960

Saul offered his design services to the various causes with which he was involved. His contributions ranged from invitations for the Southern California Peace Crusade and Plaintiffs Against the Blacklist, to stationery for the Great Issues Foundation and Transport-a-Child, and posters for Human Rights Week. In 1957 he designed a poster for a public meeting about nuclear policy at which the main speakers were Nobel Peace Prize winner, Dr. Linus Pauling, and California Congressman Chet Holifield, who sat on the government's Joint Committee for Atomic Energy. Saul's 1959 symbol for the Hollywood branch of the National Committee for a Sane Nuclear Policy (SANE), which sought to keep nuclear power within safe and human bounds, indicated that the future lies in the hands of each and every one of us.[29]

Human Rights Week
Poster
The U.S. National Commission for UNESCO promoted observance of Human Rights Week as part of its mandate to further the universal respect for the freedom and dignity of the individual.
1963

HUMAN RIGHTS WEEK: DECEMBER 10TH THROUGH 17TH

HUMAN RIGHTS WEEK

ALL HUMAN BEINGS ARE BORN FREE & EQUAL IN DIGNITY & RIGHTS; EVERYONE HAS THE RIGHT TO LIFE, LIBERTY & SECURITY OF PERSON; ALL ARE EQUAL BEFORE THE LAW; NO ONE SHALL BE SUBJECTED TO ARBITRARY ARREST; EVERYONE HAS THE RIGHT TO FREEDOM OF MOVEMENT; EVERYONE HAS THE RIGHT TO OWN PROPERTY; EVERYONE HAS THE RIGHT TO FREEDOM OF THOUGHT, CONSCIENCE & RELIGION; EVERYONE HAS THE RIGHT TO FREEDOM OF OPINION & EXPRESSION; EVERYONE HAS THE RIGHT TO FREEDOM OF PEACEFUL ASSEMBLY; EVERYONE HAS THE RIGHT TO TAKE PART IN THE GOVERNMENT OF HIS COUNTRY, DIRECTLY OR THROUGH FREELY CHOSEN REPRESENTATIVES; EVERYONE HAS THE RIGHT TO EDUCATION.

UNITED STATES NATIONAL COMMISSION FOR UNESCO, WASHINGTON 25, D.C.

Renaissance Designer 55

Saturday Evening Post
In these illustrations Saul sought to summarize the story symbolically, in a visual phrase, much as he was doing with film posters and advertising.[30]
1961–62

56　Saul Bass

Renaissance Designer

Henri's Walk to Paris
Children's book
In the only children's book he designed,[31] Saul used bold, colorful imagery and amusing type treatments. The visual pace is varied: some pages have little on them; some are full of type, others full of images. *Print* magazine commented on the cinematic quality of the graphics: "He seems to close in on the characters until suddenly he breaks the sequence with a long range shot."
1962

58 Saul Bass

Renaissance Designer 59

San Francisco International Film Festival
Both posters suggest profiles in discussion, with symbols for 'international' and 'film' for eyes, and the negative space, filled with 'dialog,' forming an exclamation point. 1959 and 1960

60 Saul Bass

San Francisco International Film Festival
For the seventh festival poster, the typography was turned into a film strip.
1963

Renaissance Designer 61

New York Film Festival
In this poster international flags become luggage tags on a film strip briefcase.
1964

San Francisco International Film Festival
The eighth festival poster features "international" strips of film hanging in an editing bin waiting to be spliced together.
1964

Identity Design

Saul did not plunge headlong into large-scale corporate identity programs until the early 1960s, but by then he had already created a considerable number of trademarks, letterheads and smaller-scale identity programs. Each of these more than thirty trademarks captured the essence of a business, from the jolly seal for Stan Freberg's advertising firm – a pun on the word "seal" for the self-professed "odd-ball" and comedian – to the cool, kinetic elegance of the letterhead for McDonnell Aircraft Corporation.

Some logos and small-scale identity projects grew out of companies wanting a new brochure or a magazine advertisement. Clients ranged from companies such as Samsonite and Bank of America to the Transport-a-Child Foundation, the Laurence Puppets and the Society of Illustrators of Los Angeles. While Saul's later commissions for such organizations as Continental Airlines (1968) and the Bell System (1969) were massive operations involving many months of research and planning, the smaller-scale projects required a similar thinking process and discipline.

Saul Bass & Associates
Business card
1965

Robert Alexander, Architect
(Top) Logo
mid-1950s

Reynold's Aluminum
(Center) Symbol for Splendor Gift Wrap, aluminum foil wrapping papers.
1958

Pet Health Plan
(Bottom) Symbol for a veterinary hospital and pet health insurance plan.
1954

64 Saul Bass

Freberg, Ltd.
1958

Transport-a-Child Foundation
1963

The Laurence Puppets
1951

Renaissance Designer

Tavris Insurance
c. 1959

The Phoenix Corporation
Independent production company headed by Daniel Taradash and Julian Blaustein, both of whom also commissioned titles from Saul.[32]
1955

Silverlake Lithographers
Southern California printer
1957

Max Yavno
Photographer
1954

Renaissance Designer

McDonnell Aircraft Corporation
This company was a pioneer in both aeronautics and astronautics. The symbol is suggestive of aerodynamic compression waves.

Am-par Record Corporation
This company owned several popular music labels ranging from classical to contemporary music.

A Portfolio of 8 Letterheads by Saul Bass
1962

Five letterheads from *A Portfolio of 8 Letterheads by Saul Bass*. The project was organized by Kimberly-Clark to promote its cotton fiber business papers and to illustrate the importance of a well-planned corporate look.

Herb Shriner
Personal stationery for a performer known for his folksy, relaxed sense of humor and satire.

Osh Kosh B'gosh
Founded in 1911 and originally known for its high-quality denim work clothing, this company was broadening out to a wider market.

Ivan Allen Co.
Office outfitter; providing office planning and organization as well as business forms and supplies.

Renaissance Designer 69

Lightcraft of California

Lightcraft of California
Lighting Company
1952

This was one of Saul's earliest corporate identity clients. For what was then a small lighting company, he created a logo, letterhead, brochure and even special tape for packing company products. The symbol encompassed both sun and light while the brochure cover featured light rays spreading out from a golden ball.

Lighting catalog
Using only two colors and a circular leitmotif, Saul managed to create great interest and variety.

Renaissance Designer 71

Panaview

Panaview
Sliding Aluminum Doors
and Windows
1954

Out-of-scale elements suggestive of family and nature reflect the indoor/outdoor California Modern lifestyle and convey the panorama that these aluminum sliding doors and windows provided. The symbol, advertising campaign and brochure sought to communicate the "visual drama of the large aperture," as well as the precision construction of these doors and windows and their appropriateness and affordability for use in family dwellings.[33]

it's
simple
arithmetic

*Take Panaview's economy in price and installation cost.
Add the enduring beauty of Panaview sliding aluminum
doors and windows. Add quicker sales of the houses
you build with Panaview. There's only one answer...*

IT ALL ADDS UP TO PROFITS WITH

PANAVIEW
SLIDING ALUMINUM DOORS AND WINDOWS

magazine ad (b&w)

the no. of frames was kept flexible - adding or subtracting as content & design required.

The trademark concept at times becomes the dominant element.

newspaper ad (b&w)

Specifications brochure (full color)

Quicker sales, faster profits, in the house with Panaview

because dogs, children, and even people go for Panaview

*Housewives and husbands want to buy the house with Panaview sliding aluminum doors
and windows...here is quality that can be recognized at a glance. Superb in design and
engineered to meet any weather conditions, the beautiful Panaview sliding aluminum
doors and windows are priced to compete with ordinary sliding doors and windows.*

PANAVIEW
SLIDING ALUMINUM DOORS AND WINDOWS 13434 Raymer Street, North Hollywood, California

Renaissance Designer 73

Frank Holmes Laboratories, Inc.

Frank Holmes Laboratories, Inc.
Color Film Duplicating
1954

This bold, colorful trademark indicated the nature of the company's work by incorporating the principle of color processing and duplicating into the symbol itself. It enlivened everything from stationery and business forms, to a wide array of packaging and labels.[34]

74 Saul Bass

Renaissance Designer 75

KLH Research and Development Corporation

KLH Research and Development Corporation
Audio Electronics Company
1957

For this company based in Cambridge, Massachusetts, with a special interest in sound systems, Saul designed an elegant, high-tech symbol suggestive of sound waves. The symbol appeared on company packaging, products and displays as well as in a series of humorous ads designed by Saul.

Renaissance Designer 77

Firstamerica Corporation

Annual Report
Firstamerica Corporation was a bank operating twenty-four branches in Southern California.
1960

78 Saul Bass

Hunt Foods and Industries, Inc.

Annual Report
This simple, elegant design conveys, through color and organic form, the company's successful integration of operations and subsequent growth. Three years later, Saul would redesign its corporate identity when the company name was changed to Hunt-Wesson Foods (see Chapter 6).
1961

Renaissance Designer 79

California Test Bureau

Report
Using only two colors, Saul designed this multilayered report issued by the California Test Bureau, which describes the organization's philosophy and the development of standardized achievement tests.[35]
1957

Renaissance Designer

Saul in his office with production assistant, Joe Youngstrom
In the 1950s and 1960s Saul undertook commissions to package a wide variety of products.
c. 1957

3D Design:
Packaging, Architecture & Environments

While environmental, architectural and product design may seem far removed from Saul's work in two-dimensional graphics and film, Saul approached the dimensions of space, volume and texture with the same attention and sensibility that characterized his approach to time and motion in his film work. He tried his hand at a range of projects, from ceramic tiles and retail display units to a transportable exhibition and children's toys, and seamlessly adapted some of his identity designs to three-dimensional applications.[36]

Saul received commissions to package a wide variety of products ranging from Flo Ball pens to Reynolds gift wrap and from Chicken of the Sea canned tuna to Rose Marie Reid's stylish California swimsuits. In typical fashion, he put as much effort into the repackaging of White Magic soap, bleach and cleanser as he did larger, more prestigious commissions such as developing a new packaging for Kleenex tissues and napkins or elegant wrapping paper for the Keio Department Store in Japan.

When Transparent Papers hired him to package Tee Pee Nylons, Saul created a series of ingenious peek-a-boo designs that functioned as cellophane windows revealing the stockings beneath. Some designs cleverly fused the looping script of the product name with a witty graphic encounter between two pairs of flirtatious eyes, while others featured a flower, birds and bees.[37]

Transparent Papers Limited

Tee Pee Nylons
Commissioned by London-based Transparent Papers Limited, these hosiery packaging designs were exhibited at the 1959 Packaging Exhibition in Olympia, London.
1958

Renaissance Designer

Anatole Robbins

SUNTAN LOTION
Anatole Robbins

HAND LOTION
Anatole Robbins

AMARANTH OIL
Anatole Robbins

SKIN FRESHENER
Anatole Robbins

Cosmetic packaging
Colorful, fresh packaging for skincare products created by Anatole Robbins, a famous Hollywood make-up artist.
c.1956

Rose Marie Reid

Bathing suit packaging and retail displays
c. 1950

Saul's retail display units of the early 1950s were influenced by interwar European exhibition design, especially that of Herbert Bayer. The point-of-sale display for swimwear manufacturer Rose Marie Reid was awarded a medal by the New York Art Directors Club in 1951, suggesting a design date as early as 1950. The gift box and hanging displays seen here feature a collage of objects of varying size, style and scale: a giant fish captured in a frozen cinematic moment as it swims across an ocean bed, a smiling sun and a swimsuit model with parasol. The display unit Saul designed for swimwear rival, Cole of California, in 1954, was a light minimal construction resembling a beach hut. Colorful beach balls caught the eye and added to the fun of the display. For the Marshall Field company, he designed a flexible display stand – Suede Sorcery – that showed the steps in the transition of an animal skin into a man's jacket.[38]

Renaissance Designer

Kimberly-Clark Corporation

Product packaging
Packaging for business papers was created in conjunction with Morton Goldsholl Associates. The Kleenex napkin and tissue boxes shown here were designed by Saul to function as table-top dispensers and were produced in an array of patterns and colors.[39]
1960–64

86　Saul Bass

Flo Ball Pens

Ball-point pen packaging and point-of-sale displays
These designs utilized a bold palette of red, black, orange and white.
c. 1953

Renaissance Designer

Stephens TruSonic

Modular cabinets
In this product line each element functioned visually by itself or in combination with others. The pieces could be assembled horizontally, vertically or wall hung.
1957

In 1957, Saul was asked to design a line of modular cabinets for hi-fi equipment, together with supporting benches, for Stephens TruSonic of Los Angeles. At about the same time, another local firm, the Pomona Tile Company, invited Saul to participate in its Distinguished Designer Series, along with other notable designers such as George Nelson and Dorothy Liebes.[40]

For Pomona, Saul created intricate interplays of light through simple sculptural forms. He commented, "What resulted is a group of designs that present the possibilities of treating the tile wall in contemporary terms as a bas-relief. Since the forms of these tiles are defined and delineated by light, one of the qualities that emerged was that they appeared to change, as the direction and intensity of the light changed."[41] He used his hemispherical tiles, together with plain tiles, for the impressive bas-relief screen wall at his new home in Altadena, better known as Case Study House No. 20.

88 Saul Bass

Pomona Tile Company

Ceramic tiles
Saul's sculptured tile designs explored the possibilities of creating dynamic, changing pattern through the play of light over dimensional surfaces.
1957–58

XIV Milan Triennale

Exhibit
Milan, Italy
For the Milan Triennale, Saul and Elaine designed a "skyscraper city" made up of uniform, stacked filing cabinets. Many of the drawers opened to reveal unusual surprises that amplified the theme of "quantification."
1968

From the mid-1950s, Saul worked with exhibit designer Herb Rosenthal on a range of architectural and environmental projects, from playgrounds for low-cost housing projects to proposals for the 1964–65 World's Fair (the U.S. Pavilion and the Eastman Kodak Pavilion, the latter prepared for the Burtin office). In 1968 they also collaborated on an exhibit at the XIV Milan Triennale.[44]

Saul was one of an international group of designers invited by the organizers of the Milan Triennale to respond to the issue of quantification and urban life. The other participants were Gyorgy Kepes, Alison and Peter Smithson, Georges Candilis, Arata Isozaki, Aldo Van Eyck, George Nelson, Archigram and Shad Woods. Saul and Elaine's idea was to draw attention to contemporary society's compartmentalization of people and life by creating an environment made out of 3,000 uniform boxes – filing cabinets piled up to form a "skyscraper city." Many of the drawers opened to reveal objects and sounds that illustrated "how the mindless proliferation of 'things' threatens the quality of contemporary life." Some messages were more hopeful and, like the newly released Bass film *Why Man Creates* (also part of the exhibit), underlined the importance of creative vision in contemporary life and of redirecting energy to "that which is most deeply human in us."[45]

On May 30, 1968, during the press conference before the official opening, the Triennale area was occupied for ten days by radical students and professors and effectively closed down. Saul was disappointed, especially since he felt his exhibit was making a pretty strong and relevant political statement that addressed many of the issues raised by the protestors. In fact, the "skyscraper city" proved extremely popular with the students and became a focus for, as well as a place in which to engage in, political debate.[46]

92 Saul Bass

Eastman Kodak, New York World's Fair

Eastman Kodak
The symbol on the matchbook was for *The Searching Eye*, a film by Saul and Elaine that played in the Eastman Kodak Pavilion at the 1964–65 World's Fair. Although the Bass/Rosenthal pavilion design was not realized, the pavilion as built was close in spirit to their proposal. 1962–64

Renaissance Designer 93

Fall Line-up, ABC
Forthcoming programs were often advertised with static screen cards, but Saul created animated previews for popular shows such as *Ozzie & Harriet, Wednesday Night Fights* and *Walt Disney Presents.*
1958

Television

Television graphics was one of the fastest-growing areas of commercial advertising in the United States in the 1950s, thanks to the rapid postwar spread of television into American homes.[47] Top agencies, such as Carson Roberts, Ogilvy, Benson & Mather, W.B. Doner and J. Walter Thompson, were involved and high standards were set by individual art directors, designers, artists and animators such as Georg Olden, Robert Guidi, John Hubley, Leo Langlois, Herb Lubalin and Gene Deitch.[48]

Given Saul's growing reputation, it is not surprising that he too was offered work in this new medium. From the mid-1950s, he undertook a variety of commissions, from commercials and show openers to short films. Clients ranged from media companies such as ABC Television, CBS and RCA (Radio Corporation of America), to Blitz Beer, Mennen skincare products, IBM and Hallmark Cards. Saul found television less creatively satisfying than film because of the smallness of scale, the extremely tight time restrictions (openers rarely ran more than thirty to forty seconds) and technology incapable of producing images as crisp and clear. With television, he explained, "you're more of a mason than an architect."[49] His caveats notwithstanding, he was well suited to work that demanded clarity, directness, compression and constraints of scale and time.

94 Saul Bass

Playhouse 90, CBS
Opening sequence for an acclaimed ninety-minute live drama series that aired weekly from 1956–60.
1956

Profiles in Courage, ABC
Opening sequence for a documentary series based on the 1956 Pulitzer Prize-winning book by John F. Kennedy about public figures who stood firm under pressure.
1964

Renaissance Designer 95

The Kid, RCA
Television commercial showing a young boy learning to tie his shoes, against a narrative expressing RCA's commitment and dedication to the future. 1968

Saul disliked "table-pounding" commercials, preferring a softer sell: "I feel there is more than one way to do a selling job ... there is a positive, consistent, coherent way, one that respects the intelligence, good taste and capacity of an audience."[50] In *The Kid*, a one-minute commercial for RCA about the company's commitment to the future, a child struggles to learn to tie his shoelaces while a voice-over speculates about the world the child will inherit and RCA's role in that future. For IBM, Saul created two extended commercials to help allay fears about computers, a relatively new invention. *History of Invention* associated the computer with famous inventions of the past, while *Men Against Cancer* focused on the role of the computer in the fight against cancer.

Saul featured his four-year-old daughter Jennifer in a commercial for Mattel's Baby Tenderlove doll (1968) that featured "fluid close-ups of a child experiencing the fantasy of playing mother to a doll."[51] Those for Mennen company's Genteel shampoo and Baby Magic lotion focused on close-ups of a baby and a caring adult (Elaine). Described by a journalist as "poetic," Saul said of the Mennen commercials: "I sought to express the tenderness between mother and child in terms of the practical concern a mother has for her newborn. There is no massive repetition, no zooming in on the package, no freeze frame on the name. It identified the product only once, during the last ten seconds. Yet ... the commercial did everything hoped for. A test survey revealed that women were reading back such keywords as love, tenderness, health, warmth, security. Their own feelings were associated with the commercial."[52]

96 Saul Bass

History of Invention, IBM
This extended commercial aimed at demystifying the idea of the computer by comparing it to important inventions of the past.
1962

Baby Magic, Mennen
This commercial for baby lotion succeeded by emphasizing the close bond between a mother and child.
1962

Renaissance Designer 97

Olin Mathieson
The opening of the Olin Mathieson-sponsored television series, *Small World*, was intended to indicate the range of the company's activities, from ballistics to packaging.
1959

Hallmark Hall of Fame
An animated translation of the existing company logo.
1964

Bridgestone Tires
Created for a Japanese company entering the U.S. market, this commercial associates the safety of a child with high-quality tires.
1963

Baby Tenderlove, Mattel
This commercial focused on close-ups of a child playing with Mattel's popular Baby Tenderlove doll.
1968

98 Saul Bass

Renaissance Designer 99

100 Saul Bass

Rainier Beer
Three meditations on the theme of the crystal-clear water and natural beauty of the Mount Rainier area.
c.1960

National Bohemian Beer
This commercial captures the moment when the day's work is done and one can relax with friends over a cold beer.
1957

The Frank Sinatra Show, ABC
A light-hearted animated opening for Sinatra's weekly prime-time variety show.
1957

Hot competition between brewers in the late 1950s and early 1960s brought commissions for commercials from Rainier Beer, National Bohemian Beer and Blitz Beer. Each was different in style. Those for Rainier Beer, for example, reinforced the association between the company and Mount Rainier, an area of outstanding natural beauty and crystal-clear water, whereas the half-dozen or more for Blitz Beer used humor and animation to recount the adventures of a beer glass in search of the perfect beer. Two of the six commercials Saul made for National Bohemian Beer emphasize the pleasures of winding down with a beer after a hard day's work; others focus on the quality of the beer and the care taken in its production.

Among Saul's 1950s television show openers were those for popular series such as *The Frank Sinatra Show* and *4 Just Men*. Openers of the 1960s included those for *Profiles in Courage*, *The Supreme Court & Civil Liberties*, the *Alcoa Premiere* television specials and the East and West Coast editions of a late-night entertainment and chat show.

Renaissance Designer 101

For *Best of the Bolshoi* Saul created not only a spiraling title trademark (he worked with John Whitney on this) but also eighteen light-hearted animated preludes for each of the filmed ballets: whirling Chinese kites for *Dance of the Chinese Acrobats* and a feverish bee for the famous "Flight of the Bumble Bee."[53]

Most of the Bass short films made for television related to corporate image and identity. For example, the 1961 live-action film *The Party*, made for the seventy-fifth anniversary of the Westinghouse Electric Corporation, imagined famous figures from the history of electricity at a fantastical party. In the 1977 animated film *One Hundred Years of the Telephone*, Saul celebrated the invention of the telephone by Alexander Graham Bell and its subsequent role in American history, using humor and animation to educate and entertain.

102 Saul Bass

PM East / PM West, Westinghouse
(Opposite) Openings for two versions of a bi-coastal, late night entertainment and chat show; one based in New York and the other in San Francisco.
1961

4 Just Men, ITV1 England
(Center) A British/U.S. action adventure series about four former World War II comrades starring Jack Hawkins, Dan Dailey, Richard Conte and Vittorio de Sica.
1959

Best of the Bolshoi
(Below) Elegant and amusing animated preludes for a series of eighteen ballets. The frames below are from storyboards for *Shurale*, a Tatar folk tale; "Gopak," a Ukrainian dance from the ballet *Taras Bulba*; "Flight of the Bumble Bee" from the ballet *Tale of the Tsar Saltan*; and *Chopinianna*, a series of dances to pieces by Chopin.
1962

Renaissance Designer 103

3

Reinventing Movie Titles

... openings, epilogues and segments in between

The screen has found in Saul Bass the creative artist capable of distracting the spectator from his own immediate experience ... those who know him see Bass constantly in love with the well-presented image, marvelously modulating each emotion, and with a sensibility perfectly balanced by a sense of humor.[1]

Raymond Gid, Graphis, *1963*

Title sequence frames
From *The Man with the Golden Arm* (1955), *Vertigo* (1958) and *Spartacus* (1960).

Portrait proof sheet
c. 1960

Saul at his desk
Explaining a point with characteristically bold hand gestures.
c.1960

Saul brought a Modernist design sensibility to film titles and revolutionized not only what they looked like, but also how they were thought about. There had been some imaginative title sequences and openings to American films in the preceding half-century; D.W. Griffith's spectacular prologue for *Intolerance* (1916) is one that stands out in early cinema. The interwar years saw greater attention paid to titles, from jazzy "Deco" lettering to words spelled out in sand, petals and neon.[2] Although moving backgrounds were more common after World War II, many postwar titles were quite unimaginative, often consisting of conventional lettering over equally conventional backgrounds that did little more than suggest the genre of the film. The status of credit sequences was low; so low that in many cinemas they ran as the undercurtain was raised, amid audience chatter and popcorn munching.[3] It was, according to Saul, "a time when the film hadn't begun yet."[4]

But things were changing. In the early 1950s, a few directors were searching for more interesting ways to open their films, including Otto Preminger (*Where the Sidewalk Ends*, 1950) and Billy Wilder (*Sunset Boulevard*, 1950), both of whom later commissioned opening sequences from Saul. In 1952, for example, John Ford opened *What Price Glory* with a silent prologue, while for *With a Song in My Heart*, Walter Lang hired special effects maestro Fred Sersen to transform bands of red, white and blue into symbols of the United States. But nothing had anything remotely like the impact of Saul's compelling titles for *The Man with the Golden Arm* (1955, dir. Otto Preminger).

Saul believed that a film, like a symphony, deserved a mood-setting overture, and used ambiguity, layering and texture as well as startlingly compact imagery to reshape the time before the film proper began.[5] He explained, "My position was that the film begins with the first frame and that the film should be doing a job at that point."[6] Indeed, his title sequences so effectively captured and distilled the essence of the films to come that they came to be regarded as part and parcel of the film itself.

Saul's early title sequences grew directly from the graphic symbols. Beginning with the relatively modest live flame that Saul placed behind the graphic symbol at the beginning of *Carmen Jones* (1954, dir. Otto Preminger), he "fell into" a new career in what had often been called title backgrounds but came to be known as title sequences.[7] Over the next fifty

years, Saul, often in collaboration with his wife Elaine, would design more than fifty opening sequences for such films as *Anatomy of a Murder*, *Vertigo*, *Psycho*, *Spartacus* and *Casino*. In doing so, he would transform our understanding of what a title sequence could be.

Because he was so well known as a graphic designer, many people assumed that Saul's role in creating title sequences was limited to storyboards and typography. Instead, in most cases, Saul was taking on the roles that normally would be divided among the film's director, producer and editor. He noted, "Of course, with each title that I did, I was responsible for the entire piece of film … the concept, the visuals, the track, the whole thing. Shooting it and, incidentally, I rarely used the cinematographer that worked on the film itself, because by the time I got into it, he was already out of it. I directed cinematography to get whatever live action was involved."[8]

As Saul's reputation for title sequences grew, more and more directors asked him to direct internal sequences within the main body of a feature film, usually key scenes that depended strongly on visual drama and suspense to carry the story. Saul's contribution to this area of film ranges from designing the shower scene in *Psycho* and directing and shooting the racing sequences in *Grand Prix*, to visualizing the opening dance scene in *West Side Story*, conceptualizing the final battle in *Spartacus* and creating a green-eyed monster cartoon for *Not with My Wife You Don't*. These types of collaboration were new; so much so that they gave rise to the credit line of "visual consultant."[9]

In 1955, Otto Preminger gave Saul the go-ahead to design the type of unified advertising that he had been aching to do. The result was the impressive campaign for *The Man with the Golden Arm*. By 1958, for a typical film, Saul offered the studios not only the main and credit titles but also a trademark, TV trailer, screen trailer, posters (four sizes), trade ads (up to six per film), newspaper ads (up to twenty per film), album cover and New York subway car card.[10] But even when he was paid in full for an advertising campaign, there was no guarantee that all or any of it would be used.[11]

Despite his international reputation as a graphic designer, Saul found himself in the odd position of being highly sought after for film titles and trade advertising, but not for posters – the most public face of film advertising. For example, although he acted as visual consultant for *West Side Story* (1961) and was responsible for the opening and closing sequences, Saul did not design the poster. In the case of *Saint Joan* (1957, dir. Otto Preminger) where he did, United Artists inserted a supplement of more conventionally designed advertisements into the press book.[12] Large amounts of money were at stake if a film bombed, and film studios were often reluctant to stake their marketing campaigns on Saul's bold designs.

In all his work, Saul said that he "looked for the simple idea." But Saul's work in film was about more than just simplicity: his designs shaped complex ideas into radically simple forms that offered audiences a set of clues, a sort of hermeneutic key to deeper meanings under the surface of the movie. Saul described the ideal title as having "a simplicity which also has a certain ambiguity and a certain metaphysical implication that makes that simplicity vital. If it's simple simple, it's boring."[13]

A New Art Form

With his work in title sequences, Saul would elevate the opening of Hollywood films to the status of an art form. In Greek drama, prologues had the practical task of filling audiences in on the back-story necessary to follow the plot. In opera, the overture usually foreshadows the story to follow. From *Carmen Jones* on, Saul explored deeper and more complex possibilities for cinematic preludes.

In later years, when artistic titles became an essential feature of many movies, Saul was often asked to speak and write about title sequences. He found himself in the curious position of having to analyze and define something he had reinvented as he went along. Never a fan of fixed categories or absolute statements, Saul came up with a series of open-ended notions, keys to understanding the role his titles could play in the work of the film.

"In the mood" was the phrase Saul used to describe the primary function of the title sequence, the point he started from: "I began dealing with titles in terms of setting mood, creating an atmosphere, an attitude and a generalized metaphor for what the film was about. And setting up the subtext of the film."[14]

Thus, the title sequence is a sort of passage, a transitional vehicle that helps the audience cross from the world outside the theater into the world of the film. In *The Man with the Golden Arm*, the titles created a mood of intense anxiety. In *Seconds* the mood is horror; in *Bonjour Tristesse* it is bittersweet regret, and in *It's a Mad, Mad, Mad, Mad World* one of good cheer and old-fashioned fun.

"The time before" was Saul's way of describing titles that expanded the time period covered by the film. Saul wrote, "As I moved along and began to do more and more titles, I began to see other opportunities and other ways in which the titles could serve the film. A title can act as a prologue. It can actually tell you about the time before the film. Sometimes it actually becomes part of the story."[15]

The time before could be years, as in those between the two World Wars (*The Victors*), the months it took a stagecoach to cross the American West (*The Big Country*) or the minutes before the start of a Formula One race (*Grand Prix*). Saul was also the first to make a mini movie out of a "time after" credit sequence, as in the extended epilogues for *Around the World in Eighty Days* and *West Side Story*.

"Seeing for the first time" is perhaps the most interesting perspective Saul offered on his work, because it suggests titles were not limited to summarizing what was already there, but could serve as a lens through which to view the film in a different light. He encouraged audiences to see things in hitherto-unconsidered ways in order to heighten awareness, create ambiguities or raise expectations that something unusual was about to happen. In *Walk on the Wild Side* we see an alley cat as a mysterious, prowling predator. In *Nine Hours to Rama* we rethink our conceptions of "watch" and "time," as the camera explores the intricate inner workings of an ordinary pocket watch.

Saul explained, "I see the really central challenge in artistic activity is to deal with things we already know and to deal with them in a way that causes us to reexamine them and understand them in a totally different way."[16] His best title sequences did more than get audiences in the mood for the film to come. They served as poetic responses to the film, uncovering implied and sometimes hidden meanings and layers. Danish screenwriter and teacher Mogens Rukov reflected on the special power of Saul's titles: "In a fragment, it connects the outer world of the audience to the inner world of a story… The simplicity here is a compression of complexity… In their simplicity [the title sequences] depict a more complex world than the story contains… It's a very delicate art. Not just simplification, but the impact of a third eye, looking at the film and at reality as fragments of a god-like creation."[17]

Saul at his moviola in the editing room
c.1960

"It's the film that counts"

Saul saw his role as working for the director: "I think the creation of a title, which is obviously a small appendage on the film, has to be approached very conscientiously and with some sense of responsibility within the film's total framework – because it is, after all, the tail of the dog and the tail does not the dog wag.[18]

"The script is only the bones. I must know how he [the director] is going to flesh it out, what his point-of-view is, and how he is going to articulate that script … My work is always preceded by very, very thorough discussions with the director about what he's going to do so that I can understand it, be responsive to it, to support it."[19]

Asked if he felt it necessary to adapt his title sequences to the style of a director, he replied: "Not really. I think what is most important is that the introduction to the film – which is what a title is – be true to its content and to its intent. Therefore, something has to be created that is expressive of that. A more profound relationship must exist beyond a superficiality of style. If you understand style to be attitude, yes, I have to conform to style, but if you think of style as confined to the visual, then I would say no."[20]

Because he viewed design as a problem-solving process and because the films on which he worked were so varied, Saul's title sequences inevitably varied as well. At a time when he was best known for animated graphic openings, *The Big Country* (1958, dir. William Wyler) opened with a live-action title sequence. A friend commented, "You know, it wasn't like a Saul Bass title." Saul's response? "What on earth is a Saul Bass title?" followed by a few strong words on how titles had to be supportive of the film.[21]

Reinventing Movie Titles **109**

The Man with the Golden Arm
Title sequence frames
1955

Markers of Modernity

Saul's early film titles were major markers of modernity. They presented the new Hollywood and postwar America to audiences around the world. Hundreds of people have spoken to me about the impact that the titles for *The Man with the Golden Arm* had upon them in the mid to late 1950s; the examples that follow give a flavor of the responses.

In Britain, the so-called youth revolution of the late 1950s and early 1960s was marked by a strong mix of art and music; many involved recall Saul's work as inspirational in their teenage years. My husband, Andy Hoogenboom, then an art student exhibiting sculpture and playing bass in Alexis Korner's Blues Incorporated, was one of those who came of age during the heavily United States-influenced cultural mélange.

Discussing the centrality of Saul to his awareness of modern art and design, he stated, "As art students we looked to America for many things, from jeans and jazz to abstract art and new ways of perceiving the world. In terms of art, that process started for me at the age of fourteen when I saw the titles for *The Man with the Golden Arm*. They

110 Saul Bass

Anatomy of a Murder
Symbol for the film
1959

opened me up to new forms of visual expression; fine art influences came later. They were my first conscious contact with abstract imagery. In my artistic development, and I suspect that of others of my generation, Bass titles predate my learning about Abstract Expressionism. Ironically, I only went to see the film because I loved jazz… yet the experience of those titles was, for me, on a par with discovering jazz. Until then I had no idea images could be abstract like music, or so powerful. I still remember the adrenalin pumping through my body as they hit the screen to that fantastic Bernstein beat."[22]

Charlie Watts, graphic designer, fellow Korner band member and, from 1963, drummer with the Rolling Stones, also saw those titles when he was fourteen. Another teenage jazz fanatic who pretended to be older than he was to see the X-rated film, he recalled, "I loved that title sequence. Really loved it. Of course, at the time I didn't know the name 'Saul Bass.' I only realized who he was when I went to work in graphic design – at the Charles Hobson Agency in London – as a layout man (although I was really more of a boy than a man and very junior in the office). Saul Bass was the person everyone in the agency admired. He was the 'hot' designer… We all aspired to that beautiful simplification. Then came *Anatomy of a Murder* [1959]. After that he was like God."[23]

In Tokyo, Katsumi Asaba, now a graphic designer, also saw *The Man with the Golden Arm* when he was a student: "I used to be a film freak, and went to see movies every day… The title back so struck me that I hardly remember the movie itself. It was extremely innovative, and made me aware that title backs could surely be considered as respectable design works."[24] A frequent visitor to the American Cultural Center in Tokyo, where a range of art and design magazines could be consulted, he began to copy designs by Saul. Although his style today is far removed from that of Saul's in the 1950s, he still feels Saul's presence in his design career, "giving me a soulful gaze just as a father would do to a son."[25]

Designers Lella and Massimo Vignelli, then young students of architecture and design in Milan, saw the film in Italy. They already knew Saul's work from design magazines, and Massimo was so excited by what he saw that he dreamed of going to America and working with his hero, Saul Bass.[26] Meanwhile, in the United States, Art Goodman, who had not then heard of the man he was later to work for, found the billboard poster for the film so compelling that he pulled off the road and parked in front of it for an hour. He sat there looking at it, "adrenalin pumping and simply marveling… you always remember moments like that because they are so rare."[27] In New York in 1956, the thirteen-year-old Martin Scorsese sneaked into a movie house to see *The Man with the Golden Arm* and during the next few years invented and sketched out his own title sequences inspired by that and others designed by Saul.[28]

No matter how many times Saul was approached by someone telling him about how a particular title sequence had affected them, he listened in that relaxed courteous way of his that made the telling easy.

Following spread:
Saul as a "bill-poster"
For an article in *Show Business Illustrated.*
1962

Saul and Otto Preminger
On the set of *The Cardinal*.
1963

Otto Preminger

"Otto Preminger is a man noted for his willingness to blaze trails. Perhaps his most notable act of courage was to have the vision or temerity, depending on how you look at it, to pick a young designer who had never worked in film before and launch him on a second career. He's a man who taught me that temperament and talent are not mutually exclusive. A man who I worked and fought with over the years and learned to love and appreciate." – *Saul Bass, 1977*[29]

On the face of it, Saul Bass and Otto Preminger should never have hit it off. Saul was warm, with a spirited sense of humor and a knack for putting people at ease, while the Viennese filmmaker's autocratic, intimidating personality had earned him the nickname "Otto the Terrible." But when it came to his craft, Saul was as tenacious as Otto, and this unlikely partnership turned out to be one of the most productive in the history of American cinema. Between 1954 and 1979, Preminger hired Saul to create thirteen title sequences and numerous advertising campaigns, the most important of which were undertaken between 1954 (*Carmen Jones*) and 1965 (*Bunny Lake is Missing*).[30]

For Saul, it was a baptism by fire. "Otto was a very tough and bullheaded kind of person. He was difficult and opinionated. In a funny way it worked for me. My world up to that point had been reasonably polite and gracious. But with a guy like Otto I had to learn how to fight. I walked into every meeting prepared to quit – I had to. I had to become totally fearless… This resulted in some very volatile scenes… I am a little nostalgic about my relationship with Otto. After the sixth or seventh picture, the whole thing became a sort of ritualistic gavotte. We would have these enormous fights in which everybody got killed, but in which nobody died. It had a certain richness about it."[31]

Of all the directors Saul worked with over the years, he felt Preminger had the strongest grasp of design, more so even than Wilder or Hitchcock. Preminger, whose art collection included Matisse, Mondrian and Klee, was also passionately interested in modern design, and in Saul he intuited a striking new talent that he wanted to tap. For Saul, "Otto had a vision. A true, artistic visual vision. He believed that what he knew… together with what would come out of our work, was worth defending to the death…

I discovered that what we wound up with together was better than what I started with on my own."[32] Saul explained, "It was stimulating to me as a designer to have such strong opinions from someone who knew what he was talking about in terms of design. The dynamic was a productive one for me."[33]

As an independent producer/director, Preminger had attracted considerable attention when he and United Artists ignored a Production Code edict to remove lines containing words such as "virgin" and "seduction" from *The Moon is Blue* (1953). Conscious that the advertising campaign of a film already labeled immoral by certain newspapers needed careful handling, Preminger was horrified to discover the proposed campaign featured semi-naked women. He pronounced it vulgar and demanded that Saul, whom he had just met, be given the job. He was impressed with Saul's idea for a light-hearted yet suggestive design of "a window with the blind down and two little birds perched on the sill, peeking behind the blind," and subsequently asked him to work on *Carmen Jones* (1954).[34]

This contemporary tale of love and desire, with an all-black cast, was based on Bizet's passionate opera *Carmen*. For the film symbol, Saul submerged a symbol of love in a symbol of passion, adding ambiguity by making the rose both red and black. "As the various credits appear, the flame leaps up, dies down, expands, contracts...momentarily revealing the rose by filling the space behind it, and alternately obliterating the rose as the flame shifts, and the black rose disappears into a black background."[35]

Saul shot a live flame at very high speed to capture the sensual, quixotic and volatile nature of the lead character, Carmen, played by Dorothy Dandridge. The flame featured less in trade advertisements and posters, where representations of musical notes and Carmen/Dandridge singing indicated a musical drama. The main poster won Saul his first prestigious New York Art Directors Club Medal.[36]

Carmen Jones
Title sequence frame and graphic symbol for the film.
1954

Letterhead
Preminger commissioned Saul to design stationery in addition to a myriad of other production-related materials for each film.

Poster
Saul preferred this pure, abstract design to the versions required by the studio that included images of film stars.

The Man with the Golden Arm
(1955, dir. Otto Preminger)

In 1954, Preminger again defied Production Code guidelines when adapting Nelson Algren's powerful novel about drug addiction, a taboo topic in mid-century America. The challenge facing Saul was how to create a symbol that captured the drama and intensity of the film without resorting to sensationalism.

He created an arresting image of a distorted, disjointed arm. The semi-abstract form helped distance the image from the harsh realities of shooting up, although they are implicit in the (dis)figuration. As well as being disconnected from a body, the black arm has the appearance of being petrified and transformed into something else, just as the Sinatra character in the film is transformed by his addiction.

The title sequence was equally compelling. Here was modern art on the movie screen. Saul stated that, "The intent of this opening was to create a mood – spare, gaunt, with a driving intensity… [that conveyed] the distortion and jaggedness, the disconnectedness and disjointedness of the addict's life – the subject of the film."[37]

Accompanied by Elmer Bernstein's driving jazz-like score, and set against a black background, white bars appear, disappear and form abstract patterns before finally coalescing into the film's symbol. Contrasts between the black and white heighten the strident intensity, and the disjunctures encapsulate the mood of the main character, a downbeat drummer with a penchant for gambling and drugs. Because of the extremely tight schedule, Bernstein had to compose the music at the same time as Saul was creating the title. Saul explained, "He gave me a beat, 'the counts' as we say, and I designed to that beat. It was a helluva moment when we first screened it."[38]

When prints went out to theaters all over the country, Preminger made sure they were accompanied by a note instructing the projectionist to run the first reel only after the curtains were drawn back.[39]

Reinventing Movie Titles 117

Trade ad
Two-color version

118 Saul Bass

"*Frank Sinatra is unforgettable in 'The Man With the Golden Arm'*" *says Time Magazine**

**216 newspaper critics and reviewers; 37 television and radio commentators; 24 other magazine critics; and voters in 20 leading motion picture surveys agree with Time Magazine's evaluation of Frank Sinatra's performance in "The Man With the Golden Arm".*

Bus / Subway ad
This horizontal format is one of many size and content variations in this extensive advertising campaign.

Trade ad
To salute Frank Sinatra's "unforgettable" performance Saul created a bold exclamation point that was as discordant as it was celebratory.

Reinventing Movie Titles 119

Soundtrack album covers
Three-part series of 45 rpm records, each with its own array of colors.

The symbol was at the center of a unified and comprehensive advertising campaign unprecedented in American cinema, indeed world cinema. The advertisements "broke the rules of what a campaign should do, because they focused on one thing – the arm. They were reductive. They were metaphorical."[40] The highly nuanced articulation and rearticulation of the imagery and colors across the wide range of advertising reveal Saul on a roll, ideas pouring out.

When the symbol alone was used on one side of the marquee at the New York opening (at the Victoria Theater, Broadway), Saul knew he had achieved his ambition to create graphics that would announce a film rather than sell it. Most exhibitors, however, thought that it was insane to advertise a movie with such reductive imagery.

Preminger defended Saul's work in his dealings with anxious executives at the releasing company, United Artists, who feared that box office receipts would suffer if advertising did not carry large images of film stars. On one occasion, Saul recalled walking into Preminger's office during a phone conversation between the director and the owner of a theater chain in Texas. "I've got to have pictures of Sinatra and Novak in the ads!" the exhibitor shouted, loudly enough for his voice to penetrate the earpiece. "Now, you listen to me!" Preminger thundered back. "We have considered everything you said, and we have decided this is the campaign as it stands. If you change the ads one iota, I will pull the picture from your chain and sue you!"[41] Sadly, Preminger lost the battle to keep the advertising completely free of film stars, but Saul managed to place them judiciously within the designs.

120 Saul Bass

Newspaper ads
Saul designed a wide variety of different configurations for the newspaper ads alone.

Reinventing Movie Titles 121

Saul and Otto Preminger
Late night work session.

The Man with the Golden Arm
This title sequence brought Saul international recognition.

"Otto liked my idea for the title but he thought it should be a series of non-moving images, stills, just like the individual frames in the storyboard.

Of course, I thought it had to move.
We disagreed. It got hot.
I stalked out of Otto's office,
went back to my own.
Sat down. And sulked.
I sat there, upset, still steaming…
Time went by. I calmed down.
I began to think 'Gee, I blew it.'
I really did want to do that title.
I thought a little…
Non-moving images…
Hmmm, it could have a certain
kind of stylistic emotional effect…
Static images. Sharp cuts.
A sort of staccato kinetic movement.
I began to warm up to the idea.
I began to like it!

The phone rang!

It was Otto's stentorian voice:
'Hallo, Saul – you know,
I've been thinking. You are rrright.
It should move!'

'But wait a minute Otto, it could
really be more interesting if it doesn't.
It could give us a sort of kinetic…'
He cut in 'No!'.

We were off again.
Another altercation!
Our voices rose…

Finally, he broke in:
'Stop! I insist! And you will see
how wrrrong you are!'

So he was right. And I was right."[42]

Reinventing Movie Titles **123**

Poster
The fragmented figure of Joan against a mosaic of vibrant color suggests the spirit of a woman broken but not defeated.

Title sequence frames
This sequence captures the intensity of the moments leading up to Joan's spiritual revelations.

Saint Joan

(1957, dir. Otto Preminger)

The symbol for this film is the broken body of a woman who in life battled conventional ideas of femininity (wearing armor and leading men), as well as the institutions of Church and State. It is one of Saul's most deeply ambiguous images for a film that explores many dichotomies, including those between the modern and pre-modern worlds. In the one-sheet poster and album cover, Saul set the symbol against a joyously colored mosaic reminiscent of the stained-glass windows of medieval cathedrals, and suggesting the sanctification to come.

The black and white title sequence is full of pattern and movement in space, producing a strong visceral sensation as well as a sense of the ethereal. Taking his cue from Joan hearing the voices of saints in the moments after church bells have stopped ringing, Saul opened with bell clappers swinging back and forth. Saul explained, "Credits appear as the bell clappers advance toward the viewer and fade after filling the screen, long cross dissolves lead to moments of both balance and tension when the credit that is fading out is of equal visual strength to the incoming one and the typography of one relates to that of the other. Eventually, a few white clappers are introduced, one of which advances and dominates the entire screen, whereupon the symbol of the film materializes within it, followed by the final credit."[43]

Soundtrack album cover
12-inch LP

Mailing label
Part of a complete stationery package used during the production of the film.

126 Saul Bass

Casting call
Announcement to the general public requesting applicants for the role of Saint Joan in the film.

Invitation
Cocktail party celebrating the selection of seventeen-year-old Jean Seberg for the title role.

Book jacket
Saul redesigned the Penguin Books edition of George Bernard Shaw's famous play.

Reinventing Movie Titles 127

Poster
This powerfully evocative symbol suggests love, loss, innocence and longing.

Title sequence frames
Playful specks of light transform into flower petals, which become a rain shower, and finally a single tear.

Bonjour Tristesse
(1958, dir. Otto Preminger)

The symbol is a haunting face created from a few brushstrokes. Here the poignant sadness embodied in the title of the film is expressed as a haiku-like eye and tear. The Madonna-like symbol represents both women in general and a specific young woman, Cecile (played by Jean Seberg).

The lyrical title sequence exquisitely captures the elusive delicacy as well as the sadness that lies at the heart of the film. It previews the film's narrative, from the lost innocence of adolescence to the sadness that knowledge and adulthood bring to the young woman.

"The title expresses, in generalized terms, the moods of gaiety and sadness in the film itself. It opens with random forms popping in against a black background. These forms are gay in color and playful in tempo. At first one form predominates and then another. Slowly the mood changes and the color deepens and becomes more somber. As it moves into the lavenders, one of the forms, which is vaguely flower-like, becomes more specifically so, developing petal-like shapes. The petals begin to drop, forming an overall pattern of dropping petals, which cover the screen at one point. These petals dissolve until only one petal is left. The face... forms around it and we realize the petal is really a tear. Throughout this development the various credits appear intermittently on the screen."[44]

Reinventing Movie Titles

Otto Preminger's
ANATOMY
OF A MURDER

STARRING
JAMES STEWART
LEE REMICK
BEN GAZZARA
ARTHUR O'CONNELL
EVE ARDEN
KATHRYN GRANT

and JOSEPH N. WELCH as Judge Weaver

Anatomy of a Murder

(1959, dir. Otto Preminger)

Of this now iconic symbol, Martin Scorsese commented, "Here's another emblematic image, instantly recognizable and intimately tied to the film. There's something lurid and garish about the black on red, which is perfectly keyed to the subject matter, then risqué, of *Anatomy of a Murder*, one of Preminger's best. And since the film is all about moral ambiguity and different points of view that never converge, it was brilliant to separate the corpse into seven pieces."[45]

Saul's pun on anatomy aligns the dissection of a human body with the dissection of a body of evidence in a court of law. The abstraction distances the viewer while the figuration pulls in the opposite direction. Here, as elsewhere in his work, we see Saul's fascination with the "primitive"; each piece looks as if it has been cut out by an untutored hand. The hand lettering in various sizes and forms signals inconsistency; every version of every letter is different, just as every version of events is different in this film about a lawyer who comes to doubt his client's story.

The symbol appeared on a wide range of items, from invitations and lobby cards to a record album and posters. Once again, to see the range in its entirety is to realize how Saul excelled at subtle variation.

Poster and billboard
Bold color and form create strong, dynamic relationships, in many subtle variations, throughout this campaign.

Reinventing Movie Titles 131

Otto Preminger presents
'Anatomy of a Murder'
starring James Stewart
Lee Remick, Ben Gazzara
Arthur O'Connell, Eve Arden
Kathryn Grant and Joseph N. Welch
with George C. Scott
Orson Bean, Russ Brown
Murray Hamilton, Brooks West
Alexander Campbell
Ken Lynch, John Qualen
Howard McNear, Ned Wever
Jimmy Conlin, Royal Beal
Joseph Kearns, Don Ross
Lloyd Le Vasseur, James Waters
music by Duke Ellington
screenplay by Wendell Mayes
from the novel by Robert Traver
produced & directed by Otto Preminger
a Columbia release

Premiere program
Two-color folder and booklet for the film's premiere.

Invitation
The symbol became so synonymous with the film that it was possible to remove the actual text of the title in certain instances.

Poster
(Opposite) Alternate version

WILL YOU PLEASE JOIN ME AT A SCREENING OF 'ANATOMY OF A MURDER' AND A BUFFET DINNER DANCE FOR THE PICTURE'S CAST AND CREW AT THE SCREEN DIRECTORS' GUILD THEATRE, 7950 SUNSET BOULEVARD ON SATURDAY JUNE 20TH AT 6 P M · *OTTO PREMINGER*

KINDLY RESPOND TO MISS COOK · HOLLYWOOD 2-3111 EXT. 821 · THIS CARD ADMITS TWO · INFORMAL

132 Saul Bass

Otto Preminger's
ANATOMY
OF A MURDER

Starring James Stewart/Lee Remick/Ben Gazzara/Arthur O'Connell/Eve Arden/Kathryn Grant and Joseph N. Welch as Judge Weaver/With George C. Scott/Orson Bean/Murray Hamilton/Brooks West. Screenplay by Wendell Mayes/Photography by Sam Leavitt/Production designed by Boris Leven Music by Duke Ellington/Produced and Directed by Otto Preminger/A Columbia release

134 Saul Bass

Newspaper ads
(Opposite) Three of many one-color variations on size and content.

Trade ad
(Right) Academy Award consideration ad for best picture.

Academy mailer
(Below) Parts of the symbol are wittily transformed into the two friendly arms of "yourself and a guest."

LAST YEAR'S NO. 1 BEST-SELLER.

THIS YEAR'S (WE HOPE) NO. 1 MOTION PICTURE.

JAMES STEWART
LEE REMICK
BEN GAZZARA
ARTHUR O'CONNELL
EVE ARDEN
KATHRYN GRANT

OTTO PREMINGER'S ANATOMY OF A MURDER

WITH
GEORGE C. SCOTT/ORSON BEAN/RUSS BROWN/MURRAY HAMILTON/BROOKS WEST screenplay by WENDELL MAYES from the best-seller by ROBERT TRAVER photography by SAM LEAVITT produced & directed by OTTO PREMINGER a Columbia release

Now playing Bruin Theatre, Westwood. Your Academy card will serve as a ticket of admission for yourself and a guest.

Reinventing Movie Titles 135

Soundtrack album cover
12-inch LP

Title sequence frames
The appearance of various body parts and credits create a disjointed visual rhythm that dovetails with the rich and sensuous syncopation of Duke Ellington's score.

The title sequence is one of Saul's most simple and most successful, with its seemingly effortless integration of text, image and sound. The symbol forms and falls apart in synchronization with the Duke Ellington score, while the bold white credits over the black fragments add another layer of contrast and syncopation.

Saul described it thus; "Working closely within the framework of a fine contemporary jazz score, the title sequence had a staccato and fragmented style. The various pieces of the segmented figure quickly form its total configuration after which arms, legs, head, body and hands pop on and off in counterpoint with the appearance of the various credits… finally, a pair of hands appears with quick, successive jumps forward, obliterating and blackening the screen. At this point the first scene of the film begins."[46]

Reinventing Movie Titles 137

Exodus

(1960, dir. Otto Preminger)

Dubbed a "Jewish Western," *Exodus* deals with the period just before, and shortly after, the partition of Palestine in 1947 and the creation of the state of Israel. This strongly pro-Jewish film came under attack from Israeli politicians for giving too much emphasis to extremist groups, from members of those groups for compressing incidents and focusing on one individual, and from Palestinians for its bias against and portrayal of Arabs.[47]

For Saul, a key issue was to devise a contemporary symbol to alert potential audiences that this was not a biblical epic, despite the name Exodus referring to a book of the Old Testament. In this case, *Exodus* was a ship carrying Jewish immigrants to Palestine. "I used guns because that definitely made it of today. More important was expressing the basic idea of conflict, the idea of a fight. It was an attempt to symbolize the struggle of the Jewish people to establish their own land. To me it had certain parallels to the American foothold in the West. But it also had something the West didn't have, a spiritual overtone. The reaching hands are an attempt to imply spirituality."[48]

Trade ad
(Opposite) The reaching hands suggest spiritual striving, as well as an armed struggle.

Trade ad
(Right) A play on the expression "It's a wrap," this ad announced the completion of filming. Saul also joked that the wrapped film can might be mistaken for a loaf of pumpernickel bread.

Newspaper ad
(Below) One in a series of ads chronicling the film's progress for the public.

ALL WRAPPED UP

TODAY PAUL NEWMAN, EVA MARIE SAINT, RALPH RICHARDSON, LEE J. COBB, PETER LAWFORD, SAL MINEO, JOHN DEREK, GREGORY RATOFF, HUGH GRIFFITH, DAVID OPATOSHU, ALEXANDRA STEWART, MARIUS GORING, FELIX AYLMER, MICHAEL WAGER & JILL HAWORTH START WORK IN ISRAEL ON OTTO PREMINGER'S FILM "EXODUS" IN NEW PANAVISION 70 & TECHNICOLOR. THE SCREENPLAY BY DALTON TRUMBO IS FROM THE BEST-SELLING NOVEL BY LEON URIS.

EXODUS

WILL OPEN AT THE WARNER THEATRE IN NEW YORK ON DECEMBER 15, 1960; THE CINE-STAGE THEATRE IN CHICAGO ON DECEMBER 16, 1960; & THE WILSHIRE THEATRE IN BEVERLY HILLS ON DECEMBER 21, 1960.

TODAY OTTO PREMINGER COMPLETED THE FILMING OF 'EXODUS.' ALL THE SHOOTING TOOK PLACE IN ACTUAL LOCALES AT HAIFA, ACRE, NAZARETH, CAESAREA, KAFR KANA, ATLIT AND JERUSALEM IN ISRAEL AND FAMAGUSTA, NICOSIA AND CARAOLOS ON THE ISLE OF CYPRUS. NOW 'EXODUS' ENTERS THE FINAL STAGES OF MUSICAL SCORING AND EDITING.

'EXODUS' STARS PAUL NEWMAN, EVA MARIE SAINT, RALPH RICHARDSON, PETER LAWFORD, LEE J. COBB, SAL MINEO, JOHN DEREK, HUGH GRIFFITH, GREGORY RATOFF, FELIX AYLMER, DAVID OPATOSHU & JILL HAWORTH. SCREENPLAY BY DALTON TRUMBO FROM THE BEST-SELLING NOVEL BY LEON URIS. PRODUCED AND DIRECTED BY OTTO PREMINGER IN NEW PANAVISION 70 AND TECHNICOLOR® — A UNITED ARTISTS RELEASE.

'EXODUS' WILL OPEN AT THE WARNER THEATRE IN NEW YORK ON DECEMBER 15, 1960, THE CINE-STAGE THEATRE IN CHICAGO ON DECEMBER 16, THE FOX WILSHIRE THEATRE IN BEVERLY HILLS ON DECEMBER 21, AND AT THE SHERIDAN THEATRE IN MIAMI BEACH ON DECEMBER 21.

Reinventing Movie Titles

In the title sequence, the symbol's boldness is offset by sensual flames that move lyrically around it. The flames burn more and more strongly, and by the final credit consume the screen. Saul stated, "The film is about Israel. In its earlier restricted form, the flame has the symbolic connotation of the Temple and the 'eternal light.' At the end of the title it provides a symbolic forerunner of the struggle for independence which is the main content of the film."[49]

The symbol and flames also featured in the main advertising. The invitations to the premiere were literally scorched, as if bona fide evidence of real events. The book published to coincide with the film's release attributes the extraordinary advance ticket sales (in excess of one million dollars two months before the opening) to a series of advertisements designed by Saul. During production the ads appeared in every major newspaper in cities where the film was scheduled to open, setting off "an avalanche of orders."[50] In one ad, the ship *Exodus* stands for the travels of the film's cast and crew; type is set in the shape of steam rising from the funnel. By contrast, "All Wrapped Up" announced that production was completed and in the can by using a film can and playing with the industry term "It's a wrap."

Poster
(Opposite) This poster sets up the illusion that the fire is consuming the poster itself.

Title sequence frames
The undulating flame refers to the eternal flame of the Jewish tradition as well as the armed struggle and conflagration involved in the establishment of Israel. Instrumental to the power of this sequence is the brilliant interplay in rhythm and movement between the flame and Ernest Gold's Oscar-winning score.

Premiere invitation
The bottom edge of each invitation was literally singed by hand.

Reinventing Movie Titles 141

Advise & Consent

(1962, dir. Otto Preminger)

Thought by many to be the best film about American politics, *Advise & Consent* was based on a Pulitzer Prize-winning novel by Allen Drury. As with other projects, Saul generated many idea sketches. Among them, politicians appear as puppets on a string, or as mechanical toys to be wound up at will. The symbol that Saul and Preminger finally agreed upon, however, is a powerful visual pun about "taking the lid off" the Capitol itself – home of the U.S. Congress.

Saul stated, "The basic idea of the book is the detailed study of the guts of our political system. The symbol says, in essence: inside Washington, what goes on underneath the surface? The 'top' is lifted off to reveal in letters the name of the picture."[51] His image was so powerful that, shortly after the film was released, it found its way into political cartoons in Europe and the United States.

The strong graphic symbol bookends the title sequence, and the theme of governmental politics is carried throughout the advertising campaign. The press book, for example, is designed in the shape of an official briefcase, complete with a label bearing the symbol of the film, while the main lobby card uses briefcases to carry credits.

Preliminary sketches
Saul explored the idea of politicians as puppets being manipulated, or as mechanical toys.

Poster
The final design "lifts the lid" off American politics.

OTTO PREMINGER PRESENTS

ADVISE & CONSENT

HENRY FONDA, CHARLES LAUGHTON, DON MURRAY, WALTER PIDGEON, PETER LAWFORD, GENE TIERNEY, LEW AYRES, FRANCHOT TONE, BURGESS MEREDITH, EDDIE HODGES, PAUL FORD, GEORGE GRIZZARD, INGA SWENSON SCREENPLAY WRITTEN BY WENDELL MAYES, MUSIC BY JERRY FIELDING, PHOTOGRAPHED IN PANAVISION BY SAM LEAVITT, PRODUCED AND DIRECTED BY OTTO PREMINGER, A COLUMBIA PICTURES RELEASE

Reinventing Movie Titles

Press kit
Designed in the shape of a governmental briefcase.

Premiere program
Ten page, two-color booklet

Title sequence frames
(Opposite) A slow-motion study of an undulating American flag in juxtaposition with the credits is punctuated by the strong graphic symbol that opens and closes the sequence.

Production Credits

Produced and Directed by	Otto Preminger
Screenplay by	Wendell Mayes
Based on the Novel by	Allen Drury
Music by	Jerry Fielding
Production Designer	Lyle Wheeler
Film Editor	Louis R. Loeffler
Director of Photography	Sam Leavitt A.S.C.
Camera Operators	Saul Midwall, Emil Oster, Jr.
Sound	Harold Lewis
Sound	William Hamilton
Electrical Supervisor	James Almond
Construction Manager	Arnold Pine
Key Grip	Morris Rosen
Makeup	Del Armstrong
Makeup	Robert Jiras
Hairdressing	Myrl Stoltz
Wardrobe	Joe King
Wardrobe	Adele Parmenter
Wardrobe	Michael Harte
Property Master	Meyer Gordon
Stills	Al St. Hilaire
Stills	Josh Weiner
Music Editor	Lee Osborne
Music Recording	Murray Spivack
Sound Effects Editor	Leon Birnbaum
Script Supervisor	Kathleen Fagan
Set Decorator	Eli Benneche
Costume Coordinator	Hope Bryce
Miss Tierney's Clothes Designed by	Bill Blass
Assistant to the Producer	Max Slater
Production Manager	Jack McEdward
Unit Manager	Henry Weinberger
Production Assistant	David De Silva
Production Secretary	Florence Nerlinger
Technical Advisor	Allen Drury
First Assistant Director	L. V. McCardle, Jr.
Assistant Director	Don Kranze
Assistant Director	Larry Powell
Assistant Director	Charles Bohart
Lyrics for "The Song from Advise and Consent" by	Ned Washington
Distributed by	Columbia Pictures Corporation
Filmed in	Panavision®
Titles Designed by	Saul Bass

144 Saul Bass

Ticket holder
Three-panel folding holder for tickets.

Invitation
Special screening for the U.S. Senate.

Reinventing Movie Titles 145

Saul as a monk
On location in Rome dressed to "blend in" while shooting stills in preparation for the title sequence.

Title sequence frames
This arresting essay in light and shadow is a short art film in its own right.

The Cardinal
(1963, dir. Otto Preminger)

The beautiful live-action title sequence for this story of a priest who rises to the rank of cardinal reveals a remarkable sensitivity to light and pattern. A commanding piece of photography and editing, its elegant restraint counterbalances a majesty and beauty that might otherwise overwhelm.

The sequence locates place, time and character: a young priest at the Vatican, the physical and spiritual center of the Roman Catholic Church, in Fascist Italy in the 1930s. A series of cross fades of steps, columns, mosaic pavements and surrounding spaces produce visceral visual pleasures. The powerful shadows and the slow movement of a solitary silhouette across a landscape, at once specific and abstract, suggest a darker side to this apparent serenity.

The obligations and control – from which the main character never quite escapes – are suggested by the length and strength of the cast shadows. The darkness of the shadows is still in the mind when the camera moves to graffiti, with its abrupt reminder of the greater shadow of Fascism. Jerome Moss's score highlights the isolation of the priest and hints at tensions between him and his Church.

It was easier to come up with a title sequence for this film than it was to find a symbol. Saul stated, "No matter how I tried to pictorialize it, I always wound up [with] a kind of ecclesiastical character in the graphic material, which tended to type it as a religious film or dull documentary. What I wanted to advertise was the film's general dramatic quality, with a sense of strength and impact."[52]

In the end, the symbol was created out of the name of the film, using lettering to convey a sense of monumentality. Imposing in its own right, the size and importance of the word "cardinal" is greatly reduced in significance by the power and towering presence of "the," the structure of which symbolizes a greater power than that of the Cardinal, namely the Vatican.

Reinventing Movie Titles 147

Preliminary sketches
Saul said that it was easier to come up with a title sequence for this film than it was to find a symbol that would indicate this was not a narrowly religious story.

Poster
Saul used the word "cardinal" to represent the cardinal himself, monumental yet dwarfed by the larger presence of the Vatican.

THE CARDINAL
AN OTTO PREMINGER FILM

THE CARDINAL STARRING TOM TRYON, ROMY SCHNEIDER, CAROL LYNLEY, JILL HAWORTH, RAF VALLONE, JOHN SAXON, JOSEF MEINRAD, BURGESS MEREDITH, OSSIE DAVIS, DOROTHY GISH, TULLIO CARMINATI, MAGGIE McNAMARA, BILL HAYES, CECIL KELLAWAY AND JOHN HUSTON AS GLENNON. ALSO BOBBY (MORSE) & HIS ADORA-BELLES ✤ SCREENPLAY BY ROBERT DOZIER. BASED ON THE INTERNATIONAL BEST SELLER BY HENRY MORTON ROBINSON. MUSIC BY JEROME MOROSS. PRODUCTION DESIGNED BY LYLE WHEELER. PHOTOGRAPHED BY LEON SHAMROY IN TECHNICOLOR® AND PANAVISION 70®. PRODUCED AND DIRECTED BY OTTO PREMINGER. A COLUMBIA RELEASE.

Reinventing Movie Titles 149

Poster and idea sketches
In the final poster, the arm of an officer suggests the driving force of war – the backdrop against which the film is played out.

Title sequence frames
This epilogue is a metaphor for the tumultuous events of the film; from the calm before the war, through the height of conflict, to the uncertainty of the return home.

AN OTTO PREMINGER FILM STARRING JOHN WAYNE, KIRK DOUGLAS, PATRICIA NEAL TOM TRYON, PAULA PRENTISS, BRANDON DE WILDE, JILL HAWORTH, DANA ANDREWS STANLEY HOLLOWAY, BURGESS MEREDITH, FRANCHOT TONE AND HENRY FONDA BASED ON THE NOVEL BY JAMES BASSETT. MUSIC BY JERRY GOLDSMITH. PHOTOGRAPHED IN PANAVISION® BY LOYAL GRIGGS. PRODUCED AND DIRECTED BY OTTO PREMINGER

Saul Bass

In Harm's Way

(1965, dir. Otto Preminger)

Preminger's sprawling two-and-a-half-hour wartime melodrama follows a naval troop from just before the Japanese attack on Pearl Harbor to the end of World War II.

Saul's metaphorical epilogue is evocative of the "violent and eternal qualities of the sea."[53] It connects the broad historical sweep of the film and the violence of war with the volatile cycles of nature. Using images of water, waves, storms and explosions, Saul created a powerful montage. Tension builds, from beautiful gentle waves against a beach to stormy seas and enormous explosions that seem to grow out of the sea itself. Finally, the sea calms again to reveal the moon's reflection on gently lapping waves.

The advertising campaign symbol – a cropped image of an officer's arm pointed resolutely forward – signals that this is a film about the U.S. Navy, but beyond that gives little away. The press book was designed in the form of a military folder with "VITAL INFORMATION" stamped across the front, but for the most part the advertising focused on "the arm."

Title sequence frames
A hand tears away at the screen in a desperate search for the truth, revealing credits along the way. The last frame, by contrast, reveals what is missing.

Poster
There is an ominous feeling of loss in this image of a child torn away, and in the fading letters of the word "missing."

Bunny Lake is Missing

(1965, dir. Otto Preminger)

Discussing the titles, Saul stated, "One of the two key protagonists in the film is a deeply emotionally disturbed person who is involved in the disappearance of the child, Bunny. The opening reflects this psychotic state of mind. It consists of a series of hands entering the screen and tearing various shaped pieces out of the screen revealing the different credits...with the final action creating the symbol for the film – the shape of a child torn out of paper."[54]

The peeling away of layers of paper is a metaphor for the peeling away of layers of mystery in this film about a child who disappears. The symbol, a child torn out of paper, relates to the child's absence and to there seeming to be no proof of her existence. The last letters of the word "missing" gradually fade away, again emphasizing the disappearance of the child.

Billy Wilder

The first director to engage Saul, after his work on the title sequence for *Carmen Jones* (1954) and before his work on *The Man with the Golden Arm* (1955), was Billy Wilder, another filmmaker who knew a great deal about modern art and design. His good friends, the designers Ray and Charles Eames, encouraged him to hire Saul, whose work they admired. Saul only created one title sequence for a Wilder movie, but he went on to design trade advertisements and posters for others.[55]

The Seven Year Itch
(1955, dir. Billy Wilder)

There was no symbol for *The Seven Year Itch*, but Saul played with the idea of an itch in the title sequence.[56] He wanted to avoid literal or sensationalist graphics for this story of a middle-aged married man (Tom Ewell) lusting after his sexy neighbor (Marilyn Monroe) during a long hot New York summer. He and Wilder agreed that establishing a playful, upbeat mood would ensure the audience would be receptive to a comedy.

In this delightfully light-hearted, slick and witty sequence, rectangles and squares of bright modern colors randomly pop out or slide into position on a black screen, eventually filling it. Credits and jokes are revealed in time to a tempo as quirky as the random opening of boxes recalling magicians' acts and popular TV game shows.

As Saul explained, "I divided the screen into a series of abstract shapes and then had those shapes get cute, funny and open flat to reveal things, like words and credits. Then I had them do funny things with each other and play games like opening and closing windows, a combination of motion and design that was not characteristic at that time in titles. Little incidents, such as the *t* in *Itch* scratching itself several times, enliven the proceedings. The title ends with the opening of a final panel from which the last credit pops out jack-in-the box style."[57]

Title sequence frames
(Opposite) Rectangles and squares in bright modern colors randomly pop out or slide into position, establishing a playful and upbeat mood.

Poster
A partially drawn window shade combined with playful graphics expresses the light-hearted nature of the film.

Love in the Afternoon
(1957, dir. Billy Wilder)

For this film about an older man and a young woman, Saul's advertising campaign used the voyeuristic device of a partially closed window blind, suggesting things hidden, if not forbidden, with which Wilder opens the movie. Bright, gay colors and dancing letters signal the playful nature of the film, while a cupid's arrow shot through two letter "O"s, which seem to kiss, spells romance.[58]

Reinventing Movie Titles 155

Some Like it Hot

(1959, dir. Billy Wilder)

Many regard the series of ads for the 1960 Oscar campaign for *Some Like It Hot* as among Saul's most brilliant. He took the theme of gangsters dressed up as musicians from the film, in which the characters played by Jack Lemmon and Tony Curtis witness a murder and are chased by the mob. Saul riffed for ten advertisements, creating a readily recognizable series even though there is no one symbol. Each design tells a story without words, while text used as part of the design tells another. Words form gunfire, liquid poured into Molotov cocktails, the body of a vehicle, musical notes, the flattened body of a gangster, a coffin, a sailing boat in a bath and part of a birthday cake. Wilder later joked with Saul, "Brilliant, brilliant. I laughed and laughed. So did everyone, but I still didn't win the Oscar." He paused, briefly but dramatically, turned to Saul and said, "Maybe your designs made people think the movie was going to be as funny as the advertisements!"[59]

Trade ads
These seven ads were part of a series promoting the Oscar prospects of this dazzling comedy.
1960

Reinventing Movie Titles 157

Proposed ad campaign
This witty symbol raised issues related to "Coca-Cola Imperialism."

One, Two, Three
(1961, dir. Billy Wilder)

The publicity campaign for this comedy about American cultural and economic imperialism in West Germany proved controversial. Saul's symbol featuring a U.S.-style flag sticking out of a Coca-Cola-style bottle had to be scotched when Coca-Cola threatened legal action.[60] The replacement campaign used three balloons to capture the film's light-heartedness – balloons that in the movie carried slogans such as "Yankees Go Home" and "Russki Go Home."

158 Saul Bass

Insert poster
Billy Wilder himself was featured in this promotional ad announcing the film.

Trade ad
The final campaign used three balloons to signal this "explosive" new comedy.

Reinventing Movie Titles 159

ATTACK

...DESCRIBES THE ACTION OF

THE PICTURE PREVIOUSLY CALLED "FRAGILE FOX".

IN RESPONSE TO EXHIBITOR REACTION,

UNITED ARTISTS CORPORATION AND

THE ASSOCIATES & ALDRICH

ANNOUNCE THE CHANGE OF TITLE TO "ATTACK".

DESIGNED BY SAUL BASS

Attack!

(1956, dir. Robert Aldrich)

For this title sequence, Saul created a montage of off-duty soldiers relaxing in a near-deserted Belgian village during World War II. It cuts in after a dramatic live-action opening in which sixteen men are slaughtered. The segue to the titles features the helmet of a dead soldier rolling down a hill. It stops at a spot where a solitary daffodil grows and fades neatly into the circular mouth of a loudspeaker broadcasting swing music.

Saul's stylish sequence uses the beat to focus on close-ups of men walking, eating, stamping their feet, sitting on steps and warming their hands over a brazier. The sequence closes with the same circular form of a loudspeaker, from which a woman's voice from Armed Services Radio announces, "That's all for today fellas … goodbye."

The release of *Attack!* was announced in the *Hollywood Reporter* in an unprecedented ten-page advertisement designed by Saul, which itself reads as a moving sequence. Each double-page spread features the same blood-red still with men in combat gear moving across the frame, while the credits unfold in clear type within bullet-like white circles.[61]

Cutting has been completed by producer-director Robert Aldrich and film editor Mike Luciano on FRAGILE FOX, *the most exciting war picture of our times. Composer Frank deVol will record within 20 days. Our next ad will report on the sneak preview reactions, before* FRAGILE FOX *is turned over to United Artists for August release. An Associates & Aldrich Production.*

Trade ad
(Opposite) Announcing that the title of the film had been changed from *Fragile Fox* to *Attack!*

Trade ad
Teaser ad announcing the completion of filming.

Reinventing Movie Titles 161

Title sequence frames
An engagingly paced montage of off-duty soldiers in Europe during World War II.

Announcement
Die-cut holes blast through the imagery.

Ten-page advertisement
This release ad itself reads as a moving sequence.

Reinventing Movie Titles 163

Newspaper ad and billboard

Title sequence frames
(Opposite) The first frames reveal the open pages of a book, then a child's face (Saul's daughter Andrea) and flames that threaten to consume the screen.

Storm Center
(1956, dir. Daniel Taradash)

The theme of this film, an early open criticism of McCarthyism, is book censorship and anti-Communism. The setting is small-town America. The story revolves around a librarian (Bette Davis) who refuses to remove a purportedly Communist book, and one of the children in the community who sets fire to the library. There is no single symbol for this film, but the titles and advertising feature a face, a flame and text from a book.

Saul explained: "Our first frames reveal the open pages of a book. As the credits unfold, the close-up of a child's face superimposes over this image. The child glances slowly about herself and soon we notice that the edges of the book are smoking and in a moment they burst into flame, slowly charring the dual image of the page of the book and the face of the child. As the credits come to a close, the flames spread and become more intense until the entire screen is an inferno."[62]

In the image of the burning book, Saul sets up a disturbing parallel between the anti-Communist witch hunts of 1950s America and the anti-Semitic witch hunts and book burning of Nazi Germany – a connection the main character herself suggests in the film.

"If the book be false in its facts, disprove them; if false in its reasoning, refute it. But, for God's sake, let us freely hear both sides, if we choose." —From a letter by Thomas Jefferson, April 19, 1814.

BETTE DAVIS IN **STORM CENTER**

watch for this MOTION PICTURE at your local theatre

Poster
Here an abstracted version of a face was used in order to convey more forcefully the destruction of the human spirit.

Reinventing Movie Titles **165**

Around the World in Eighty Days

(1956, dir. Michael Anderson)

There were so many people to be credited in this movie extravaganza that Saul persuaded producer-impresario Mike Todd and director Michael Anderson that the film would be best served by an epilogue. The result was a hilarious six-minute recapitulation, in animated form, of the preceding three hours. In order to retain audience attention after an already long film, Saul created amusing parodies of incidents from the movie as well as humorous caricatures of the main characters.

"The main thread of continuity is maintained by the bicycle and top-hatted clock, symbols of Passepartout, Phineas Fogg's jack-of-all trades valet and the punctual, precise Phineas Fogg…," he explained, adding, "The final sequence finds Phineas Fogg and Aouda (the Indian princess he rescues) colliding – the watch enlarges and opens revealing its inner works, which explode leaving a pulsating heart."[63]

Both film and epilogue were smash hits. Animator John Halas noted that, "In spite of the fact that the credit titles containing hundreds of artists' and technicians' names were placed at the tail end of the film…the audience not only stayed to see them all but applauded them, admiring the graphic invention and witty visual ideas."[64]

Work in progress "paste-up" (above) and epilogue credit sequence frames

166 Saul Bass

Reinventing Movie Titles 167

Print ad and billboard
(Above, and lower right) Drama is established by a man's body running off the edge of the frame.

Title sequence frames
(Above right) The title sequence serves as a prologue, introducing the main character as he makes his way through New York City at night.

168 Saul Bass

Lobby card
Featuring bold color and type accompanied by scattered rectangles suggestive of city lights.

Newspaper ad
Another variation emphasizing letters that bleed off the edges of the frame.

Edge of the City
(1957, dir. Martin Ritt)

This title sequence establishes mood and reveals a few moments of "the time before" the film begins by introducing a young man on the run in a waterfront freight yard. The fast pace and the dramatic photography of nighttime New York hint at the dark drama to come.

Saul described the sequence thus: "Against the live-action background play a series of animated rectangles which function in different ways in relation to the background action. At the beginning they create a sense of 'drive' (as the protagonist runs down the pathway to a ferry) by popping on and off screen in long horizontal patterns. Later (as the figure crosses the river on the ferry), they assume a symbolic representation of the lights of the Manhattan skyscrapers as they flicker on and off the screen. They once again resume the horizontal 'drive' character (as he moves through the freight yard on the other side of the river) interspersed with random flickering 'thought' patterns near his head. Finally, they lead us visually to the bright light of the hiring office door and end as our story begins."[65]

Sadly, these rectangles that echo and emphasize the action and mood of the John Cassavetes character do not appear in the final cut. They do, however, appear in the intriguing advertising campaign. The staccato-like rectangles can be read as a code, adding to the ambiguity that Saul so loved.

Reinventing Movie Titles 169

170 Saul Bass

Premiere program cover and interior spreads
(Opposite) The vellum cover featured die-cut "bullet holes." Inside there was a book within a book, each spread a different color.

Premiere invitation
(Opposite, below) The multicolored invitation was accordion folded.

The Pride and the Passion
(1957, dir. Stanley Kramer)

Saul had worked with Stanley Kramer since the late 1940s, creating advertising campaigns for at least fourteen Kramer productions. His two title sequences for Kramer were for vastly different films: *The Pride and the Passion* (1957) and *It's a Mad, Mad, Mad, Mad World* (1963).

For *The Pride and the Passion*, set during the 1810 Spanish War of Independence, Saul used images from Goya's powerful contemporary *Disasters of War* etchings, which depict Spanish civilians fighting against Napoleon's army. Details from the etchings fill the screen and are overlaid in blood red. Saul then added jarring superimpositions of muskets, spears, a spray of bullets and exploding gunpowder. The first scene of the film, a panoramic view of the retreating Spanish army, fades in under a red screen and, for a few moments, the images are suffused with the color of blood.

Saul designed particularly imaginative items in strong, rich colors for the premiere, but did not claim the main publicity campaign. The album cover, however, is very similar to Saul's storyboards for a trailer, as are some posters that include sketches of the film's stars, suggesting that he may have devised a campaign that was altered by the studio.[66]

Title sequence frames
Images from Goya's powerful *Disasters of War* etchings are intensified by the staccato graphics of bullets, explosions and spears.

Reinventing Movie Titles 171

Billboard

Title sequence frames
These three frames are from Saul's original version, which explored different parts of the "stranger's" face, before zooming into one eye and then dissolving into live action.

The Young Stranger

(1957, dir. John Frankenheimer)

John Frankenheimer admired Saul enormously, referring to him as "an Artist with a capital A."[67] This, Frankenheimer's debut as a film director, was the first of three films they worked on together.

Saul created a short, deceptively simple, but appropriate sequence for this low-budget film based on a television series that Frankenheimer had also directed. In it, Saul played with the idea of what a stranger is, and of trying to know someone or something through appearance.

The first four credits are presented as the viewer contemplates the face of a young man or, more correctly, his eyes, nose and mouth, because the rest of the face blends in with the screen. Just as one becomes intrigued by this face, Saul switches to live action. The rest of the credits play out against a young student walking in the grounds of a high school and greeting his friends. We see him and a friend walk toward his car as the film proper begins…[68]

Title sequence frames
A series of graphic devices, sub-plots and visual puns capture the flavor and humor of this film about the Old West.

Cowboy
(1958, dir. Delmer Daves)

Cowboy is based on the real-life story of a former hotel clerk turned tenderfoot cowboy (Jack Lemmon) who joins a cattle drive led by a tough trail boss (Glenn Ford). Set in the Old West, it conveys some of the unglamorous realities of the cowboy way of life in nineteenth-century America.

Describing the title, Saul stated, "The title attempts to recapture the flavor, the excitement and the rich humor of that period by the use of the typical pen and ink line drawings and typography of the time. It opens with the appearance of horizontal, typographic border elements that turn into a front page of a newspaper of the period … over which some credits appear. As we pan into the newspaper, we discover that subsequent credits are continued in the various and several advertisements, bringing us finally to a 'hat' advertisement that eventually dissolves, leaving one hat which is then filled by a Western character. After a lassoing incident, in which only his boot is retrieved, we find ourselves back in the newspaper in a 'boot' ad. As the spurs pop on the boots, we dissolve to the open range. The spurs become twinkling stars which, in turn, are transformed into twinkling brands. The brands zoom up to fill the screen in a series of quick cuts, after which the final brand zooms back to come to rest on the rump of a cow. Color is strong and bright, mainly in ochers, reds, oranges and lavender. A musical score, composed of a potpourri of Western folk themes, is closely cued to visual mood changes in the title."[69]

Reinventing Movie Titles 173

The Big Country

(1958, dir. William Wyler)

Saul created a title sequence, a symbol and a comprehensive advertising campaign for this drama about a cultured Easterner (Gregory Peck) trying to make peace between two Western families fighting over water rights.[70]

Saul recalled, "This was a film about an isolated community in the West, a primitive place where the long arm of the law had not yet reached, and where feud-like animosities bubbled. Into this community came a cultural misfit from the East. What I tried to do in the title sequence was to dramatize, in tightly compressed montage, the three-month journey that Peck's character has made before the story starts.

"To express the distance from the East, to convey the vastness of empty spaces, and thus dramatize the isolation of the Western town, I used a series of shots showing a stagecoach as a tiny object on the horizon, cross-cutting to intense ultra close-ups of the stagecoach on the move ... the horses' hooves flashing, hitting the ground, the blurred wheel spokes and hubs as they revolved furiously, the horses' manes whipping through the air, their heads and eyes flashing through the frame.

"Then we cut back to the stagecoach. It's so small that it takes an unfolding puff of dust to tell you that it's there. It barely seems to move. Cut to more close-up furious activity, and it moves an eighth of an inch on the horizon. The time sense is amplified by extremely long cross-dissolves so that for discernible periods of time the image we lose and the image we gain are superimposed on the screen simultaneously. The juxtaposition of the furious close-up activity and minimal movement of the coach in the long shot dramatizes the amount of energy it took to cover the vast distances. So that finally when the stagecoach gets to the settlement, you know you are in ... *The Big Country*."[71]

Title designer Wayne Fitzgerald noted, "It took five minutes to get across the screen. Then he put a tiny little title on there, so, by God, that country was big. Bass showed that if you put a small title in an area where you can read it, it's more readable than a big title."[72]

Trade ads
The symbol, a sun inside a dust cloud, was often accompanied by a string of distant horses and riders in silhouette. Though Saul's ideas were used for the trade advertising, in the final ad campaign the studio used only particular aspects of his designs.[73]

Reinventing Movie Titles 175

Title sequence frames
"The juxtaposition of the furious close-up activity, and minimal movement of the coach in the long shot, dramatizes the amount of energy it took to cover the vast distances [in the American West]."

The Cloud of Dust

That cloud of dust took some doing.

When I arrived outside of Stockton, California, where the exteriors were being shot, I was pleased to find that Wyler had reserved the stagecoach and horses for my use. But it had rained the day before, and – catastrophe! – the possibility of the hooves or wheels raising a cloud of dust was zero.

Willie Wyler told me I could have the coach for one day, beginning now, and that was it. Desperate, I got an idea. I sent a crew into Stockton for a couple of dozen bags of flour. We ripped out the back of the stagecoach. Put two grips in the back, with as many bags of flour as we could cram in. And as the coach rattled across the landscape, these two guys were dumping the flour out. It worked. We got a respectable cloud of dust.

When I told this story to a group of Japanese students as an example of ingenuity in times of stress, it seemed to go down well until one person asked "could Mr. Bass please tell us what sort of flowers he threw out of the coach?"[74]

Reinventing Movie Titles 177

Poster, six-sheet, billboard and advertisement
Each element of the ad campaign was different – each color and design spinning the viewer in another direction.

Vertigo
(1958, dir. Alfred Hitchcock)

Alfred Hitchcock, who began his film career by designing inter-title cards for silent movies, commissioned Saul to create titles for *Vertigo*, *North by Northwest* and *Psycho*. Saul, who greatly admired Hitchcock's work, responded with compelling, at times near-abstract sequences that capture the undertones of and echo key elements in these three remarkable films. Hitchcock almost certainly knew of Saul's work well before the *Vertigo* commission, not least because he kept a close eye on movie graphics, subscribing to *Graphis*, a journal that had already featured Saul's work.[75] Now one of Hitchcock's most admired films, *Vertigo* confounded contemporary audiences. Saul's title sequence and advertising designs, by contrast, immediately began to win awards and have always been among the most admired in his repertoire.

In the titles, Saul sought "to express the mood of this film about love and obsessing" and to capture "that very particular state of disequilibrium associated with vertigo."[76] He explained, "Here is a woman made into what a man wants her to be. She is put together piece by piece. I tried to suggest something of this, and also of the fragmented mind of Julie (Kim Novak), by my shifting images."[77]

The main poster also encapsulates the sensation of vertigo by having a couple sucked into a vortex. The slightly off-kilter, irregular capitals further hint at the vertiginous. The figures were drawn by Art Goodman, who recalled Saul specifying and sketching out a black silhouette for the man and a light outline, like an apparition, for the woman of his obsessions.[78]

The title sequence opens with the camera exploring different parts of a woman's face, coming to rest on her eye (an organ Saul thought the most vulnerable in the entire body). Then, from the depths of the eye and accompanied by shatteringly violent chords, the title of the film emerges. Spiraling light patterns (Lissajous forms) emerge from the pupil as the music makes a vertiginous climb. The rest of the credits play out over mesmerizing spiral forms and the darkly pessimistic love theme. Colors change as each new form overlaps the old one until, finally, one disappears into the pupil itself and out comes the final director credit.[79]

Saul's interest in spiraling Lissajous forms and other ways of notating light and vibrations was part of a wider Modernist interest in bringing together science and art. It relates to his classes with Kepes in the early 1940s, as well as to 1950s preoccupations with outer space.[80] Saul commissioned experimental filmmaker John Whitney to produce the forms.[81]

Reinventing Movie Titles 179

The Origins of the Vertiginous Forms in Vertigo

I was browsing through the remainder bin in a Third Avenue bookshop. I leafed through a book and was stunned by some beautiful images. They were by Lissajous, a French mathematician of the late 1800s.

From a Swiss scientist's later description of these images and how they were made, I was able to reconstruct a device used by Lissajous to create them. It consisted of a recording pendulum with an attached and smaller free-swinging eccentric pendulum which introduced variables into the motion of the recording pendulum. The recording device was a tiny brush with an ink reservoir and a stop cock regulator. Very tricky to operate. But when it worked the images were extraordinary. Watching them grow as the pendulum swung, not knowing what their final form would be, was a magical experience. I made a batch. Sat on them for years. And then Hitchcock asked me to work on "Vertigo." Click!

I did not invent them, they had already existed, but were not fully recognized for their aesthetic potential since they were mainly seen as scientific expressions. You could say I was obsessed with them for a while – that I had fallen in love with them – so I knew a little of what Hitch was driving at.[82]

Title sequence frames
Spiraling forms overlap in space and advance hypnotically toward the viewer as the credits appear and disappear in relation to Bernard Herrmann's haunting score.

180 Saul Bass

Reinventing Movie Titles 181

Title sequence frames
This multilayered sequence moves from flat color to a grid, which reveals itself to be the glass facade of a skyscraper reflecting the busy life of New York City, where the film takes place.

North by Northwest

(1959, dir. Alfred Hitchcock)

The cool sophistication of this title sequence reflects that of the main character – a New York advertising executive who sees his world go haywire when he is mistaken for a spy. The title sequence picks up the theme and plays on the notion of mistaking one thing for another.

Saul explained, "The titles open on a violent-green screen, over which dark blue lines race in from top and side, forming a lattice-work pattern. Credits appear from out of the top of the frame, running up and down the surface plane of the pattern – pausing long enough to be read. After the appearance of the title of the film, a live-action scene dissolves through, and we see that the pattern was an abstraction of the side of a gigantic glass structure in mid-town New York. In the glass we see reflected the opposing streams of automobile traffic on the street below. As we watch this, the credits continue to move up and down the side of the building like elevators."[83]

The sequence ends with the director credit running over Alfred Hitchcock himself, playing a pedestrian who has just had a bus door shut in his face. On that humorous note of everyday life in a bustling city, the film proper begins.

182 Saul Bass

Psycho
(1960, dir. Alfred Hitchcock)

So pleased was Hitchcock with Saul's work for *Vertigo* and *North by Northwest* that the reigning master of suspense asked him not only to create titles for his next film but also to act as a consultant. The film was *Psycho*, a low-budget horror/suspense story about a psychotic motel manager. Hitchcock involved Saul from the earliest stage. They had meetings before writing began, and Saul received each section of the screenplay as it was completed.[84]

For the titles, Saul aimed at a mood of dysfunction within a wider sense of order. Simple bars suggest clues coming together without ever offering a solution: "Put these together and now you know something. Put another set of clues together and you know something else."[85]

Bars of equal weight slide onto the screen in various patterns disturbed by irregularities of speed and length. Oppositions are strong: black and white; vertical and horizontal; short and long; on and off-kilter; on and off-screen. Parts of each credit appear on different bars but are only legible when they are in alignment – another signal of the disturbing uncertainties to come. Bernard Herrmann's score moves from tension to terror to harmony, sometimes reflecting, sometimes complementing the unpredictability and slippage between ease and unease, function and dysfunction that lie at the heart of this sequence. At the end, the lines shape up with what become the edges of buildings in Phoenix where the first scene takes place.[86]

Title sequence frames
The title suggests both order and disorder, function and dysfunction, unease and foreboding.

Reinventing Movie Titles

Shower sequence frames
Saul translated the script into powerful visuals, designing a highly stylized murder, fast cut after fast cut.

Saul's task as consultant, for which he was paid the substantial sum of 10,000 dollars, was to "do something" with the shower sequence, the murder of the detective, the revelation of the mother's dead body and the house on the hill.[87]

Hitchcock had identified the shower scene as in particular need of special handling because he knew that the audience would be shocked by the murder of the heroine only forty-five minutes into the film. This was not the first time Hitchcock had brought in an artist to come up with a special sequence: Salvador Dalí had created one for *Spellbound* (1945), and John Ferren had created a dream sequence for *Vertigo* (1958).[88]

For the shower scene, Saul translated the script into powerful visuals, designing a highly stylized murder, fast cut after fast cut in simulation of the frenzy of the act itself — an act we do not see. Skilled at the visualization of ambiguity and metaphor, Saul used montage, tight-framing and fast cutting to render impressionistically a violent bloody murder as a ritualized, near-bloodless, one.

Some of the images were prompted by passages in the script; others, like the pulling down of the shower curtain, came from Saul's imagination. The dramatic intensity was reinforced by repetition. As he put it, "She's taking a shower, taking a shower, taking a shower. She's hit-hit-hit-hit. She slides, slides, slides. In other words, the movement was very narrow and the amount of activity to get you there was very intense. That was what I brought to Hitchcock. By modern standards, we don't think that represents staccato cutting because we've gotten so accustomed to flashcuts. As a title person, it was a very natural thing to use that quick cutting, montage technique to deliver what amounted to an impressionistic, rather than a linear, view of the murder."[89]

Hitchcock's initial reaction to the storyboards was one of uncertainty. Saul recalled, "Having designed and storyboarded the shower sequence, I showed it to Hitch. He was uneasy about it. It was very un-Hitchcockian in character. He never used that kind of quick cutting; he loved the long shot. Take the opening shot in *Psycho* where the camera moves over Phoenix, over the buildings, closes in on a building, into a window and into a room where Janet Leigh and John Gavin are making love. That sort of camera move was his signature. My proposal was from a very different point-of-view.

"His misgivings made me a bit nervous too so I borrowed a camera (a little Eymo wind-up with a twenty-five-foot magazine) and kept Janet Leigh's stand-in on the set after the day's shooting. I put a key light on her and knocked off about fifty to a hundred feet of film. Then I sat down with George Tomasini [Hitchcock's editor] and we put it together following my storyboards, not worrying too much about finesse — just wanting to see what the effects of these short cuts would be. We showed it to Hitch. He liked it.

"When the time came to shoot, I was on stage near Hitch, who was sitting in his elevated director's chair in his Buddha mode, hands folded on his belly. He asked me to set up the first shot, as per the storyboard. After I checked it through the camera, I turned to him and said 'Here it is.' Then Hitch said 'Go ahead, roll it.'

"It was an amazing moment. On Hitch's set, no one would issue orders other than Hitch. So I swallowed hard, gulped and said 'Roll camera!... Action!' He sat back in the chair, encouraging me, benignly nodding his head periodically, and giving me the 'roll' signal as I set up each shot, matching them to the storyboard."[90]

After the sequence was shot, Hitchcock insisted on two inserts: a spray of blood and a close-up of a knife into the belly. Saul was not entirely convinced, preferring the visual and conceptual purity of his "bloodless" murder with no knife contact, which held back the horror of the blood until the very end when it swirled down the drain. Trusting Hitchcock's vision Saul agreed. In later years, he would occasionally wonder how the original sequence, without the inserts, would have worked in the film.[91]

Saul's major contribution to what has become one of the classic moments of cinema was ignored for many years by auteurist commentators. They took their cue from Hitchcock's evasive reply to a question about the shower scene posed by François Truffaut in 1966 in which he (Hitchcock) stated that Saul was only involved in the scene where the detective walks up the stairs. One is left to speculate as to why Hitchcock would hire one of the world's leading graphic designers to visualize the shower scene, a designer he admired for making strong visual marks, and pay for it out of his own pocket, only to deny him credit a mere six years later.[92]

Both Hitchcock and Saul enjoyed impression, ambiguity and metaphor, but it was Saul, rather than Hitchcock, who so beautifully translated Joseph Stefano's impressionistic script for the shower sequence into visuals.[93] To those who know design as well as film, this sequence is as different from the rest of *Psycho* as the Eameses' montages for Wilder's *The Spirit of St. Louis* (1957). No one has problems crediting the Eameses or considers that their input detracts from Wilder's talents. It is time for Saul's contribution to the shower scene to be acknowledged fully, while Hitchcock, in turn, deserves credit for collaborating with a relatively new cinematic talent on such a key scene.

Frames from the shower sequence storyboard
Saul envisioned a fast-cut, impressionistic murder, with no blood until the very end when it swirls down the drain. The script suggested certain images; others he invented, like the pulling down of the shower curtain.

Saul, Alfred Hitchcock and Janet Leigh
On the set between takes, at the Bates Motel.

House on the Hill

One of the problems Hitch asked me to work on was how to "strangify" the house on the hill. I built a simple model and experimented with lighting. Up-lighting, back-lighting, cross-lighting – it all looked hokey and obtrusive.

Finally, I hit on it. I matted in a time-lapse moonlit, cloudy night sky – but no scudding clouds – just moving somewhat faster than normal. In the two to three-second cuts to the house (which was not long enough to reveal the abnormal rate of movement), it resulted in an undefined sense of weirdness.[94]

Working with Hitch

Anybody who worked with Hitch had no doubt that he was in total control of everything that happened on his film. There's no doubt he was an autocrat. But, as far as I was concerned, he was a benevolent autocrat – open to new ideas, generous with his praise, always helpful and supportive. And, what really impressed me, a wonderful teacher.

I hung around as often as I could to watch Hitch work and hear him talk. He seemed to like having me around and I liked being around. His understanding of film was profound. It was a revelation to me. Why something worked, why something else didn't. Hitch was the master and I was the student. It was the graduate course in film theory I never took. I'd ask him "Why did you select take five when four seemed better?" And he'd typically say, "You don't understand. I'm only using the first half of five. Then I'm cutting away to the other angle, and will come back to five for the end moment," and so on. He had the whole film in his head. He knew what he wanted to achieve with each sequence in advance, so what happened on set, in a sense, wasn't new information.[95]

Reinventing Movie Titles **187**

Title sequence frames
Here the rituals of courtship provide the elements for a witty animated sequence.

The Facts of Life
(1960, dir. Melvyn Frank)

This comedy about a romance between two middle-aged people (Bob Hope and Lucille Ball), each married to someone else, was an opportunity for Saul to create funny gags to the strains of Eydie Gormé and Steve Lawrence's upbeat title song, "The Facts of Life." The rituals and accoutrements of courtship provide the raw material for a series of visual jokes.

Saul stated, "This title attempts to outline the ingredients of a 'boy-girl' situation, utilizing the typography of the cast names and the technical credits as active ingredients in the incidents. We begin with gifts of flowers; with candy which reveals the names of actors in the bottom of the paper wrapper when the candy is removed; gifts, one of which is composed of credits. Eventually our twosome progress to a friendly drink, the ice cubes of which are credits; a typographically jeweled necklace is proffered; cigarettes are smoked leaving typographic ashes; telephone conversations ensue; a tryst is arranged; typographic coats are hung; soft music and lights follow – all employing the typography as intrinsic actors in the situation. Finally, as the typographic lampshade is dimmed for the second time, the film begins." [96]

Ocean's Eleven

(1960, dir. Lewis Milestone)

The amusing animated title sequence for this "Rat Pack" movie, starring Frank Sinatra, Dean Martin, Sammy Davis Jr., Angie Dickinson, Peter Lawford and Richard Conte, who pull off the biggest casino heist in Las Vegas history, unfolds to music composed by Nelson Riddle.

Saul stated, "This is a film about Las Vegas. The style of the title, therefore, derives from the extravaganzas of the night life in this town, with its spectacular signs, color and gambling. The images in the title, including the cast names, are composed of dots, which simulate multiple-lightbulb colored signs. Along the way, the slot machine turns up three martinis and a drunkard, instead of the normal slot machine symbols. The final frames of the title consist of a toss of the dice, which, when they come to rest, turn up the name of the director, Lewis Milestone. As they are removed from the screen by the croupier's stick, we lap dissolve into the beginning of the film."[97]

Title sequence frames
The fun and humor in this sequence comes from Saul's inventive use of gambling iconography and references to the bright light displays of Las Vegas in the late 1950s.

Reinventing Movie Titles 189

THE MAGNIFICENT SEVEN · DIRECTED BY JOHN STURGES

Trade ads
These magnificent ads were sadly never used.

The Magnificent Seven

(1960, dir. John Sturges)

For the now-famous Hollywood Western based on the Japanese film, *Seven Samurai* (1954, dir. Akira Kurosawa), Saul designed two stunningly reductive trade advertisements. One is evocative of a "wanted" poster with bullet holes blown through it; the other marks out the number seven as notches on the handle of a gun in a manner reminiscent of Japanese calligraphy. Saul designed the latter as the symbol for the film. Publicity department heads had trouble accepting something so different from the normal advertising for action-packed Westerns featuring major stars, however, and neither of these powerfully evocative ads was used.[98]

Reinventing Movie Titles 191

Trade ad
The bold symbol of slave resistance that Saul created for the film was mostly restricted to use in trade advertising.

Saul with film props
The plaster Roman head was used for the *Spartacus* title sequence; the road signs in the background were for the epilogue in *West Side Story*.

Spartacus
(1960, dir. Stanley Kubrick & Anthony Mann)

The story of a gladiator who leads a slave revolt against the might of the Roman Empire, *Spartacus* was a high-profile project for Kirk Douglas, who both produced and starred in the movie. A long-standing admirer of Saul's work, Douglas hired him not only to create the title sequence and advertising campaign, but also as a visual consultant. His responsibilities included the design and storyboarding of the battle sequences, conceptualizing and designing the gladiatorial school and scouting the Nubian mine locations.

Douglas stated, "Saul is a tremendous talent. A real artist who captures real feelings. He went much further than anyone could have imagined in visualizing key scenes. And on top of that, he came up with a most powerful graphic image for the ads. The studio [Universal] fought me on that one. They wanted prancing horses that looked effeminate, and banners that didn't capture the spirit at all. What Saul brought to us was this image of a slave with a sword and a broken chain: when you saw that you knew the issue was freedom." [99]

The symbol of heroic slave broken free from his chains with short sword in hand was, for the most part, restricted to trade advertising and Douglas's personal greeting card. With a few exceptions, such as the billboard, the main publicity campaign used only elements of Saul's designs. It would appear that the politically charged symbol and lack of focus on stars proved too much for those promoting the film.

Saul and Elaine (this was the first sequence on which Elaine was a full collaborator) wanted the titles to establish the powerful presence of the Roman Empire. Saul explained, "What we were going for in the *Spartacus* titles was the multiple layers of elegant and disdainful faces, which express the duality of Roman rule – the oppressiveness and brutality, as well as the sophistication that made possible so many contributions to Western civilization. It seems very rich to see the growth of those profiles forming a full face, and full faces dissolving into profiles before the final face starts to crack apart and the camera zooms into the empty eye, signaling that all is not well." [100]

The concept was relatively simple, but the precise effects they wanted proved difficult to achieve, especially because there were no zoom lenses available for the wide-screen Super Technirama 70 process in which the film was shot. Saul recalled, "We solved the problem by buying a few plaster heads, for thirty dollars a head, at a place across the street from the old Goldwyn studios that made plaster casts. At that price it didn't matter if we broke more than we used, and it saved renting an expensive studio and creating expensive special effects. We put the camera on a track and shot every frame as we made a series of tiny incremental move-ins. At each stop, Elaine would start and extend cracks in the head, getting nearer and nearer, until it was riddled with cracks and ready to fall apart. So far, so good…"

Shooting the title sequence
Elaine directing for the first time when Saul was in Japan for the World Design Conference. The location was the Norton Simon Museum in Pasadena.

Title sequence frames
"The multiple layers of elegant and disdainful faces… express the duality of Roman rule, the oppressiveness and brutality, as well as the sophistication…"

"But how to have the head crack open and retain the mood of slow decay? We had to think of a way of it coming apart slowly. We wracked our brains and Elaine came up with a great idea. She recalled the Japanese Bunraku Theater where puppeteers dressed in black manipulate the puppets. Well, Elaine put on a pair of black gloves and draped herself in black cloth. She was on-camera while it was rolling and slowly pulled chunks out of the statue, just taking them away slowly until it fell apart."[101]

Discussing the visualization of the gladiatorial school, Saul stated: "The tendency is to think of them as ruffians who were just thrown into the ring – but the gladiators were viewed as prized animals, and they were carefully treated, though not as individuals or human beings. So I thought, 'What's the allusion then?' At one point I thought of creating a pit into which they would be lowered for training and practice. But then I began to think of the circus, and animals in cages, and I sensed that maybe the circus allusion was a good one, the idea of the big cats, of ferocious and potentially dangerous animals which are cared for, highly trained, and spectacular. That's what led to the eventual set, which was really a large-scale circus with bars and barred pathways into the practice ring."[102]

Saul also conceptualized and storyboarded the final battle between the slaves, led by Spartacus, and the well-trained forces of the Roman state: "I visualized two armies whose equipment and tactics would express, in compelling detail, the nature of the cultures that had produced them. The slave ranks would be relatively loose, their battle formations irregular. A people's army whose fighting skills far outstripped their organizational skills.

"The Roman army would be highly mechanized, a rational force with the Centurion blocks executing intricate geometric maneuvers with terrifying precision. In one scene I had rows of Roman soldiers stepping forward with locked shields that suddenly opened, like venetian blinds, allowing rows of troops behind them to step through, hurl their spears, and step back before the shields snapped closed again."[103]

When Kubrick took over as director, he imprinted his own strong mark on the film. Nevertheless, Saul's "hand" is discernible in the final battle. Saul and Kubrick admired each other's work, and twenty years later Kubrick asked Saul to design a poster for his now-famous horror movie, *The Shining* (1980).

Reinventing Movie Titles 195

196 Saul Bass

Battle storyboards
Examples from the many versions of the final battle between the slaves and the Roman army as conceived and storyboarded by Saul.

An All-out Battle

One may well ask (as did I) what qualified me to create a major all-out battle? But asking me to do this battle made a certain kind of sense. The film was relatively modestly budgeted for a "big" historical drama. We agreed that I would design a symbolic battle. It could be interesting, unusual, and less costly than an all-out realistic battle.

I did a lot of research. Read "Caesar in Gaul." Looked at every battle on film; "Alexander Nevsky," "War and Peace," "Gettysburg," etc. Scripted. Storyboarded. I came back with a symbolic battle.

Eddie and Kirk looked at it and said, "That's terrific. It's really great. But we have a little problem. You see, the budget has escalated, and you know we need a little more. We should see more." So I said, "How about an impressionistic battle?" They said, "Sounds good."

OK, I went back to work and re-storyboarded. Showed more. The stanchions advancing, banners swirling in the wind, trudging Roman feet, running slave feet, flashes of action, shields dented, swords broken, bird flocks shooting into the sky, cavalry hooves flashing, etc. I came back with that.

They looked at it, and said, "Listen, you do a terrific impressionistic battle. But the budget is now up still further. And I don't think we can have that final battle going on, and have somebody on stage telling the audience that there's a helluva battle going on out there. So what we need now is an all-out battle, Saul." And that's how I came to do an all-out battle.[104]

Reinventing Movie Titles

Something Wild

(1961, dir. Jack Garfein)

In this strange and harrowing film, Carroll Baker plays a young woman who is brutally raped. Unable to address or articulate her trauma, she runs away from home and tries to lose herself in the anonymity of Manhattan, only to face circumstances potentially as menacing.[105]

Saul and Elaine created a powerfully *noir*, at times near-abstract, sequence that captures the impersonality of the city and creates a mood of underlying threat. Accompanied by an Aaron Copland score, the sequence proceeds from shots of skyscrapers, whose grid-like facades suggest the bars of a cage or prison, to overhead shots of pedestrians and traffic, to a cloud of pigeons exploding into the sky.

There is a pause as the sun sets and then the movement of the city returns in a blurred montage of neon lights that seamlessly dissolves into the subway station where the film picks up.

Saul explained, "The film deals with a random, mindless, tragic event, made possible by the big city; and the effect of this event on the life of one of its inhabitants. The title is intended to provide a setting for the story by indicating the furious pace at which the city lives and the anonymity of the individuals who are caught up in its pace. In the midst of this there is a girl, and one day "something wild" happens – and our story begins."[106]

Title sequence frames
The city is the star of this sequence. But this is a different city from that in *North by Northwest*, 1959, or *West Side Story*, also 1961. Here, what is conveyed is the impenetrability of the city, which evokes the feelings of anonymity and isolation experienced by the main character.

198 Saul Bass

Prologue sequence frames
An abstract linear rendering slowly transforms into an aerial view of Manhattan.

Graphic symbol
Used during production on stationery, signage and other printed material.

West Side Story
(1961, dir. Jerome Robbins & Robert Wise)

Saul was visual consultant on this musical, which retold Shakespeare's *Romeo and Juliet* in an urban gang milieu. Saul and Elaine created an unusual opening sequence that accompanies Leonard Bernstein's romantic overture. Brilliant, saturated hues slowly change color over a single delicate drawing. The image is indeterminate and abstract, until it dissolves into the tip of the Manhattan skyline and we understand what we have been gazing at all along. Saul was also responsible for directing the superb aerial photography that followed – starting high above the tall buildings and deep canyons of the city and finally zooming down in one seamless take to the teeming streets of New York City.

There, in the stylized language of dance, the audience is introduced to rival gangs, the Sharks and the Jets, as they contest and defend their turf.[107] Saul and Elaine laid out detailed storyboards and shot extensive tests for this sequence on the streets of Los Angeles. It was ultimately filmed in New York by Jerome Robbins.

Reinventing Movie Titles 199

Saul with storyboard cards

Storyboard sketches
Saul and Elaine's storyboards for the opening dance sequence in which rival Puerto Rican and "Anglo" gangs (the Sharks and the Jets) contest and defend their turf.

Research stills
For the opening dance sequence.

200 Saul Bass

Reinventing Movie Titles 201

Saul with props

Title sequence frames
Placed at the end of the film, credits are discovered within the fabric of graffiti symbolic of the conflict between rival gangs, the Sharks and the Jets.

The lengthy credits for *West Side Story* were shifted to an epilogue, because those for the Broadway musical as well as the film had to be incorporated. This also gave viewers time to compose themselves after the tragic climax. Saul likened the effect to a decompression chamber; "The epilogue is a recapitulation of the environment within which the film's story takes place. Thus all the walls and surfaces (which were part of the background of the story) are intimately explored. As the camera moves over these walls, fences, doors and signs, it discovers, among the graffiti on them, different credits. I had a lot of fun making those credits. Look out for SB & EM in a heart – that's Elaine Makatura, of course – we had just got engaged! And I put the credit 'Music by Leonard Bernstein' on a 'No Left Turn' sign. Figure that one out!"[108]

Robert Wise later wrote to Saul, "Your concept of handling those credits, starting with chalk on the walls and old doors and ending with an actual street sign saying END was a brilliant stroke. Your filming of those endless credits in that style made them play like part of the picture itself and helped hold audiences in their seats until the lights came up in the theater."[109]

Graphic designer, Bob Gill, still cites the sequence to students as a "classic" example of title design. "The film is set in the ghettos of New York. It is about a certain time and place and what better way of producing a credit sequence than to take an art form that is so closely associated with that city and with those ghettos. He found a natural canvas and the result was brilliant."[110]

Reinventing Movie Titles 203

Saul, Elaine and Tippi-Tu
Test shots made in the garage behind their office at 7758 Sunset Boulevard, using the family cat.

Walk on the Wild Side
(1962, dir. Edward Dmytryk)

For this film, now regarded as one of the all-time Bass classics, Saul and Elaine decided upon a live-action title sequence starring a black tomcat on the prowl, as a metaphor for the "back-alley conflicts" within a film set in the red-light district of New Orleans during the Depression.

Saul described the title sequence thus; "The film's setting is New Orleans in the early thirties, and deals with the disenfranchised, tough, seamy characters of a despairing time. Symbolic of this is the black cat and its movement through this environment. The title opens with him emerging from a culvert and looking around. We watch him prowl through the back alleys, roam through his territory, meet another cat, an outsider, a quick fight, the intruder scuttles off. The cat resumes his stealthy 'Walk on the Wild Side.'"[111]

The feline eyes and paws keep moving to the bold, sexy rhythm of Elmer Bernstein's jazz-like score while the credits come and go. When the miniature drama shifts to a staccato-like fight, horns blare out as the cuts occur, in one of the best Bass/Bernstein collaborations.

Saul recalled, "*Walk on the Wild Side* was one of my very early live-action titles. I decided I would, in this title, try to come to grips with what seemed a challenging aspect of creative endeavor. And that is, to deal with ordinary things, things we know so well that we've ceased to see them. And deal with them in a way that allows us to understand them anew. The challenge was how to restore our original view of a cat, when it was new, strange, exotic (perhaps even before our point of memory), and transform it into a pervasive presence.

"We used various devices. We overcranked. That dramatically increased the size of the cat. The slower the motion, the greater the apparent body and weight, because big cats, leopards, move more ponderously than small domestic cats.

"Then we closed in on the cat's paw. Something one never sees ordinarily. Overcranked and close-up, the way that paw meets the ground forces you to reexamine the whole notion of what this animal is."[112]

Steven Spielberg remembers the "profound impression" made upon him as a sixteen-year-old by the titles for *Walk on the Wild Side*. He recalls, "I attempted to mimic Mr. Bass, using an 8mm camera and my dog on a leash walking along the narrow retaining wall outside my home in Scottsdale, Arizona. In trying to make my own movie…I made a foul error. I used a dog because we didn't have a cat. And as everyone knows, dogs are somewhat less sure-footed than felines. My cocker spaniel, Thunder, kept falling off the wall just as he got to the writer credit, did a tremendous pratfall on the producer credit, and when he got to the director credit, his legs went out from under him, and I got out of the title business for good."[113]

The Cat Fight

As I began working with live-action imagery, I learned about the joys and uncertainties of directing living organisms – animals, people – whose responses could not be plotted on an animation cell. They had a life of their own.

During production, we set up for the cat fight sequence. We threw a white cat on a black cat. They rolled over twice. Stopped. Glared at each other. And had the good sense to back away.

That left us without the cat fight but we had the roll overs. So, we made a shot, holding the black cat. Put the camera on him, waved the white cat over him. He did a snarl and a reach. We did the same with the white cat. Did a few camera swish-pans over the faces of the cats. Some swish-pans around the stage.

Then we took the roll overs. Flopped it. Double-framed it. Enlarged it. Skip-framed it. Reversed the action. Used it about eight times. And it became a cat fight! We learned a lot about editing.[114]

Storyboard sketches
An alley cat on the prowl.

Title sequence frames
Slow motion and close-up shots force viewers to reexamine the notion of what a cat is.

Reinventing Movie Titles **207**

Nine Hours to Rama

(1963, dir. Mark Robson)

The ability to magically heighten realism and transform the ordinary into the extraordinary is evident in the titles for this film about the nine hours leading up to the assassination of Mahatma Gandhi. The ticking of an old-fashioned pocket watch symbolizes the final hours, minutes and seconds of this great man's life.

Saul stated, "The entire title consisted of a series of close-up images of a clock face and its interior. By concentrating on these images, two things happen…we establish the intensity of the passage of each moment of time, but also the contradictory nature of time, the inexorability of the passage of each moment – especially if one knows that a momentous killing will soon occur – and yet so elastic that a single moment can feel like an eternity.

"First, the camera confronts the watch's filigreed face, which is the color of a blood orange. Next, it follows the tip of the minute hand leaping clockwise, as it must, and propelled by the throbbing music of an Indian raga. Then we plunge inside the watch, which now seems like a giant factory, or a universe, where the mainspring drives the wheels of the escapement at a wild pace. Then we're quickly out again and back to the face, where the second hand swings toward sixty, and inside once more, where the escapement has taken on a hurtling life of its own. Finally, fatefully, our view dissolves from watch wheels to the wheels of a locomotive, spinning us headlong into the picture."[115]

Title sequence frames
This powerful sequence weaves together intensely beautiful close-ups of a ticking pocket watch with lush color and pattern, and the driving rhythm of an Indian raga.

Sometimes You Get Lucky

We're on the set in India. Mark Robson is directing a sequence of the film. It's an Indian nightclub. Conspirators are at a back table plotting.

A small group of Indian musicians are providing some background music. I know Mark is going to use a Western score for the film. But as I'm listening, I'm thinking "This sounds wonderful. It would be so effective to have a driving Indian score for the title."

During a lull in the shooting, I pull them aside. Set up a Nagra to record, and ask them to give me 10–15 minutes of improvisation. They do. I used a piece of it for the title and it had an amazing effect. It really powered the images in a way I had not envisioned possible.

It was only some years later that I realized that the great Ravi Shankar was one of the performers! [116]

Reinventing Movie Titles

The Victors

(1963, dir. Carl Foreman)

A good example of an opening sequence showing the "time before" is this for *The Victors*, a film set in the immediate aftermath of World War II. It examines the interactions between American GIs and the shattered European survivors whose land they have both liberated and occupied. The prologue covers the previous twenty-seven years of history, from World War I to the Battle of Britain, while in the sequence that follows, also created by Saul and Elaine, the titles are played out against the marching allied armies.

Saul and Elaine spent days in film archives searching through British, American, German and Russian documentary footage, as well as combat film from the U.S. Signal Corps. To fill in the historical and dramatic gaps, they borrowed a few cuts from Sergei Eisenstein's *October* (1927), and took moments of tumult from the earthquake sequence in the MGM film *San Francisco* (1936, dir. W.S. Van Dyke). They recreated the infamous shot of Hitler dancing a jig after the surrender of France, since the actual footage proved too brief and deteriorated for their purposes. In one of the final shots, the recreated Hitler jig is superimposed in miniature over the anguished face of a corpse. Newspaper headlines and clips from Hollywood films offer viewers historical markers to guide them through the period. However, it is images such as the unforgettable jig, men shot in action, the hands of a dying soldier grasping at barbed wire, exploding bombs and a close-up of Hitler's mouth in a grotesque Munch-like scream that stick in the mind.[117]

Prologue sequence frames
In this three-minute prologue, before the title sequence, Saul and Elaine cover the tumultuous history prior to Hitler's triumphant jig after the fall of France, during World War II.

Reinventing Movie Titles 211

Original storyboard frames
These indicate Saul and Elaine's early thinking about what became the prologue and title sequence.

Reinventing Movie Titles 213

It's a Mad, Mad, Mad, Mad World
(1963, dir. Stanley Kramer)

For this zany, comic extravaganza of a movie, Saul wanted "to get across a feeling that would create a sense of madness and keep the audience continually surprised and amused."[118] The title sequence is a three-and-a-half-minute animated cartoon with mood-setter music by Ernest Gold, which unleashes "a series of visual puns on a symbol of the world. The mood was fun; the challenge was to see how much comedic mileage one could make out of the idea of a globe. The symbol becomes, in turn, a ball, a balloon, a can opener, a spinning top, a yo-yo, and an egg. It is bounced, kicked, inflated, tossed, hatched…and zipped open, cracked, sawed, flapped, unhinged. In the course of all this, and much else, the credits are revealed."[119] Like the film, the basic premise of which is much-ness, the title sequence took a joke and pushed it "beyond a reasonable point."[120]

Magazine ad (detail)

Title sequence frames
A globe travels through a profusion of fun and humorous iterations, as the background bounces from orange to red to bright pink.

Reinventing Movie Titles 215

216 Saul Bass

Title sequence frames
The dramatic quality of the imagery is intensified by the fluidity of the distortions, which stretch and reconfigure the human face in fascinating yet disturbing ways.

Seconds

(1966, dir. John Frankenheimer)

Frankenheimer, who was already working with Saul on *Grand Prix*, was of the opinion that Saul was the only person capable of designing an appropriate title sequence for *Seconds*, a Faustian sci-fi drama about a secret organization that offers the wealthy the chance to assume new identities and bodies. Rock Hudson stars as a respectable sixty-year-old banker who, through advanced surgical procedures, takes up a "second" life as a bohemian painter. Frankenheimer recounted how he actively pursued Saul until he agreed, although Elaine recalls that it was pressure of other work rather than any lack of interest in the project that made them hesitate.[121]

For the title sequence, Saul and Elaine manipulated intense close-up photography of a human face to create strange, undulating patterns that are both lyrical and horrifying. Saul explained, "Tampering with humanity in that way is pretty scary, so in the title we broke apart, distorted and reconstituted the human face to symbolically set the stage for what was to come."[122]

As Andreas Timmer notes, "As in all of Bass's work, the physical elements of the sequence are referential to plot, while their juxtapositions and reconfigurations become psychological and visceral communicators for mood and theme. He prepares the spectator for the nightmarish cinematography of [James] Wong Howe, whose fluid camera movement is combined with extreme wide-angle lenses and off-centered perspectives."[123]

Described by Frankenheimer as "breathtaking," the sequence seems to be the result of state-of-the-art technical effects, but in fact the process could hardly have been simpler – photographing the reflection of a perfectly normal physiognomy onto aluminum sheets that were manipulated to create distortions. In the strange, contorted images on screen, it is difficult to imagine that we are actually looking at the friendly face of Art Goodman, Saul's long-time collaborator, who gamely volunteered to model.[124]

SECONDS

A JOHN FRANKENHEIMER FILM · ROCK HUDSON · SALOME JENS · WILL GEER · JOHN RANDOLPH · JEFF CORY
WESLEY ADDY · MURRAY HAMILTON · KARL SWENSON · KHIGH DHIGH · FRANCIS REID · RICHARD ANDERSON
SCREENPLAY BY LEWIS JOHN CARLINO · BASED ON A NOVEL BY DAVID ELY · MUSIC BY JERRY GOLDSMITH
PRODUCED BY EDWARD LEWIS · DIRECTED BY JOHN FRANKENHEIMER · A JOEL PRODUCTIONS RELEASE

Poster and idea sketches
For the graphic symbol, Saul explored ways of representing the disconcerting physical transformation of one human identity into another.

A JOHN FRANKENHEIMER FILM IN CINERAMA

STARRING
**JAMES GARNER · EVA MARIE SAINT · YVES MONTAND
TOSHIRO MIFUNE · BRIAN BEDFORD · JESSICA WALTERS
ANTONIO SABATO · FRANCOISE HARDY · ADOLFO CELI**

Directed by John Frankenheimer · Produced by Edward Lewis

Grand Prix

(1966, dir. John Frankenheimer)

Saul was just recovering from hip surgery when Frankenheimer asked him to create a title sequence for a film about Formula One auto racing and the lives of the drivers, on and off the track. It was to star James Garner, Eva Marie Saint and Yves Montand. Under the circumstances, Saul reluctantly declined, but offered to shoot sufficient footage to provide a "vocabulary of images" that would indicate the type of approach Frankenheimer might take. The results were so good that Frankenheimer convinced Saul not only to do a title sequence but also to play a wider role as visual consultant, including designing and directing all but one of the races, editing two races in order to establish a house style for the rest and supervising the final editing.[125]

The title prologue deals with the minutes immediately before the start of the Monte Carlo rally. Focused on feverish preparations for the race, the sequence is a montage of fast-cut close-ups printed singly or as multiples: tire treads turning, wrenches tightening down spark plugs, needles swinging across tachometer dials, helmets pulled onto heads, gloves onto hands, expectant faces in the crowd and the heartbeat of a driver as we experience with him the last seconds before the flag comes down for the start of the race.

One of the most dramatic moments comes at the very start. The name of the film emerges from a single black circular object that fills the screen.

Then, the camera pulls back, the soundtrack explodes – "vrroooom" – and we realize we have been looking into the exhaust pipe of a racing car. The sequence ends with a countdown from "Five" to "Go!" and, as the race begins, so too does the film proper – in this case, a race directed by Saul.[126]

Poster and idea sketches
The final poster design and a small selection of sketches from the many explorations Saul created.

Reinventing Movie Titles 221

Editing the Grand Prix Titles

"After completing my shoots on the 'Grand Prix' racing sequences, I began to edit the material. I started with the sequence of preparations for the Monte Carlo race. I had several really excellent shots of each moment (close-ups of wheels rolling into position, tachometer dials revving, hands shuffling lap sheets, close-ups of jostling news cameramen, loudspeakers, etc.).

I hated to give up any shots in each category, even if they were very similar. So my first edit covered the key areas with one shot of each group. And then, as I covered the subsequent areas, I threw in an occasional alternate shot from a previous group. It didn't work… it felt circular. And the alternate shots felt as though they were repeats of the earlier shots from that group.

In my next crack at it, I treated all the shots on each subject as a group. Something interesting occurred. When each series (let's say, the shots of tires rolling into position) was cut end-to-end, the difference between the shots (which disappeared when they were separated) became apparent. This approach created a rich tapestry of differences within similarities, and imparted a dynamic rhythmic pattern to the whole sequence. It was an editing point-of-view I found useful over the years."[127]

Reinventing Movie Titles 223

The first race
The "role" of this race is to introduce the drivers, as well as the excitement of the sport and the city of Monte Carlo.

224 Saul Bass

Frankenheimer wanted a strong documentary feel to the race sequences. The problem facing Saul was to somehow differentiate them sufficiently to maintain the interest of nonafficionados. He commented, "For anyone but the real fanatic race-hound, one race looks like another. So I had to characterize them, to give each one a somewhat different flavor, both conceptually in terms of emotional character, and also reflecting its position in the story; and at the same time, imparting visual differences, or… kinesthetic qualities… One race took on the form of an all-out hard-driving, sort of gut, speed race where the intent was to get the audience to feel that actual sensation of racing – the jolting quality of the thing. Another one I did as a sort of ballet-like, romantic race – this is during Yves Montand and Eva Marie Saint's love affair – almost a period style, with flowers, everything seen through a sort of miasmic haze."[128]

Saul shot this romantic race with a long lens, creating a narrow plane of focus and blurring the rest of the frame to produce a dreamy effect.

"Another race was shot from the perspective of the driver in an all-out battle for the lead. This sequence combined wide-angle shots from the cockpit with overhead helicopter sweeps barely able to keep apace with the cars. Yet another was shot from the point-of-view of the crowd, vaguely indifferent to the immediate, continuous potential for danger to the drivers. And another focused on the technology of the process: the pit, the clockings, lap charts, tachometers, engines, tires, gears…"

In the film, we experience beautifully choreographed race sequences, but achieving them was a dual staged process. "The races themselves were composed of two kinds of shooting. One was unstaged documentary material of the trials and races, on which I used up to twelve cameras. I could only give general instructions to the cameramen, like, I know a red car had to win, so I said 'My God, any time the pack comes around and there's a red car leading, shoot.' The other kind of shooting was after the race was over and I'd assessed the material I'd got. I then restaged the race to make up the sequence we needed. There I used no more than two cameras, because the shooting was very precise, totally staged."[129]

The "romantic" race
(Above, and following page) This race starts with a study of the spectators and transitions into footage of the race through the eyes of Eva Marie Saint's character, who is falling in love with one of the drivers.

Reinventing Movie Titles 225

Directing the Racing Sequences in Grand Prix

Shooting the races in "Grand Prix" brought into focus for me the Director-as-Performer mode. Until then I had been directing in the Repertory mode. Small companies, with accumulated experience working together. All in tune with an exploratory point of view. Shifts in concept or staging understood as a process, rather than uncertainty.

This all changed when I began directing the races for "Grand Prix." The first race was at Spa in Belgium. We had permit problems with the Racing Association. We didn't know if we could even get on the track. If we did, I would have no advance opportunity to study the track or even to know what part of the track we would have.

Suddenly, at the end of one day, we unexpectedly got permission to shoot the next day. I arrived at an assigned section of the track at 8:30 am. I saw unfamiliar terrain, a multilingual crew, a slew of Formula One racing cars and drivers, 1,500 extras, and others – waiting for "the word."

I looked around. What's my first shot? A race start.
I called out my requirements.
"Put the cars over there.
The No. 1 Camera here. 600mm lens. The crowd…"
I had another thought.
I started again.
"Let's have the cars further back. No. 2 Camera there. 1000mm lens. Put the 600mm lens…" Pause.
I had a better idea. "Here's what we do…"
I stopped.
I could see the crew looking at each other and growing restless. My authority eroding. It was a very long day. But, somehow I got through it.

The next day, I arrived on the set. New piece of track. New terrain. A thousand pairs of eyes zapped in on me. Silence.

In a panic, I grabbed my cane. Plunged it into the turf. "OK! No. 1 Camera here. 200mm lens. No. 2 Camera there, 600mm lens. No. 3 Camera in the stands. All cars lined up for a start there. 1,000 extras in the stands. The rest in the woods. And call me when you're ready!" A beat. Pandemonium broke loose, and everybody went to work.

I hopped into my jeep with my first cameraman, tooled around a curve in the track, stopped where no one could see, and said to myself, "OK. What the hell am I going to do today?"

I knew it would take them a little time to get that all sorted out. So I calmed down. Went down the track a bit. Set up some angles and figured out my day's work… my shot list.

My first assistant came running up. They were ready. We drove back to the set. I looked everything over.

"Fine. Alright. We're ready to go."
"Ready?"
"Ready."
"Camera ready?"
"Camera ready."
"Roll camera."
"Camera rolling… speed!" "Action!"
VVRRROOOOMMMMM!
The cars took off.
"Cut. Print. Next shot!"

People exchanged glances. "He knows what he wants. We're in good hands."

Of course, I never actually used that shot. It was a question of morale… I learned that when you have an army, you may have to ride a white horse.[130]

4

Beginnings, Middles & Ends

...short films and Phase IV

After creating prologues, epilogues and internal scenes for films,
I began to want to make films with beginnings, middles and ends.
That was the impulse for the short films I made with Elaine.[1]

Saul Bass

On location
(Opposite) Saul and Elaine in Bremerton, Washington, shooting *The Searching Eye*. 1963

Saul and Elaine
(Above) In Death Valley, California, filming *Notes on the Popular Arts*. 1976

Saul and Elaine
Working out a special effect.
1967

Saul and Elaine began to make short films in the early 1960s. For almost a decade, they had been creating titles and internal sequences for some of the most creative directors in the film industry. While each movie had presented different problems to solve, one condition had remained constant – the movie belonged to someone else. Their next step as filmmakers was to strike out on their own.

Over the years, their short films progressed from the captivating tone poems made for the 1964 World's Fair to increasingly complex philosophical narratives and meditations. In 1974, Saul completed his only feature, *Phase IV*, released by Paramount Pictures. Although Saul quipped that he wanted to make films with beginnings, middles and ends, he and Elaine often used nonsequential structures that relied on an accumulation of images, mood, ideas and narratives. They were adept at fashioning an impressionistic whole out of individual sequences that added up to more than the sum of their parts. The short films garnered a host of awards from film festivals all over the world, including top prizes at Venice and Moscow, as well as two Oscar nominations and one Oscar.

When asked about which specific attributes graphic designers brought to filmmaking, Saul replied: "The designer's general visual awareness is unquestionably helpful – this plus the kind of understanding he has about the particular problem he is dealing with from a content point of view. But the qualities that make a graphic designer a good filmmaker really haven't got to do with the specific aesthetics of design. They have more to do with his sense of story, his inventiveness and his visual/aural sensitivity."[2]

In order to visualize their ideas or feelings, Saul and Elaine drew on a wide range of cinematic techniques including animation, live action, fast cutting, split screen, wide screen, zoom photography and underwater photography. They both firmly believed, however, that the medium had to serve whatever message it was conveying, not vice versa. Some films have a science-fiction feel to them and make considerable use of special effects, while others use hand-drawn animation. Some correspond more directly to the abstract lyricism and technical virtuosity of experimental films; others draw more on traditions of storytelling and mainstream moviemaking.

What ties these films together, however, is their willingness to tackle enormous ideas – the vastness of geologic time, the history of thought, what it means to see, even what it means to be human – and then bring them into immediate, intimate focus. With warmth, simplicity and plenty of humor, these short films continually make us aware of the connectedness of things.

Jennifer and Jeffrey Bass
The children always had space at the studio to create their own art and design.
1975

A Creative Partnership

It would be difficult to imagine a closer collaboration than the work Saul and Elaine did together on the short films. While their official credits shifted from film to film, their partnership was so reciprocal that the films should be considered joint work. Discussing their filmmaking, Elaine stated, "One of the wonderful things about working together is that there is no conflict because we are both totally committed to the project. Like parents to a child, you both want the best for the project. Working as a duo, you share the good and the bad."[3]

Saul elaborated, "Elaine is the only person whose artistic judgments and sense of appropriateness I completely trust. She is an ideas person who also comes up with imaginative ways of making those ideas happen, sometimes after I've said, 'Great idea but there's no way you can pull that off.' It's often a simple solution. She sees things very clearly, has an aversion to waste and excess (she is a true child of the Depression in that), and an ability to cut through extraneous matter. But that's just a part of the wonderfully imaginative contribution she makes. And, of course, she is far more musically gifted than I am. Our interactions are always very lively, very probing. It's as though we're climbing a mountain together. There's always a lot of testing, lots of discussion about the right route. Everything is open for discussion. Elaine is not an aggressive, confrontational person. She is much more polite than I am but if she feels strongly about something she will stick to her guns."[4]

Elaine added, "I always felt a full partner. Saul never dismissed anything I said out of hand. I am quieter but can be forceful when I feel something will work well. It's hard to describe how we worked. When you are so close to someone and know them so well, you often don't need to complete a sentence because they will know what you mean; one will grasp something immediately when the other starts to put a new idea into words. Don't get me wrong and imagine we always thought along the same lines. Of course we'd say, 'No. Sorry, but I don't think that will work – it's far too simple,' or 'I don't think that will come across as funny.' Then, if the other thought it had merit, they'd keep pushing the idea. Not forcing the issue but saying, 'Let's think this one through more. Let's go back and look at it again.'"[5]

Although Saul usually spoke of "we" when he discussed the short films, contemporary critics almost always focused on Saul alone. For instance, in a 1964 *Hollywood Reporter* review of the films the Basses made for the New York World's Fair, it was noted that "Both films were conceived and designed by Elaine and Saul Bass," but thereafter the journalist referred only to "he," "Bass" and "a master."[6]

With his larger personality, Saul took a more active role in finding projects and pushing them forward, but thereafter their roles were fluid and depended on their schedules. Elaine often directed individual sequences when Saul was away, and participated as equal partner in the tasks of producing, writing, cinematography and editing. Elaine had a knack for finding simple solutions to daunting technical problems and always played a leading role in choosing the music and working with the composer, though Saul often provided curious vocal effects like the caveman voices in *Why Man Creates* (1968).

Even after their children were born (Jennifer in 1964 and Jeffrey in 1967), Elaine and Saul continued to collaborate on every project. In fact, the short films offered the couple more flexibility than was possible with the high-profile corporate design projects that the Bass office took on in this period. Both Elaine and Saul had workspaces at home and equipped the office with playpens and high chairs when the children were small. Later, they were allowed to play freely in the studio, borrowing pushpins and typewriters for their own art projects and making towers and forts out of plastic film cores. During filming, Saul and Elaine not only brought Jennifer and Jeffrey to the set, but put them to work in small roles in *Notes on the Popular Arts* (1977), *The Solar Film* (1980) and *Quest* (1983).

Context: Experimental and Sponsored Films

When Saul arrived in Los Angeles in 1946, the city was home to some of the greatest avant-garde filmmakers in the world. Oskar Fischinger, Maya Deren, Alexander Hammid, Kenneth Anger and Curtis Harrington were among the many who put experimental filmmaking on the map. The films they made subverted the rules of conventional commercial moviemaking and instead were notable for their fascination with movement, abstraction, light, metamorphosis, sensuality and the self.[7]

By 1950, L.A. boasted at least five theaters that programmed experimental films. The year Saul arrived, Deren and Hammid's groundbreaking 1943 short, *Meshes of the Afternoon*, was re-released. Saul loved its moody, dream-like visual poetry. He told me, "I became aware of … Cocteau, Maya Deren and Kenneth Anger, all of the experimental filmmakers. [Their films] were all terribly exciting, terribly upsetting and created a great yearning in me to emulate this, to do something that would embrace this kind of daring … It seemed to me like truly the future … And that's what I wanted to do."[8]

In this period, many of these filmmakers were trying their hand at sponsored films, not only as a way to pay the bills, but because – paradoxically – corporations often offered greater creative control than was possible with the film studios. Sponsored films date back to 1922, when the furrier Revillon Frères sponsored Robert Flaherty's *Nanook of the North*. During the 1930s, new government agencies produced documentaries about the plight of American agriculture and the promise of New Deal public works projects, but it was not until World War II that sponsored films were made on a large scale. Largely of a documentary, educational and morale-boosting nature, they paved the way for more adventurous sponsored filmmaking in the postwar era, when such films as Bell Telephone's *Adventure in Telezonia* (1949) and General Electric's *A is for Atom* (1953) became an important sector of the U.S. film industry.[9]

By 1959, the number of short "business" films made was 5,400, compared to 223 longer entertainment features. Articles and books were written about them, and the journal *Business Screen* promoted them. Seduced by claims of "1,000,000 new customers … from one little reel," film was seen as the perfect vehicle to convey everything from the germ-killing powers of a new cleaning product to the ideology of a nation.[10]

Most of the big companies were in on the act, or thinking about it. The bigger the company, the more inclined it was to "soft-sell" advertising that never mentioned a specific product but instead put forward an image of the company as a benevolent patron of art and culture.

By the late 1950s, Wheaton Galentine had directed the strikingly imaginative *Color and Texture in Aluminum* (1956) for Alcoa, and IBM had commissioned Charles and Ray Eames to direct a film about computers. Francis Thompson went from making independent art films such as *NY, NY* (1957) to artistic sponsored films such as *To Be Alive!* (1964, with Alexander Hammid) for Johnson Wax, which was shown at the same World's Fair as Saul and Elaine's first films. By the time the federal government commissioned a multiscreen presentation on science for the Seattle World's Fair, it was thoroughly respectable for major institutions to commission films of a type considered too experimental for mainstream culture only a decade earlier.[11]

The more imaginative sponsored filmmakers were often asked how they got away with creating the types of films they did for the types of clients they had. For Saul, it was a question of winning the sponsor's confidence. Saul and Elaine were fortunate that, once a concept was accepted, Saul's powers of persuasion and the clarity of their proposals convinced company managers to grant them a remarkable degree of creative control.[12]

Saul's friends Morton and Millie Goldsholl were among the first graphic designers in the U.S. to also make experimental films, sponsored films and television commercials. Morton Goldsholl chaired the Aspen International Design Conference in 1959, and shortly afterwards he and Saul collaborated on design projects for Kimberly-Clark. Saul also assisted the Goldsholls on a film, *Faces and Fortunes*, and in 1962 was asked to work on a film for CBS, *Apples and Oranges*.[13]

Apples and Oranges
Saul's first short film was made for CBS.
1962

Apples and Oranges (aka *Taking the Measure of Two Media*) came about after Louis Dorfsman, art director of CBS television, invited Saul to work with him and George Bristol, head of television advertising. The aim was to find a way to translate a forty-five-page market research report into an entertaining short film targeted at media buyers. Saul's task was to show how television commercials (apples) led to greater product awareness per dollar spent than magazine advertisements (oranges). "If film was so clearly the best way to get across a message," Dorfsman recalls, "then why not use it and who better to communicate in film than Saul Bass?"[14]

Saul stated, "We had to make a story of the research … [and] find a way to communicate highly complex data to an audience which was not generally research-oriented."[15]

This fourteen-minute film combines animation with live action, contrasts black and white with vibrant colors and lets the statistical data of graphs and flowcharts run riot in delightfully sophisticated arrays of numbers and type. At times, Saul purposely adopts a rather literal-minded approach to the information, to tongue-in-cheek comic effect, while multiples of a cartoon-style private eye figure (not unlike the "mobsters" in the *Some Like It Hot* trade ads) represented the 6,000 researchers who conducted the survey. "Research of this type is really a socially approved kind of spying. We brought this figure into the film only when we were illustrating that there was something to find out," explained Saul.[16]

Beginnings, Middles & Ends

The New York World's Fair, 1964–65

Saul and Elaine's first joint venture into short filmmaking came with commissions from United Airlines and Eastman Kodak to create promotional films for their pavilions at the 1964 World's Fair. These fairs had long offered visitors exciting new ways of seeing the world, as did both *From Here to There* and *The Searching Eye*. Both short films went on to win awards at film festivals around the world.[17]

Saul behind the camera
At the Los Angeles International Airport shooting take-offs and landings.
1963

From Here to There
After a short opening the screen doubles in size, emphasizing the panoramic beauty of the landscape as seen from an airplane.
1964

From Here to There
(1964, United Airlines)

This eight-minute lyrical essay captures the magic that accompanied jet travel in the mid-1960s. A poignant and gently humorous prologue and epilogue function as emotional parentheses to a visual evocation of the world from the air.

The opening scenes, shot in 35mm, focus on the joys and anxieties of departing passengers at a busy airport. As their plane takes off, however, the screen opens up to a wide-screen width, and the images change from intimate, black and white close-ups to full-color panoramas of the American landscape, shot in 70mm. It is here that the film is at its most abstract and impressionistic. In the aerial sequences, the film plays with time and perspective by interspersing the majestic panoramas seen from above with brief close-up glimpses of the same landscapes from the ground. After the plane lands, we are returned to the smaller-format screen for the pleasures of warm welcomes from family and friends, encounters that surprisingly mirror those seen at the beginning of the journey.

Beginnings, Middles & Ends **235**

The Searching Eye
(1964, Eastman Kodak)

The Searching Eye explores the relationship between the commonplace and the magical. The film expands upon the dual premise that all learning, thinking and doing begins with observation and that most people pass through life without truly "seeing." Saul and Elaine intended "seeing" in the broadest sense, where the human eye is the conduit not just to observation, but to insight and imagination. This deceptively simple twenty-two-minute film opens the eye of the spectator to the beauty and wonder of the world by showing us what a boy does not see as well as what he does.

The film, shown in the Eastman Kodak Pavilion at the World's Fair, ran continuously on a semi-circular ultrawide screen. Views of the boy were projected in 35mm; those of what he did and did not see in 70mm. The theater housed 500 people, and each day up to 35,000 watched the boy leave his house and walk to the beach, go for a swim, catch a crab, eat an apple, chase a seagull, build a sandcastle and have his photograph taken before returning home. At one point, the boy picks up a rock and briefly examines it before discarding it. Then, in extreme close-up, the viewer sees strata revealing part of the history of the earth, which has escaped the boy's attention. Later, a shot of the boy's feet splashing in the wet sand opens to microscopic footage of the incredible living geometries in a single drop of water. Without ever mentioning Eastman Kodak, the film reminds us of how the camera lens does not just record what the human eye can see, but can reveal the mysteries it hungers to discover.[18]

This is an aesthetically and technically dazzling film of luscious time-lapse sequences, superimpositions and unexpected close-ups. It shifts between single and multiple images, reflecting shifts from abstract to personal experiences. The final cut was put together from 25,000 feet shot by fifteen camera operators specializing in underwater, aerial, time-lapse, high-speed, telescopic, microscopic, split-screen, superimposition and flexible-lens photography, undertaken to heighten viewers' awareness of the beauty of the everyday, be it a stone, a drop of water on a rose or a sandcastle being washed away by the sea. A self-described "practiced sandcastle builder," Saul built the first one on a beach in Santa Monica and made a mold from it. At one point in the shoot, seven castles stood along the beach, ready for the waves.

Although the Fair was, according to the *New York Times*, "absolutely bursting with bold and creative cinema," *The Searching Eye* was singled out for praise time and time again. Unlike some of the other experimental films shown, it achieved a greater integration of content and form and avoided losing its message amid technical wizardry.[19]

Setting up a shot
Santa Monica, California
1963

Symbol for the film

Film frames
In the opening sequence a series of animal eyes are seen in close-up, ending on a human eye, the eye of the young protagonist.
1964

On location in Washington
Elaine worked closely with the child actor, Walter Lane, who was cast after auditions with more than fifty boys.
1963

Collaboration

During the World's Fair, I was interviewed on the "Today" program about the two short films Elaine and I had made. Elaine couldn't be there because she had just given birth to Jennifer. At the end, the interviewer said, "Mr. Bass, I understand that you worked with your wife on these films. Can you tell me a little about your latest collaboration?" I seized the moment and held up a photograph of the baby.[20]

Beginnings, Middles & Ends 237

238 Saul Bass

Frames from
The Searching Eye
1964

A Sympathetic Soul – Gene Kelly

Elaine and I had just gotten back our first answer prints of two short films for the 1964 New York World's Fair. One was "The Searching Eye" for Eastman Kodak, and the other was "From Here to There" for United Airlines.

United and Eastman sponsored a preview in Los Angeles at the huge Todd-AO dubbing stage. The screening was to start at 6:00pm, with guests invited to stay for drinks and dinner catered by Chasen's (both films together ran only about thirty minutes).

An illustrious crowd turned up, including Billy Wilder, Robert Wise, Willie Wyler, George Stevens, John Sturges and Otto Preminger. They filed into the dubbing room and settled down.

The lights dimmed. The first film began.

Suddenly an ear-splitting screech emanated from the soundtrack. The booth shut the film down, and turned the lights back up.

Murmers from the audience. A shout of "It's all right Saul, it's happened to all of us!"

The film starts again. The screech starts again, but worse; there's a terrible rackety-ratch on top of it. Lights up. More restlessness.

Another start. This time the soundtrack has developed a whine. Catastrophe! People squirming, about to sneak out of the theater.

I rush madly up to the booth. The projectionist can't figure out what's wrong. We check the plugs, re-rack the film.

By this time, everyone has seen the first two minutes of an eight-minute film three times, and people are heading for the aisles.

Suddenly, a figure rushes up on stage. It's one of our invited guests, Gene Kelly. "C'mon," he tells everyone, "I know this is worth waiting for." He settles people down, opens the bar. And then starts a soft shoe routine, taking orders for drinks and choreographing his steps to the patter: "One Martini, fifth row; white wine, lady in front." He's magnificent. His spontaneity is infectious.

Up in the booth, I tell the projectionist desperately, "Give it a shot!" We start up. The sound is clean. It's OK!

The film ran without a hitch, the audience stayed put and the response was good. All because of a sympathetic soul whom we hadn't yet met.

Thanks, Gene.[21]

Beginnings, Middles & Ends **239**

240 Saul Bass

Why Man Creates
(1968, Kaiser Aluminum)

The twenty-nine-minute *Why Man Creates*, a wonderfully creative film about creativity itself, is one of the most successful short films ever made in terms of number of prints sold and awards won.[22] It was, perhaps surprisingly, commissioned by Kaiser Aluminum & Chemical Company. Vice President of Advertising and Public Affairs, Robert Sandberg, believed strongly that creativity and imagination were the lifeblood of change and that big business should show itself to be socially responsible. He persuaded the "top brass" to invest $250,000 in a film about ideas and the importance of imagination within the company. After a year-long search, the commission went to Saul.[23]

As Saul recalled: "Kaiser's theory was if they could show how aluminum was being used creatively and how Kaiser was a hell of a great place to be, then that would be exciting for a creative engineer or scientist. But we said, 'The best thing you could do is deal with the subject of creativity directly, in an exciting way. By the mere commitment to such a film you'd be signaling to these people that you were serious about providing a creative environment.' It took some time to turn them round."[24]

Saul and Elaine wanted the film "to express to the audience how it feels and what it looks like to work creatively in a committed life sense ... It's an emotional film, not an explaining type of film."[25] Episodic in structure and laden with humor, the film is composed of a series of sequences that illuminate the character and contradictions of the creative process.

In the sequence called "The Edifice," Saul and Elaine offer "an animated history of the world man has built on ideas"; "Fooling Around" illustrates "how ideas can begin in the play of the creative mind"; "The Process" shows the young creator struggling "to dominate material which resists, fights and develops a life of its own, with timely advice from creators of the past"; "The Judgment" illustrates how "society makes its contributions to the creative process"; in "A Parable," "the fate of an unaverage bouncing ball throws some light on the creator's place in the world"; "A Digression" is "a statement of the possible relationship between ideas and institutions"; "The Search" offers "a close-up view of the patient process by which scientists develop new ideas"; while "The Mark" uses examples drawn from the history of art, science, religion, politics and technology "to explore the question of why men create."[26]

Frames from "The Mark"
This sequence, at the end of the film, explores creative expression throughout the ages.

Saul and Elaine at work
1967

Saul and Art Goodman
Laying out the plan for the "The Edifice" sequence on the floor of Saul's office. 1967

"The Edifice" sequence
(Opposite) A humorous animated history of the world that has been built on ideas (sequence runs from bottom to top).

"The Edifice"
Sequence from *Why Man Creates*

Jefferson
"All men are created equal…"

Renaissance
"The Earth moves!", "The Earth is round!"
"The blood circulates!", "There are worlds smaller than ours!"
"There are worlds larger than ours!"

Two Scribes
"Allah be praised! I've invented the zero."
"What?"
"Nothing nothing…"

Rome
"Roman law is now in session!"

Egypt
"Hiya huh. Hiya huh, hiya huh…"

'The Modern World'
"Cough, cough, cough…heeeeelp."

Leonardo & Michelangelo
"What are you doing?"
"I'm a-painting the ceiling.
What are you doing?"
"I'm a-painting the floor."

The Middle Ages
Gregorian chant (in call and response):
"What is the shape of the earth?" "Flat."
"What happens when you get to the edge?" "You fall off."
"Does the earth move?" "Ne-e-e-e-e-ver."

The Dark Ages
"Hmmmmmm…"

Greece
"What is the good life and how do you lead it?"
"Who shall rule the state?"
"The philosopher king?" "The Aristocrat?"
"The people!"
"You mean all the people?"

Early Man
"Grummble, grummble, grummble…" "Oou!"
"Eee?"

Beginnings, Middles & Ends 243

The Process

We were setting up to shoot the "building block" sequence in "Why Man Creates." We were on a very tight schedule. We had budgeted three days to shoot this sequence. I couldn't go over.

I storyboarded the sequence very carefully. We had so many set-ups that we calculated that once we rehearsed and started shooting, I would have no more than ten minutes for each shot. While each individual shot was simple, ten minutes was a push.

My AD was wary of the notion of breaking my concentration and risking my ire by signaling to me repeatedly that I was running out of time.

He was ingenious. He brought a traffic light to the set. Adjusted its timing. When I started the shot, the green came on. Seven minutes later, it went yellow. At ten minutes it was red! He was off the hook! I could only get mad at a set of lights![27]

Frames from "Fooling Around"
This section of the film asks the question, "Where do ideas come from?" and answers, "From looking at one thing, and seeing another. From fooling around…"

Saul on set
Setting up the "building blocks" for "The Process" sequence.

On Humor in Film

Humor is the most evanescent of all forms. But you can find out if it's working. It can be tested. In film, you run your rough cut. They either laugh or they don't. You hear it. Or you don't. It's more difficult to know whether a film that involves feelings is working or not. You can't "hear" feelings. You can't observe feelings. People don't do anything when they're "feeling." It's all happening inside.

The key problem with humor in film is the sheer accretion of exposures to the same gag. By the time you've written, rewritten, reexamined, planned the shoot, rehearsed, shot multiple takes, watched the dailies, edited, reedited – you've had your nose against that line about a hundred and thirty times. At that point, is it funny? No! But you remember it was funny, once. So you leave it in.

In "Why Man Creates" I went through this with one humorous line and finally lost confidence in it. There was no time to test it with an audience. Afraid of an awkward pause for a laugh that wouldn't materialize, I cut the sequence very tightly and butted the next (hoped for) funny bit right up against it. In release, the first bit turned out to get a big laugh which wiped out the next series of lines that really worked, but could not be heard…

I did a title for a Warner Bros. film with George C. Scott and Tony Curtis (directed by Norman Panama), "Not with My Wife You Don't." There was a funny line in the title. During preproduction, shooting and dailies, I would see Norman frequently. At some point, he would always turn to me and say, "Listen. That line. Do you think it's funny?" I would say, "Yeah. It's funny, Norm." He'd say, "OK."

A few days later he'd say, "Saul, do you really think it's funny?" "Yes, Norm, it's funny." "OK, Saul."

One day I said, "Norm, I'm setting up to shoot that little shot for the title." He said once again, "Listen, Saul, is it funny?" "Yeah, it's funny."

He kept saying, "Is it funny? Is it funny?" Finally one day he said, "Is it funny?" And I said, "No. It's not funny!" He said, "Saul, what are you saying?" I said, "I thought it was funny up until about the twentieth time you asked me. From twenty to forty it began to get flat. And from forty to now, it was not funny. But I remember it used to be funny, way back when we were both young."

I shot it. Put the title together. Norman kept it up all through the editing, until the film was ready for release.

By this time I had become obsessional. I was thinking, "Wait. Maybe it's not funny." But if it wasn't funny, I was in deep trouble. You know, there are two kinds of funny. There is basic funny. And there's could be funny/could not be funny. For me, this line was basic, sure-fire funny (maybe not a belly laugh, but certainly a good chuckle). But if this, which I see as basic, is not funny, then I'm out of business on humor. I felt at a career crossroads.

They are going to preview the film at a theater in Pacific Palisades. I am in the hospital, coming out of hip surgery. But I've got to find out if the line "plays!" I get a big limo and two male nurses. They carry me out to the limo and then into the theater, put me half supine in the first row because I can't bend my hip. The audience files in and the film starts. It plays into the title. It reaches "the line." The audience laughs. Not big, but respectable.

And then some people may have noticed two large men in white pick up a third semi-prone figure up front, carry him out of the front side-exit of the theater.

I go back to my hospital bed with a sigh of relief.

I could go on! [28]

An Academy Award
Tony Curtis (whom Saul had known since *Spartacus*), presenting.
1969

Frames from "A Digression"
Snail one: "Have you ever thought that radical ideas threaten institutions and then become institutions and in turn reject radical ideas that threaten institutions?"
Snail two: "No."
Snail one: "Gee, for a minute I thought I had something."

In the early stages, the film lacked a linking device. Then Elaine suggested filming Saul's hand in the act of writing to connect the sequences, because this way they could convey some of the hesitancies and indecisions that accompany all creative processes. When discussing the film, Saul commented, "The creative process is an unpredictable, desperate, yet disciplined kind of activity. It has the discipline of order but the guts of what happens comes from other wellsprings. I think the statements in this film are true – of how the creative process feels, of how society tends to view the creative guy, of the importance of what he does in spite of society's general tendency to reject. I don't fault the attitude of society, I merely describe it. Society has many good reasons to be reluctant to accept new ideas. Many are impractical or dangerous. But some of them are the ones that advance society, make it move ahead, make it come to grips with things it has to understand or solve in order to survive and grow."[29]

This brilliant and quirkily funny film deserves a study of its own. Segments include a snail talking about digression, the invention of zero and a high-spirited, rebellious ping-pong ball. Saul supplied the voiceover, and it is easy for those who knew

him to see Saul's own spirit in this ball, which bounces off a production line, having been rejected for bouncing too high. The ball bounces through a world of less adventurous ping-pong balls and finally bounces right out of the frame. The cracked eggs gag uses novel images to introduce thought-provoking propositions: one has a yellow yolk, another is filled with a thick black goo, while a butterfly emerges from yet another. When someone asks "Where do ideas come?", the film offers the answer "from looking at one thing and seeing another," a recurrent theme in the work of Saul and Elaine.[30]

At first, Kaiser's top executives were uneasy about the film, especially the innovative disjunctures, obvious non sequiturs and staccato montages. In an effort to reassure his client, Saul sent copies of the film to the chief executives of two corporations for which he had already worked – Frank Stanton at CBS and Harold Williams, then president of Hunt Foods and later of the J. Paul Getty Trust – as well as to a reporter at the *Wall Street Journal* who wrote on corporate affairs. Their approval helped calm nerves at Kaiser and the film went on to become a major corporate asset. Frank Stanton remembered the incident with amusement; "I really loved the film, and remember thinking I'd love to see that on television. And oddly enough, it did actually come to pass."[31]

Indeed, *The Smothers Brothers* ran segments and finally the whole film, while *60 Minutes* showed about half of it as an example of corporate responsibility; it also ran the ping-pong sequence at the time of President Nixon's "ping-pong diplomacy" in China. For years, the film was a staple of high-school education and has become one of the most widely seen short films ever made. *Why Man Creates* won the 1968 Oscar for best documentary short, and in 2002 it was inducted into the National Film Registry of "culturally, historically, or aesthetically significant films."[32]

Frames from "Fooling Around"
"…playing with possibility, speculating…"

Beginnings, Middles & Ends 247

248 Saul Bass

Notes on the Popular Arts
(1977, Warner Communications)

Like *Why Man Creates* almost a decade earlier, the Oscar-nominated *Notes on the Popular Arts* grew out of a corporate commission. Warner Communications' CEO Steve Ross wanted a film that would convey his firm's capabilities to the financial community. "They originally viewed it as a kind of annual report," Saul said, "But as we did with Kaiser Aluminum, we converted it into a commentary. I looked at the company and said, 'Well, what is it that they're really up to?' And looking at their activity, I realized everything could fall under the umbrella of the popular arts. So the idea emerged of having the film define the popular arts as a vehicle for fantasy and self-projection, and treat it in a somewhat ironic style."[33]

The resulting film is humorous in tone and episodic in structure. Irony, parody and satire all play a part in the five "windows," each based on the notion that we create fantasy worlds through television, music, comics, books and movies to compensate for the difficulties of real life.

The fantasy sequence for comics uses full-color animation to tell the story of a young boy who is rejected as a student by his violin teacher. As he looks around his room at posters of Superman and Spiderman, he imagines he is Superfiddle, capable of vaporizing villains with a screech of his bow!

The sequence on movies opens with a wry comment on celebrity. Surrounded by an adoring throng, a movie star places his feet in the wet cement outside the famous Grauman's Chinese Theater in Hollywood. The cement, however, turns out to be quicksand into which the actor slowly sinks and, eventually, with a "plop," disappears. But the crowd, by then, has turned its attention to the next celebrity…

Like so much of Saul's best serio-comic work, the film's humor is consciously self-deflating. In the climax, a parody of a Spaghetti Western firing squad scene, "El Capitan asks the prisoner if he has any last words. Alas, the prisoner does – words upon words of excruciating pomposity: 'The popular arts bring new meaning, new experiences and new stimulation,' he declaims in dreadful, subtitled French. Members of the firing squad nod off. 'They enable the mind to soar in transcendental flight above a moribund existence…' Finally the members of the firing squad rouse themselves from their torpor and shoot. The hero goes down, disappearing through the bottom of the frame. But he will not be silenced. His voice drones on, from the grave, with the same excruciating earnestness and pomposity."[34]

Frames from the sequences related to Comics, Music and Movies

Saul and Elaine
Being interviewed at a film festival in d'Annecy, France.
mid-1970s

Beginnings, Middles & Ends **249**

Frames from The Solar Film
This Oscar-nominated film was commissioned to publicize the facts about solar energy.
1980

Narration and the Omnipotent Voice

In my early film work, I wrestled with the voiceover narration. It was a maddening problem. It almost always veered toward the omnipotent, the disembodied, the programmed. How do you create the sense of a person thinking and sharing some thoughts with you? It seemed very difficult.

Some years ago, Orson Welles did a narration for an opening I did for a four-hour NBC Anniversary Special. I didn't direct him. He just did it.

I listened very carefully. And that was when I finally understood what makes a narration work; how an intelligence can shine through. It was in the eccentric pauses. Orson would deliver it as, "… it was … in the eccentric … pauses."

They didn't necessarily occur in normal places; at commas, at the end of a phrase, or even at the end of a sentence. Those "wrong" pauses gave me the sense that he was inventing the words as he was going along. He was a person. Not God.[35]

The Solar Film
(1980, Consumer Action Now)

"The world is becoming more and more complex and bewildering … the more complex things become, the more we become accustomed to the idea that massive problems require massive high-tech solutions. Solar energy is a low-tech decentralized solution. One of those rare simple answers."[36]

The Solar Film began when Consumer Action Now (founded by Ilene Goldman and Lola Redford) decided to make a film to publicize solar energy. Executive producer Robert Redford (who a few years later would invite Saul to be a Founding Trustee of his Sundance Institute) asked Saul and Elaine to join the team. Redford explained, "We wanted to do what the administration had not been able to do, that is create an awareness that there are other alternatives before the American public."[37]

"We had to undertake what amounted to a crash course on solar energy," Elaine noted. "Our readings and interviews exposed us to an enormous diversity of opinion and facts. There were myths and negativisms, even hysteria. But as well, a lot of interesting, revealing data. This process eventually brought us to the view that solar energy had the capacity to shoulder a substantial share of our energy needs."[38]

Saul added: "We all agreed that the film had to reach a mass audience and play in theaters on the big screen. With Redford's help, it seemed possible to achieve this. To make this feasible, the film had to be very short. One reel. Ten minutes. No charts, graphs or statistics. Entertaining."[39]

The first part of the film deals with the sun's impact on the creation of life and civilization represented in simple, allusive photography of sea and sky, plants and hieroglyphs. The film then shifts to a zany, breakneck cartoon that sums up the exploitation of fossil fuels. In the final section, overlapping voices of different ages and origins describe the feel of sun on the skin, the smell of fresh clothes from the line, finding a house with a southern exposure, and then transition into a discussion about the effectiveness of contemporary solar technology. Each section makes its point effectively, but viewers also absorb a wider message about the power of the sun. "Never was so much urgent information communicated so painlessly," commented one reviewer.[40]

Saul recalled, "We had to constantly guard against didacticism. There's a moment in the animated sequence – an aerial view of the populace pouring into the town square. As it turns dark with figures, we hear this dense cacophonous track of contentious voices arguing about why not solar energy, ending in 'Why doesn't the government do something?' 'What government? We are the government!' It was getting a little preachy, pretentious, politically correct, so we put in a throwaway line over the ensuing babble to take the 'curse' off of it. A barely audible little voice mumbling irrelevantly and trailing off: 'Did anyone see my dog?… he's a little white dog with a black spot…'"[41]

Redford's commitment to the project helped ensure the film reached a wide audience. Warner Communications and Norton Simon Inc. (both of which had environment-friendly mission statements in place) also agreed to support distribution. The National Association of Theater Owners ran it in over 12,000 theaters as a public service and it was translated into five languages for international distribution. At one point it even played on the same bill as *Superman*![42]

The Solar Film

Beginnings, Middles & Ends 251

Frames from Quest
This thirty-minute allegorical journey is set in a world where life, from birth to death, is limited to eight days.

Quest
(1983, Mokichi Okada Association)

Over the years, Elaine and Saul had often discussed making a film about human potential. An opportunity presented itself when a Japanese cultural organization called the Mokichi Okada Association (MOA) invited the Basses to develop a film for its art museum in Atami City, which would express the group's guiding principles.[43]

The Association, founded in 1980, supported holistic regeneration – spiritual and physical, individual and collective – through its own organic farms and holistic clinics, and advocated an end to inequalities. As contemporary organizations go, Okada was guided by unusual principles, the cardinal ones being Truth, Beauty, Organic Processes and Light.

Elaine said: "Our ears pricked up when they mentioned Light because that is a central element in our work. We believe that there are mysterious qualities in the ways we experience light and spent a lot of time ensuring that our home resonated with it."[44] Even more compelling, however, was the promise of artistic freedom. Once agreement had been reached on a script and a budget, Saul and Elaine, as co-producers and directors, would be left entirely to themselves during the production of the film.

Saul and Elaine had planned to write the screenplay together, but just before they began, their home was consumed in a catastrophic fire. As Elaine took charge of rebuilding, Saul asked his old friend, the celebrated science-fiction writer Ray Bradbury, to collaborate on the script. Saul and Ray had often talked about taking on a project together, and *Quest* seemed like the perfect opportunity. Still, Saul maintained his habit of talking through key issues with Elaine, whose sensibility resonates throughout.

Bradbury recalls: "Working with Saul wasn't work, it was always play; we're identical twins in that respect. We started by sitting around for a week or ten days and picking each other's brains… It was such a delight to go there and just talk about anything. Eventually I remembered a book by the French philosopher Henri Bergson, who asked how one would know if the dimension of time changed around one, if each generation were born and died within a short space of time. Well, people would experience a loss of intelligence and knowledge that would endanger the whole civilization. 'That's it,' said Saul, and set me to work. I reported in every morning for a week or so. He'd sit there and read what I'd written and say, 'Ray, this is brilliant, just brilliant… but now let's make it more brilliant.'"[45]

Quest is a classic narrative journey set in a world, at once archaic and post-apocalyptic, where human lifespan is limited to eight days. Periodically, men are trained and make the attempt to "open the gate" that will extend their lifespan. But they age too quickly and die before they can make it. The emissary must begin as a young person. Finally, a young boy successfully travels beyond the world of eight-day lives to a place where life is lived for 20,000 days or more. The eight stages of the journey correspond to the eight days of his expected life. Our hero breaches "the gates" that lead to a sunny verdant place. The quest is over. The nurturing and healing light of the sun has been found and a normal lifespan is bestowed upon his people.[46]

Much of the power in the film comes from images of pure form – caves, stone labyrinths, vast rocky landscapes – created almost entirely within the limited confines of a 50 x 150-foot soundstage. The single outdoor sequence, when the hero plunges through the gate into a verdant field, was shot in Malibu, on the only patch of green the Basses could find during a particularly scorching summer.

The illusion of an ominous light-starved world was achieved through shifting the color balance of the film toward the blue end of the spectrum. Viewers, like the hero, experience light deprivation and yearn for the warmth that comes only at the end. What is striking is the simplicity of the hero's reward – a field like any other field. The film reminds viewers just what an extraordinary gift it can be to stand in the sun in a simple field.

Saul stated: "I have always been interested in the primeval physicality of life, the endlessly eternal. The stuff that is so atavistic in character that it is fascinating and compelling – sand, sun, fire, water, birds. Forms that are always what they are in general, but never the same in particular. Endless variety within the framework of an eternal form. Light is another one. We have a mysterious relationship to the idea of light."[47]

A decade after the film was made, Elaine reflected: "Process, like life, is a journey, with all that implies… Very often we live goals instead of living life. When we do that we short-change ourselves. When we learn to savor the joys of life, we learn to value life. Not just our own, but the lives of others."[48] Saul, who knew what life was like in the fast track, added: "We all rush through life. We're rushing to get somewhere, like people on a train, an express train. As the local stops go by, we peer out, fascinated by what we can only glimpse, and wish we could stop. But we go by. We're on our way to somewhere. Destination is everything."[49]

The game begins!
The pieces form up....

Ⓐ Preliminary moves
① ② ③

Ⓐ Prelim. moves.
Ⓑ Ape launches laser attack
Ⓒ Ape down 2/3
 Boy has 4 left
Ⓓ Boy launches counter attack
Ⓔ Ape has 1
 Boy has 2
Ⓕ Boy eliminates last cone
Ⓖ Alarm

Image Splitter
Screen
Projector
Camera

The "Game"
(Top, left to right) Storyboard sketches drawn by Saul; a frame from the final sequence and Saul shooting.

The "Earthquake"
(Left) A frame from the film; below, the actor standing on boxes with the backdrop projected behind him; sketches by Saul of the ancient ruins before the earthquake hits and a diagram of the technique used to shoot the scene.

The "Magritte Rock"
(Opposite) Idea sketches; Saul touching up the rock while shooting and a frame from the film.

254 Saul Bass

George Lucas admired Saul and Elaine's ability to weave a rich visual narrative with the simplest technologies; the only computer-generated effect is a small, scintillating ball that rises up beneath a silver cone. Indeed, Lucas was so impressed by the inventive special effects that he showed it as a lesson in cost control to his staff at Industrial Light and Magic, the Lucasfilm company responsible for special effects in a host of major motion pictures, including the *Star Wars* trilogy.[50]

Irvin Kershner, director of the second in the series, *Star Wars: Episode V: The Empire Strikes Back* (1980), stated, "Working with limited means, and in a relatively small space, they discovered new ways of creating the illusion of a vast mysterious world full of magical details and altogether free of sci-fi clichés... the imaginative images create a visual equivalent to the written story. It is a film that transports us into an illusionist world that is totally real. It is a modest film, free of pretension, and competes in quality with the most grandiose and expensive Hollywood productions. But, there is a difference. *Quest* leaves us with an appreciation of the gift of life. It plays simultaneously on the screen, and in our unconscious. It is a dream, and a haunting experience."[51]

Bertrand Tavernier, the French film director and critic, wrote: "The special effects of *Quest*, in spite of their inventiveness, their humor even, are not a back to a cellophane-like galactic universe. The ambition of Saul and Elaine Bass is different. It is more restless, more serious, and more literary. In fact, this magical film asks questions of us, speaks of ourselves to us."[52]

Shortly after its release, *Quest* won a Silver Cup at the Moscow Film Festival and the Golden Halo at a festival for religion-oriented films. When asked to explain this apparent contradiction, Saul joked, "It's either a tribute to the film's universality, or to its total ambiguity."[53]

Beginnings, Middles & Ends 255

Phase IV
Saul's only feature film was an ecological parable set within the science fiction genre. These frames include images from the epilogue that was never made.
1974

Saul and family on location
Rift Valley, Kenya
1973

Phase IV
(1974, Paramount Pictures)

Saul described *Phase IV* as "a sort of sci-fi, surrealistic, ecological suspense story … a confrontation between man and other species – in this case ants – over the apportionment and control of the resources of Earth."[54] The combination of inventive cinematography and special effects elevated a low-budget B-movie script into a mood piece set within a science-fiction framework. Saul spoke of *Phase IV* as "an interesting, if not entirely successful film. As a life experience, it was absolutely extraordinary. On the one hand full of anxiety, frustration and even despair, on the other hand, exhilarating and energizing. Talk about life on the edge! But even when it drives you nuts, you're stimulated and engaged. Until then my work had been in relatively short forms. Long forms are another kind of creative experience. Like walking on a high wire without much training. It can break your back, but you sure know you're alive."[55]

As in a number of his other projects, here Saul was fascinated with existence in miniature which, upon close scrutiny, reflects the broader cosmos.

As Gaston Bachelard, the French phenomenologist, stated, "… the minuscule, a narrow gate, opens up an entire world."[56] The somewhat familiar theme of mutant life forms developing intelligence and in the process threatening to overtake the earth gave Saul the opportunity to create a believable world of ordinary ants that exhibit extraordinary sophistication.

Together with Dick Bush, director of photography, art director John Barry and entomologist Ken Middleham, Saul created images that reverberate in the mind long after the film ends. Middleham's credit for "special effects ant photography" hardly begins to do justice to the magic he created on screen. He specially bred ants to acquire different colored features, including abdomens full of luminous liquid. In one shot, mega-magnification makes truly unsettling an ant giving birth to an egg turned bright yellow by the insecticide humans had hoped would kill it. The ominous otherworldly music, composed and conducted by Brian Gascoigne, was augmented by montage music by Stomu Yamashta and by David Vorhaus's electronically simulated ant noises.

The ants are the center of the movie. Their lives become vivid to us as we observe their activities and mutual interaction and see humans from their point of view. The humans have a geodesic dome; the ant hives are a Stonehenge-like ensemble of obelisks. Not only does Saul credit these architect ants with magnificent structures of their own, he also gives each clan of ants a symbol. Occasionally one is allowed to empathize with the ants. In one of the most moving scenes of the film, we see them mourn their dead in ways similar to humans.

At the time, the film was read mainly as an ecological parable, but it can also be read as a commentary on outmoded ways of dealing with problems – social, political and personal. To make the ants not only more intelligent but also victorious, was a provocative statement at a time when the United States was at war in Vietnam.[57]

Publicity and marketing executives were not sure how to handle a B-movie that was more of an art film than the average sci-fi horror flick. Nevertheless, the beauty of the imagery was widely acknowledged, and the transmutation of the two species and the suggestion of a reconfiguration of the human race led to comparisons with not only *2001: A Space Odyssey* (1968, dir. Stanley Kubrick) but also *The Andromeda Strain* (1971, dir. Robert Wise). Despite Saul's brilliance as a poster designer, the film was released with an advertising campaign over which he had no control.

In London's *Sunday Times*, Dilys Powell described *Phase IV* as "a film of design, of unsentimental forces set against one another in lines, curves, angles, shining surfaces. Beautiful but always threatening, mysterious, forbidding."[58] She might also have added that it is a film of luscious color – rich blues, lurid yellows, uncanny reds – eerie light, haunting sound and, above all, an accumulation of "mood" that builds to an apocalyptic foreboding. Jay Cocks in *Time* picked up on the foreboding, noting sequences "that seem to have been lifted from a surrealist's fever dream: gigantic anthills looming like pylons against a gloomy sky; a dead man's hand, unclenched, revealing ants crawling out of the holes they have chewed in the palm."[59]

Saul, who was extremely frustrated by Paramount's handling of the film, commented, "Jay Cocks did a wonderful review of the film. He really positioned it. You see, it was not a horror film, even though there were elements of horror in it. [But] Paramount advertised it as a horror film because they knew what to do with that. It had decent openings, but then went right down the tubes because the horror fans showed up and said, 'Come on, where's the horror?' There wasn't enough horror for horror, and there was too much for something else … So it got a very bad release. But it did fantastic business in France."[60]

The film enjoyed a brief cult following in the mid-1970s. It won the Golden Asteroid at the 1975 Trieste Annual International Festival of Science Fiction Films, and more than broke even at the box office (the budget was only 1.2 million dollars) before sinking into near oblivion. Today it has been rediscovered by a new generation of viewers who have again granted it cult status.[61]

258 Saul Bass

Frames from Phase IV
1974

Change

We developed a project for a film, the working title of which was "Change." This project was initiated by us. Unlike all the other work, this was not the result of a commission. It was not "on order."

We developed a script on the subject of "change." It was interesting and it was lively. It was a poetic vision of the effect of change on people. It was intended to provide the viewer with the impact of going through the experience of change. How it disorients, confuses, frightens, liberates. How we find ourselves running faster and faster through new, unknown and increasingly dangerous territory. And finally, it deals with some clues about the possibility of controlling change.

I undertook the task of getting a company to underwrite it. I was reasonably well networked, and was able to set up meetings with the CEOs of about fifteen major corporations. I went "on the road." I did a "reading" of the script, complete with sound effects, voices, narration, actions, etc. I got applause but no sale. Finally, I got to Frank Stanton, then President of CBS. When I finished my reading for Dr. Stanton there was no applause. There was a long pause. Then he said, "What's the budget?" That was real. CBS wanted to "go."

Just then, Paramount asked me to direct a feature film. Bam! I dropped the "Change" film and agreed to do "Phase IV." And there I was "on commission" again! [62]

Beginnings, Middles & Ends 259

260 Saul Bass

Epilogue: Paradise Lost & Paradise Regained

Instead of the film closing with the end of *Phase III*, Saul had planned an extended epilogue that would have brought a more dramatic sense of closure to a film that many feel ends too abruptly. Unfortunately, funding was withdrawn after a change of studio head and the epilogue was never made.[63]

If realized on film, this impressionistic series of images would have been a hallucinatory tour-de-force. Based on John Milton's epic poems *Paradise Lost* and *Paradise Regained*, the epilogue begins with "Man Controlled" (*Paradise Lost*), a terrifying sequence of giant monoliths and tiny human figures who fall through space, lose their features and finally catch on fire. Then comes "Transformation," wherein a sun shape appears behind the people and then becomes incorporated within their bodies. In "Rebirth," a human being gives birth to a sun. The final images captioned "Man at One with Nature" (*Paradise Regained*), are of cataclysm, learning and ultimately oneness with nature. The message contained in the storyboards is uplifting, although it is clear that "Paradise" will not be regained easily, and in this sense it can be read as a call to arms.[64]

Epilogue storyboards
A selection of storyboard sketches for a powerful extended epilogue that was never made.
1973

Beginnings, Middles & Ends **261**

5

The Wheel Comes Full Circle

... a new path intersects an old one

You write a book of 300 to 400 pages and then you boil it down to a script of maybe 100 to 150 pages. Eventually you have the pleasure of seeing that the Basses have knocked you right out of the ballpark. They have boiled it down to four minutes flat. It is quite an experience to see your own work encapsulated so beautifully. If you are doing serious work then it is critically important that the opening captures the mood. It is such a precious time.[1]

Nicholas Pileggi

Title sequence frames
From *Cape Fear* (1991), *The Age of Innocence* (1993) and *Casino* (1995).

Saul and Elaine
Masquerade Ball, Alliance Graphique Internationale (AGI) Conference, Munich. 1980

Saul and Elaine
1978

For over two decades, from the mid-1960s to the late 1980s, Saul and Elaine moved away from main titles, for reasons that came partly as a consequence of the pioneering work they had done in previous years. Saul told me, "I call it 'Fade Out' and 'Fade In.' At first I was so busy with the corporate identity work – our first big commissions came in the 1960s, and Elaine and I were so involved with our filmmaking and with the arrivals of Jennifer (1964) and Jeffrey (1967) that we hardly noticed the change in pattern."[2]

"There were several reasons, it wasn't just that my type of titles became the thing to do – almost an industry in itself – but also the fact that producers, filmmakers and title-makers began to regard the titles as a tap dance that they did before the film began. Elaine and I feel we are there to serve the film and to approach the task with a sense of responsibility. We saw a lot of pyrotechnics and fun and games and I suppose we lost interest. At the same time, an increasing number of directors now sought to open their own films in ambitious ways rather than hire someone else to do it. Whatever the reasons, the result was 'Fade Out.' We did not worry about it: we had too many other interesting projects to get on with. Equally, because we still loved the process of making titles, we were happy to take it up again when asked. 'Fade In' …"[3]

In the late 1980s and early 1990s, a number of directors and producers for whom Saul had long been a hero invited him to create titles for their films. The wheel had turned full circle and more. Saul was back in the field that had brought him international recognition, but now with greater experience as a filmmaker and in close collaboration with Elaine, who by then was herself an experienced filmmaker. These commissions brought Saul and Elaine back to the close-knit partnership they had enjoyed during the making of the short films and the title sequences from *Spartacus* (1960) onwards.

Elaine says of this time, "With the later titles, it was just the two of us at the idea stage and again in the editing room away from telephones and the hustle and bustle of the rest of the office. At other times we would work with office staff and outside people as and when necessary – Art [Goodman], for example, often worked with us. It was simple and flexible, ideally suited for discrete manageable pieces of work that we could discuss at home as well as in the office where the back studio was used as a soundstage. It suited us very well."[4]

They found titles just as challenging as short films, and liked the idea that they could be completed within a short space of time. As Saul pointed out: "In two or three months you have a very nice little piece of film and you've been involved in a very dynamic process. We love doing titles, we do them in a nice, obsessive way – we futz with them until we're happy and do things that nobody else will notice but us. We like the notion of the bottom of the table being finished even though nobody sees it. There's a Yiddish word for it, 'meshugas,' which is 'craziness.'"[5]

Frames from the end of Broadcast News
1987

Saul and Elaine
Creating a nighttime, aerial view of Las Vegas, as it would have been in the 1970s, for the *Casino* title sequence.
1994

The return to film title sequences came out of the blue. "We got a call from Jim Brooks, who turned out to be a fan. It was as simple as being asked," said Saul.⁶ Between 1987 and 1989, Saul and Elaine worked on three films in which James Brooks was involved, the first as director, the other two as producer – *Broadcast News* (1987), *Big* (1988) and *The War of the Roses* (1989). According to Saul, "None of these titles was terribly ambitious, but they were interesting. Frankly the main and greatest interest was working with Jim. He is very open to ideas and very smart."⁷ Much more ambitious was the title sequence commissioned by Japanese director Junya Sato for *Tonko/Dun Huang/The Silk Road* (1988), a film that went on to win him the Japanese "Best Director" award the following year.

For *Broadcast News*, Saul and Elaine did not want to detract from Brooks' live-action prologue that introduced the three main characters as children, complete with dialogue. Saul explained, "Elaine and I talked it through and decided that a minimal input was all that was needed. We didn't want to interfere with what was there, but we had to find a way to signal that this was going to be a movie about serious issues. We tried to convey that through simple, strong and fairly plain lettering and credits that appear and disappear without any tricks. Our input was so discreet that some people were surprised to see a credit for the titles."⁸

Brooks also enlisted Saul and Elaine's help with the end of his film. Preview audiences had understood the final scene, in which the main characters meet after twenty years, as hinting at a reconciliation to come, and felt cheated when the film ended on this ambiguous note. The question was how to appease audiences without compromising Brooks' vision. "It was just the sort of problem we love," said Saul. "The task was how to alter audience reaction. What we suggested was very simple. Almost as soon as the scene begins, the picture on the screen starts to shrink as the camera pulls back and the end credits begin. This distances the viewer visually and emotionally while signaling the end of the film as the scene is played out. The real achievement was to shift the audience to a position of grudging acceptance."⁹

After *Broadcast News* came titles for *Big* (dir. Penny Marshall), a film about a thirteen-year-old boy in the body of a thirty-one-year-old man, which also featured a live-action prologue introducing two of the characters. Saul and Elaine wanted to allow audiences to focus on the scene, while signaling that this would not be a "kids' picture." Saul explained, "We wanted to introduce a dynamic and indicate that the movie has a quality emotional intent."¹⁰ Confident white lettering sets the tone for the adult world the boy will enter, while the playfulness of credits zipping on and off the screen are indicative of what he brings to that world. Ambiguities are hinted at in the movement of titles across the screen in alternating directions, and the concept of doubleness is reinforced in the double underlining of each credit – one line is thick (man); the other is thin (boy).

The Wheel Comes Full Circle **265**

Title sequence frames
This elegaic prologue was shot in the vast barren stretches of the Gobi Desert.

Tonko / Dun Huang / The Silk Road
(1988, dir. Junya Sato)

The Japanese film director, Junya Sato, asked Saul and Elaine to create a title sequence prologue to an action-packed, romantic melodrama. The film opens with the discovery, in 1900, of a cache of scrolls and mantras from the mid-eleventh century, which had been sealed in caves near the ancient city of Dun Huang. The story is set in the northwest edge of the Chinese Empire at the last caravan stop on the Silk Road. Discussing this Sino-Japanese co-production (it was called *Tonko* in Japan and *Dun Huang* in China), Saul joked: "In either language, it's a $40 million extravaganza."[11]

Elaine recalls that a trigger for this sequence was the Percy Bysshe Shelley poem "Ozymandias" and what it expresses about the evanescence of power and civilization.[12] The result was a title sequence of brooding intensity. The cyclical emphasis of the visuals, in which the ruins of an ancient city come to life only to be reclaimed by the sands of time, is accompanied by the contrast of sound and silence. Silence accompanies our discovery of the city and its eventual disappearance; sound is reserved for its brief return to life. Elaine and Saul hoped that the sequence would invite reflection about the cyclical nature of human history and the natural world.[13]

Title sequence frames
In this extended visual pun, the sensuous contours are revealed to be the folds of a handkerchief, setting up this film's satirical look at marriage.

The War of the Roses
(1989, dir. Danny DeVito)

For this black comedy about a bitterly feuding husband and wife, each trying to force the other out of the marital home, Saul and Elaine created a title sequence with an unexpected twist.

It opens with shadows playing across a flat white surface. As folds appear, we wonder if we are looking at white linen. When a single red rose is placed against it, one is reminded of the titles for the sophisticated romantic comedies of the 1930s and 1940s. Soon the whiteness coalesces into what appears to be a vast wind-carved landscape. Then it all comes clear, or seems to; we're surveying the voluptuous mounds and valleys of a piece of fabric, and it is surely, considering the topic, a crumpled white bed sheet. Wrong again. The camera pulls back to reveal a handkerchief, into which DeVito blows his nose.[14]

Mr. Saturday Night
(1992, dir. Billy Crystal)

For Billy Crystal's directorial debut, about an old Jewish comedian reminiscing about his beginnings, Saul and Elaine created a sequence evocative of the humor, richness and rituals of Jewish life in 1940s America. Saul recalled, "It opens with the making of matzos. An extreme close-up of a wet blob of matzo meal lands on a kitchen table. We see it shaped into a ball by two hands. Next, close-ups of the matzo ball splashing into a pot. Hands dice onions, stuff sausages, massage a brisket, fold kreplachs, slice challah, sizzle latkes in a frying pan, dish out gefilte fish and masses of cabbage, mounds of mashed potatoes, and huge portions of pot roast. While all this is going on, we hear a voiceover in which Billy Crystal's comic character, Buddy Young Jr., tosses off a string of one-liners.

"Finally, the meal, which has taken shape before our eyes in less than two minutes, appears at the dining table and becomes, even more quickly, a graveyard of leftovers, fish bones, coffee grounds and cigar stubs."[15]

For the test shots, Saul and Elaine bought a hundred dollars' worth of food at Canter's, the venerable Los Angeles delicatessen, and used their dining-room table as the set. The demonstration convinced Billy Crystal to let the Basses proceed.

The final sequence provides a luminous illustration of the art of Jewish cooking and the art of montage. These three luscious minutes evoke the literal and metaphorical nourishment of a closely knit family, suggest obsessive undercurrents without naming them, and manage to do it all without showing a single actor. The visuals, alongside Buddy Young's jaded voiceover, set up exactly the right resonance for the story to come, about a standup comic who spends his life trying to recapture a feeling of well-being in the bosom of his family.

Title sequence frames
Jewish culture is introduced through food and the hands preparing it.

Billy Crystal & the Chopped Liver

When you're making a movie, you can get caught up in details that, in retrospect, are terribly silly. There was quick agreement on how to deal with all the food (the matzo balls, the brisket, the stuffed cabbage etc.) in the opening for "Mr. Saturday Night." Except the chopped liver.

There was a long, somewhat bizarre, discussion about the chopped liver. We had different points-of-view on how to handle it.

In my childhood experience, we made the chopped liver by putting chunks of liver, the onions and the chicken fat into a wooden bowl. Then (I was usually the one), chopped at it with a wood-handled metal chopper, turning the bowl periodically to vary the attack. After some time it became a nice even mush. Billy's experience (which my family disdained) involved putting this all through the meat grinder and just cranking it out.

Long discussion.

We put it through the grinder.[16]

The Wheel Comes Full Circle 269

Working with Scorsese

Something special happened when Saul and Elaine began to collaborate with Martin Scorsese. He offered them near creative freedom, and the Basses responded with title sequences that so perfectly captured the mood, and suggested the deep currents and ambiguities running beneath the surface of the films, that they transcended the expectations of Scorsese and audiences alike.

These last three titles Saul and Elaine created together for Scorsese – *Cape Fear*, *The Age of Innocence* and *Casino* – share a quality that is at once mythical and dream-like. With their lush colors, elemental contrasts and unbounded sense of space, they have the power to astound, the result of an intense cinematic conversation between three artists at the height of their creative expression.

Writer Nicholas Pileggi, who collaborated with Scorsese on both *Goodfellas* and *Casino*, commented on the rarity of the trust Scorsese placed in Saul and Elaine: "For a director such as Scorsese, who is totally committed to every last inch of the film, there is no greater tribute than to hand over the opening of your film to them. That he hands over part of what is most sacred to him is an extraordinary compliment to the Basses."[17]

Quentin Tarantino made a similar point: "Saul Bass was undoubtedly the greatest title sequence maker. Brilliant – just brilliant. He has been a 'hero' for years. But, and it's a big but, I could never do what Scorsese does – give up control of the opening of my film to someone else, not even Saul Bass – I guess I should say Saul and Elaine Bass. I need to keep control of everything and Scorsese is too great a filmmaker not to know the importance of control. It can only mean one thing: Scorsese must have absolute, *ab-so-lute*, confidence in them. And that is nothing less than amazing to me."[18]

Martin Scorsese, Saul and Elaine
1991

Title sequence frames
High-speed credits mirror the frenzied pace of this film about the mob.

Goodfellas

(1990, dir. Martin Scorsese)

Scorsese recalls, "I had a placement for the credit but didn't have the right lettering. I had the right music cue but something wasn't right. I just didn't know what to do with it. I was watching a movie called *Big* and I see the end credits – Elaine and Saul Bass. I said 'My God, this is great! They are working… they are still around. This is fantastic.' I said to my producer, 'Do you think we should venture to call and see if they would do this?'"[19]

Saul's response: "Were we interested in doing titles for Martin Scorsese? You bet your ass we were."[20]

The title sequence was resolved fairly quickly, partly because Scorsese already had an approach in mind, partly because there were no "backgrounds" to be considered, only lettering, and partly because Saul and Elaine came up with what was used after only one or two attempts. Scorsese wanted the sequence to reflect the frenetic pace of the film based on *Wiseguys*, Pileggi's composite biography about Italian-American mobsters, but since the credits would bookend the extremely powerful opening scene involving cold-blooded murder, Saul and Elaine were anxious not to overwhelm the action with elaborate visuals.[21] The lean, hard-edged credits rush across the screen, blurring like a car passing at high speed – just like that in which the "Goodfellas" are traveling – to a background of doppler-effect traffic sounds. Before the murder the typography is white on black; afterwards it changes to red.

The Wheel Comes Full Circle 271

Internal sequence frames
An eerily undulating reflection conveys a key piece of information and an ominous sense of foreboding.

Cape Fear
(1991, dir. Martin Scorsese)

Cape Fear is a tale of revenge and confrontation. A psychotic rapist recently released from jail stalks and terrorizes the family of his defense attorney, seducing his fifteen-year-old daughter and unleashing demons that threaten to destroy the family from within. For the opening titles, Saul and Elaine created a sequence that plays on exquisitely delicate balances between the sheer beauty of color and form and the disturbing nature of the imagery, between the surface and what lies beneath, between innocence and terror. For the main body of the film, Elmer Bernstein reworked the Bernard Herrmann score from the original *Cape Fear* (1962, dir. J. Lee Thompson) that Scorsese adapted, but he created an entirely new piece of music for this stunning opening sequence.

Saul and Elaine knew the original film, but realized that Scorsese intended to make the story even more "noir." "We didn't know how, but we sure as hell knew he would give it an edge…We had read the script, but were much more interested in his approach, in what he was going for."[22]

"Our concept for the film title was based on the notion of submerged emotions – the black potentials of the psyche. The spine of the concept was water. The entire title consists of water, and the water changes: it becomes more and more abstract until what you see are flickering reflections. The greens, golds and blues change and finally become red. The water becomes blood. It is a powerful color and we carried it over into Marty's opening shot of Juliette Lewis's eyes.

"It was a perfect piece of continuity flowing out of our use of distorted eyes under the reflections early in the title. Then we began to introduce other images that added levels of unease and uncertainty. Using simple optical devices, we put the images underwater and distorted them. Eventually the water becomes an emotional whiplash of form and color with disturbing emotional undercurrents. We hoped this process would escalate the sense of threat so that when you first see De Niro, his tattoos become more than strange – they become quite terrifying. The sequence was intended to give a very simple signal of dysfunction. We added to this by cutting the letterforms in half horizontally and offsetting them. It was a simple reinforcement of the implications of the live action."[23]

This is water as we have never seen it before – swirling mixes of hauntingly beautiful colors in which we briefly glimpse eerie images such as a bird of prey, a human silhouette, a nightmarish eye and parts of a human face distorted by the movement of the water, all of which appear to be more than mere reflections. Finally, the water changes from smoothly swirling abstraction and pattern into a river of blood.

These images and effects were achieved through remarkably low-tech means, thanks to Elaine's ingenuity. What we perceive as a rippling, ominous sea was created by pouring water into a Pyrex tray, and blowing it with a hair dryer. Elaine sculpted several human forms and heads for the "underwater" shots, and they borrowed footage from *Seconds* (1966) for the menacing close-ups of a man's face. The entire sequence was shot with a crew of four: Elaine, Saul, a cameraman and an assistant in the back lot of Saul's office. For the final shoot they used a larger container – a kitty litter box![24]

Simple technology also proved to be the answer for a shot in the film itself. Scorsese wanted the audience to know that when Robert De Niro straps himself under the family's car, their destination is Cape Fear. Saul and Elaine suggested the reflection of a road sign in water and created the whole shot by using a reversed blow-up of a Cape Fear sign, a few inches of water mixed with India ink and the same hair dryer.[25] It works beautifully within the film, creating just the right amount of eeriness.

The Wheel Comes Full Circle

Robert Sean Leonard
Norman Lloyd
Miriam Margolyes
Alec McCowen

Music by Elmer Bernstein

The Age Of Innocence

Siân Phillips
Jonathan Pryce
Alexis Smith
Stuart Wilson

Costume Designer Gabriella Pescucci

Title sequence frames
Time-lapse photography of blossoming flowers revealing patterns of lace and Victorian calligraphy suggests the suppressed sexuality at the heart of this film.

The Age of Innocence
(1993, dir. Martin Scorsese)

The Age of Innocence is an adaptation of Edith Wharton's novel about life, manners and suppressed sexuality in late-nineteenth-century New York high society. In this tale of illicit love, Scorsese examines the paradoxes of an era where cruelty was cloaked in graciousness and eroticism was both restrained and heightened by elaborate codes of etiquette.

By the time Elaine and Saul came on board, Scorsese had already cut together several scenes, which he showed them on video. They reread the novel, read the script and decided to go for "a strong sensuality because it is a film about love, yearning, and suppressed desire."[26] Elaine suggested using time-lapse photography of flowers unfolding and dissolving one into another and then overlaying the flowers with a delicate layer of lace and the beautiful calligraphic texts from etiquette books of the period.[27]

Scorsese recalls first seeing it: "Quite honestly, I'd never seen anything like it. I was stunned, because the whole movie was there. I said, 'This is better than the picture!' They achieve a certain beauty that I had hoped for, and also a certain unease. There is a slightly sinister quality to the underlying impact of the opening credits, a sense of conflict right from the beginning. It has the essence of the film – the longing, the hidden passion. The audience sees a flower, some lace, and some scripts, yet it feels like something is going to happen – and that's very delicate."[28]

Saul explained, "The title was deliberately ambiguous and metaphorical. The kinds of notions we had in mind involved an attempt to project the romantic aura of the period and still signal its submerged sensuality and hidden codes. The concept consists of a series of metaphorical layers. One layer is of lush time-lapse blossoming flowers evoking the romanticism of the Victorian period. Each starts as a closed bud and slowly and inexorably explodes to fill the screen.

"The continuous series of long dissolves from flower to flower creates a sensuous overlay to the notion of Victorian innocence. The first flowers blossom slowly, sedately. As the dissolves progress, the tempo increases, resolving into an intense compressed montage of flower openings. To achieve this we optically double and triple-framed already highly overcranked footage and framed the flowers very tightly.

"The superimposed lace patterns are another layer. When the flowers are closed, the lace is barely perceptible. But when the flowers open and fill the screen, the lace textures are fully revealed and become the filter through which we view the flowers. Another layer was the patterns of nineteenth-century calligraphy to augment the Victorian character and suggest the film's literary origin in Wharton's novel."[29]

Elaine's idea of cutting the title sequence to a passage from Charles Gounod's opera *Faust* (1859), which opens the film, worked so well that Scorsese and Elmer Bernstein, who was expecting to score the sequence, decided to retain it.[30] The minor-key overture echoes the captive beauty of the flowers, and adds a layer of passion and obscure foreboding that provides the perfect transition into the story.

Casino

(1995, dir. Martin Scorsese)

The staggeringly beautiful title sequence for *Casino* was the last one made by Saul and Elaine. Screenwriter Nicholas Pileggi described it as "simply brilliant," adding, "I was so touched that they had understood the writing; that they knew what the film was trying to do. There must have been a hundred Hollywood films about Las Vegas that have tried to capture the essence of that city, but none quite like this. Part of the brilliance of the Bass opening is that their project is so clear. Elaine and Saul have found the perfect metaphor for the film as a whole – for Las Vegas in the 1970s, and for descent of the Mafia into Hell."[31]

The Bass titles for *Ocean's Eleven*, 1960, also featured Las Vegas, but as soon as they read this script they knew the sequence would have to be very different. As in *Goodfellas*, the titles do not open the movie. They follow the first scene in which Ace Rothstein (Robert De Niro) leaves a casino and gets into his car, turns on the ignition and the car blows up! At that moment the title sequence begins.

Saul described it thus: "Think of Dante's *Inferno* and Hieronymus Bosch, set against Bach's *St. Matthew Passion*, and you begin to get an impression of what we're after."[32] In Saul and Elaine's vision, Ace's body, or soul, rises and falls within a fiery Las Vegas purgatory. Between his ascent and descent, the flames dissolve into a montage of surreal neon lights that capture the city's throbbing assault on the senses.

In the sequence, the main character's excess energy and flashiness are rendered simultaneously distorted and hyperreal, repulsive and desirable, not unlike the strip of casinos itself. The result is a work of startling visual poetry. There could be no more befitting finale for the greatest film title designer of the century, or a more moving elegy to his long and fertile collaboration with Elaine.

The Wheel Comes Full Circle 279

6

Corporate Identity

Thinking made visible...

The ideal trademark is one that is pushed to its utmost limits in terms of abstraction and ambiguity, yet is still readable. Trademarks are usually metaphors of one kind or another. And are, in a certain sense, thinking made visible.[1]

Saul Bass

Saul with Art Goodman and Mamoru Shimokochi
(Opposite) Refining the United Airlines logo.
1974

Saul with designers
(Above) Working on the Bell System graphic standards manuals.
1968

Corporate identity design is the creation of a distinct and unified visual identity for a company or institution, usually centering on a trademark. According to Saul, "The fundamental objective of altering the visual look and house mark for any corporation is to make the change faithfully represent the company, and reflect the role it plays in the environment. On the surface that sounds simple. But, before you start changing anything, you have to clearly understand what you are changing, and why you are changing it."[2]

Advertising copywriter Barbara Baer Capitman observed that corporate identity systems are "the closest a giant corporation can come to anthropomorphizing itself, to presenting a face, a personality."[3] Saul, who created "faces" for more than fifty well-known companies, and as many again for lesser-known ones, understood this – just as he understood that new identities lacked what he called "the authority of existence." They entered the marketplace with only their intrinsic visual qualities, acquiring currency through exposure, familiarity and people's experiences of a company's products or services.

Corporate identity design, as we understand it today, dates back to the 1890s and 1900s, when architects and designers became involved in the creation of new visual identities, mainly for large companies. In 1898, the American-owned film and photographic business, Eastman Kodak, commissioned a revised identity from British designer George Walton prior to expansion abroad. In cities as far apart as Dublin, Moscow and Alexandria, the company's shop fronts, retail interiors and hoardings were designed in a bold and distinctive house style.[4]

It is the German architect and designer, Peter Behrens, however, who is regarded as the pioneer of modern corporate imagery, partly because of the comprehensive nature of the work undertaken between 1907 and 1915 for Emil and Walter Rathenau of the German-based AEG, then the largest industrial firm in Europe, and partly because graphic design constituted a sizeable part of the commission. Behrens designed not only a logo, advertising and in-house graphics, but also AEG products and the factories in which they were made.[5]

The AEG/Behrens model of "enlightened" client and "progressive" designer greatly influenced Walter Paepcke, head of the Container Corporation of America, who in 1934 appointed Egbert Jacobson to devise a corporate identity program including stationery, advertising, trucks, offices and factories. Former Bauhaus teachers László Moholy-Nagy and Herbert Bayer strengthened Paepcke's view that "good design" was part of responsible corporate culture.[6]

In the years after World War II, faced with fierce competition in lucrative national and international markets, many American companies sought to project strong, up-to-date images, and hired top designers to give graphic form to their new identities. Mergers and takeovers further stimulated commissions, as executives sought to give coherence to what were, in effect, new corporations.

In 1951, the year of the first Aspen Design Conference, which helped shape corporate America's attitudes toward design, William Golden's "eye" logo for CBS set high standards for reductive Modernist imagery. Indeed, such was the rapid growth of this type of corporate identity design in the late 1950s and early 1960s that many thought of it as a new development – and in size and scale it was.[7]

The large, comprehensive corporate identity programs of the postwar era are usually seen as beginning with Lester Beall's logo and related designs for Connecticut General Life Insurance Company (from 1956) and International Paper (1960).[8] Also, at this time, Paul Rand began to update the image of IBM (from 1956), becoming more heavily involved in corporate identity design in the 1960s. Saul entered the field in the early to mid-1950s, before he began his film identity work, but always felt that his involvement with large comprehensive programs started with the 1959 Lawry's commission, closely followed by Alcoa (1963), Fuller Paints (1963), Hunt-Wesson (1964), Celanese (1966) and Continental (1967).

Because Saul's film work generated so much popular attention, it is easy for those not familiar with his early graphic work to overlook the fact that he was part of a small group of American designers who were instrumental in developing a strongly rationalist approach to corporate identity design. In sheer volume as well as the quality of work, Saul was possibly the most prolific designer in this field over the period 1960–96, and one of the most influential. He went on to work for some of the largest and most high-profile companies in the world, including the Bell Telephone System, United Airlines, AT&T and Minolta.

Saul was also one of the first U.S. designers to create house style manuals, those for Alcoa and Celanese dating to 1963 and 1966 respectively.[9] Given the huge amounts of time and effort put into large identity programs, design manuals were a way of ensuring the work would remain visually intact over the years and across many applications. Saul thought of manuals as part of an educational control system, always with some flexibility built in. He devised each manual "with an awareness that arbitrary rules were less likely to be embraced, than those for which reasons are clearly enunciated and rationally presented. "We made each manual a persuasive document as well as an instructional one."[10] As corporations grew in both size and complexity, so too did manuals: those the Bass office created

for the Bell System in 1968 and Exxon in 1981 were both among the most comprehensive of their day. The Bell commission itself was one of the largest ever undertaken by any designer and therefore, by the late 1960s, the Bass office was regarded as one of the offices most capable of dealing with the very largest and most complex corporate identity programs.

Be it large or small-scale, Saul's basic approach remained the same. He tried to grasp the essence of what a company was about in order to represent it to itself and to the public. He found, however, that while film clients shared a common vocabulary and were familiar with thinking visually, for the most part, this was not the case with corporate clients. For the majority, this was their first experience of working in the visual realm.

Saul's ability to listen to what company executives wanted, or thought they wanted, and to their hopes and fears about their businesses, proved an important asset. He also had a rare capacity not only to come to a powerful and appropriate image, but also to successfully convey the rationale behind the designs to his clients. He took great care to guide executives through each stage of the process, creating a rational structure within which visual forms could be evaluated in order to bridge any potential divide. Saul was also able to make sense of huge amounts of information generated by in-depth studies of major corporations. Lou Dorfsman was but one of many contemporaries who marveled at Saul's ability to digest and synthesize it all. Dorfsman also regarded Saul's final presentations as "second to none – the finest I ever witnessed in half a century in the design profession."[11]

Saul with his work
1980

Saul with Art Goodman, and designers Sharon LeClercq and Vince Carra
Refining the airplane graphics for United Airlines.
1974

Saul with project team
Research and analysis for Rockwell International.
1968

The Bass Process

"Usually we become involved because a company has a practical problem. They've changed their name. They've merged. They've had a trademark for a long time and their business has changed so the trademark no longer reflects what they do. Or, there may be a basic need for updating.

"We've developed a way of approaching the task that makes what we do more comprehensible to non-designers. It's a straightforward problem-solving technique that has come to be used by many design consultants these days.

"It starts with a study and analysis phase, during which we arrive at the critical strategic decisions that will guide our efforts. There's nothing mysterious about what we do. We start by learning the client's business as thoroughly as we can. Products or services: we learn their history, their unique characteristics, their strengths, their weaknesses. We analyze competitors. Who is doing well or poorly and why.

"We collect and analyze all the client's communication materials, everything that carries the corporation's identity. If market research exists, we enlist it. If it doesn't, we might recommend that it be undertaken, and though we don't do the research ourselves, we participate in creating the design of the research to make sure that our questions are answered.

"By far the most important element of our study is the interviews with key company officers and personnel. In some companies we talk to the chief officers, the head of marketing and a few division heads. But in others it might be more important to talk to an outside member of the board, an assistant to the president or a key scientist. The point is that every company is different and must be approached as such.

"The interviews themselves are the key to our study. Typically they occur after we have done our other homework. We meet with only one executive at a time. We promise confidentiality. We work from a questionnaire but not rigidly. The interview is planned to last forty-five minutes but usually spills over because there is always more to say than time will allow. It's among the most interesting aspect of my work. I get to ask powerful and often interesting people about their work and their lives. It is in their heads that the real blueprint for the future exists or is being formed.

"Okay, by now we have the whole picture. Well maybe not everything, but a great deal. Only at this point are we prepared to devise a set of objectives for our design project. These objectives are the true road map of the work that will proceed from this point on. They tell us what is most important to communicate, and what's next most important, and so on.

"These objectives are vital to us for two reasons: first because our 'canvas' is very small, and we will likely have to make hard choices about what to go for. Equally important is that we must have some rational basis for evaluating the work that will emerge. It's essential that we move away from the dreaded I like that, or I don't like that, syndrome.

Saul with Herb Yager
Preparing for a presentation to the Mokichi Okada Association.
1982

"At that point, having been intellectually rigorous, you can begin the process of design that cannot be rigorous in the same way. You go to work and the process becomes an odd amalgam of objective awareness and intuitive expression. But it's a process that we share with the client. We expose everything we've done – good, bad, or indifferent. We usually drop true dopiness. But it does occur. It's in the nature of the beast.

"In presenting the work I might say we tried this, but it was too frivolous (or too didactic). And we tried that, which was rather promising. So we developed that further, but then it went over the edge and the notion became incomprehensible. Finally, there will be two or three designs that I think are really viable and worth considering seriously. We then review the original objectives to see how what we've done measures up.

"But then I may point out that there's a place I go where they, the executives, can't follow. It has to do with my intuitive feeling about whether it's really going to fly. And that's a judgment that comes from inside me and results from my many years of thinking and worrying about these things. I might then make an assertion that I'm convinced that this will work. Or do a good job. Or become an outstanding trademark, if I really believe that.

"In corporate identification, you're looking for the essence – the metaphor for the company's activity. But there are certain general things that any identity must achieve. It has to have an impact, a presence, yet also be timeless rather than particular to a moment in time. Because of the long-range nature of corporate identity – a company doesn't go through an identification program more than once or maybe twice in its lifetime – you must be very careful not to do something that will prompt people five years later to say, 'Oh, yes. That's what they used to do five years ago.'" [12]

Bell System presentation
At the end of the formal presentation, Saul pressed a button and the curved screen magically rotated up to reveal a whole warehouse full of applications for the new Bell System identity, from vehicles and personnel dressed in uniforms to phone booths, telephones and a retail store.
1969

Putting on a Show

"I often think that presentations are more difficult than the work itself. A presentation has to share just enough of the process so that someone who has not been a participant can understand the 'inevitability' of the solution, and that the solution is the culmination of a rigorous and systematic investigation of all reasonable possibilities. When you present work to a client, it is important to have a point of view. The tricky part is to provide several good solutions to a problem and then not allow the client to choose other than the best one. It's surprising how hard that sometimes can be."[13]

Saul was one of the few top-class corporate identity designers able to present complex materials with clarity, artistry and panache. It helped enormously that he was a meticulous planner and a patient teacher, always willing to go back to basics to be sure the client could understand the design process and why each decision was made. No matter how off-the-cuff and casual his presentations might have appeared, scripts were polished to perfection and then tweaked again; every pause and emphasis was noted. But Saul had excellent comedic timing and was nothing if not a great improviser. His quick wit, command of the material and ability to connect individually with each client meant that he could come up with new ideas quickly, as and when necessary.

Continental Airlines presentation
1966

Saul in a meeting
mid-1960s

286 Saul Bass

Discussing Saul's many talents, Lou Dorfsman stated, "Saul was brilliant in presentations. After he had dissected a design problem, delved into it and come up with an elegant solution, he would then present what he had done with great aplomb, grace and style. He had a great way of connecting with people and a marvelous use of language, conjuring up wonderful word imagery so that you could picture in your mind whatever it was he was talking about. His best were worthy of Oscar nominations – at the very least! To be successful to the degree he was, working for some of the biggest companies in the world, it isn't enough to be a good designer, put forward the work and hope someone will like it. For example, Saul and Will Burtin each gave presentations on different projects related to the Eastman Kodak presence at the 1964 World's Fair. Will, a superb thinker and designer, talked in highly abstract, aesthetic and philosophical terms, but did not connect with his audience. Saul, by contrast, talked clearly, with wit and insight, about what he was doing and why, and what the outcomes would be."[14]

Saul even conducted presentations while in the hospital. Art Goodman recalled how, in the mid-1960s, Saul ran the office from his hospital room: "I'll never forget the sight of Saul, just out of hip surgery, meeting with the people from the Howard Gossage agency, for which we were doing a beer commercial. We were all wearing masks and hospital gowns, but Saul acted exactly as if we were in the office. He introduced the main ideas and started flipping through images on black cards, saying, 'this will be happening at this moment and then this will happen next.' He hummed all the way through, reaching crescendo with certain images. He even had a moviola moved into his room."[15]

Saul presenting
mid-1970s

Continental Airlines presentation
Discussing vehicle graphics with Mark Kramer, Vice President of Continental Airlines.
1966

Ajinomoto presentation
1973

Corporate Identity 287

The Authority of Existence

The authority of existence is an important concept in this business. It's what you're constantly battling. That is to say, you present something, and not only does the client know it doesn't exist out there in the culture, but it hasn't existed in his or her own consciousness.

Time is very significant; utilization is very significant. Eventually this new icon will have its own authority of existence, but it's difficult to simulate that in advance. In some cases, though, and this is very interesting, if the presentation goes on long enough, and the discussion goes on long enough, this new thing acquires an authority of existence by the mere length of time you've been looking at it and talking about it – sometimes just another hour.

I've had people say to me, "You know, when I first looked at it I wasn't sure, but since we've been talking about it I've gotten to feel a lot more comfortable about it – I think it's really working."[16]

Client and Designer

Saul enjoyed exceptionally good relationships with his clients. Although not all captains of big business shared his liberal outlook, they appreciated his professionalism, intelligence, integrity and good company, and often retained his services for many years. Lawry's Seasoning & Food Company, for example, was a client for forty-seven years, and AT&T for more than twenty-eight. Harold Williams, "struck by Saul's ability to understand and capture what I wanted to convey," utilized Saul's talents in one way or another for more than thirty-five years.[17]

Williams recalled, "In about 1960, Hunt Foods, the company I was working for, was trying to redesign the Wesson Oil bottle – unsuccessfully, until I met Saul. One of the people working the phones with me at a charity telethon said that he was an accountant for a talented designer. I told him of our design problem and he suggested we talk to Saul.

"It was a surprisingly complex assignment. We wanted to get away from the then standard tube-shaped bottle and compete with the narrow-waisted bottle of a new product put out by Crisco. Saul seemed to hit all the buttons, both functionally and aesthetically. His design did exactly what we wanted it to do, and did it better. Then, when I was heading Hunt Foods and we wanted a corporate symbol, along with a redesign of our label's fundamentals, Saul once again captured what we were trying to convey.

"When I left Hunt Foods to head the Graduate School of Management at UCLA (University of

288 Saul Bass

Avery International
Trademark
1975

Avery International

California, Los Angeles), I again commissioned Saul to create a symbol. And when I entered government service and chaired the Securities Exchange Commission (SEC), I retained Saul to find out how the SEC was perceived by the public. His presentation, based on taped interviews, really opened our eyes. It wasn't only that the SEC was seen more negatively than we'd expected but also that there were serious misunderstandings of its role in certain areas. The study didn't really go any place because it was too difficult for us to move the government bureaucracy, but the results were certainly instructive. When I became head of the Getty Trust, Saul was a logical choice to deal with issues of how that body was perceived.

"It's atypical of many artists, but Saul starts with a systems approach, an effort to understand the problem and the objective, then to articulate it, and finally to translate what he's learned into an artistic solution. Often it turns out to be a different problem than the one that the client himself might articulate, but Saul really takes you along with him through all the steps, the logic of what he's doing, the process of elimination. There's an elegance to his artistry, but also a simplicity and modesty."[18]

Edward Block of AT&T, who described Saul as "the great guru of corporate identification and a delight to work with," emphasized that Saul was "not one of those who is up on a pedestal. I've worked with some who have great reputations and can do great work but it can get tedious. You want a letterhead and they want to build the Taj Mahal. Saul is very straightforward and practical in seeking solutions to design problems. We knew of his reputation in Hollywood, but he was not at all a 'Hollywood guy.' He did great work for us without making a lot of waves. He did it on time and he did it right."[19]

Saul turned down work when he was not convinced of a commitment to excellence on the part of a prospective client or when his talents would benefit a product that he knew to be harmful to living things. He was not a mild person by any means, but he could rein in his frustrations so long as he felt the points under discussion were valid ones and that his opinions would be considered. He was willing to concede certain issues, but there was no compromise in terms of design. Saul was always prepared to rethink a design, but refused to accept a CEO, group of executives or anyone else altering one.

In 1975 Stanton Avery, the inventor of the self-adhesive label, tried to do just that. Saul recalls, "I spent months on the project, researching the company and visiting Avery Products facilities all over the world. Finally it came to the presentation. I went through every alternative and finally 'unveiled' my choice (an 'A' formed by links of a chain). The room was silent, as everyone waited for the boss's response.

"Stan Avery, a tall patrician man of great intelligence and thoughtful demeanor, rose from his seat, walked up to the design on the wall, and studied it closely.

"He took a fountain pen out of his pocket and unscrewed the cap. 'Listen, Saul,' he said, 'I hesitate to… can I draw on that?'

'Sure,' I said.

"Avery crossed out the 'International,' leaving only 'Avery,' and drew a circle around the design.

'What do you think? Does that make it better?'

"I walked to the wall, looked at the design, removed the pushpin and held the design in my hand. 'Stan,' I said quietly, 'when I was a kid my mother told me never to argue with the boss. So I asked her, even if he's wrong? And she told me that when the boss was wrong, it was really important to find a nice way to let him know. Pause… 'Stan, you are wrong.'

"Everyone remained silent until Avery spoke. 'Well, Saul. What can I say? A long time ago I learned that if a man goes to a doctor he respects, and ignores his advice, he does so at his own peril. So I think I will defer to your judgment.'

"But I knew that Avery was still dissatisfied, and I understood why. Unlike other trademarks that had been around for years or decades, this one had just been exposed to the light of day.

"To allay Avery's qualms, I did what I had sometimes done in such circumstances. I put the new icon on a small board, together with several other well-known marks, and asked Avery to display the card in his office in a prominent place where he would see it every time he went in or out. A week later, Avery called me. He said, 'The design is beginning to grow on me.'"[20]

Corporate Identity 289

**Lawry's Seasoning
& Food Company**
1959

Salad dressing mixes
Tricolor packaging
reminiscent of national flags.
c. 1963

Seasoned Salt
1959

Salad dressings
Bottle and label design.
c. 1967

LAWRY'S

Saul's first major identity campaign was for Lawry's Seasoning & Food Company, based in Los Angeles. It was founded in the 1930s by Lawrence Frank (known as L.L.), who first created Lawry's Seasoned Salt in his garage and opened the popular Lawry's Prime Rib Restaurant.

His son, Richard, who became president in the late 1950s, had new ideas for expanding the product line, which had barely made a dent in the nation's giant food seasonings industry, and a conviction that the company needed a new look. Its trademark, originally designed for the restaurant, consisted of an English gentleman in a top hat and the name "Lawry's" in an old-fashioned script. When Frank asked his in-house advertising manager for advice, the man suggested a designer named Saul Bass.

Richard Frank recalled, "He came in with a pile of drawings and covered the walls of our conference room. Saul provided very careful explanations of what he had done. He went through everything and said, 'The best thing to do is use the letter "L" … and if the design is unique and distinctive enough it might do the trick.' Before he could make a specific recommendation, I said, 'Go no further, Number Two is the one.' It's a bull's-eye and a very powerful symbol. Now, you can't do that to Saul unless you hit on the right button, but it seems I did. He did a lot of work for us over the years, but the most important thing from our standpoint is that he took our main product, Seasoned Salt, the one with the greatest franchise, and made it a standout product. We had a lot of fun together over the years. He respected me and I respected him."[21]

Delivery truck
The new logo on delivery trucks telegraphed that the Seasoned Salt and other specialty products originated at the famous Lawry's restaurant.
1960

Corporate Identity 291

Doggy bag
Whimsical illustrations on the front and back made taking home leftovers a fun treat for "pooch" and for people.
c. 1965

Fiftieth anniversary logo
1988

An array of applications
(Opposite) Designs carried out over more than three decades.
1960–96

LAWRY'S 50

Saul's view was that, in a highly competitive marketing situation, this medium-sized company had to stand out visually and establish itself as innovative. The new design was the launching pad for a profusion of new seasonings. Since the budget did not cover designs for all of these new products, Saul incorporated a space in the label design for the name of each particular product. Saul continued to design all the company packaging thereafter, as well as graphics for the restaurant branch of the business, from exterior signs to menus and doggy bags. With Saul's help, the company established itself as a market leader in the U.S., and he acted as design consultant even after Liptons took over the company in the 1980s.

For Saul, this business relationship represented something new and important in his career. "It was a very telling experience for me. Suddenly, I'm making a design that becomes the lifeblood of a company."[22] At the outset, however, Saul's design was met with great skepticism on the part of L.L. Frank. He recalled, "It was only Richard who was very strong about the new identification, but he finally prevailed. A year or two later though, L.L. recognized that it was really working for them. His attitude was wonderful, because whenever I'd present another new element he would do his little number. He'd always grumble and mumble but then say, 'Well, all right, if that's what you want to do…'"[23]

Corporate Identity 293

In March 1961, after a five-month search, the Aluminum Company of America appointed Saul as graphic consultant with a view to revamping the company's public face. The company had already established itself as an industry leader, committed to imaginative development programs and adventurous advertising. The new symbol was unveiled in January 1963.

A company's vision is only as acute as that of its most clear-sighted executives. "Each one of those early programs," Saul said, "came about because of some idiosyncratic, especially imaginative force at work, some visionary within the company. At Alcoa it was a man named Lawrence Litchfield, who became their CEO."[24] Litchfield, in turn, saw Saul as a kindred spirit.

Early conversations between Saul and Litchfield focused on problems with the existing logo – a triangle inverted above another – designed only six years earlier by Harley Earl Associates, which had proved difficult to protect as a trademark. The company, as a producer of raw materials, had allowed its trademark to appear on its customers' products as well as its own. When those products proved shoddy or poorly designed, the Aluminum Company of America got the blame. Consequently, the integrity of its trademark was being steadily eroded. Saul's task was to offset this erosion of reputation against the equity remaining in the logo.

**Aluminum Company
of America (Alcoa)**
1963

**Graphic design manual
and special font**
(Opposite) A guide to the new logo and corporate identity system, including a custom Alcoa font.

Presentation
Saul with Alcoa's manager of design, Samuel L. Fahnestock.

**Graphic design manual
(interior spread)**
Introducing the objectives of the identity program.

Corporate Identity **295**

Proposed signage
mid-1960s

Brochure cover
This project was commissioned before the corporate identity campaign.
1959

Saul's recommendation was to acknowledge the reality of the situation by relinquishing the old mark entirely and designing a new one for the company's exclusive use. He devised a new emblem in which three diamonds combined to form a highly stylized letter "A" that suggested the sleek, modern precision of aluminum itself. In order to retain continuity, he incorporated the triangles of the original into the new symbol. It formed the basis of a corporate identity system, complete with its own typeface, design manuals and an opening sequence for sponsored television programs.[25]

But changing the trademark turned out to be only the beginning of an extensive program. Saul's influence also extended to what the company decided to call itself. The name "Aluminum Company of America" hardly seemed expressive of the company's reputation for being innovative and light on its feet.

"I suggested adopting the name Alcoa, among other recommendations, during a lunch with Lawrence Litchfield. At one point he turned to me and said, 'I agree and understand the need to do it, but I'm personally not comfortable with it.'

"He was an interesting and accomplished man, a man who could read and speak Sanskrit, and I took what he said very seriously. I told him very seriously that I thought it would not be inappropriate for his personal letterhead to carry the name Aluminum Company of America. And he said with equal seriousness, 'Thank you very much.'

"As one might guess, Litchfield soon developed a strong attachment to his company's new name and his stationery followed suit. The moral of the story: that corporate identity can carry deep meaning for those within a corporation, and it is not to be lightly changed or lightly shed."[26]

Alcoa Premiere
In this television opening sequence for an Alcoa sponsored anthology, abstract forms become an aluminum cityscape. As the camera sweeps up to an overhead view, the word Alcoa is revealed.
1963

Saul and Elaine
(Right and below) At work on the sequence.
c.1963

Corporate Identity

Annual Report
1962

298 Saul Bass

Hunt-Wesson Foods
1964

When Hunt Foods & Industries originally approached Saul it was not for a logo or a letterhead but rather to redesign an oil bottle (Hunt had merged with Wesson Oil Company in 1960). Four years later, when the company changed its name, Saul also created a new logo and identity program.

Wesson Oil bottle
(Opposite)
1960

Symbol applications
1964

Corporate Identity

In the early 1960s, Hunt Foods took over W.P. Fuller & Company, one of the oldest manufacturers of paint in the United States. Saul was asked to devise a new logo – an abstracted tin of paint and color spectrum, which was used on everything from brushes to stepladders to calendars. In collaboration with exhibit designer Herb Rosenthal, Saul also created signage for fifty Fuller home decorating centers. Sited outside one of the largest stores, three sixty-foot totemic pylons of painted aluminum, known as the Towers of Color, rotated in synchronized motion like giant medieval pennants. In addition, a thirty-four-foot-high sculpture, made out of eighty-one poles that ranged across the entire color spectrum, gave the corporate headquarters a more colorful public face.[27]

Fuller Paints
1963

Sculpture for Fuller Paints Corporate Headquarters
Sacramento, California
(Opposite, top) A series of vertical poles were painted with colors across the spectrum, creating a kinetic, shimmering effect when combined with the movement of the viewer.
1964

Towers of Color
Anaheim, California
(Opposite, and this page) These rotating sculptures were both signage and advertising, conveying the excitement and drama of color and paint.
1964

Presentation
Saul presenting a model of the proposed Towers of Color for Fuller home decorating centers.
1963

Corporate Identity 301

Ohio Blue Tip Matches
A division of Hunt Foods
(later Hunt-Wesson).
1963

Strike Anywhere matches
(Opposite) This classic package was found in millions of American households in the 1960s
1963

Matchbook sets
(Opposite and this page) A small selection from a wide array of patterns and motifs created for Ohio Blue Tip decorative matchbook sets.
c. 1963–65

Corporate Identity 303

306 Saul Bass

Corporate brochure
This brochure focused on the company's worldwide activities. The bold, innovative graphics portrayed the company as dynamic and forward looking.
1966

Corporate Identity 307

The brief Saul was given by Continental Airlines was "heralding the future." This energetic and growing company had undergone eight changes of image in the twenty-three years before Saul was commissioned in 1965 to mastermind yet another. The company operated in the American West and Southwest, but CEO Robert Six planned to incorporate the Pacific Far East within five to ten years.[30]

This was Saul's first corporate identity commission from an airline, although he and Elaine had made a film for United Air Lines in 1964. Saul went about the task methodically. He and his team took 1,500 color photographs related to the experience of traveling with Continental, from ticket purchase to point of arrival. They also examined the operations of major competitors before concluding that Continental "was in every respect an up-to-date airline, yet it looked as if it was out of another era. Its visual character had no relationship to its business character."[31] Saul told a journalist, "They were no longer emitting the signal that they were doing new things."[32]

The first recommendation was to abandon the existing golden bird logo. Saul explained, "Birds and bird-like forms are the most frequently used airline symbols. They are inherited from the early years of the airline industry, when flying like a bird was a wonderful notion indeed. But it's hardly the most appropriate symbol for a jet-age airline. The objective of the new Continental symbol was to capture the basic power thrust notion of the jet engine, as well as the airflow patterns of high-speed flight."[33]

The appropriateness of the design for future markets was also a major consideration. For ticket offices, waiting areas and company buildings, the color palette was China red, orange and gold. According to Saul, this combination triggered cultural references to the Far East and flagged the warmth with which the company was, and hoped to be, regarded.[34]

Continental Airlines
1967

Airplane graphics and other applications
(Opposite) The symbol captured both airflow and jet engine thrust imagery and combined it with an elegance that suggested warmth, high quality, precision and efficiency.

Presenting explorations and final designs

Corporate Identity 309

"On the old planes," Saul stated, "CONTINENTAL AIRLINES runs the length of the body, with the windows underneath, so that at a distance you can't tell which are letters and which are windows. The double gold stripe between the letters and the windows only serves to increase this messiness. In its place came a broad stripe of orange, red and gold that ran across the windows located in the middle of it; above the stripe and bookended toward the front of the plane by the logo and the American flag was the simplified name Continental."[35] The gold color swept up into the tail to form the "proud bird with the golden tail" that had been the focus of Continental's advertising for many years. The planes were, in effect, flying billboards delivering a new message about Continental Airlines.

This was one of Saul's most comprehensive identity programs to date. By 1967, more than 456 items had been designed or redesigned, including aircraft, baggage labels, china, glassware, flight bags, business cards, infant seats, overalls, pilot badges, napkins, airsickness bags and slippersox.

Comprehensive applications
A few of the hundreds of applications created. Gold was used for first class tableware.

Bell System
1969

Service truck
The new identity was applied to over 135,000 vehicles serving over 80 million customers in the U.S.

In 1968, when Saul was invited to update the corporate identity of the gargantuan Bell network of companies, it was the largest corporation in the world. It employed almost one million people and served one hundred million telephone lines. It had yearly sales approaching $100 billion and a fleet of vehicles almost as large as that of the U.S. Army. Although company stock sold under the name AT&T, it and its twenty-three operating companies were better known as the Bell System.[37]

At the time Saul became involved, the Bell companies, historically defined as a regulated monopoly, were already under investigation by the antitrust division of the U.S. Department of Justice. The parent company claimed that, in order to best serve the American public, it needed to function as an integrated unified telephone network, a claim undermined by the profusion of trademarks and corporate graphics.

Saul commented: "It's hard to admit you look old-fashioned, but in this case the evidence was overwhelming. In addition to the trademarks looking dated, their vehicles looked suspiciously like war surplus equipment and telephone directories were visually confusing. In short, it was a mess."[38]

Saul with staff members
In the midst of what was, at that time, one of the most extensive corporate identity programs ever undertaken.

Comprehensive applications
An enormous range of item and equipment designs were created, from letterheads, packaging, wallpaper and uniforms to graphics for a fleet of vehicles almost as large as that of the U.S. Army.

"Our work had two primary goals. First, to unify the disparate-looking Bell entities; second, to modernize the look of the corporation. With a more contemporary look, the Bell System might convey what it actually was, a source of state-of-the-art technology and an organization you'd like to work for."[39]

The overhaul was, at that time, the largest corporate identity project ever undertaken. It began with a bold modern bell set within a circle. Stripes were introduced into the identity campaign because of their contemporary associations with sports; they signaled a company that was competitive, dedicated, efficient and up-to-date. Saul saw the new identity as "Alert, crisp, strong, unified, enterprising – a new ring to the Bell."[40]

The Bass office designed an enormous range of items and equipment, from letterheads to vehicle livery, and from packaging and wallpaper for public offices to uniforms designed by Elaine. The size and scope of the project can also be gauged by the creation of a dozen manuals including one each for stationery, business forms, vehicles, signage, color specifications and telephone directories.[41]

316 Saul Bass

Corporate Identity 317

Graphic standards manuals
An initial set of seven manuals was created and then updated every few years to ensure consistent and high-quality graphics as new requirements arose.
1969

Television spot
Presenting the new bell, through state-of-the-art technology, using images created with pioneering computer techniques.
c. 1969

The go-ahead for implementation was given in 1969 and by the early 1970s the new logo had achieved a remarkable ninety-three percent recognition. More people knew it to be the telephone company logo than knew the name of the president of the United States. Saul stated, "They could now run ads signed with just the new bell and the phrase 'We Hear You' and everyone understood it was the phone company."[42]

Such market penetration owed much to both the design and the enormous publicity campaign that surrounded its introduction. Saul continued to consult on design matters until 1984, when AT&T, under pressure from the Department of Justice, divested itself of the Bell companies.

Looking back, Saul commented: "Of course we would have loved to stay involved with everyone. By the time of divestiture we had been working for AT&T and the Bell System for fifteen years. We had friends all over the place. But it was clear we couldn't. Everyone knew that the future meant competition. So, we were forced to make a decision. We cast our lot with AT&T."[43]

Corporate Identity 319

When Quaker Oats turned to Saul for a new visual identification in 1969, the company was more than a century old and enjoyed an abundance of goodwill. Company executives, however, felt that its trademark no longer served its needs.

Oatmeal products were the company's mainstay in 1877, when its Quaker Man, with long white hair, quiet smile and ruddy cheeks, became the first trademark for breakfast food registered in the United States. The company grew enormously in the 1950s, and by the late 1960s produced chemicals, needlecrafts and toys (it took over Fisher-Price in 1969), along with a host of food products from pancake mix to pet foods. This presented an enormous challenge: how to create an instantly recognizable, appropriately descriptive and aesthetically pleasing symbol for a business that was ever more diversified, abstract and difficult to define.

For Saul the necessity was clear: a mark that would connect with the Quaker Oats Company's wholesome, whole-grain reputation while also signaling its broad new product line. Another design firm

had recommended replacing the Quaker Man with an abstract letter "Q" but Quaker's management was uneasy about such a radical change. Saul agreed, "I reinforced their uneasiness. I felt that for them to give up the accessibility, the humanity and the particularity of the Quaker Man was a serious error. I myself have always striven for accessibility, more or less successfully, and the Quaker Man was, after all, something we'd all grown up with, something we'd seen at breakfast all through our childhood and youth. It was an icon that conveyed feelings of trust, integrity, comfort and dedication to quality."[44]

Saul recommended changing the name to Quaker for everything except the cereal product and having two symbols. Food products would retain a subtle redesign of the familiar man in Quaker-style hat, while for the company as a whole Saul created a more stylized version, which transformed the old gentleman into a modern icon. Both hark back to early American values of simplicity, honesty and simple living.

The Quaker Oats Company
1969

Old-fashioned Quaker Oats
(Opposite) Aside from a subtle update, the familiar oatmeal carton was kept the same.

Annual report cover
1975

Instant oatmeal packaging
These classic designs were in use for more than two decades. Saul also designed the Life cereal box featuring the word "Life" in a sunburst of bold, hot colors.
1972

Annual report cover
1970

Corporate Identity 321

**The Dixie Cup Company
(American Can Company)**
1969

Dixie cups
For several years after designing the logo, Saul created the packaging and graphics for Dixie disposable paper cups.
c. 1968–71

**Northern Tissue
(American Can Company)**
1968–69

Magazine ad and packaging
Saul created an identity through advertising and packaging for a variety of Northern paper products.

Corporate Identity 323

United Airlines
1974

Airplane graphics
At the heart of the new identity campaign was the "flying U" logo accompanied by the orange, red and blue stripes.

A seemingly insignificant issue brought Saul one of his biggest corporate identity commissions of the 1970s. Edward Carlson, the relatively new chairman of United Air Lines, disliked the random ways in which stripes were placed on the company's airplanes. Happily for Saul, Carlson mentioned it to a board member, Robert Stewart, who, as chairman of Quaker, had worked closely with Saul on its identity campaign.

Saul recalled, "I was in London during post-production on *Phase IV* but agreed to meet Ed Carlson to discuss the stripes. To me, this was like someone saying, 'I've got this large corporation and something funny is going on in the mail room.' It sounded more like the symptom than the disease. But troubleshooting has always been an important part of my work, and I'm used to hearing symptoms from clients who don't always define the problem in the most accurate terms. It was clear the stripes were part of a larger problem – the lack of any coherent point of view of what the airline should look like."[45]

"Through the years and changes of management, United Air Lines, one of the largest carriers in the world (second only to Aeroflot), had developed a muddy image. The stripes did indeed go every which way, and it wasn't just the stripes that were incoherent. From one airplane to another, the company identified itself with a slash on the tail and the word United running through it, a shield on the fuselage with United running through it, United as a single word in a gothic typescript, Air Lines as a two-word unit, United Air Lines as a three-word unit. As if to compound the visual clutter, the phrase 'The Friendship Line' appeared as a subtitle, and the names of aviation pioneers like Eddie Rickenbacker were inscribed on individual airplanes.

"When I proposed a study of possible solutions I said to Carlson, 'You may not choose to embrace these possibilities for economic reasons, or for political reasons because it would shake up your corporate culture too much. You may also not agree with me that the options I've identified represent real opportunities for you. But you owe it to yourself, as chief executive of the company, to understand how what you're doing fits into the potential of what can be done.'"[46]

Saul felt that the visual clutter was not simply a housekeeping issue; it directly impacted air travelers' most basic concern – safety. Therefore, it was vital for the new graphics to convey a reassuring sense of efficiency and technological sophistication. For the aircraft themselves, Saul acknowledged that stripes had become clichéd but nevertheless decided to retain them, albeit in a different configuration. He explained: "Before dismissing a cliché you have to ask why it was good in the first place. If you find that ingredient and figure out a way to refresh it, then you have something very effective. The original value of stripes lay in their ability to diminish the messy 'dots' created by the windows. And, more importantly, to convey a strong feeling of forward motion, reinforcing the aerodynamic look of the plane."[47]

Saul meeting with designers
Discussing conceptual directions for the symbol and its application to airplane graphics. (Left to right) Vahe Fattal, Vince Carra, Sharon LeClercq, Saul, Art Goodman, Mamoru Shimokochi and Mike Mills.

Corporate Identity 325

Logo applications
The identity campaign was applied to more than 1,800 categories of items from aircraft to food service material, from terminal facilities to boarding passes.

Advertisement
(Opposite) One of two posters introducing United's new corporate identity, this one featuring "the stripes."

326 Saul Bass

At the heart of the new identity campaign was the "flying U" logo based on the first letter of the company name. Saul further simplified United's visual signature by changing the name to United Airlines. Orange was added to the existing red and blue color scheme, partly to distinguish it from the red, white and blue of other airlines and partly to add a touch of warmth and punch. Further impact came from using a very bright white for the base color. Saul called it "Cape Canaveral white," and stated, "We were saying in effect that the plane should have the pristine, advanced look that people associate with the *Apollo* moon shots. They should look like pure projectiles."[48]

Over a three-year phased introduction, beginning in September 1974 (based on normal maintenance schedules to reduce the costs of conversion), the identity system was applied to more than 1,800 items. The only source of resistance came from the pilots' group who, to Carlson's consternation, refused to embrace the new logo. They wanted the wings on their uniforms to remain as they were. Saul understood the depth of their attachment and reassured Carlson that the identity program as a whole would not be compromised if the pilots did not wear the "flying U." A year or so later, Carlson was delighted to receive a letter from the head of the pilots' association asking why their wings had been left out of the corporate identity program.[49]

Corporate Identity 327

1939 1964 1969 1984

American Telephone & Telegraph Company
1984

MacNeil/Lehrer NewsHour television spot
(Opposite) Lines of light shoot across the screen and encircle the globe, symbolizing the international high-speed communications capabilities of the new global AT&T.
1984

After finally divesting itself of the Bell System, the company that came to be known as AT&T needed a corporate identity program, and it needed it fast. "Usually, when you do a giant corporate identity program," Saul commented, "it's more important to do it right than to do it fast, but in this situation the Justice Department had stipulated that AT&T could not use the Bell System name or mark beyond a specific date – about five months."[56] It was a major undertaking, not least because the company had no name at the time. At first the client favored the name American Bell and Saul devised an appropriate logo. The Department of Justice, however, ruled that the name was too similar and that any representation of a bell would cause confusion. The job of coming up with a name and a logo was given to Saul.

Discussing the campaign, Saul stated: "For the name we recommended AT&T, which was its stock designation on Wall Street. As a communication name it didn't have much purchase, but it at least had awareness in the financial community and we felt it was better than some totally new name. It was an opportunity to signal the international scope of AT&T because their vision at that time was that the company was going to be a global communications player.

"It was this viewpoint that led to the current symbol. When I've been asked to describe the meaning of the new AT&T mark, I've said it described the world girdled by information. Little did I know when I said that ten years ago that the 'Information Superhighway' would become the buzzword of the 1990s."[57]

The Choo-choo Train

Charlie Brown was the Chairman of AT&T during all the planning for divestiture. There was considerable discussion within AT&T about what sort of fundamental identity strategy the new AT&T would follow. One day Ed Block asked Herb Yager and I to join him and Hal Burlinghame in discussing the major strategic alternatives with Charlie.

Charlie said, "Alright, but make it simple – I have a short attention span." I drew two diagrams. One was a series of rectangular boxes. In each, I wrote a different letter of the alphabet. This represents one sort of identification system, I explained. Each business rises or falls on its own merits. It's sort of like General Foods with Jello, Maxwell House and Post Cereals. Each brand is pretty much on its own.

Then I drew another series of boxes, this time with no letters. I added a slightly larger box to the front of the series and connected it to the other boxes with a line. Inside the larger box, I wrote "AT&T." In this system, the AT&T engine pulls the entire train. Cars get added or subtracted but the engine keeps chugging away. Everyone benefits from supporting the powerful engine.

"I like the choo-choo train," said Charlie. The meeting was over.[58]

Corporate Identity 331

Uniforms and vehicles
(Top right) Saul refining the vehicle stripes.
1983

Television tag that aired during the Olympic Games
The AT&T symbol coalesces in the central Olympic ring, symbolizing the company's role as a key sponsor of the games.
1988

Saul didn't expect the public to immediately understand the new logo's symbolism. So, when AT&T commissioned him to create animated tags to punctuate their television commercials, he took advantage of the opportunity by amplifying the meaning inherent in the symbol. One tag shows a field of abstract but recognizable bits of information flowing toward and wrapping itself around the globe. Another version was created to accompany the *MacNeil/Lehrer NewsHour*. Each of these tags reinforced the metamorphosis of a gargantuan national phone company into a global communications giant. The new symbol achieved rapid recognition. After only two years in circulation, recognition stood at seventy-six percent.

Edward Block, then chief marketing executive, commented, "The enormous value of Saul's design was how it built some kind of franchise around a company that was only known on Wall Street. The consumer had never bought anything from AT&T, had never seen any reference to it on a package. As a matter of policy, the local phone company had always been our public face. So a strong graphic system was immeasurably significant in a short period of time."[59]

332 Saul Bass

AT&T television commercials
Moving graphics are an opportunity to reveal more about a company. These two TV tags are from a series that expanded upon the idea of global communications. mid-1980s

Following spread:
Moving graphics
Bell System (1969), Hanna-Barbera (1979), Geffen (1981), Kibun (1984), General Foods (1984) and National Film Registry (1989).

Corporate Identity 333

Nevada Bell		
Mountain Bell		
Illinois Bell		
Bell Labs		
Bell System	Hanna-Barbera	A GEFFEN FILM

KIBUN

GENERAL FOODS

NATIONAL FILM
REGISTRY

Girl Scouts of America
1978

"We found a new world…"
(Above) These cookie boxes offered glimpses of the "worlds" that could be explored through scouting.
1982

Poster
Announcing the new trademark.
1978

The commission to modernize the image of the Girl Scouts of America grew out of redesigning Girl Scouts cookie boxes for the Burry division of Quaker. Saul regarded seventy million boxes mostly sold door to door to homes across the country as a marvelous opportunity to communicate the fun, self-reliance and self-realization of scouting to parents and girls alike. The cookie boxes were a resounding success – so much so that the Girl Scouts subsequently hired Saul to update the organization's symbol.[60]

The experience touched Saul deeply. He admired the determination of its leaders to make explicit that scouting for girls was not a pale version of scouting for boys, was open to girls of diverse cultures and colors, and sought to help shape the "new women" of the future. The stylized profiles of the new symbol were an emphatic statement about diversity and difference, on the one hand, and unity on the other. The impact of the Women's Liberation Movement is evident in this and other images that presented girls as active, learning and united in sisterhood.

336 Saul Bass

Frances Hesselbein, then executive director of the organization, recalls, "Saul became a historian and a sociologist, as well as a communicator, as he plunged into research. He went back to 1912 to understand the origins of the movement.

"He interviewed us and talked with the leadership, both volunteer and staff, until he had absorbed the culture of the organization. He understood the importance of the trefoil and eagle pin – handed down from mother to daughter, sometimes over generations. He understood its spiritual and emotional basis, the very powerful ties we had with the past. We wanted to carry the best of our traditions into the future, and Saul understood that perfectly too. When he redesigned the pin he preserved the trefoil, but now there were profiles of three girls who were clearly of different races. When you looked at that pin it said, 'this is a contemporary program, a diverse program, these girls are facing the future.'

"I suggested he present the new identity to our triennial conference in Denver. He gave his rationale for the change and described the redesign process with the most wonderful graphics and slides. Halfway through his presentation he was a member of the family. It was one of the loveliest moments for me because this was not a stranger making a business presentation, this was a warm and trusted friend."[61]

Although many of the 10,000 adult delegates had strong emotional attachments to the existing symbol, Saul's commitment and sincerity won them over. Saul recalled, "It was electrifying for me personally. They began applauding everything I showed them, even the options that I would identify a moment later as ones we'd rejected. After the standing ovation, I was thronged; if they could have put me on their shoulders they would have. As I went through the crowd, one young woman came up to me and asked, 'Do I have to give up this pin? It came down to me from my mother and grandmother.' I looked at her, and said, 'No, absolutely not, we will be offering the new pin to those who are comfortable with it. But those who'd rather retain the old pin will absolutely have the right to do so.'"[62]

When the results were tracked after a year or so, however, the new pins had been accepted into everyday use.[63]

"I'm a Girl Scout…"
(Above, left) These cookie boxes profiled individual Girl Scouts and shared what scouting meant to them.
1976

"I'm not like anyone else… We have a lot in common"
(Above) Cookie boxes celebrating both individual uniqueness and the common bond shared through scouting.
1979

Corporate Identity 337

BOYS CLUBS OF AMERICA

Boys Clubs of America
The symbol shows the strength of hands clasped in solidarity.
1980

After the success of Saul's designs for the Girl Scouts, he was approached by both the Boys Clubs of America and the YWCA. At the time Saul was brought onboard, the Boys Clubs were opening up to girls, somewhat reluctantly in certain places, and therefore needed a logo that was not gender-specific. The mission of the Boys Clubs of America, founded in 1860, was "to enable all young people, especially those who need us most, to reach their full potential as productive, caring, responsible citizens." Saul described the new symbol as, "visualizing the primary commitment of Boys Clubs of America: connection," implying not only the guiding or helping hand of an adult but also the hands of club members clasped in solidarity and connected across race, age and eventually also gender. The name was changed to Boys & Girls Clubs of America in 1990.[64]

YWCA
A strong, uplifting symbol for
an organization which supports
and empowers girls.
1988

In 1988, the leadership of the YWCA, founded in New York in 1858, felt that its somewhat fuddy-duddy image did not accurately reflect the organization's aims and activities. For Saul, the aim was to portray the YWCA as a dynamic force among young women's groups, one that had recently placed greater emphasis on feminist issues such as girls' empowerment, and wider social issues such as civil rights and racism. The new logo announced the YWCA as an organization as strong as a tree, as vibrant as a beam of light and as hopeful as a sunrise.[65]

Corporate Identity 339

THE J. PAUL GETTY MUSEUM

The J. Paul Getty Museum
1981

Getty font
A special font was created with both a modern and classical sensibility.

The J. Paul Getty Museum
Malibu, California
The identity campaign had to be contemporary but also appropriate to the classical context of the museum building – a recreation of the Villa of Papyri at Herculaneum.

Saul's involvement with the J. Paul Getty Museum in Malibu and the J. Paul Getty Trust came about through one of his earliest and most loyal patrons, Harold Williams. When Williams became President of the J. Paul Getty Trust in 1981, he was well aware of the mounting apprehension within the art world after J. Paul Getty had bequeathed in excess of a billion dollars, and the Trust had become legally obliged to spend tens of millions of dollars a year in order to preserve its nonprofit status. The Getty Museum could potentially outbid every other museum and collector in the world, and Saul was hired to engender trust and visually convey the institution's good intentions.[66]

Williams commented, "Saul had consistently demonstrated his ability to understand objectives and achieve them with a strong aesthetic sense, and I was confident that he could handle this difficult challenge. He developed an elegant new Getty font that spoke in a restrained quiet voice of timeless dignity. It underlined the seriousness of our intent to act responsibly and to foster serious scholarship. There's an elegance to his artistry, but also a simplicity and a modesty."[67]

340 Saul Bass

The J. Paul Getty Trust
1993

The Getty Center
Los Angeles, California
The logo refers to the five main departments of the Getty and the contrast of Richard Meier's white buildings against the blue California sky.

Just over a decade later, the J. Paul Getty Trust reenlisted Saul's help. Williams takes up the story: "The moment seemed right to re-present the Trust. We had ambitious plans, including a new site that would allow us not only to display the collection but also to pay greater attention to scholarship, conservation, education and public outreach, but lacked a unifying visual identity. In other words, we asked for an identity campaign in much the same way as a large commercial company would. We wanted to raise the institution's profile significantly but discreetly and alter the perception of the Getty to that of a cultural enabler as opposed to a controlling bureaucracy."[68]

The large number of potential logos and typefaces, each in a variety of colors, to say nothing of the variations and permutations, bear out the protracted but open nature of the discussions. In the final version of the logo, the separate letters not only spell out a single word that has come to stand for a major cultural institution, but also symbolize the different institutes and departments within it. Elegant crisp white letters are beautifully held in balance and space within a blue field. The refinement of the Zen-like design is tempered by the offsetting of letters of differing sizes and the slicing away of edges.[69]

Saul had found an appropriate solution to Williams's request for a common visual identity that would acknowledge the disparate elements within a unique and relatively new entity at a particularly transformative moment in its evolution.

Corporate Identity 341

私は、このマークに
ユナイテッドの願いをこめた。

United Airlines ad in Japan
Saul is quoted here as saying "The higher the density of my thinking, the higher becomes the density of my designs." He had such high stature in Japan at this time that United Airlines ran this full-spread, color newspaper ad focusing on Saul and their connection with him. The headline says "Good designs have wings" and goes on to say that some people describe Saul Bass "as a God of CI (corporate identity)."
1989

**World Design Conference
Tokyo, Japan**
Saul, co-chair of the American delegation, talking with Seiji Chihara of Dentsu advertising agency.
1960

Keio Department Store
Wrapping paper for a Tokyo department store.
1964

Ajinomoto presentation
1972

Saul and Kenji Maeda
(Opposite) Both Saul and the president of Maeda appear in this ad announcing the company's new trademark.
1991

Design for Japanese Companies

Saul's work was much admired in Japan from the mid-1950s. Indeed, it sat so well within Japanese design traditions that someone joked that if the Japanese Rising Sun flag had not already existed then Saul would have designed it.[70] Between the early 1960s and his death in 1996, Saul undertook many commissions for Japanese clients, beginning with packaging but moving fairly quickly into identity graphics.

Japanese interest in American design and business management was part of a wider process of Westernization dating back to the nineteenth century. In the years after World War II, U.S. aid, military personnel and Hollywood films brought about an increasing awareness of America, American design and the new consumer lifestyles.[71] Among the greatest visual impact were films, including those with title sequences by Saul. By 1960, when he co-chaired the American delegation to the World Design Conference in Tokyo, Saul was already well known and highly regarded in Japan. Indeed, he was mobbed by fans and reporters as he arrived at Tokyo's Haneda Airport.[72]

Saul visited Japan again two years later, probably in relation to his first Japanese commission – wrapping paper for the Keio Department Store in Shinjuku, then a new center of Tokyo. The 1964 advertisements announcing the store opening and a new look based on the wrapping paper featured a photograph of Saul. The text reminded readers that he was the famous American designer of the titles for *Bonjour Tristesse*, *West Side Story* and *Around the World in Eighty Days*.[73] About the same time, he was commissioned to create a commercial to be shown on American television. The client was Bridgestone Tires, a Japanese company aiming to expand its share of the U.S. market.

The mid-1960s saw a new approach to corporate identity in Japan. For example, TDK (Tokyo Denki Kagaku Kogyo) was the first Japanese firm to adopt Western letters as a name and logo and to compile a manual of standards for its application. The early to mid-1970s saw several companies, including Ajinomoto, which commissioned Saul

344 Saul Bass

in 1973, reassessing their corporate identity and, in 1975, Mazda undertook the type of systematic evaluation of managerial strategy and tactics in conjunction with design policy that would distinguish Japanese corporate identity.[74]

Such a systematic and holistic approach to design fitted in extremely well with Saul's own approach. In 1978, the newly named Bass/Yager & Associates (Herb Yager had become Saul's business partner that year) entered into an agreement with Takahiro Yamaguchi, President of the Tokyo-based market research consultancy ODS, to act as its agent in Japan.[75] After his extensive identity program for Minolta in 1981, Saul became extremely well known there as a corporate identity designer, and by the early 1990s he undertook more corporate identity commissions in Japan than in the U.S.[76]

Saul found working in Japan extremely rewarding, but remained slightly bemused by his status there as a design guru. He experienced in Japan not only a greater connectedness between company and executives but also a greater striving for what he described as "spiritual value." He likened the Japanese businessmen he worked with to many of the American entrepreneurs of the 1950s and 1960s – men who were either founding CEOs or from the next generation of the same family.[77]

In 1995, Saul commented, "Historically, companies were started by people who invented something or who created a set of circumstances that made a company fly. They were visionaries, entrepreneurs, persons of great imagination, and also, very significantly, they were risk-takers.

"Today in the United States we have a managerial society in which heads of companies seldom play that role. Typically, they run a company that already exists. It's a creative role, but a transient one. Many Japanese companies, however, are still in the state that American companies were thirty years ago. The original entrepreneur of a Japanese company may have died, or become emeritus, but power still resides in the family. Continuity still exists. And, more frequently than not, the managers of companies in Japan today still come out of the entrepreneurial mode. They share the original vision; they're part of the founder philosophy.

"What is really interesting about Japanese clients from my own perspective is that no matter how practical they might be, and how focused on marketing objectives, or on communicating the things their company is trying to accomplish, they're not satisfied if what you are doing lacks a poetic level. They are not happy if you can't add a certain aspect of aspiration into the process. And this is not a hard thing to do. It's lovely. It's just lovely."[78]

Corporate Identity 345

AJINOMOTO

Ajinomoto
1973

**Packaging, symbols
and gift boxes**

Saul's first major commission in Japan was prompted by the Japanese custom of giving food and food products as gifts. Ajinomoto, a well-known food processing and distribution company, wanted Saul to create a new logo, a gift box and related packaging. Since packaging was a field in which Japan was world-renowned, Saul felt especially honored to be given this project.[79]

Two related identification marks were developed, one for corporate use and the other for packaging. The success of the gift box and related wrapping materials led to the redesign of all major product packages, such as oils, margarine and seasonings.

Corporate Identity 347

In 1978, at the time of its fiftieth anniversary, the Minolta Camera Company was a producer of a wide range of opto-electronics, not just cameras, exporting about eighty percent of its products. It was decided, therefore, to generate a new corporate identity program, but only after a reappraisal of aims and objectives. These were expressed as: "A desire to create high-quality instruments which handle and process light, to consolidate the utility of the visual and to create a spiritual richness by enhancing the quality and expanding the scope of visual information; and, in order to do so, to acquire the most advanced technologies as early as possible, while co-existing in harmony with others in international society."[80]

Company President, Hideo Tashima, understood that to create a symbol and identity campaign that reflected such a mission would not be easy. It was decided to bypass advertising agencies and appoint "a top-ranking artist who shared Minolta's concepts and ideas, and who could be trusted to create a 'sympathetic' design entirely in tune with management's feelings."[81] In 1980, after a lengthy selection process, Bass/Yager Associates was given the commission on the strength of Saul's reputation as an imaginative designer.[82]

The result was one of the most successful logos of the late twentieth century. However, Saul never forgot a particularly sticky moment early on during a visit to the company's Osaka headquarters: "Although his son, the President of the company, had initiated the corporate identity program, the Chairman and retired founder, Kazuo Tashima, remained skeptical of such fancy new ways.

"During the initial consultation process, he listened to my proposals in stony silence. At one point when I was speaking, Mr. Tashima plucked a miniaturized Minolta camera from its display stand, and said 'Gentlemen, we have a very small product. There is hardly enough room on it for a name, let alone a symbol!'

"I paused a moment. 'Mr. Tashima,' I said, 'your company has a perfectly symmetrical name – three letters on each side of a circle – and the circle is the perfect place for a symbol.' I then reached over and took Herb [Yager]'s pipe out of his hand; it was a Dunhill pipe. I pointed to the traditional white Dunhill dot and said, 'This is what you need – a magic dot.' That did it. From then on the old lion was intrigued."[83]

Minolta Camera Company
1981

Television tag, camera and packaging
For extremely small sizes where close, fine lines would bleed together, two specially altered versions of the symbol were created which, when reproduced at the appropriate scale, looked identical to the larger-sized version.

Building on that moment of inspiration, Saul designed a luminous blue trademark that evoked rays of light refracted through a lens. He kept in mind the company's desire for "something poetic and spiritual," and decided "to use the metaphor of light – as the origin of all visual information – to express Minolta's pursuit of excellence in the visual field."[84]

In his 250-slide presentation, Saul argued the case for this blue luminous form that was not quite a circle, not quite an oval, readily read as a globe, and expressed concern for innovation, the cosmos and Minolta's mission statement about international harmony and cooperation. The company was delighted with this all-embracing logo, which worked well on its own and as part of the company name. The extensive corporate identity campaign, of which it was a key part, was launched in 1981.[85]

Kibun Foods
1984

Gift boxes
Four elegant boxes, each using the logo in a different way.

Kibun Foods, a company that concentrated on traditional fish-based products, asked Saul to redesign its image. After discussions within the company, Saul concluded that an internationally accessible symbol was necessary if the company was going to compete successfully in world markets. At the same time, he deemed it important to convey some of the traditional Japanese characteristics of the company.

Saul decided against any direct reference to fish and created a symbol based on readily recognizable shapes: the heart and the flower. "We developed this notion of three hearts, or the 'heart flower,'" said Saul. "It's hard to deal with hearts and not be corny, because the last thing anyone wanted was Hallmark hearts, but this goes back to the issue of clichés and their power. What we looked for was something that evoked the power of the heart but that was fresh enough to transcend the banality of the cliché."[86] In the television tag, a single red heart transforms into a multicolored, multipetal flower that gradually reduces to a trefoil and finally forms the Kibun symbol.

Recalling the Kibun commission, Saul commented, "Every corporate program functions on two levels: external communication and internal understanding, cohesion and morale. This latter function is particularly important to Japanese companies, with their commitment to long-term employment. We presented the Kibun trademark just before the New Year, when the Japanese traditionally visit relatives and family all over the country. In this case, everyone involved stayed in Tokyo for the presentation. There must have been three or four thousand people in a huge room. The meeting was chaired by the CEO who gave an extraordinary, emotional speech in which he reaffirmed his obligation to his employees, and gave his apologies for perhaps not having fulfilled all their needs."[87]

Kosé
1991

Packaging and store graphics
An international cosmetics and skincare company based in Japan.

Corporate Identity 351

Maeda Construction Company
1991

Construction graphics
Bold graphics help advertise the company and its commitment to and respect for the environment.

Impressed by Saul's body of work and reputation for innovative design, Kenji Maeda, CEO and son of the founder of the Maeda Construction Company, asked Saul to create a new corporate identity program in 1990. The catalyst was the company's move from heavy industrial construction, including hydro-electric plants, to upscale office buildings. Maeda also conveyed his desire for the image to convey the company's respect and concern for the environment.

Saul's new squared-off trademark – a rising green globe beneath a puff of fair-weather clouds in an M-shaped azure sky – announced that this company built big things, but it also suggested cleanliness, spaciousness and grace.

Saul recollected, "After I presented my proposal, I was somewhat perplexed when Maeda admired it a lot but did not give me an immediate go-ahead. I knew my work was strong. What I didn't know, and didn't understand until later, was that it was inappropriate and disrespectful for Mr. Maeda to respond until he had shown the proposals to his father, who still played an emeritus role in the corporation. Not until an hour before my departure for Los Angeles did Mr. Maeda call to say that his father had seen the proposal. He was happy with what he saw and wanted me to know that the company was ready to go ahead with the new corporate identity program."[88]

Kenji Maeda later recalled, "Just meeting Mr. Bass so impressed me with his dynamic personality and charm that I resolved to leave everything to him. Having quickly grasped an overall picture of our firm – its history, frame of mind, vision – he went to work, and presented us with a superb herald, one we call 'Celestial Horizon.' Delighted with what Mr. Bass had done, I raised the new logo high as a banner for the entire Maeda Group, one which symbolizes our ongoing hope for the future."[89]

Corporate Identity 353

One of Saul's last commissions in Japan came after a merger resulting in the newly formed Japan Energy Corporation. The company was not a market leader, but, in a relatively static marketplace, it wanted to draw attention to its growing reputation for creativity.

After discussions with CEO Kazushige Nagashima and key staff members, the main aims of the company were narrowed down to a desire to sell gasoline and be sensitive to the environment at the same time. The logo, which Saul called "Heaven and Earth," married two pure geometric forms in tension and balance, an appropriate metaphor for the duality of the company's goals.

The new identity program was applied to a wide range of items, from state-of-the-art service stations and trucks to employee uniforms and product packaging. JOMO was keen to establish a uniform identity across its network of 6,400 service stations. The Bass office-designed stations were launched in April of 1994, and by the end of that year surveys rated JOMO stations more highly than any others in Japan.[90]

Japan Energy Corporation
1994

Saul in Japan
Visiting a newly opened amusement park featuring miniatures of important historic and contemporary architecture. Saul plays Godzilla and 'conquers' an Exxon gasoline station, the full-scale version of which he had designed thirteen years earlier.
1993

Romanticism vs Pragmatism

During my first week of working on this project in Japan, I was just getting to know key personnel when the company head, Kazushige Nagashima, hosted a dinner party for myself and Elaine to meet JOMO executives and their wives.

During dinner one of the executives asked, "What was your impression of Mr. Nagashima?"

"Well," I replied with a glance in Mr. Nagashima's direction, "I found Mr. Nagashima to be a curious mixture of romanticist and pragmatist, in exactly what proportions I'm still trying to find out."

This elicited nods of agreement from Mr. Nagashima and his colleagues. It also prompted the rest of the diners to rate themselves on a scale of romanticism vs pragmatism. Once that was done, the men were rated by their wives, who next rated themselves, and who were rated in turn by their husbands.

When it came to me, I simply smiled and said that I could not possibly participate because if word ever got out that I was more pragmatist than romanticist my reputation would be ruined.[91]

Saul's experience in service station design went back to 1978, when he began working for the corporation known as Exxon in the United States and Esso elsewhere. Had the initial Exxon/Esso brief been to design service stations from scratch, the Bass office may well not have been selected, because Saul was known primarily for graphic design and filmmaking. However, the commission was to study the company's worldwide chain of 30,000 stations in 100 countries with a view to suggesting improvements.[92]

In the mid-1970s, following the OPEC oil embargo, the selling climate grew fiercely competitive, and gas station operators introduced such innovations as convenience stores and self-service pumps. One consequence was "visual clutter," what Saul described as a cacophony of discount banners, revolving placards, competing signage and used-car-lot-style decorations.

There was no desire for radical change within the company, but after intensive research (Saul and his team traveled over a quarter of a million miles and took 19,000 photographs of gas stations), Saul concluded that the best way forward was a complete redesign. First he had to persuade the company executives of this; then he had to persuade them that his firm could carry it out.

Saul pointed out, "When a new gas station is designed, it's done by architects. And typically, after the architecture exists, a graphic design company will be hired. Our position was that this was putting the cart before the horse. A service station is really a retail store and should be conceived as such. From an architectural point of view it's not complex – not a cathedral, or even multilevel. Usually it's just a rectangle that accommodates a few simple functions. It's an office and/or a store and/or service bay. So we said, look, if this is a retail marketing structure, let marketing specialists like us design it and then we'll bring the architects in to make sure it doesn't fall down."[93]

In the context of rising oil prices, the company did not want to be seen as wasting money on new edifices. It was decided therefore that Saul would not attempt to rival the best service station designs of the past, such as the Mobil stations reimagined by Eliot Noyes in conjunction with Chermayeff & Geismar in the 1960s, but rather provide new stations at the current cost of existing ones and to save money in the long term by devising a highly flexible modular system – a kit of parts that could be assembled in whatever configuration was needed. Strong, clean-lined architecture was reinforced by a crisp, clear graphics system – white borders, black frames and colored fields – to create a clean, coherent look.[94]

Corporate Identity 355

Exxon/Esso
1980

Exxon service station
(Above, right) For both the Exxon and Esso stations, strong, clean-lined architecture was combined with a flexible modular system that could be assembled in whatever configuration was necessary.

Station prototypes
To test the design, full-sized prototypes of the final stations were created.

The final design task was to create replicas of what the final stations would look like – one for the Exxon brand and one for the Esso brand. The site selected was a ranch in Newhall, a rural area north of Los Angeles. As a convention of local cows watched impassively in the blazing sun, earthmovers tore into the arid topsoil, followed by an asphalt crew, who laid out a short road where none had run before. On the side of the road arose two red-and-blue structures that were essentially movie sets, inasmuch as no gasoline could flow from their pumps at any price, but they looked like brand-new service stations beckoning brightly to passersby.

Finally, up the desolate country road came a caravan of buses carrying a committee of Exxon executives who had traveled from all over the world. While they strolled and stared, one of Saul's people climbed into his Jeep, drove into the Esso station, pulled up to an island, unscrewed his gas tank cap and stuck a prop nozzle in the filler neck. It was a good joke but wasn't needed. The delegation approved the design.[95]

Erected all over the world, the stations were cited in *Time* magazine as one of the ten best "good-looking objects that work" in 1981.[96] Exxon later reported that the program had cost only marginally more than past refurbishings and that, when the first new stations went into operation (in Japan), there was a twenty percent increase in business.[97]

Saul's next service station project was for Standard Oil of Ohio, where company executives had noted the success story at Exxon, a former branch of Standard Oil. A group of Bass office staff, led by Saul, spent six months studying this substantial company, which sold oil under eight different brand

356 Saul Bass

Exxon/Esso graphic standards manual
Pages from this comprehensive guide to the new flexible modular system.

names and owned stations across the United States, many of which did not bear the company name. They concluded that there was a clear need for a unified national identity program, even before the company acquired another 400 stations from Gulf in 1985. Saul suggested a shorter, snappier name – Sohio.[98]

The station design was bold, clean and uncluttered. A distinguishing feature was the bull-nosed fascia. The kiosk and pump columns also shared this streamlined aesthetic. The decluttering of the forecourt was largely achieved by reducing and containing the amount of graphics, and by the integration of gas pumps and other products into the canopy support columns.[99]

In 1988, just as the first red, white and blue stations were being rolled out, British Petroleum acquired Standard Oil. The name changed to BP America, and the color scheme changed to accommodate the BP green. What had begun as a regional project was now an international one.[100] Thus, by the late 1980s, the Bass office had built up a considerable reputation as designers of service stations. It was the last new field that Saul, the most versatile of designers, was to enter in his long and illustrious career.

Sohio and BP
Service stations
1988

Corporate Identity 357

7

Personal Handwriting

... a postscript

Some years ago I was asked, 'When you were a kid what did you want to be when you grew up?' Back then I thought the answer I gave was funny. I said, "Saul Bass." It was no joke.[1]

Saul Bass

Self-portrait
(Opposite) Created for a
Strathmore Paper promotion.
1991

Saul close-up
(Above)
c. 1990

Stomu Yamashta
Album cover (front and back)
for a Japanese percussionist
and composer.
1973

Directors Guild of America
Fifty year anniversary poster.
1986

Saul used the term "personal handwriting" to refer to a certain category of work, mostly posters, where he was free to create and explore images and ideas on his own terms. This work was often for clients, such as film festivals or cultural institutions, who did not interfere, largely because the commissions were pro bono (carried out voluntarily and without payment), but also because they were grateful to have a poster by Saul. Such was also the case with work for causes and organizations with whose aims Saul sympathized – for example Human Rights Watch or the Special Olympics. Looking at these posters, we see Saul playing around with a theme, an idea, a form or a palette; sometimes over a very short period, and sometimes over a period of years.

360 Saul Bass

Filmex
Los Angeles, California
1985

United States Film Festival
Park City, Utah
1988

10th Chicago International Film Festival

November 8-21

10th Chicago International Film Festival
1974

20th Chicago International Film Festival
1984

30th Chicago International Film Festival
1994

Personal Handwriting **365**

Los Angeles International Film Exposition, Filmex
Hollywood, California
1981

Fifth Israel Film Festival in the USA
New York and Los Angeles
1988

Personal Handwriting 367

63rd Annual Academy Awards
1991

65th–68th Annual Academy Awards
(Opposite, clockwise)
1993, 1995, 1994 and 1996

368 Saul Bass

Personal Handwriting 369

370 Saul Bass

Games of the XXIIIrd Olympiad
Los Angeles, California
1984

UCLA Extension course catalog
Los Angeles, California
1987

75th Year Anniversary, UCLA Extension course catalog
Los Angeles, California
1993

Personal Handwriting

Human Rights Watch Film Festival
New York, New York
1988

Human Rights 1789–1989
Commissioned by Artis 89, to celebrate the Bicentennial of the French Revolution "Images Internationales pour les Droits et du Citoyen."
1989

Personal Handwriting **373**

AIGA–50 YEARS OF AMERICAN GRAPHIC ARTS

American Institute of Graphic Arts (AIGA)
Fiftieth anniversary
1974

American Institute of Graphic Arts (AIGA)
Design annual cover
1981

374 Saul Bass

Freedom of the Press
Cover for a government pamphlet commissioned by the American Civil Liberties Union (ACLU).
1973

Ameryka
Cover for a U.S. government cultural exchange publication distributed in the USSR. The magazine featured the work of leading U.S. artists, photographers and writers, from Ben Shahn to Norman Mailer.
c. 1968

Personal Handwriting 375

Harper Collins textbook Psychology
Three in a series of posters exploring the landscapes of the psyche created for a psychology textbook. The designs above were used for the chapter dividers and the design opposite was used on the cover.
1993

PSYCHOLOGY

Third Edition / Harper Collins

Carole Wade & Carol Tavris

**The Music Center
Unified Fund**
1979

**Sinfonia Varsovia
World Tour**
1987

The Music Center Unified Fund:

*Los Angeles Philharmonic
The Center Theatre Group
Los Angeles Master Chorale
The Music Center Opera
Association*

LET ME WIN. BUT IF I CANNOT WIN, LET ME BE BRAVE IN THE ATTEMPT

SPECIAL OLYMPICS

1989 INTERNATIONAL WINTER GAMES

Special Olympics
Poster featuring the new symbol designed by Saul.
1989

Watercolor/stamp collages
Created for Mitsukoshi Department Store in Japan.
1988

Saul's "personal handwriting" extended to many other areas, ranging from photography and doodles to the collecting of artifacts and his involvement in the annual Aspen Design Conference.

Saul spoke of "an emotional need for direct contact with a surface," adding "I like to feel the pencil's abrasion, or the brush's slither. It's where I started, and what I need to come back to periodically: a free and open area of expression."[2] Well-sharpened pencils and his favorite pens were among the few tools on his desk, always carefully placed near a clean pad of paper.

Saul also took hundreds of photographs, usually when traveling, as a sort of sketchbook or diary of images. For him, these "frozen moments" were both document and source of inspiration. Some were taken to capture an idea or an insight, others to record an image, a new way of seeing an everyday object or as a study in light, texture and pattern.

An habitual doodler, Saul's were mostly done while on the telephone, on vacation or during conferences. His doodles included lettering and abstract forms, as well as sketches of people, places and imaginary landscapes. Many doodles were done at the Aspen Design Conferences – of fellow board members and speakers, from Lou Dorfsman to Peter Reyner Banham. Doodles aside, Aspen, the debates and the people were all important sources of creative energy for Saul.

So too were the artifacts that Saul and Elaine collected. Originating from ancient or "pre-industrial" societies, they were mostly Native American but also Pre-Columbian, African, Middle Eastern, Greek and Roman. To them, such objects were carriers of myths and meanings: at once knowable and unknowable, material yet mysterious. Saul surrounded himself with them in his office and at home because he thought that, in addition to their intrinsic beauty, they brought "a special kind of mystery – a quality of the unknown that reaches the very deep and hidden place," and showed how, despite working within particular traditions, conventions and forms, each was unique. For him and Elaine, the creators of these objects were kindred spirits.[3]

In the following pages, Saul's voice is interwoven with images of this more personal material. His comments are from conversations, interviews and lectures, and range from subjects such as creativity, work and process to his passions outside of work and his thoughts about retirement. In essence, they give Saul the final word.

Personal Handwriting **381**

Saul in his office
c. 1968

Sketch / doodle
1970s

On Creativity

It seems to me that the creative process is one that reexamines those things we already know and understand, and forces us to reconsider them, usually involving new insight to [sic] their nature. The creative act then is an act that transforms the ordinary into the extraordinary.[4]

Interesting things happen when the creative impulse is cultivated with curiosity, freedom and intensity.[5]

A good part of creative work consists of unconscious activity. There are certain capacities a designer must have. He has to be able, at will, to enter the world of fantasy and to leave it too. If one can't, that's trouble. Having entered and exited, and having lived out a disciplined experience in this world, the creative person must edit his experience and apply it to the issue at hand.[6]

What makes the creative person different? I think it is the capacity to manipulate reality without inhibitions, to manipulate the environment, and use observation as a base for imagination.[7]

Sometimes when an idea flashes, you distrust it because it seems too easy. You qualify it with all kinds of evasive phrases because you're timid about it. But often, this turns out to be the best idea of all.[8]

On Collaborating with Elaine

It's a total collaboration… We do everything together, so we're in a lock-step throughout the process. She's remarkable. What can I tell you? I love the lady. I love her for who she is, and I love her for what she does.[9]

When your wife is very talented, very smart and very sensitive to the nature of such a relationship, it's very easy… I'm lucky in more ways than one.[10]

On Humor

Humor is a central device for the absorption and acceptance of an idea that you would quarrel with in any other context. If you laugh with an idea you are opening yourself to it.[11]

Somehow, you learn more when you are laughing – when you can sense the good feeling and warm intent of the person who is talking to you. You are more open to positive and joyful people, even if you don't agree with what they have to say.[12]

When I say humor, I use the word very broadly. It can be wit, or personal warmth. It can be friendliness, combined with a sense of seeing some of the irony, the contrasts, and the juxtapositions of

Photography by Saul
early 1960s

Elaine
late 1950s

life in relation to the material you are dealing with. I believe very strongly in the value of humor and the beautiful, as avenues for reaching people and helping them to open their minds to what is said.[13]

Humor is a wonderful medium for ideas; a leavening.[14]

On Work

Work? It's just serious play.[15]

Unless I have to stretch, then I'm not really interested.[16]

I like the hand of the designer to show. I like it to be powerful. I like to have some humanity in it – either in the image or in evidence of the hand process.[17]

I try to evoke the essence of a story, summarize the fundamentals, not the details, to identify something with a sort of shorthand where you quickly see and understand.[18]

A successful communication entices the viewer to participate. The minute you're in a position of getting him to pick up a shovel and hurl a spadeful on the pile, you're beginning to reach him. I try to create a Gestalt in which one element is missing. And that element has to be filled in by the viewer. I want to get him in the game, the association game.[19]

When a piece of design really works, it appears seamless – that's part of the quality of a good thing. You have no awareness of how it was put together. It has a sense of inevitability. It looks so easy that, when someone looks at it the feeling that he has is "well, if I had been working on that problem, I'd have probably thought of that as well."[20]

If you do something to some degree uncharted for you, it becomes a more intensive learning experience. It's walking on a slippery surface, managing to stay up. That's the tension that makes the work interesting.[21]

There are two factors important to me. One is that I work with people that I like, and with whom I have an appropriate sense of community. With clients I can respect, who respect me, and with whom I can have rich interchange. The other, is to do interesting work within this framework. And when push comes to shove, working with the right people may be most important. You know, the problem may be less challenging, but it can be just fun and rewarding to be in interaction with good people.[22]

Personal Handwriting 383

On Refusing Commissions

The truth is that I've frequently turned down clients who sell things that are bad for people… What I do believe is that we all have the obligation to stand for something, to have values and to do our best to support the values in which we believe. A long time ago I made the decision never to knowingly use my talents for the benefit of any product which is harmful to living things. It's sometimes difficult to know when that is so. You can't always be right, but you do your best.[26]

On Criticism

You see an artist, a creative person, can accept criticism or can live with the criticism much more easily than with being ignored. Criticism makes you feel alive. If somebody is bothered enough by what you have done to speak vituperatively about it, you feel you have touched a nerve and you are at least "in touch." You are not happy that he doesn't like it, but you feel you are in contact with life.[27]

On Clients

Clients? I have a sign in my office that reads "They need us more than we need them" but on the other side it reads "We need them more than they need us."[23]

We try very hard to deal with the essential contradiction inherent in the client relationship. On the one hand we must pointedly look at things from the client's internal perspective. And yet still retain our objectivity as outside consultants. That's the trick. To see the problems as intimately as an insider, yet retain an outsider's objectivity.[24]

On Problem Solving

…The most stimulating source for a solution to a problem comes from the problem itself. This is the real source – the problem defines the solution. It is when you look at what other people are doing that you are liable to come up with a stereotyped answer to your problem. Each problem contains unique elements. No problem is exactly like any other. The only way you can find a good answer is to clearly understand the question. You can't find the answer by using somebody else's answer to another question. I am not even saying this is bad. It is merely untrue. It is not so much a moral issue. It just doesn't work![25]

Watercolor / stamp collages
Created for Mitsukoshi Department Store in Japan.
1988

Pen and ink drawing
Maui, Hawaii
c. 1980

384 Saul Bass

Doodles
Coasters from Tiny Naylors, an all night coffee shop and drive-in, a few doors down from the Bass office for many years. mid-1970s

Saul Bass laundry bag
In a spontaneous moment Saul decided to begin a lecture wearing this. 1983

On Communication

My intent in my work is almost always to find a visual phrase which is more than it first seems, or in some way different than it first seems. Ambiguity and metaphor are often central to my work, and certainly to the work of most of the filmmakers and designers I admire. Things that are what they appear to be make their point and soon grow tiresome. The ambiguous is intrinsically more interesting, more challenging, more involving, more mysterious and more potent. It forces reexamination, adds tension, gives it life.[28]

On the Care and Feeding of Creative People

When a client repeatedly rejects good ideas, the effect on creative people can be devastating. Joy evaporates, motivation diminishes. Conversely, when a client recognizes and supports excellent work, the motivation to be even better is enhanced.[29]

A client who will give you the benefit of a doubt, who will be patient, perhaps even take a gamble in letting you move ahead – is worth his or her weight in truffles.[30]

On Decision Making

Herb Yager: We were once in a meeting presenting a new trademark. The client made a particularly terrible suggestion. Everyone sat in stunned silence until Saul spoke up.

Saul: Here's my view of it. We all have to make decisions from time to time that are not perfectly clear. These are the forty-nine percent to fifty-one percent decisions. So we weigh the facts. Reach a judgment. And hope that we are right. In these marginal situations, if one is right more often than wrong, that constitutes effective action. There is, however, another kind of decision which is black or white – a 100 percent decision, so basic that if you are wrong then you had better reconsider what it is you are doing with your life. For me this is a 100 percent decision. Your suggestion is a mistake. And if I'm wrong, then I had better start looking around for a new career. (The recommended trademark was eventually accepted without modification.)[31]

Everybody says you're really nice in spite of your fame. How do you keep your feet on the ground?

It's very easy. All we've talked about is past work. What counts is the present. And that is humbling because no matter how much experience you have, the blank page is still terrifying…

There's fun, anxiety and concern. But in the end, it's so wonderful when you do make it happen. You live in a sort of threatened state and then it's delicious when you get out of the danger zone.[32]

On Craft

Once you have the concept everything's craft. You're in a series of steps. Each one has its own characteristics. Each one would drive you mad if that's all you did. Of course, the thread running through this is – are we going to end up with something? You know that half of what you do is wasted, but you don't know which half. Later you say "Why on earth did we do that?" That's hindsight. It could have been a marvelous thing that would have transformed everything.[33]

Personal Handwriting

Photography
A group of images for
Pagina magazine, Milan.
1962

"6"
Sketch
1978

On Process

There are several capacities vital to the creative process. One is the ability to create a hypothetical world of events, conditions and forms that do not exist in real life. The second is that you have to be able to enter this world and live within it as though it were real. However improbable or impossible it may be. The third is your ability to get out of that world at will. Finally, you have to have the capacity to assess the total experience of what you have learned and felt, and organize it into a coherent statement.[34]

The ability to fantasize without getting "uptight" is important, to fantasize without becoming concerned or anxious… to freely leap from one associative concept to another, and jump without a premeditated plan. You allow the accident to occur, the subconscious to emerge. You allow a strange positioning of elements that you would never usually allow, rationally or logically. You observe something interesting and allow it in turn to catapult you further.[35]

Next to imagination you have to have perseverance in order to create something of value. I may even say that perseverance is more important than imagination in a certain sense. A modest amount of imagination with a great ability to persevere can produce an important work. Great imagination lacking the perseverance to develop, shape and carry it out can result in failure.[36]

The nature of process, to one degree or another, involves failure. You have at it. It doesn't work. You keep pushing. It gets better. But it's not good. It gets worse. You go at it again. Then you desperately stab at it, believing "this isn't going to work." And it does![37]

The ability to deal with failure, disappointment, depression and difficulties and come back and stay with your work, keep going and maintain the vision, is very significant.[38]

When I hit a blank wall, I stop and go to another problem, hitting each one at a productive point. When things are clicking, I keep going all the way. Next thing I know, I'm past it and going on. By simultaneously working on a variety of problems, I find that one creative problem helps me solve another. The underlying ideas and emotions of one problem can often validly be related to another.[39]

Self-portrait
Created for a Strathmore
Paper promotion.
1991

Saul in his office
1970s

I have often discussed this with students. They report that their experiences can be very discouraging when the pieces don't seem to come together, when you have to organize, to rethink, and even do it again. Finally something happens and it turns out rather well, although they are discouraged by the fact that it was extremely hard to do.[40]

The process is hidden. You don't really know what causes you to leap from this to that... But in the end, having gone through a process of rationalizing and sorting out, and developing an intellectual construct, you go to work, and intuition comes into play, and something happens.[41]

I view this as the nature of process. One can be very accomplished in the work you produce, but the process remains as difficult. The finished work may seem to be seamless and it may have a certain sense of inevitability... The most accomplished creative people constantly struggle with this process. The struggle is always accompanied by disappointment, failure, exhilaration, and all the range of emotions.[42]

So, the good news, I say to students, is that what you are experiencing is exactly what everybody else experiences, even those people you most admire. The bad news is that it doesn't get any better.[43]

What sort of assignments do you personally enjoy most?

Let me see. There are so many. Assignments that force me to challenge my own assumptions. I'm pleased when I find a preconceived notion crumbling or my position on something moved. I love the kind of problems that when I first see, I haven't the vaguest idea of how to solve. Assignments for clients that expect a miracle. Assignments that require an unusual solution. Assignments that yield a visually beautiful solution. Assignments that have driven others nuts. Assignments in businesses that I have absolutely no experience. Reviving a brand that is dying. Positioning a company in a useful way for growth and then watching it grow. But more than anything else, assignments that ultimately have a real effect on people.[44]

More, On Creativity

If you don't risk everything every time out, your creative reservoir goes dry, and ultimately you fail.[45]

You know, we hear a lot about the joy of creating. What we don't acknowledge is the anguish and anxiety that come with the territory...Of course the pleasure when it does come can be very intense. Also, the play between pleasure and anxiety is part of the dynamic that makes the creative experience so compelling.[46]

Getting elected (the assignment) is like being a dog that finally caught the car it was chasing. What do you do with it now?[47]

Personal Handwriting 387

Photo by Saul
Elaine, Jeffrey and Jennifer
Malibu, California
c. 1970

Pre-Columbian Colima figures and Native American bear fetishes from Saul's office
mid-1970s

Photo by Saul
Daughter Jennifer on Navajo rug.
1965

On Work and Family

I'm in the extraordinary position where my life and my work are so interesting and rich that the normal distinctions simply don't exist. Elaine and the kids are deeply involved in my work. And that has created a marvelous bond between us.[48]

Children tend to be very much aware of the rewards of achievement. If they are not exposed to process … they develop unrealistic expectations. Seeing me wrestle with a problem, they realize that to excel requires real effort.[49]

On choosing one piece of work for a time capsule

That's hard. I guess it would have to be the creativity film. Because I had to use all the tools at my disposal. It forced me to operate at my most intense level. And I feel the film worked on its own terms. I feel best about a piece of work when it is successful on two levels; the visceral or emotional level, and the more complex intellectual level. To make people feel as well as think is the goal, and "Why Man Creates" probably came closest.[50]

If you hadn't done with your life what you have, what would you have done?

Either I was an archaeologist in my last reincarnation or I will be one in my next life because I have a passionate interest in archaeology… I am not just interested in the past, but in the very, very, very distant past. What fascinated me is the mystery and unreality of it all. The most intriguing culture is one about which we know a good deal but not everything. That leaves holes which can be filled with our own fantasies and imagination.[51]

On Collecting

I respond to the object as a fragment in time and experience.[52]

These tiny remains of ancient human civilizations, in addition to their intrinsic beauty, bring with them a special kind of mystery – a quality of the distant past, the unknown…[53]

I like seeing the variations of expression that are possible within an apparently rigid convention. I'm reminded that making an old idea seem new is almost as important as generating a new idea, and often harder to do.[54]

Do you believe in God or another power?

I think there is too much in the universe and in our lives which is mysterious, to preclude the possibility of some omnipotent force being involved. Yet, I have no religious point-of-view. But I believe

388 Saul Bass

Native American baskets and kachinas
Saul's office was full of artifacts from many cultures.
1969

Saul, Jeffrey and Jennifer
Aspen, Colorado
mid-1970s

that the gaps in understanding, knowledge and what happens are so overwhelming, that I have to allow for the possibility that there is some force at work in whatever form it may be.[55]

On Retirement

Retired? I may as well go into deep freeze. There's too much fun. I love what I do. There's nothing I don't like. I work hard. It's my life. It's what I do. I find it fascinating.[56]

I don't believe it is possible for people like me to retire. I consider myself a creative person in the deepest sense of the word. It's what I am. My self-definition. I guess it's possible to retire from a particular kind of work, but it's impossible to retire from what I am, nor would I want to.[57]

I don't think of myself as old. I lose my sense of chronological time when I'm doing things. Once in a while I will walk by a reflective surface of some kind, and see an older person there. And I'm surprised. (I think they don't make mirrors the way they used to!)…[58]

About death? I don't think about it… The only thing that's important to me is that my children and my grandchildren should know me. And to that end, I'm doing a book… for Amanda, so when she grows up, she'll know more completely who her grandfather was.[59]

Personal Handwriting **389**

Notes

Abbreviations: In order to reduce the density of the notes, initials are used for Saul Bass, Elaine Bass, Jennifer Bass, Art Goodman, Al Kallis, Lou Dorfsman, Robert Redford, Harold Williams, Martin Scorsese, Joe Morgenstern and myself. Interviews are denoted by a forward slash (e.g. AG/PK); conversations by "to." Places are noted if other than Los Angeles.

The following sources are abbreviated:

AMPAS SC: Academy of Motion Picture Arts and Sciences. Margaret Herrick Library, Fairbanks Center for Motion Picture Study, Beverly Hills, Special Collections.

Aspen Interview: *Designer Interviews in Aspen*. no. 4: *Saul Bass*, VHS, 1986.

Awards List: List of awards (mainly c.1954–76), AMPAS SC.

BA: Bass Archive: In family custody at time of writing; to AMPAS SC, 2010.

BC: Bass Collection at AMPAS SC.

"Celebration": ("Saul Bass 1920–1996. A Celebration of an Extraordinary Life," Los Angeles and New York, May 1996, videotape).

OH: *An Oral History with Saul Bass* (1996 interview with Douglas Bell, AMPAS SC).

SB/JM: Audio tapes of Saul talking to Joe Morgenstern.

Sidebar: Prepared by Saul for a book he hoped to publish, BA.

Statement: Text prepared by others for a book Saul hoped to publish, BA.

Introducing Saul Bass

1 Milton Glaser. Letter to EB 1996, BA; Steven Spielberg tribute, "Celebration"; HW/PK, 2003 and tribute, "Celebration"; Louis Dorfsman, *Saul Bass, Tokyo*; Irving Kirshner tribute, "Celebration"; and Ray Bradbury tribute, "Celebration."

2 Catherine Sullivan, "The Work of Saul Bass," *American Artist*, vol. 18, no. 178, October, 1954, p. 30.

3 MS to PK 1996, New York, and tribute, "Celebration."

4 Daniel Taradash. Letter to EB 1996, BA.

5 Richard Khan and Bruce Davis. Letters to EB 1996, BA and Arthur Heller tribute, "Celebration."

6 RR to PK 2004 (Annandale-on-Hudson) and tribute, "Celebration." In the latter, Redford noted, "Every time I was with him I came away with such good and positive feelings. I will always be grateful for our connection."

7 HW/PK 2003 and tribute "Celebration."

8 George Lucas's statement for Saul's proposed book included, "Saul was looking for student filmmakers to create four short films around the making of Carl Foreman's *McKenna's Gold* (1968). After viewing *THX-1138: 4 EB*, Saul chose me to shoot a tone poem. I have always been in awe of Saul's talent and was honored that such a gifted artist had noticed me. When I turned my film in, Saul loved it but Carl initially rejected it. Carl had a hard time understanding what a surrealistic celebration of the desert had to do with his feature film. Saul stood by my film and eventually won Carl over. Subsequently, the film was honored at a multitude of film festivals. Soon after, Saul asked me to shoot a "flame" shot for... *Why Man Creates*. I set up different kinds of blazes all over the kitchen and took the camera right into the flame – it was like an experiment in microphotography... Although Saul claimed it was an extraordinarily beautiful flame... The ending changed and my footage was left on the cutting room floor... His confidence in my ability gave me an emotional boost when I needed it most... I cherish the friendship that has developed as a result of that initial flame." Before teaching at USC, Saul taught at the Kahn Institute of Art, Beverly Hills, from the late 1940s to the mid-1950s ["Saul Bass," *Art Director & Studio News*, vol. V, no. 1, April 1953, p. 6]. In 1949 members of his Kahn class designed a brochure for the Fred Archer School of Photography. Credits: Douglas Kennedy & Charles Estvan (designers), Elbie Eiland & John Gregory (assistants), Saul Bass, instructor (Awards List).

9 Michael Lonzo. Letter to EB, 1996, BA. Lonzo recalled "the long after hours editing sessions with Saul and Albert Nalpas" and told how when Saul had to be away for a few days, all staff involved with a particular project, from Art Goodman down, had to meet with Saul before he left to go over every detail, even if it meant meeting at 2 am.

10 Arnold Schwartzman, "*Saul Bass – Anatomy of a Mentor*," *Baseline International Typographics Journal*, no. 22, 1996, pp. 17–24 and Rudolph de Harak. Letter to EB 1996, BA.

11 Bob Gill/PK 2003, New York. The film was *Plunder Road* (1957, dir. Hubert Cornfield).

12 Saul was ambidextrous and could draw extremely well with both hands. He was left-handed as a small child but when he went to school he was forced to learn to write with his right hand, as was customary in those days. He continued to use his right hand primarily for writing and drawing.

13 For "Postmodernism" in Modernism see Peter Wollen, *Raiding the Icebox: Reflections on Twentieth-Century Culture*, London: Verso, 1993.

14 SB/PK 1993 [in preparation for "Looking for the Simple Idea," *Sight & Sound*, vol. 4, February 1994].

1

From the Beginning

1 AG/PK 2004.

2 In 1906, the peak year for immigration, more than 152,000 Jews from Eastern Europe arrived in the U.S. (Moses Rischin, *The Promised City: New York's Jews 1870–1914*, New York: Corinth, 1962, p. 270). Although part of the Russian Empire when his parents left, Satanov became part of Romania after World War I and Saul grew up with family members referring to themselves as "Rumanian Jews" (JB/PK, 2004). Today Satanov is in Ukraine.

3 His father was recorded as Harry Aaron Bass in census returns and as Harry on Saul's wedding certificate (note 35). Although he adopted the anglicized version of his name, Harry, after arriving in the U.S., in the family he was known as Aaron, with Harry being used only as a nickname. (EB and JB to PK 2004). Recorded as unemployed in the 1930 census, he may have started what Saul referred to as "his little operation" in Manhattan's Lower East Side about then (OH, p. 1 and SB/PK 1994). I am grateful to Elaine and Jennifer Bass for information about Pauline.

4 See Deborah Dash Moore, "Defining American Jewish Ethnicity," *Prospects*, vol. 6, 1981, p. 387; Deborah Dash Moore, *At Home in America: Second Generation New York Jews*, New York: Columbia University Press, 1981, p. 23; and Lloyd Ultan, *The Beautiful Bronx 1920–1950*, New Rochelle:

Scratchboard illustration by Saul, published in his high school's literary and arts magazine, 1935

Arlington House, 1979, p. 36. From the beginning of the century, sections of Brooklyn and the Bronx (the area immediately north and northeast of Manhattan Island, from 148th Street to 241st Street) replaced Manhattan's Lower East Side as the main centers of Jewish settlement. In 1930, Hunt's Point, Morrisania and Grand Concourse were all 60–80% Jewish, with Fordham at 40–60%. Only in Pelham Parkway, Washington Heights and Parkchester (where Saul lived after his marriage in 1940) did the percentage drop to below half (Moore, *At Home*, p. 32).

5 SB/PK 1994.

6 Aspen Interview, 1986.

7 SB/PK 1994.

8 Aspen Interview, 1986.

9 SB/PK 1994.

10 "A few words about Henry and Lou," BA. Saul reminisced about playing baseball ("stickball" in the Bronx), with broom handle, manhole cover (home plate) and rubber ball.

11 *Childhood Fantasies*, Stamford, CT: Champion International Corporation, 1991, p. 12. Elaine is also extremely interested in archaeology.

12 Saul, who liked to sing, thought of becoming a cantor at one point in his adolescence [Arnold Schwartzman, "Saul Bass – Anatomy of a Mentor," *Baseline International Typographics Journal*, no. 22, 1996, p. 21].

13 See Glenn A. Bishop, *Chicago's Progress: A Review of the World's Fair City*, Chicago: Bishop Publishing Company, 1933 and John E. Findling, *Chicago's Great World's Fairs*, Manchester: Manchester University Press, 1994.

14 Esther Kraines. Letter to EB, 1996, BA. Saul and his mother stayed with "Uncle Izzy" (his father's brother), "Aunt Temma" and their daughters. Esther was a niece of Saul's aunt Temma.

15 Esther Kraines. Letter 1996.

16 SB/PK 1994. Saul spoke to me of "a certain pressure" from home to do well in school. The legal age of employment was sixteen but, according to film director Stanley Kramer, who also graduated early, the fast tracking of bright students was not uncommon in New York because of overcrowded schools (Stanley Kramer and Thomas H. Coffey, *A Mad, Mad, Mad, Mad World: A Life in Hollywood*, New York: Harcourt Brace, 1997, p. 21). See also Nettie P. McGill and Ellen N. Matthews, *The Youth of New York City*, New York: Macmillan, 1940, pp. 75–77. For medals see "City Students Win 97 Awards In Art," *New York Times*, June 23, 1936 and Awards List. Saul made "a few extra bucks" creating signs for local firms and as a delivery boy for Bucknoff's (SB/PK 1994).

17 JB to PK 2003.

18 SB/PK 1994. His friend's uncle worked for Nagler & Nagler (OH, p. 2).

19 OH, pp. 2–4 and SB/JM. For Trafton see Leon Friend and Joseph Hefter, *Graphic Design: A Library of Old and New Masters in the Graphic Arts*, New York: Whittlesey House, McGraw-Hill, 1936, p. 276 and *The Art Students League of New York, Winter Season: September 15, 1938–May 26, 1939*, New York, 1939, p. 20. Saul completed the full academic year 1936–37, missed one month in 1937–38 and two in 1938–39. He attended for the autumn semester 1939 but missed January 1940, attending only half time for the rest of the session. Thereafter, his name appears only for two weeks in February 1941, suggesting that he may have gone to the ASL to work on a particular project ("Student Records," Archives of the Art Students League of New York). The Trafton class photograph was donated by Dave Weiseman of Brooklyn, who identified himself as an "MGM Publicity Artist" and the person peering over Saul's shoulder (I am grateful to archivist Stephanie Cassidy for this information).

20 SB/PK 1993, OH, p. 4 and SB/JM.

21 SB/PK 1993. Most of Trafton's students worked in commercial art studios but he justified his focus on fine art by insisting that "they could learn all about printing, half-tone reproduction, and the rest of it at any agency" (obituary, *New York Times*, September 26, 1964). Gene Frederico, another Trafton student, recalled lessons about the effects of "dumb light," distortion, negative space and African sculpture (Steven Heller, "The Art Directors' Art Director" for AIGA Medal, www.aiga.org/content.cfm/medalist-genefrederico, viewed May 1, 2006).

22 OH, p. 4.

23 McGill and Matthews, pp. 121, 131, 136, 154–156.

24 SB/PK 1993.

25 SB/PK 1993.

26 SB/PK 1993 and OH, pp. 6–7. Most films were made in Hollywood but, for the most part, film advertising remained in New York, the center of the advertising industry.

27 For commercial art/graphic design, see Steven Heller, "Advertising: The Mother of Graphic Design," in Steven Heller and Georgette Balance (eds.), *Graphic Design History*, New York: Allworth Press, 2001, pp. 295–302; Philip B. Meggs, *A History of Graphic Design*, New York: Van Nostrand Reinhold, 1992, p. 187; Mildred Friedman, "Opening a History," p. 9 and Ellen Lupton and J. Abbot Miller, "A Time Line of American Graphic Design, 1829–1989" in Mildred Friedman et al., *Graphic Design in America: A Visual Language History*, New York: Harry N. Abrams and Minneapolis: Walker Art Center, 1989, p. 43. For the newly emerging design professions of industrial design and interior design see Arthur J.

Drawing by Saul, c.1937

Pulos, *The American Design Adventure, 1940–1975*, Cambridge, MA: MIT Press, 1988.

28 SB/PK 1994.

29 SB/PK 1994. For Lucian Bernhard in New York see Steven Heller, "Lucian Bernhard: The Master Who Couldn't Draw Straight," in Heller and Ballance (eds.), pp. 104–112. Flagg, Leyendecker and Rockwell Kent were included in a list compiled by Saul of people whose work impressed him (untitled sheet, c.1995, BA).

30 SB/PK 1995. The Democratic Party, the American Labor Party and the Communist Party were all active in the Bronx at a time when "liberalism grew into a distinctive American Jewish faith" (Moore, *At Home*, p. 401).

31 OH, p. 8 and SB/PK 1995.

32 OH, p. 8 and SB/PK 1995.

33 McGill and Matthews, p. 141.

34 OH, p. 8. He recalled working on ads for *Jezebel* (1938, dir. William Wyler) when he was about age 18 (SB/PK 1994).

35 Saul and Ruth (both born 1920) grew up two blocks away from each other on Bryant Avenue, the Bronx. Marriage records cite her as "laboratory technician" (she graduated from Hunter College in 1940), Saul as "commercial artist," her father as a Russian Jew and her mother as Polish (wedding license, July 24, 1940. Marriage License Bureau, The City of New York, Office of the City Clerk and marriage certificate July 27, 1940, Yonkers, Westchester County, NY). For Ruth Bass Weg see *American Men and Women of Science*, New York: R.R. Bowker, 2000. Saul and Ruth separated and divorced in the late 1950s.

36 OH, pp. 8–9, SB/JM and SB/PK 1994. Saul told me "Jonas was very nervous about it because I had never really done an ad campaign." I am grateful to Joe Morgenstern for the main Rosenfeld quotation.

37 SB/PK 1994. See also OH, p. 8.

38 SB/PK 1994.

39 SB/PK 1994 and OH, p. 9.

40 SB/PK 1994 and OH, pp. 15–17.

41 See Gyorgy Kepes, *Language of Vision*, Chicago: Paul Theobald, 1944 and "About the Author" (inside cover). See also Michael Golec, "A Natural History of a Disembodied Eye: The Structure of Gyorgy Kepes's Language of Vision," *Design Issues*, vol. 18, no. 2, Spring 2002, pp. 3–16 and Nanyoung Kim "A History of Design Theory in Education," *The Journal of Aesthetic Education*, vol. 40, no. 2, 2006, pp. 18–20. For the Bauhaus see Hans Maria Wingler, *The Bauhaus: Weimar, Dessau, Berlin, Chicago*, trans. Wolfgang Jabs and Basil Gilbert, Cambridge, MA: MIT Press, 1969. For European Modern Movement graphics see Jan Tschichold, *The New Typography: A Handbook for Modern Designers*, trans. Ruari McLean, Berkeley: University of California Press, 1997; Steven Heller, *German Modern: Graphic Design from Wilhelm to Weimar*, San Francisco: Chronicle Books, 1998; Jeremy Aynsley,

Design by Gyorgy Kepes, title page for the special issue "Gyorgy Kepes" of PM magazine, 1940

Graphic Design in Germany, 1890–1945, Berkeley: University of California Press, 2000 and Alston W. Purvis, *Dutch Graphic Design, 1918–1945*, New York: Van Nostrand Reinhold, 1992.

42 SB/PK 1994, OH, pp. 5–11 and Sullivan, Catherine, "The Work of Saul Bass," *American Artist*, vol. 18 (October 1954), p. 31. See also László Moholy-Nagy, *The New Vision: From Material to Architecture*, trans. Daphne M. Hoffman, New York: Brewer, Warren & Putnam, 1932.

43 Several, including Rudolph de Harak and Saul, noted that, despite Kepes's brilliance as a teacher, they often did not always fully grasp what he was driving at conceptually (SB/PK 1993, OH, p. 11 and www.aiga.org/content.cfm/medalist-rudolphdeharak, viewed May 27, 2006). Today, the formalist and functionalist language in *Language of Vision* and the absolute certainties about art and vision expressed therein read as somewhat abstruse whereas the sections dealing with exercises offer clear models for understanding all manner of concepts, from fields of spatial forces to integration of plastic forces.

44 SB/PK 1993. See also OH, p. 4.

45 See Kepes, *Language of Vision*, passim., esp. pp. 1, 29, 176–177 and 221.

46 Sullivan, p. 31 and SB/JM. For the CWI see Allan Winkler, *The Politics of Propaganda: The Office of War Information, 1942–1945*, New Haven, CT: Yale University Press, 1978.

47 CH, pp. 4–5 and 29–31. See also Kenneth Garland, "Structure and Substance," *The Penrose Annual*, vol. 54, 1960, p. 7. Because of the impact of Saul and others working outside New York (he was based in Los Angeles from 1946), historians now refer to an "American School" of graphic design in the postwar years rather than a "New York School" (Lorraine Wild, "Europeans in America" in Mildred Friedman et al. (eds.), pp. 152–169).

48 OH, pp. 5 and 31. Shown at the *25th Annual Exhibition of Advertising and Editorial Art*, it won an award of distinctive merit (*25th Art Director's Annual: Advertising and Editorial Art*, New York:

Watson-Guptill, 1946, Section: "Design of Complete Unit," no. 4. Credits: Saul, art director and artist. The design concept relates a product that gives a hairdresser control over a cold-wave process to the control needed for the elephant to balance. In 1996 Douglas Bell mentioned that the ad looked "Constructivist." Saul disagreed, saying it had a "Bauhausy look" (OH, p. 31).

49 OH, p. 16.

50 OH, p. 16 and Iain F. McAsh, "Saul Bass: One Black Rose over a Crimson Flame," *Films Illustrated* 2, March 1973, pp. 22–23. Radin headed many ad campaigns during his long career, including that for *Algiers* (1938, dir. John Cromwell). In his capacity as a producer, he asked Saul to direct *Phase IV* (1974).

51 SB/PK 1995 and AK/PK 2003.

52 SB/PK 1994. See also OH, pp. 19–20.

53 SB/PK 1995. Saul caught the Garden of Allah just before it lost its cachet as a place to live (George Oppenheimer, "Hollywood's Garden of Allah," www.americanheritage.com, viewed February 18, 2007).

54 SB/PK 1995.

55 SB/PK 1995 and OH, pp. 23–27. Saul worked on at least two ad campaigns for Sturges (probably *The Sin of Harold Diddlebock* and *Vendetta*). They used to meet for lunch at Sturges's special table at the back of The Players restaurant (owned by Sturges) and the director often gave Saul small presents, including one of the first pens to write in different colors (SB/PK 1995).

56 SB/PK 1995.

57 Steven Heller mentions the Society of Contemporary Designers in "Down the Pigeonhole," *Print* (January–February 2004) and AIGA Medal citations for Lustig and de Harak (www.aiga.org/content.cfm/medalist-rudolphdeharak and www.aiga.org/content.cfm/medalist-alvinlustig, viewed February 18, 2007). The other founders were Jerome Gould and Hy Farber (Lou Danziger to PK, email 2009). For Lustig's announcement graphics see Alvin Lustig Collection, Rochester Institute of Technology, Box 6; for Saul's cover, Georgine Oeri, "Saul Bass," *Graphis*, vol. 11, 1955, p. 258.

58 "Script for speech given on the occasion of a lifetime award to Jack Roberts," 1987. BA.

59 SB/PK 1994.

60 For the "progressive" cultural life of Los Angeles see Victoria Dailey, Natalie Shivers and Michael Dawson, *LA's Early Moderns: Art, Architecture, Photography*, Los Angeles: Balcony Press, 2003; Elizabeth A.T. Smith "*Arts & Architecture* and the Los Angeles Vanguard" in Elizabeth A.T. Smith et al., *Blueprints For Modern Living: History and Legacy of the Case Study Houses*, Cambridge, MA: MIT Press and Los Angeles: Museum of Contemporary Art, 1989, pp. 145–165; Mike Davis, *City of Quartz: Excavating the Future in Los Angeles*, London: Verso, 1990; and Paul J. Karlstrom, *Turning the Tide: Early Los Angeles Modernists 1920–1956*, Santa Barbara, CA: Santa Barbara Museum of Art, 1990.

61 See note 60 and SB/PK 1995 (Saul and Perls).

62 SB/PK 1994.

63 SB/PK 1994. For *Arts & Architecture* see Barbara Goldstein (ed.), *Arts & Architecture: The Entenza Years*, Cambridge, MA: MIT Press, 1990. Alvin Lustig designed the logo and reworked the masthead in February 1942 (Smith, "Vanguard," 147.) Saul's contact with the *Arts & Architecture* crowd may have come through Jack Roberts who worked there in the late 1940s.

64 SB/PK 1994.

65 *Arts & Architecture*, November 1948, inside cover. In the 1950s and early 1960s Saul became involved in a range of socially responsible design projects (see Chapter 2).

66 SB/PK 1994.

67 Ephraim Katz, *The Film Encyclopedia*, New York: Crowell, 1979, p. 1175.

68 Saul Bass, "Film Advertising," *Graphis*, vol. 9, no. 48 1953, p. 281 and OH, p. 16.

69 OH, pp. 26–27.

70 SB. Sidebar, BA and OH, pp. 26–27 and 74. Radin, who headed the Los Angeles office in 1946–47, claimed to have worked on this campaign (www.mst3kinfo.com/rolodex/Radin.html, viewed January 21, 2006. See also note 50). Radin may have been the account executive referred to by Saul. After communications broke down between Chaplin's company and United Artists, UA's publicity department created a new campaign (Joyce Milton, *The Tramp: The Life of Charlie Chaplin*, New York: Da Capo Press, 1998, pp. 458–460). N.B. Radin claimed responsibility for the ad campaign for Frank Capra's 1946 *It's a Wonderful Life* (www.mst3kinfo.com/rolodex/Radin.html, viewed January 21, 2006); the lettering looks as if it might have been done by Saul.

71 OH, pp. 16, 21–22 and 45–46. Another ad features Douglas with the three women stars. Some United Artists executives thought *Champion* might do well at the box office and it received "decent promotion." The money allocated, however, was but a fraction of that for *No Way Out* (Kramer and Coffey, p. 27).

72 SB/PK 1994 and OH, pp. 20–22, 45–50 and 58–59. Re: *High Noon* ads, Saul recollected, "a pair of legs...through which you see Gary Cooper...you see the face-off"; the poster campaign draws on this concept and an ad matching this description is illustrated in Joe Morella, Edward Z. Epstein and Eleanor Clark, *Those Great Movie Ads*, New Rochelle, NY: Arlington House, 1972, p. 13.

73 SB/PK 1994. According to Lou Danziger and Al Kallis, both of whom knew Saul well in the early to late 1950s, Saul and Ruth were part of a leftish, socially committed circle that included filmmakers and artists (Danziger to PK, email 2009 and AK/PK 2003). For Kramer's collaborators see Kramer and Coffey, pp. 83–91. Foreman, who won an Academy Award for *High Noon*, moved to Britain after being blacklisted for refusing to "name names" to the House Un-American Activities Committee (HUAC).

Saul spoke of those days as "shameful," emphasizing that his "blacklisting" in the 1960s related to much more petty incidents than the HUAC-related blacklistings of earlier years. He did not want to be seen as claiming to be part of something he regarded as altogether more heroic. He spoke of how, in the 1960s, many studio executives continued to abuse their power. His being banned from working for particular studios involved refusing to comply with an executive's request to accept a credit other than the one director Stanley Kubrick was insisting on for Saul's work on *Spartacus*. Informed that if he did not accept the studio's suggestion, he would not work there again, Saul, who did not take well to intimidation, refused to undermine Kubrick's stance. Another incident related to his taking "the fall" when Vincente Minnelli spent a large amount of money ($40,000) on a lead-in shot to a montage for *Four Horsemen of the Apocalypse* (1962, MGM). Saul had only asked for a simple linking shot but got blamed for Minnelli's expenditure. Typically, he refused to blame Minnelli but felt disappointed that Minnelli, with whom he had been on friendly terms, did not make it clear to studio bosses that Saul was not at fault. Saul recalled being banned by four major studios in the years c.1962–66 but not worrying about it because he had so much other work. When Frankenheimer insisted on using Saul in 1966 for *Grand Prix*, the MGM "ban" was quietly forgotten (See SB. Sidebar "Four Horsemen of the Apocalypse," BA, SB/JM and SB/PK 1995.)

74 Saul Bass, "Film Advertising," p. 279.

75 Jonas Rosenfield to JM 1996. I am grateful to Joe Morgenstern for this quotation. It is not generally known that Saul

No Way Out, insert poster, 1950

was involved in this commission, let alone to the extent Rosenfield claimed.

76 *No Way Out* press book, 1950 and OH, p. 31. Nitsche designed billboard campaigns for Universal's *The Egg and I* (1947, dir. Chester Erskine), *All About Eve* (1950, dir. Joseph Mankiewicz) and *Fourteen Hours* (1951, dir. Henry Hathaway). See Steven Heller, "A Contemporary Man," *Print*, vol. 52, January–February 1998, pp. 104–110 and 220. A signed Nitsche design formed the front cover of the *No Way Out* press book; Rand's signed billboard design the back cover. Saul, still working for Foote, Cone & Belding, did not sign his designs but an insert poster was published under his name in the *30th Annual of Advertising and Editorial Art*, New York: Pitman, 1951, no. 25. Credits: Saul Bass, designer; Saul Bass, artist; Charles Schlaifer & Co., agency. Victor Sedlow, an art director who worked with Rosenfield, was cited as art director.

77 Sullivan, pp. 28 and 31.

78 SB/PK 1995. See also OH, p. 16–17, 23–26, 51 and 54.

79 SB/PK 1995, SB/JM and OH, pp. 51–52. Hughes suffered from what today would be called obsessive compulsive disorder.

80 SB. Sidebar, BA.

81 SB/PK 1995.

82 SB/PK 1995, OH, p. 50 and SB/JM. Within a week of leaving Foote, Cone & Belding, Saul pulled in sufficient work to cover his salary for a year, including advertising for producer Alex Gottlieb and for Universal International (three films). The U.S. government disallowed the RKO sale because members of organized crime were involved (Tony Thomas, *Howard Hughes in Hollywood*, Secaucus, NJ: Citadel Press, 1985, p. 107) but Saul decided to remain freelance.

83 Designer Phyllis Tanner and calligrapher Maury Nemoy, with whom Saul shared office space, worked on several projects with Saul (AK/PK 2003; AG/PK 2003). Lou Danziger recalled, "Maury Nemoy often did some lettering for him and he would farm out some of the illustration work to Al [Kallis]. Phyllis Tanner sometimes did some production (paste-up and assembly) for him… Saul actually could have done the work all by himself. He was enormously skillful (probably as good an illustrator as Al [Kallis], perhaps better). Farming out pieces of the work was mostly a question of expediency… Saul was amazingly skillful which gave him a much larger visual vocabulary to draw upon. He was able to choose any 'look' that he felt was appropriate to the problem, be it cartoon, illustration, or photos… Saul always felt and often made a point of how important it was to be able to draw. Of course later… photography became one of his great skills" (Danziger to PK, email 2009).

84 EB/PK 2001.

85 EB/PK 2003.

86 EB/PK 2002.

87 EB/PK 2002.

88 EB/PK 2004.

Lightcraft catalog, inside cover, printed vellum overlay on photo (the boy is Saul's son Robert), 1953

89 SB/PK 1994 and EB/PK 2003.

90 When asked "Does 'Saul Bass & Associates', as you've sometimes been credited, mean that you weren't as personally involved as usual?", Saul replied, "No, I've been personally involved on every one of them, but I've been aided and abetted by a number of associates that I want to give some recognition to. So it's not 'Saul Bass and Associates' like a company, but Saul Bass and his associates" [David Badder, Bob Baker and Markku Salmi, "Saul Bass," *Film Dope* 3 (August 1973), p. 6]. Illustrator Al Kallis was one of those associates. He loved working for Saul because of his endearing human qualities and the extreme thoroughness with which Saul approached each job. He recalled, "No matter how small an image or job, Saul always articulated exactly what he wanted. In the explanation of a job, he showed a deep understanding of the motivation of the material. He spent a lot of time on that sort of thing. It was rare to get such an intensive briefing from anyone else. Others would state briefly what they wanted. It would all be over in five minutes. With Saul it was different. He knew exactly what he wanted you to do!" (AK/PK 2003). Goodman and Dorfsman also recalled extremely thorough briefings (AG/PK 2003; LD/PK 2004, New York).

91 SB/PK 1993 and AG/PK 2003.

92 "The Compleat Designer," in Laurence S. Sewell (ed.), *Design Forecast* 2, Pittsburgh, PA: Aluminum Company of America, 1960, p. 28; Richard Coyne, "Saul Bass & Associates," *Communication Arts*, vol. 10, no. 4 (August–September 1968), pp. 14–31; and information from Art Goodman, Jennifer Bass, Elaine Bass and Brad Roberts.

93 SB, "Collaborators and Friends," c. 1996, BA.

94 AG/PK 2003.

95 AG/PK 2003.

96 In preparation for the book he hoped to publish, and in recognition of design being a collaborative process, Saul began compiling a list of employees and associates. The list was extremely long but office records were not complete and Saul decided against publishing a list lest he offend anyone by omission. A few months before he died, he prepared this statement: "It's impossible for me to adequately thank the people I have worked with over the years. In the beginning, I did everything: designed, illustrated, specified the type, did the paste-up, took the pictures, negotiated the contracts, handled the billing, the client contact, even the telephones. Obviously, as the firm grew, and the clients we worked for multiplied and were larger and more demanding, I needed help. And the fact is that through the years, I was blessed to have worked with some of the most talented people on the planet. I'd like to think they signed on because they were attracted by the quality of our work. But sometimes I think that maybe our work was so good because they came." After naming Elaine and Art Goodman, he continued, "It's impossible to name all the others. But how can I not mention Dean Smith, a great designer who died too young, Morrie Marsh my first partner, Herb Yager, my partner for 21 years, Nancy von Lauderback, my miracle worker production manager, and Dick Huppertz who keeps everything running smoothly." (SB, "Collaborators and Friends," c. 1996, BA.)

97 In the Bass Archive there are several lists of acknowledgments, none of which were complete at the time of Saul's death. It was his intention to acknowledge particular people in a personal statement at the beginning of the book and to have a longer list of acknowledgments elsewhere. One of the shorter lists (both office staff and associates) reads: George Arakaki, Jennifer Bass, Robert Bass, Katherine Bennett, Bruce Blackburn, Becca Bootes, Bill Brown, Paul Bruhwieler, Vince Carra, John Casado, Michael Cervantes, Frank Cheatum, Chuk Yee Cheng, Jim Cross, Carl Davis, John Divers, Lou Dorfsman, Tom Earnist, Brenda Ehlert-Hayden, Mort Fallick, Vahe Fattal, Alan Fletcher, Jerry Frutchman, Don Handel, Darryl Hayden, Bruce Hopper, Al Kallis, Kraig Kessel, Larry Klein, Herb Klynn, Jerry Kuyper, Jonathan Louie, George Mather, Ken Middleham, Mike Mills, John Miyauchi, Dave Nagata, Albert Napas, Maury Nemoy, Jeff Okun, Ken Parkhurst, Terry Paul, John Plunkett, David Reidford, Brad Roberts, Herb Rosenthal, Marvin Rubin, Rick Runyon, Clarence Sato, James Selak, Mamoru Shimokochi, Arnold Schwartzman, Phyllis Tanner, Bob Taylor, Jay Toffoli, Fulton Van Hagen, Kirby Veach, Eileen Wan-Xie, Don Weller, Jerry White, Lowell Williams, Ray Wood, Theresa Woodward, Max Yavno, Howard York, Bob Zoell.

2

Renaissance Designer

1 Ludwig Ebenhöh, "Saul Bass, USA," *Gebrauchsgraphik*, vol. 27, no. 11, November 1956, p. 20.

2 "Wide Range of Saul Bass' Work Shown," *Print*, vol. 11, May 1958, p. 18.

3 David Rose, "Los Angeles Advertising Art," *Graphis*, vol. 14, no. 75 (January–February 1958), p. 60. The Eameses were Los Angeles' best known "Renaissance" designers at the time but they rarely undertook advertising design. The description better fits Saul, a close friend (politically and personally) of Rose. Saul, Rose and Lou Danziger worked together in the early 1950s with the Urban League "to locate and integrate black designers into the design community" – then entirely white (Danziger to PK, email 2009).

4 For entrepreneurs see "Design on the West Coast," *Industrial Design*, vol. 4, no. 10, October 1957, p. 47. Credits for Eger program cover: Saul Bass, art director; Saul Bass, artist (Awards List).

5 For Aspen see Sidney Hyman, *The Aspen Idea*, Norman: University of Oklahoma Press, 1975; James Sloan Allen, *The Romance of Commerce and Culture: Capitalism, Modernism, and the Chicago–Aspen Crusade for Cultural Reform*, Chicago: University of Chicago Press, 1983; and Arthur J. Pulos, *The American Design Adventure, 1940–1975*. Cambridge: MIT Press, 1988, p. 212.

6 Richard Farson, fellow IDCA board member, claimed Saul was a "real leader" and that it was partly because of him that the IDCA became "an affection-based organization" (Farson tribute, "Celebration"). In 1954, when Saul chaired the planning committee, the conference attracted a greater number of participants from film, television, radio, newspapers, sociology, education and museums (Pulos, p. 212. See also "Aspen Connections," BA).

7 SB. Sidebar, BA. See also "Saul Bass Believes in Magic" (interview with Nancy Hopkins Klein, July 15, 1994, pp. 4–6, BA (published as "Saul Bass: On The Real Priorities," *Design Firm Management* 41, Evanston, Illinois: Wefler & Associates, Inc. 1994, pp. 1–6) and "Aspen Connections," BA.

8 1950s publications on creativity include Alex Osborn, *Wake Up Your Mind: 101 Ways to Develop Creativeness*, New York: Charles

On the Threshold of Space, billboards, 1956

Scribner's, 1952, Alex Osborn (ed.), *Applied Imagination: Principles and Procedures of Creative Problem Solving*, New York: Charles Scribner's, 1953 and Harold Anderson (ed.), *Creativity and its Cultivation*, New York: Harper, 1959.

9 Paul Smith (ed.), *Creativity: An Examination of the Creative Process*, New York: Communication Art Books, Hastings House Press for the Art Directors Club of New York, 1959, pp. 121–142. Speakers included designers, psychologists, scientists, technologists, marketing strategists, musicians and performers. Victor Borge spoke on "Creativity in Humor" in the debate as to whether significant breakthroughs in creativity came from collective brainstorming (then in vogue) or from individualized rumination and experiment. Saul, who always liked "alone time" to play around with ideas, favored the latter. He considered brainstorming alone too simplistic and superficial for the type of "fundamental creativity" necessary to meet the needs of the modern world (Smith, *Creativity*, "Q & A" section).

10 SB/PK 1995.

11 "World Design Conference in Japan," *Industrial Design*, vol. 7, July 1960, pp. 46–49. The magazine's observer was Joella Bayer.

12 "World Design Conference in Japan," p. 48. There were 84 delegates from 26 countries, and over 300 "guests." Herbert Bayer and Jean Prouvé were among those who spoke in Bauhaus-style functionalist language and concepts. Peter Smithson, part of the Independent Group (there were no formal members) which admired American popular culture, spoke to me of the group's admiration for Saul's work (Peter Smithson to PK, 2002, New York). See also David Robbins (ed.), *The Independent Group: Postwar Britain and the Aesthetics of Plenty*, Cambridge: MA: MIT Press, 1990 and Anne Massey,

Suede Sorcery, flexible display stand for the Marshall Field company, c.1954

The Independent Group: Modernism and Mass Culture in Britain, 1945–1959, Manchester: Manchester University Press, 1995. Credits for Keio wrapping paper: Saul Bass, art director, designer and artist (Awards List).

13 Associated with this new type of poster design in Germany in the 1900s and 1910s were designers Lucian Bernhard and Ludwig Hohlwein and the magazine *Das Plakat*. Such graphics were influential in many areas of U.S. advertising even before Bernhard moved to New York in 1923. Saul recalled advertising by Bernhard in the subways during his youth (Chapter 1) and in the mid-1930s Paul Rand tried (unsuccessfully) to persuade Bernhard to give him a job (Steven Heller, *Paul Rand*, London: Phaidon, 1999, p. 18). For *Plakat* design see Alan and Isabella Livingston, *The Thames and Hudson Dictionary of Graphic Design and Designers*, London: Thames & Hudson, 1998, p. 157; Jeremy Aynsley, *Graphic Design in Germany, 1890–1945*, Berkeley: University of California Press, 2000, pp. 76–85; and Steven Heller, "Lucian Bernhard: The Master Who Couldn't Draw Straight," in Heller and Ballance (eds.), p. 107.

14 SB/PK 1995.

15 SB/PK 1995 and untitled list, BA. Ben Shahn's art and moral commitment also inspired Saul (SB to PK 1996, New York).

16 SB/PK 1994. See also SB/Archie Boston, 1986 (video: transferred to DVD 2007 as part of *20 Outstanding Los Angeles Designers*) and Lou Danziger to PK (email) 2009.

17 For the promotion of Abstract Expressionism see Nancy Jachec's "Transatlantic Cultural Politics in the late 1950s: The Leaders and Specialists Program," *Art History*, vol. 26, no. 4, 2003, pp. 533–555 and her *The Philosophy and Politics of Abstract Expressionism*, Cambridge: Cambridge University Press, 2000.

18 SB, Sidebar, BA. Saul later felt that the trade ad "Equation" (p. 37 and *Hollywood Reporter*, July 3, 1953, back page) for *Return to Paradise* (1953, dir. Mark Robson) epitomized the more blinkered aspects of his "High Modernist" work, declaring it formally interesting but "absolutely inappropriate" to the mood of this "emotional South Seas tale" (OH, p. 31 and SB/PK 1994).

19 See Georgine Oeri, "Saul Bass," *Graphis*, vol. 11 (1955), pp. 259–261 and "Wide Range of Saul Bass' Work Shown," p. 38. When Saul began designing film titles and ad campaigns, he continued to design "bread and butter" trade ads, including those for *Vera Cruz* (1954) and *Kiss Me Deadly* (1955), both directed by Robert Aldrich, an independent director/producer and major supporter of Saul's work in the mid to late 1950s (Chapter 3). Saul designed trade ads for three films produced by Stanley Kramer, two of which Kramer also directed (*The Sniper*, 1952, dir. Edward Dymtryk, *Not as a Stranger*, 1955, and *The Defiant Ones*, 1958), as well as a Kramer Company brochure and press premiere invitation for *The Four Poster* (1952, dir. John Hubley and Irving Reis). Credits for the latter: Saul Bass, art director; Robert Guidi and Art Goodman, illustrators (Awards List). In 1955, the same year as *The Man with the*

Golden Arm, another downward-thrusting arm choked a doll in a trade ad for *Night of the Hunter* (dir. Charles Laughton), conveying the murderous menace at the heart of this suspense thriller. Saul was art director and designer (Awards List). Al Kallis has photographs of designs for some of these commissions, including *Not as a Stranger* and *The Sniper*. As published, some bore more relation to Saul's original concepts than others (AK/PK 2003). Three "promos" for actor Jack Palance sought to counter the stereotyping of him as a B-movie bad guy. One (p. 37) used a diagram (Awards List) Saul prepared for a scene in *Shane* (1953) while another highlighted his acting talents (p. 35). Credits for *No Voodoo* promo for Saul's San Francisco agent Dick Danner (p. 37): Saul Bass, art director; Todd Walker, artist (Awards List).

20 Al Kallis has photographs of designs for some of these (note 19). Those for *On the Threshold of Space* and *A Star is Born* are fairly close to the original designs; some for *Magnificent Obsession* less so. The "roughs" are more dynamic and more sensitive to "negative space" than the published ads. Some "roughs" included sketch portraits of film stars as placement markers for photographs but some studios saved money by using sketches rather than photography (AK/PK 2003).

21 The ad agency for the Blitz Beer posters and TV commercials was J. J. Weiner & Associates, the art director of which, George Dippel, was credited alongside Saul. The illustrators were Phyllis Tanner and Fritz Willi (Awards List). For the Pabco Paint series, the agency was Brisacher, Wheeler & Staff and its art director Ettore Firenze was sometimes credited as art director along with Saul. For some ads Saul, Al Kallis, Maury Nemoy and Art Goodman were credited as artists; for others Saul and Kallis or Saul and Firenze were credited as artists (Awards List).

22 *AP2: Artist Partners Present* London: printed by Walter and Whitehead Limited, c.1957 (Kirkham Archive). A two-page spread of Saul's work featured his *Arts & Architecture* cover, ads for National Bohemian Beer, California Test Bureau, Glide Windows, *Attack!* and Enfield Cables and a calendar for International Paints. The agency for the Enfield ads was John Carr & Associates Ltd. Phyllis Tanner worked as an illustrator on at least one of them [*Portfolio of Western Advertising*, February 1958, p. 68]; Art Goodman was cited as co-designer of another [*Graphis Annual*, no. 777, 1960–61]. Saul also

undertook several ads for Qantas Empire Airways, working with Firenze, then art director at Cunningham & Walsh.

23 For Shell see John Hewitt, "The 'Nature' and 'Art' of Shell Advertising in the Early 1930s," *Journal of Design History*, vol. 5, issue 2, 1992, pp. 121–139.

24 Speedway credits: Saul Bass, art director; Saul Bass, designer; Don Jim, photographer (Awards List).

25 The N.W. Ayer & Son agency held the Container Corporation of America ad account. Credits: Saul Bass, artist & designer; Walter Reinsel (Ayer agency), art director (*37th Annual of Advertising and Editorial Art*, 1958, no. 136). See also Georgine Oeri, "Container Corporation of America. Great Ideas of Western Man: Advertising by Inference," *Graphis*, vol. 13, no. 74 November–December 1957, pp. 504–513.

26 General Pharmacal credits: Saul Bass and Louis Danziger, art directors; Todd Walker, photographer; Yambert-Prochnow, agency (Awards List). The company went bust and Saul was not paid but he paid Danziger for his contribution, and credited him too. For the text, Saul hired John Howard Lawson, "one of the blacklisted Hollywood writers and a friend [of Saul's]" (Danziger to PK, email 2009).

27 Columbia Records' art director Alex Steinweiss introduced illustrated record sleeves for 78 rpm records in 1940 and for LPs in 1948. *Barber Shop Harmony* credits: Jerry Novorr, art director; Saul Bass, artist; Abott Kimball Company, agency; Columbia Records, advertiser (*29th Annual of Advertising and Editorial Art*, 1950, no. 210). The design date was probably before 1950.

28 Frank Sinatra, Statement, 1995, BA. *Blues & Brass* cover credit: Don Jim, photographer [*Portfolio of Western Advertising*, February 1959, p. 92]. Saul designed the *Trilogy* cover (1979) for Sinatra, who used to invite Saul and Elaine to recordings in Los Angeles (EB/PK 2004) and a cover for Sinatra's friend Sammy Davis Jr. (*Golden Boy*, 1964). Other album covers include Stomu Yamashta *Freedom is Frightening*, 1973, and *Sea & Sky*, 1984, *Brothers* (Taj Mahal, 1977) and *Blow Up* (1991 CD), for The Smithereens (long-term Bass fans).

29 SANE (Committee for a Sane Nuclear Policy) poster and invitation credits: Saul Bass, designer; Saul Bass, illustrator;

Art Goodman, illustrator (Awards List). SANE was founded in 1957 as a response to nuclear bomb testing and the arms race. Its mission was to "develop public support for a boldly conceived and executed policy which will lead mankind away from war and toward justice and peace." By 1958 it had over 25,000 members. In 1959 Steve Allen was active in the formation of the Hollywood group. Other graphic artists and designers involved in the national organization included Ben Shahn, Edward Sorel and Jules Feiffer.

30 *Saturday Evening Post* illustration credits: Saul Bass, art director; Saul Bass, designer; Saul Bass and Art Goodman, artists (Awards List).

31 A huge amount of research lay behind these designs. In typical Saul

Committee of Aluminum Producers, a playful brochure introducing the advantages of aluminum-hulled boats, 1960

fashion, he set about what was for him a new departure in a very systematic way, reading voraciously on child development and studying how others had approached illustrating books for children. He wanted to understand how children experienced images, the better to convey particular narratives to small children through images (SB/JM and "Top Drawer. A 'first' for Saul Bass," *Print*, vol. 16, no. 6, November 1962, p. 55). Credits: Saul Bass, designer; Art Goodman, designer [*Graphis Annual*, 1960–61, no. 777]. The images are bold, colorful, flat and "primitivist," and type is made to do amusing things. On the cover, a near-animated image summarizes a small boy's walk to and from Paris; Saul made the words of the title walk by tilting them and placing them over a pair of boots, as if legs. In one image the eye is directed through a huge pair of legs (Henri's), to trees on a horizon. As with *The Big Country* film titles (1958), one has a sense of both immediacy and distance. This beautiful book, long out of print, was Saul's only attempt at illustrating a children's book.

32 The films with Bass titles were *Storm Center* (dir. Taradash and prod. Blaustein) and *The Racers* (prod. Blaustein). Silverlake Lithographers printed the premiere invitation for *Exodus* and Max Yavno, a freelance photographer, undertook work for Saul (Awards List). Saul also produced a letterhead for Sy Wexler, of Wexler Film Productions, who co-produced *The Searching Eye* (Chapter 4). One of the awards for the portfolio of letterheads on pp. 68–69 cited Don Handel but without specifying a role (Awards List).

Notes 395

33 Panaview ads credits: Saul Bass, art director; Marvin Rand, photographer; Todd Walker, photographer (*33rd Annual of Advertising and Editorial Art 1954*, no. 68 and Awards List). Saul's ads for another California window manufacturer, Glide Windows, which featured images of skyscrapers and grids, were designed to appeal more to architects and builders. Glide Windows ads credits: Saul Bass, art director; Saul Bass, artist (Awards List).

34 In a similar vein, Saul used difficult-to-obtain effects in fine color printing for a range of full-color mail-out advertising for Brett Lithographing Company of New York (1953) so that potential customers could witness the quality of the firm's printing.

Lightolier, lighting company brochure cover, c. 1959

35 Saul humanized an image of a test recording by juxtaposing an image of a child.

36 Although best known as a graphic designer and a creator of film titles, Saul's high profile vis-à-vis product design in the late 1950s and early 1960s led Esther McCoy to refer to him as an "industrial designer" (*Modern California Houses: Case Study Houses*, New York: Reinhold, 1962, p. 148). See also "Proposed Traveling Exhibition – Art of Pre-History," BA.

37 The packaging was made from laminated cellophane – DIOphane and DIOlam – on board, folded flat for easier storage and transport. Phyllis Tanner, brought in to strengthen the "woman's perspective," was credited as co-art director with Saul [Wim Crouwel and Kurt Weidemann (eds.) *Packaging: An International Survey*, New York: Praeger, 1968, p. 44]; Art Goodman was also cited as co-designer in *Graphis Annual*, 1960–61, no. 777. See also Transparent Paper Limited, *Packaging Perspective: An Exhibition of Imaginative Thinking by Six International Designers*, London, 1959 (BA). The other designers were Olle Oksell, Sweden, Fritz Bühler, Switzerland, Willy de Majo, Britain, Yusaku Kamekura, Japan and Alberto Steiner, Italy. N.B. Another packaging project for a gender-specific product undertaken by SB&A was Fem napkins (Kimberly-Clark). For Saul and patent for cellulosic product see note 39.

38 For Bayer see Arthur A. Cohen, *Herbert Bayer: The Complete Work*, Cambridge, MA: MIT Press, 1984 and Gwen Finkel Chanzit, *Herbert Bayer and Modernist Design in America*, Ann Arbor, MI: UMI Research Press, 1987. For Bass and retail display see Oeri, "Saul Bass" 1955, p. 263 and Ebenhöh, p. 22. The agency for the Rose Marie Reid commission was Carson Roberts, headed by Saul's friend Jack Roberts. Saul, who was artist, designer and art director for the Rose Marie Reid packaging, mentioned the influence of Man Ray's "Rayograms" on it to Douglas Bell (OH, p. 35).

39 The Kleenex tissue boxes illustrated by Goldsholl in *Inside Design* (pp. 12–13) are similar to the tissue box shown here (p. 86), which probably dates to 1961, by which time the two men were designing some boxes separately. *Time* (March 16, 1962) noted that Saul had designed "another award-winning Kleenex box, now being marketed in the West" while Goldsholl had designed a new "color-drop Kleenex package" (http://time-proxy.yaga/com/time/magazine/article/0,93 93562,00.html, viewed August 28, 2006). In 1964, however, Saul and Goldsholl were jointly credited, together with Arthur Altree, as "inventors" of a Kimberly-Clark patent for a Carton for Cellulosic Product (CIPO Patent no.688408) that bears similarities to two Bass projects; the easy-to-open carton that divided into two dispensers and the Tee-Pee Nylons "purse pack" that appears to have been designed before the Bass/Goldsholl collaboration began (shown on p. 83).

40 The modular cabinets were test-marketed through "decorator sources." The amplifiers and tuner cabinets had white Formica fronts with control knobs in two color combinations (warm or cool). Tape recorder, turntable and speaker enclosures were faced in teak or walnut (Rita Reif, "Battle of Decibels And Décor," *New York Times*, November 16, 1958, X2 and "Cabinet Contains a Variety of Ideas for Housing Hi-Fi Equipment," *New York Times*, October 4, 1958, X25). Fred Usher was credited as "associate" on the speaker enclosure (Robert C. Niece, *Art: An Approach*, Dubuque, Iowa: Wm. C. Brown Company, 1963, p. 107). The design did not go into mass production. N.B. In 1956 Stephens TruSonic had commissioned the Eames Office to design speakers; these too did not go into mass production. For Pomona, Saul created tiles that could be sold individually or as part of a wider "tile wall." Advertisements for his "Sculptured Tile" group featured three designs based on a sphere, a star and a diamond, but he also designed other forms that, in conjunction with plain tiles, could be used to form larger designs. Saul also designed modular credenzas for himself and those who worked at the first Sunset Boulevard office, including the receptionist (for office locations see Chapter 1, pp. 24–25). The credenzas for the designers had dividers inside the drawers for the easy storage of art supplies. The credenzas moved with the personnel to the new (and final) office at 7039 Sunset Boulevard. Saul also designed versions for use at home; some customized to hold stereo components, records, etc.; others were for his and Elaine's studio areas. A few examples of these units survive in the family.

41 Pomona tile ads: *Arts & Architecture*, September 1958, p. 5 and November 1958, p. 30.

42 "Case Study House no. 20 by Buff, Straub & Hensman in Association with Saul Bass," *Arts & Architecture*, September 1958, pp. 20–21 and "Case Study House no. 20 by Buff, Straub & Hensman in Association with Saul Bass," *Arts & Architecture*, November 1958, pp. 11–17. Credits are usually given as the architects and landscape architects in association with Saul Bass but occasionally as Saul Bass in association with the architects and landscape architects. See also *The Case Study House Program, 1945–1966: An Anecdotal History and Commentary* (dir. Peter Kirby, video recording), Media Arts Services, Museum of Contemporary Art, Los Angeles, 1989.

43 Esther McCoy, *Case Study Houses*, p. 143, cited in Amelia Jones and Elizabeth A.T. Smith, "The Thirty-six Case Study Projects," in Elizabeth A.T. Smith (ed.), *Blueprints For Modern Living*, p. 68.

44 See "Saul Bass," *Print*, 1958, p. 22. Saul's 3-D work reveals a strong sculptural sensibility. Undulating forms are evident, from the layout of the proposed *Art of Pre-History* exhibition and urban playgrounds and toys to the model for a proposed Eastman Kodak Pavilion (1964, World's Fair). For the latter, and as realized by the Burtin office, see Roger Remington and Robert Fripp, *Design and Science: The Life and Work of Will Burtin*, Aldershot, England: Lund Humphries, 2007, pp. 106–107. The idea behind the playground designs was to offer different types of play for children of different ages and levels of physical ability and daring. The modular multipurpose components were intended for mass production. For playgrounds at the Capitol Towers housing development, Sacramento, see "Recreation and Playground Designs by Saul Bass," *Arts & Architecture*, no. 75, October 1958, pp. 20–21 and 33 and "Two Playgrounds by Saul Bass and Associates," *Arts & Architecture*, February 1960, pp. 14–15 (Associate Design credits: Herb Rosenthal and William Carmen; landscaping: Lawrence Halprin). A playground complex designed for City & Suburban Homes, California, is illustrated in Niece, p. 107 (Herb Rosenthal cited as associate) and "The Compleat Designer," p. 28 and a prototype scheme for Longwood Redevelopment East Corporation in Ralph Caplan, "Designs by Saul Bass," *Industrial Design*, vol. 5, October 10, 1958, p. 94.

45 David Badder, Bob Baker and Markku Salmi. "Saul Bass," *Film Dope* 3 (August 1973), p. 6 and *Saul Bass and Associates* (IDEA special issue), pp. 102–103.

46 EB/PK 2004 and http://hosting.zkm.de/icon/stories/storyreader$17?printfriendly=true and www.thesnowshow.com/en/participants/teams/ono-isozaki/index.html, viewed February 18, 2007.

47 See introduction to "Television Art" in *34th Annual of Advertising and Editorial Art and Design*, New York: Art Directors Club of New York, 1955. In 1950, 11% of U.S. homes had television; by 1960, 88%.

48 See "Advertising and Editorial Art: Television Commercial," in *34th Annual of Advertising and Editorial Art and Design*, no. 364–406, and introduction to "Television Art" in same volume. Other art directors, artists and animators mentioned in these two publications include Leo Salkin, Chauncey Korten, Rollins Guild, Art Babbit and Stan Walsh. Leading advertisers in the early to mid-1950s included Heinz, Goodyear, Ford, National Speedway Petroleum, Bank of America, General Foods, Mennen, CBS and the Ford Foundation. For Georg Olden, Director of Graphics at CBS Television in the mid-1950s, see Julie Lasky, "The Search For Georg Olden" in Heller and Ballance, eds., pp. 115–128. For television and design see Lynn Spigel, *TV by Design: Modern Art and the Rise of Network Television*, Chicago: University of Chicago Press, 2008; for Saul and television see *Saul Bass and Associates* (IDEA special

EB, Saul created this logo, which was embossed on Elaine's personal stationery, c. 1961

issue), pp. 112–115. References to television are taken from the latter unless stated.

49 Stewart Kampel, "Giving Credit Where It's Due – In Graphic Arts," *New York Times*, January 12, 1964, X19. See also "Playhouse 90 Show Opening Design by Saul Bass," BA, and Gid, "Saul Bass: New Film Titlings," p. 156. The series included *Flashing Spikes* (1962, dir. John Ford). Sometimes Saul is credited with the very brief opener but he never claimed it. Credits for ABC Fall line-up: Saul Bass, art director; Art Goodman, artist; Robert Cannon, artist; Richard Barlow, artist; National Screen for ABC, producer/client (Awards List). Credits for Olin Mathiesen commercial: Saul Bass and SB&A, art direction and design; Art Goodman, artist; Bill Melendez (National Screen Services), artist (Awards List). Art Goodman and Bill Melendez worked with Saul on the TV opener for *4 Just Men* (Awards List).

50 SB/PK, 1994 and Lane, p. 19.

51 *Saul Bass and Associates* (IDEA special issue), p. 115.

52 SB/PK, 1994 and Lane, p. 19. The Mennen commercials were made for the

Chicken of the Sea, tuna packaging, c. 1958

Grey Advertising Agency. The Baby Magic commercial won first prize at the Cannes Festival for TV Publicity, 1963 (Awards List).

53 SB. "The Best Of The Bolshoi," BA and Gid, "Saul Bass: New Film Titlings," p. 158.

3

Reinventing Movie Titles

1 Raymond Gid, "Saul Bass: New Film Titlings and Promotional Films," *Graphis*, vol. 19, no. 106, March 1963, p. 150.

2 SB/PK, 1993 and Kirkham, "Looking for the Simple Idea," *Sight & Sound*, vol. 4 (February 1994), p. 16.

3 Dean Billanti, "The Names Behind the Titles," *Film Comment*, vol. 18, no. 3, May–June 1982, p. 68. Other examples of imaginative openings in pre-sound U.S. cinema include *Stage Struck* (1925, dir. Allan Dwan) that opens with a fantasy daydream in 2-strip color (Van Nest Polglase was art director). In the 1930s, when feature films were about 90 minutes, the average title length was 1.8 minutes, i.e. 2% of the total. By the 1960s, when many feature films were two hours long, some credits took up to six minutes, i.e. 5% of the total (Joseph Mathewson, "Titles Are Better Than Ever," *New York Times*, July 16, 1967, J1). See also Deborah Allison, "Novelty Title Sequences and Self-Reflexivity in Classical Hollywood Cinema" (www.latrobe.edu.au/screening thepast/20/novelty-title-sequences.html, viewed March 3, 2007); Merle Armitage, "Movie Titles," *Print*, 1947, pp. 38–44; Leonard Spinrad, "Titles: There's More to Them than Meets the Eye and Ear," *Films in Review*, 6, April 1955, pp. 168–70; Saul Bass, "Film Titles – A New Field for the Graphic Designer," *Graphis*, vol. 16, no. 89, May 1960, pp. 208–216; and Gemma Solana and Antonio Boneu, *Uncredited: Graphic Design & Opening Titles in Movies*, Barcelona: Index Book, 2007. N.B. When Saul and Elaine created the title sequence for *That's Entertainment, Part II* (1976, dir. Gene Kelly), their research included a study of the openings of "old movies" (see note 131).

4 Kirkham, "Looking for the Simple Idea," p. 16, "Academy Presentation 10/4/82," BA, and Billanti, p. 68. To help change how title sequences were regarded, from the mid-1950s Preminger tried to ensure that the screening of his films only began after all curtains were fully raised (SB/PK, 1993).

5 Aspen Interview.

6 Kirkham, "Looking for the Simple Idea," pp. 16–18.

7 SB/PK 1993.

8 "The American Film Institute Seminar with Saul Bass held May 16, 1979," BA.

9 When Saul designed and storyboarded the battle scenes for *Spartacus*, he functioned as production designer, art director, choreographer and assistant director rolled into one. When he conceptualized and made preliminary sketches of the gladiator school he functioned more as a production designer; indeed his work was handed over to the film's production designer, Alexander Golitzen, for development and realization. Golitzen, however, was concerned that Saul's credit should be clearly differentiated from his (SB/JM). For Boris Leven's similar worries vis-à-vis *West Side Story* see Leven Collection, file LF-172. Boris Leven to Arthur Knight, October 13, 1961, AMPAS SC.

10 Peck Collection. Box 4 (Saul Bass). Fred Steinmetz to William Wyler, May 16, 1957 and Gregory Peck to Leon Roth, April 11, 1957, AMPAS SC. Saul designed several trailers, including those for *The Man with the Golden Arm* and *The Pride and the Passion*. We do not know how many he designed but it is likely that more will emerge as film scholars pay greater attention to trailers, a task that should become easier now that trailers are increasingly included in the supplementary material featured on DVDs of Hollywood films.

11 The final ad campaigns for *The Big Country* and *The Pride and the Passion* are examples of studios using only particular aspects of Saul's designs. Many of the main one-sheet posters that Saul designed in the 1950s and 1960s were altered (to greater or lesser degrees) because of studio requirements, or in some cases not used. Saul had silkscreen versions of his preferred designs printed for his own use (including a trade ad for *The Magnificent Seven*). The silkscreen versions usually involved a more pure treatment of the symbol that he created for each film. He often signed these posters and gave them as gifts to people visiting the office. When, by the mid-1980s, supplies were running low, he decided to print more and, in some cases, further refined the image. Only some are included in this book, namely *The Man with the Golden Arm*, p. 117; *Anatomy of a Murder*, p. 133, *Advise & Consent*, p. 143; *The Cardinal*, p. 149; *In Harm's Way*, p. 150; *Bunny Lake is Missing*, p. 153; *The Magnificent Seven*, p. 190; *Seconds*, p. 218; *Grand Prix*, p. 220; *Nine Hours to Rama*, p. 398 and *The Fixer*, p. 405.

12 Saul designed a symbol for the production stationery for *West Side Story* (p. 199) but he did not claim the final campaign. For *Saint Joan* see United Artists Advertising Supplement to the press book. *Psycho* and *North by Northwest* are examples of films for which Saul designed the titles but not advertising, as opposed to *Vertigo* for which he designed titles and advertising.

Bonjour Tristesse, newspaper ads, 1958

13 Kirkham, "Looking for the Simple Idea," p. 20.

14 *Who Knows Saul Bass?* (DVD, Germany, 1991, Carl Schmid production).

15 SB/PK, 1993 and "notes," BA.

16 *Who Knows Saul Bass?* DVD.

17 Mogens Rukov, "Simple Notes on Saul Bass's Fragments," in Thomas Kray and Tim Volsted (eds.), *Title Sequence Seminar: Saul and Elaine Bass*, Copenhagen: The National Film School of Denmark, 1995, pp. 6–7.

18 "Academy Presentation 10/4/82," BA. See also Bruce Kane and Joel Reisner, "A Conversation with Saul Bass," *Cinema*, vol. 4, Fall 1968, p. 34.

19 Kane and Reisner, p. 34. Saul preferred to be involved from the very earliest stages of a film or at least to have the script well before beginning work. Making a title sequence while the film was being shot, as opposed to after it was completed, he felt, made a tremendous difference in terms of refining ideas and making changes (SB/PK 1994).

20 SB. Notes on typed draft of Saloment Cort, BA. See also Kane and Reisner, p. 31.

21 SB/PK 1993, SB and BW/PK 1994, and Kirkham, "Looking for the Simple Idea," pp. 16–18.

22 Andy Hoogenboom/PK 2003.

23 Charlie Watts/PK 2003.

24 Katsumi Asaba, "A Man with Soulful Gaze," in *Memorial Writing – So Long, Saul Bass*, 1996, BA.

25 Katsumi Asaba, "A Man with Soulful Gaze."

26 Lella and Massimo Vignelli/PK 2000 and 2008 (New York).

27 AG/PK 2003.

28 Martin Scorsese, tribute, "Celebration."

29 SB "Otto Preminger Tribute 1977," BA and "AT&T Management Conference" (in pencil), BA.

30 Saul worked on three other Preminger films but not to anything like the same extent. He told *Film Dope* that he had done little for *Such Good Friends*, 1971 (Badder, Baker and Salmi, p. 2). Conceived by Saul and designed by him and Art Goodman, the symbol of intertwining legs owed much to Milton Glaser and Matisse in graphic terms. It proved apt for a film about an unfaithful husband and a wife exploring her sexuality. Some of the advertising featured the symbol alone; some in conjunction with pages of a diary noting rendezvous. For *Rosebud*, a 1975 film about a "Black September" kidnapping of five girls, the symbol is a dagger, while for *The Human Factor*, a 1979 spy thriller, it is a telephone handpiece left dangling midair.

31 Pamela Haskin, "Saul, Can You Make Me a Title?," *Film Quarterly*, vol. 50, no. 1, Fall 1996, pp. 14–15. Saul spoke to me of "fangs-bared fights" with Preminger. Art Goodman recalled, "I don't know to this day how Saul managed to work with such a badly behaved man. After a particularly difficult meeting with Otto, Saul was so upset that he threw a telephone out of a window. I'll tell you an interesting thing about Saul: he had a temper but could rein it in as long as whoever it was had something to say that made sense" (AG/PK,

Newspaper cartoons, in the U.S. and Europe, inspired by the Advise and Consent symbol, 1962

2003). Preminger's realization that Saul would quit if he felt bullied or that design was not being improved upon, together with Preminger's huge admiration for Saul's work, are key to understanding the tenor of their working relationship after their initial skirmishes. In his autobiography, for which Saul designed the dust jacket, Preminger described Saul as "the best graphic artist I know" (*Otto Preminger: An Autobiography*, Garden City, NY: Doubleday, 1977, pp. 109–110). N.B. I am constantly told, or asked to confirm, that Saul was Preminger's son-in-law (Emily King, "Taking Credit: Film Title Sequences, 1955–1965," unpublished MA thesis, Royal College of Art, London, 1993, p. 16: posted online at www.typotheque.com/site/article.php?id=91). This was not the case. Indeed, Preminger's only daughter, Virginia, was not born until 1960 (the year before Saul married Elaine Makatura – see Chapter 1).

32 SB/PK 1994.

Critic's Choice, Broadway play, 1960

33 Haskin, p. 12.

34 Preminger, p. 110 and *The Moon Is Blue* press book.

35 SB. Sidebar, BA, SB/PK 1994 and *Carmen Jones* press book.

36 The sensual slow-burning flame was achieved by over-cranking – "not just slightly but 8–10 times" (SB to PK 1995, London). Main poster credits: Saul Bass, art director; Saul Bass, artist; Al Kallis, artist. At Saul's request as art director, Kallis, an illustrator, was responsible for final drawing of the figures (AK/PK 2004).

37 "Frames from the Title by Saul Bass," BA. The title sequence cost $3,500 (Peck Collection, Box 4. Saul Bass to Tom Andre, June 11, 1957, AMPAS SC).

38 SB/PK 1993. See also Badder, Baker and Salmi, p. 2, and *Saul Bass and Elmer Bernstein: Harmonious Overture*, VHS interview, NRD Concepts, London, 2003.

39 See *The Man with the Golden Arm* press book. Saul later printed a silkscreen version of the one-sheet poster that conformed to his preferred design, i.e. without any images of film stars. Many of Saul's poster designs, especially one-sheets, were altered because of studio requirements and he had silkscreen versions of his preferred designs printed for his own use (see note 11). In terms of credits for *The Man with the Golden Arm* advertising campaign in general, Saul was

Notes 397

usually credited as art director and artist but award citations (almost certainly supplied by him) credit him as both art director and artist, plus Phyllis Tanner, Al Kallis and Maury Nemoy (lettering) as artists (Awards List). The symbol, accompanied by the name of the film and "A film by Otto Preminger," appeared on smaller items; newspaper ads, stationery, invitations, window cards, TV announcement cards, an audience questionnaire and sheet music. For larger items, including most posters and trade ads, the symbol and name were incorporated into a collage-like design resembling a maze.

40 SB/PK 1994.

41 SB. "Lecture Notes," BA.

42 SB. Sidebar, BA.

Theater marquis, with just the symbol, 1960

43 "Frames from the Title by Saul Bass," BA. See also Saul Bass, "Film Titles," p. 210. One-sheet poster credits: Saul Bass, art director; SB&A, Phyllis Tanner and Morton Dimondstein, artists. Trade ads, album and book cover credits: Saul Bass, art director; Tanner and Dimondstein, artists (Awards List). Preminger went to great lengths to ensure that the identity program was respected: Mort Nathanson of United Artists (distributor) issued a memorandum stating that even the smallest items of correspondence must use Saul's specially designed stationery. Those who forgot were strongly reprimanded (Memoranda, November 14, 1956. Kirkham Archive).

44 "Frames from the Title by Saul Bass," BA. See also John Halas and Roger Manvell, *Design in Motion*, New York: Visual Communication Books, 1962, p. 89 and *Bonjour Tristesse* press book. The name of the film was spelled out in strong but unobtrusive capitals with a slight "kick" to the first "R" to break the uniformity. In the larger posters and album cover, the color on the eyebrows flakes away, adding texture to an otherwise deliberately flat design and emphasizing the hand nature of the stroke. Main poster credits: Saul Bass, art director; Saul Bass and Henry Markowitz, artists [Victor Trasoff, "Art Directors Club of New York," *Graphis*, vol. 15, no. 81, January–February 1959, p. 38]. The same credits plus Harold Adler (lettering) were given on an award for the poster while an award for an ad cites Saul as art director and him and Adler as artists (Awards List). A sticker for the Dell reprint of the Françoise Sagan novel on which the film is based, the script cover and some ads use an alternate pink, black and white color scheme.

45 Martin Scorsese, "Saul Bass: Anatomy of a Synthesist," *New York Times Magazine*, December 29, 1996, p. 45. See also Saul Bass, "Film Titles," pp. 209–214. Symbol, "body," trade ads and announcement folder credits: Saul Bass, art director; Saul Bass, artist. Title sequence credits: Saul Bass, art director; Art Goodman and Paul Starr, artists [Awards List and *Western Advertising*, February 1960, pp. 147 and 151]. The common color configuration in the main advertising is red background and black "body" but in the one-sheet poster a strong orange background takes up just over half of the space while the red block below carries the names of the lead players and the production company. Some posters featured images of stars and horizontal bars that suggest clues or slices of evidence that reveal some but not all of the "picture" or story.

46 "Frames from the Title by Saul Bass," BA and Saul Bass, "Film Titles," p. 214.

47 See Preminger, *Autobiography*, pp. 166–169. Preminger stated that MGM sold the script because it feared an Arab boycott of that and future MGM films. He added that the then Israeli Opposition leader, Manachem Begin, complained to him that the Irgun was not given sufficient credit in the film for its role in the armed struggle that preceded the establishment of the state of Israel. Prime Minister, David Ben Gurion, Golda Meier (then Minister of Foreign Affairs) and General Moshe Dayan felt the script gave "too much credit to the extremists – the Irgun and the Stern Gang" and Arab groups objected to the biased representation of Arabs (*Autobiography*, pp. 166–167). Symbol credits: SB&A, art

Nine Hours to Rama, poster, 1963

direction; Saul Bass, designer; Art Goodman, artist. Ad campaign credits: Saul Bass, art director; Don Jim, photographer. One- and 24-sheet poster credits: SB&A, art direction; Saul Bass, design; Art Goodman, artist; Dave Nagata, artist; Don Jim, artist. *All Wrapped Up* credits: SB&A, art direction; Saul Bass, designer; Art Goodman, artist; Gerald Trafficanda, photographer (Awards List). See also "Saul Bass: Recent Work," *Print*, vol. 15, May 1961, p. 43.

48 PK/SB 1995 and SB. Sidebar, BA. See also Richard Warren Lewis, "Box-Office Bait By Bass: A Designer Masters the Fine Art of Hooking an Audience," *Show Business Illustrated*, January 23, 1962, p. 50. The imagery of the symbol, like that for *Spartacus* (also 1960) draws on graphics associated with radical politics. The clenched fist with gun here poses the militants as freedom fighters. David Crowley kindly pointed out to me that, at this date, photographs of U.S. civil rights demonstrators show arms raised high and clenched fists as markers of resistance. These images, as well as earlier radical imagery, may have influenced Saul, who had a strong interest in civil rights.

49 "Frames from the Title by Saul Bass," BA and "Saul Bass: Recent Work," *Print*, vol. 15, May–June 1961, p. 43.

50 Tom Ryan, *Otto Preminger Films "Exodus": A Report by Tom Ryan*, New York: Random House, 1960, p. 28. They were designed to mark the first day of filming, the company leaving Haifa for Jerusalem, moving from Jerusalem to Cyprus and the final day of shooting.

51 SB/PK 1995 and "Academy Presentation 10/4/82," BA. Saul designed some 20 symbols for this film before returning to his first ideas (Lewis, "Box-Office Bait," p. 50).

52 Will Lane, "Anatomy of an Image Maker," *Media Agencies Clients*, December 7, 1964, p. 22. See also "Academy Presentation 10/4/82," BA. Ad campaign credits: Saul Bass, art director; Art Goodman, artist (Awards List).

53 *Bass on Titles*, Santa Monica, CA: Pyramid Film & Video, 1977. Saul also designed the cover for the "tie-in" paperback edition of the novel by James Bassett (Signet books/Paramount Pictures, 1965).

54 "*Bunny Lake is Missing*. Title designed by Saul Bass," BA. The symbol was used on trade ads and posters, stationery, and script and album covers.

55 See Kirkham, "Saul Bass and Billy Wilder: In Conversation," *Sight & Sound*, vol. 6, June 1995, pp. 18–21 and *Charles and Ray Eames: Designers of the Twentieth Century*, Cambridge, MA: MIT Press, 1999, pp. 63, 134–135, 312, 320 and 323. Wilder's interest in design went back to his days in Germany where he bought modern furniture, including tubular steel furniture by Bauhaus "master" Marcel Breuer. He left it behind when, in 1933, he decided that, as a Jew, there was no safety in returning to his native Austria and moved to the U.S. (BW to PK 1994). Wilder admired furniture by the Eameses, who became close friends. He engaged them to create montages within *The Spirit of St. Louis*, 1957. *The Seven Year Itch* sequence was one of the most expensive of Saul's early titles. Shot in Cinemascope color, it cost $8,000 (Peck Collection, Box 4). Saul Bass to Tom Andre, June 11, 1957, AMPAS SC. N.B. The "How would Lubitsch do it?" sign in Wilder's office was designed by Saul at Wilder's request (Charlotte Chandler, *Nobody's Perfect: Billy Wilder, A Personal Biography*, New York: Simon & Schuster, 2004, p. 79).

56 Kirkham, "Saul Bass and Billy Wilder," p. 20. Wilder remarked that both he and Saul missed what has become the *de facto* symbol for the film, namely Marilyn Monroe with the skirt of her dress blowing up (BW to PK and SB, 1994) but at least one contemporary trade ad used it (*New York Times*, May 29, 1955). The lettering used in the sequence was executed by Harold Adler who stated that, at a meeting of about six or seven people, including Saul, the idea for the letters to scratch an itch came from one of the animators (Harold Adler/David Peters, 2001). This may well have been the case. Saul was always willing to listen to ideas and invariably knew a good one. Art Goodman, however, was skeptical about the idea not coming from Saul, pointing out how typical it was of Saul's humor and emphasizing Saul's own facility with lettering. Goodman felt that if the idea had come from someone else, then it most likely would have emerged

In Harm's Way, press book, 1965

from one of the "fun brainstorming sessions" Saul so loved; one in which Saul would have asked something like "What tricks can we make these letters do?" (AG to PK 2004).

57 Saul Bass, "Film Titles," p. 209.

58 A partially pulled blind was used as a background by Paul Rand on a 1945 Orbach's store ad (Steven Heller, *Paul Rand*, p. 66) but Rand did not use it metaphorically. A blind also features in Saul's 1953 ads for *The Moon Is Blue*. *Love in the Afternoon* poster credits: Saul Bass, art director and artist; Art Goodman, artist (Trasoff, p. 38) and with the addition of SB&A after Goodman as "artist" (Awards List). N.B. Some of the trade advertisements for *Sabrina* (1954, dir. Wilder) may have been designed by Saul, and the lettering for the posters for *Some Like It Hot* (1959, dir. Wilder) may have been part of an ad campaign initially designed by Saul.

59 Kirkham, "Saul Bass and Billy Wilder," p. 20. Credits: SB&A, art direction; Saul Bass, design; Art Goodman artist (Awards List).

60 When I met with Saul and Billy Wilder in 1994, Saul presented Billy with original artwork for the "Coca-Cola" campaign. Beautifully executed, this otherwise two-dimensional piece featured a miniature silk flag of the U.S. on a matchstick-like pole.

61 The distributing company felt that the original name, *Fragile Fox* (after a Broadway play about an eponymous infantry company), was not sufficiently well known to convey that this was a war movie. This name change explains not only Saul's change-of-name ad (*Hollywood Review*, October 18, 1956) but also the exceptionally large (10-page) release ad. Aldrich, who had commissioned trade advertising from Saul in the early 1950s (Chapter 2), was one of the first producer/directors to commission a title sequence – for *The Big Knife* (1955), a film openly critical of the Hollywood studio system. Saul used live footage, moving the camera in on a man clutching his head in despair; jagged cracks create a visual metaphor for him "cracking up" as his career collapses. Two other titles

created in 1955 also reveal Saul feeling his way in a new medium. The simple live-action sequence for *The Racers* opens with black and white checks that become a starter's flag. Credits are cued by flag movements and off-stage sounds: the producer credit, for example, appears to the sound of a skid crash. For *The Shrike*, a misogynistic drama about destructive love, Saul symbolized the disintegration of a marriage and psychological castration by a pair of giant scissors. Today the Freudian references seem heavily clichéd but at the time established the film as "modern" and "adult." See '*The Racers* – Title Design by Saul Bass," BA, Badder, Baker and Salmi, p. 2; Halas and Manvell, p. 86; and press books for all three films.

Bunny Lake is Missing, press book cover, 1965

62 Saul Bass, "Film Titles," p. 214. The face in the title sequence is that of Saul's daughter Andrea. The face of a young actress (not Bette Davis) was used for the advertising. Credits for ad campaign, including the 24-sheet billboard poster that won the Kerwin H. Fulton Medal (p. 164) and a trade ad that won a Distinctive Merit award (both from the New York Art Directors Club): Saul Bass, art director; Saul Bass, artist; Al Kallis, artist (*36th Annual of Advertising and Editorial Art*, New York: 1957, pp. 181 and 154 respectively, and Awards List). Credits for the poster illustrated on page 165: Saul Bass, art director; Saul Bass, artist (Awards List). In the latter, Saul reinforced the "anti-American" nature of the attack on free speech by quoting Thomas Jefferson in clear, measured type: "If the book be false in its facts, disprove them, if false in its reasoning, refute it, but for God's sake let us freely hear both sides, if we choose."

63 Saul Bass, "Film Titles," p. 210. For technical difficulties related to animation and wide-screen formats see Bob Allen, "Designing and Producing the Credit Titles for *It's a Mad, Mad, Mad, Mad World*, *American Cinematographer*, vol. 44, no. 12, December 1963, p. 707.

64 John Halas, "Titles and Captions," in Walter Herdeg (ed.), *Film and TV Graphics: An International Survey of Film and Television Graphics*, Zurich: Graphis Press, 1967, p. 134. The credit sequence cost $60,000 to produce, excluding Saul's fee (Lewis, "Box-Office Bait," p. 50). N.B. Saul did not design the main advertising for this film.

65 "*Edge of the City*," BA. See also "Radio Announcements" in the press book. The sequence cost $3,300 (Peck Collection, Box 4. Saul Bass to Tom Andre, June 11, 1957, AMPAS SC).

66 The Peck Collection (AMPAS SC) contains material related to Saul's work on this film, including the title sequence that cost approx. $7,000 (Box 4, Saul Bass to Tom Andre, June 11, 1957). Features such as boxed sketches of the stars and an extended line of silhouetted figures (a device also used re: *The Big Country*) suggest Saul's "hand" somewhere in this ad campaign. Direct mail graphics credits: Saul Bass, art director; David Fredenthal (photographer), artist. Credits for booklet: Saul Bass, art director; Saul Bass, artist; Bob Guidi, artist; Ed Renfro, artist (Awards List). For trailer sketches see *The Pride and the Passion* press book, p. 5.

67 John Frankenheimer, tribute, "Celebration."

68 Badder, Baker and Salmi, p. 2. Little is known about the ad campaign but the billboard design in the Bass Collection suggests that Saul was involved at some point. One ad, featuring a black and white photograph of "*The Young Stranger*" (James MacArthur) and minimal text, was produced by the J. Walter Thompson Agency (*36th Art Directors Annual*, New York: 1957, no. 186). This and an insert poster have a "Bass" feel to them.

69 "Cowboy," BA. Saul also designed some of the advertising, including trade ads.

70 Tom Andre of Melville Productions pushed hard for Saul to get this commission, informing director William Wyler that Saul had done "an outstanding job" on the advertising for Robert Wise's 1956 *Somebody Up There Likes Me* (Peck Collection, Box 4; Tom Andre to William Wyler and Gregory Peck, June 3, 1957 AMPAS SC). Producer and star Gregory Peck (familiar with Saul's work from *The Pride and the Passion*, if not before) was also keen to have Saul. When studio executives procrastinated about paying $10,000 for a full ad campaign, plus $5,000 for the title sequence, Saul's lawyer informed them that his client was not interested in doing the advertising if he could not also do the titles and, on another occasion, that "Mr. Bass's services" might be lost. How much was bluff we will never know but the $5,000 for the title sequence was subsumed within the production budget; the $10,000 advertising fee within the distribution budget. Saul was reassured that Peck and Wyler were "most anxious" to have him start work on the picture, and he began designing before receiving an advance. He estimated the production of this live-action title at $3,000–$3,500. (Peck Collection, Box 4, Gregory Peck to Leon Roth, April 11, 1957; Steinmetz and Murrish to William Wyler, May 16, 1957; Tom Andre to Messrs. Tyler, Feck, Swink, June 5, 1957; Tom Andre to Marvin Mayer, June 12, 1957; Fred Steinmetz to Marvin Mayer and Tom Andre, June 21, 1957. AMPAS SC. See also "Academy Presentation 10/4/82," BA.)

71 SB. Sidebar, BA and Ccrt, p. 325.

72 Mitch Tuchman, "Wayne Fitzgerald Interviewed by Mitch Tuchman," in Billanti, p. 39.

73 Photographers Don Jim and artist Morton Dimondstein were credited as artists for the ad campaign (Awards List). Saul originally proposed a full ad campaign [titles, trademark, trailers (TV and screen)], posters, trade and newspaper ads, album cover and New York subway car card (see note 10).

74 SB. Sidebar, BA.

75 For Hitchcock and inter-titles see Donald Spoto, *The Dark Side of Genius: The Life of Alfred Hitchcock*, Boston: Little Brown, 1983, p. 54 and Stephen Rebello, *Alfred Hitchcock and the Making of Psycho*, New York: Dembner Books, 1990, pp. 57 and 142. N.B. Before Hitchcock's *The Lodger* (1926, GB) was released, designs by Edward McKnight Kauffer (a graphic designer admired by Saul) were added to the title cards (BFI Screenonline). All three title sequences Saul created for Hitchcock were produced by National Screen Services. Harold Adler, a designer of film advertising and lettering, who worked on them, noted that Saul's storyboards were always "very complete and precise" (Rebello, p. 140).

76 SB/PK 1994. See also Kirkham, "The Jeweller's Eye," p. 18. The face is not that of star Kim Novak but rather that of a little-known actress whose features Saul considered both universal and specific (Dan Auiler, *Vertigo: The Making of a Hitchcock Classic*, New York: St. Martin's Press, 1998, p. 155).

77 SB/PK 1994 and Kirkham, "The Jeweller's Eye," p. 18.

78 AG/PK 2003. Versions of the main poster appeared as trade ads. Long before the film's release, and before Saul's involvement, Paramount executives worried about its financial viability, considering it too costly, too arty and too abstruse [see Hitchcock Collection, Folder 1003 (Titles). Memo, October 22,

Grand Prix, two-page trade ad, 1966

1957, AMPAS SC]. Saul's advertising was regarded in much the same light. Rebello noted that, after poor opening box-office receipts, Hitchcock was persuaded that more hard sell advertising was necessary (p. 151) but subsequent box-office receipts remained poor (Robert Kapsis, *Hitchcock: The Making of a Reputation*, Chicago: University of Chicago Press, 1992, p. 52).

79 Kirkham, "The Jeweller's Eye," p. 19.

80 Lissajous forms were named after Jules Antoine Lissajous who, in the 1850s, used sounds of different frequencies to vibrate a mirror, then traced the patterns made by the reflected light. See Sidebar p. 180 and www.math.com (viewed October 11, 2003). A Kepes image in *PM magazine* [see vol. 6 no. 3 (February – March 1940)], see illustration p. 393 and a Rayograph illustrated in Kepes's *Language of Vision*, p. 158 resemble the forms used in *Vertigo*. These, together with Saul's knowledge of Moholy-Nagy's light forms (independently and from studying with Kepes), indicate that Saul was well acquainted with this type of imagery from the early 1940s, if not earlier. Given that the Russian satellite *Sputnik* orbited the earth in 1957, it is difficult not to see contemporary preoccupation with outer space at work in the *Vertigo* sequence wherein Saul used swirling forms receding in and out of metaphorical spaces and places unknown as a means of accessing the experience of vertigo and alluding to uncharted regions of the mind. N.B. The opening credits for *The Blob* (released September 1958 – four months after *Vertigo*), a B-movie about an ever-expanding blob-like form from outer space that terrorizes an American small town, play against an ever-expanding spiraling form (special effects credits: Bart Sloane).

81 John Whitney, an experimental filmmaker who had worked in animation studios and for the Eames Office, performed mechanical miracles to produce the forms in the middle section of the sequence. In later years Whitney felt that his role in this title sequence did not receive sufficient attention, even though he was credited at the time. I hope that this publication will alter that. Lissajous forms, holograms and light forms and recorded or notated forms in general were popular in the late 1950s. Besides the continuing influence of Moholy-Nagy, sculptors Naum Gabo and Antoine Pevsner helped popularize curved forms with taut lines in the late 1930s and 1940s and Lissajous-like images appeared on the April 1946 cover of *Arts & Architecture*.

In Harm's Way, a frame from the trailer, 1965

Such Good Friends, poster, 1971

Very Happy Alexander, posters, 1969

The Human Factor, poster, 1979

Artists such as Peter Keetman and Ryuichi Amano, working in Germany and Japan respectively, were photographing light patterns in the late 1940s and early 1950s (Tom Maloney, ed., *U.S. Camera*, U.S. Camera Publishing Corp. 1952, pp. 225 and 207) and electronic light abstractions were featured in *Graphis* in 1954 and in 1957 when it was noted that such forms were increasingly used in commercial graphics (King, p. 31). Among those working with electronic abstractions was Morton Goldsholl who, like Saul, was influenced by Moholy-Nagy via Kepes, as well as by Kepes himself.

Whitney developed a mechanical analog computer using war surplus equipment shortly after *Vertigo*, and, according to his sons and the Whitney Foundation archivist, before then he used a mechanized pantograph. Just before Saul commissioned him, Whitney used a huge Foucault pendulum to etch Lissajous-like forms onto glass partitions in a restaurant interior. Saul saw them and engaged Whitney to make the forms he envisioned for the *Vertigo* title sequence [Auiler, p. 152; Michael Whitney, "The Whitney Archive: A Fulfillment of a Dream," *Animation World Magazine*, vol. 2, no. 5, August 1, 1997, pp. 1–3; and Michael Friend to PK, 2003. See also http://whitney.org/Research/Library/Archives, viewed February 18, 2006.]

Unfortunately, since Dan Auiler shifted from describing Whitney as making and moving the spiraling forms in *Vertigo* to referring to "Whitney's spiral designs" (p. 154) and "Whitney's images spiral in" (p. 155), there has been a tendency to confer design authorship upon Whitney. I do not want to take anything away from Whitney, without whom the forms used in *Vertigo* would not have been so beautifully produced, or perhaps not produced at all, but his role was that of maker. It needs to be remembered that Saul came up with the idea of using spiraling forms for this sequence and he designed, storyboarded, art directed and directed a three-part sequence, only one part of which involved spiraling forms. Furthermore, it is clear from Kepes's interest in such forms and Saul building a machine to reproduce them (see Sidebar and notes 80 and 82) that his interest in Lissajous and other recorded/notated forms was independent of Whitney.

Very shortly before the film was released, the title sequence had to be extended and additional forms were supplied by Whitney. These may have been the more spirograph-like forms of the type Whitney and his brother James had been experimenting with for over a decade and may have included the spiraling form that looks slightly less well finished than the others. Whitney was paid $800 for the additional work. Saul informed Herb Coleman of Alfred Hitchcock Productions that the forms supplied by Whitney would be "rendered with a thinner line and with more lines per area to match the character of the Storyboard forms," indicating that additional work was envisaged [Hitchcock Collection, file 1003, *Vertigo* (Titles). Saul Bass to Herb Coleman, February 26, 1958, AMPAS SC]. Crew member and special effects expert, John Fulton, helped with photographic distortions on the sequence. Art Goodman, who worked freelance for Saul at the time and was closely involved with the advertising for *Vertigo*, recalled Whitney producing the animation to Saul's art direction, just as he (Goodman) produced the posters according to Saul's art direction (AG/PK, 2004). Further research is needed on the production of this wonderful sequence. When it won the Club Medal for Best Motion Picture Title at the 1958 14th Western Exhibition of Advertising and Editorial Art the credits (almost certainly supplied by Saul) included Saul as art director and, in addition, Saul, Fulton and Whitney are noted as "artist" (Hitchcock Collection, Bass file, AMPAS SC). When the same organization gave an award for the *Vertigo* advertising, these same credits were repeated but other credits include Art Goodman, whom Saul frequently acknowledged as responsible for the illustration in the posters and other advertising designed and art directed by Saul (Awards List; see also AG/PK 2003). Whitney worked again with Saul, on *Best of the Bolshoi* (Chapter 2), and again Saul credited him in contemporary journals.

82 SB/PK 1994 The "Lissajous machine" that Saul constructed remained in his office well into the 1990s.

83 "Frames from the Title by Saul Bass," BA. The credits moving up and down the screen in this dynamic sequence suggest an elevator and there is an elevator scene early in the film.

84 Rebello, pp. 48 and 57.

85 SB/PK 1993 and Rebello, p. 140. Hitchcock told scriptwriter Joseph Stefano that Saul "was also going to storyboard the shower scene" and Stefano's first efforts went to Saul (Rebello, p. 48). Janet Leigh stated, "Mr. Hitchcock showed Saul Bass's storyboards to me quite proudly… telling me in exact detail how he was going to shoot the scene from Saul's plans. The storyboard detailed all the angles…" (Rebello, p. 102). Re: the titles, when the bars on screen are regularly massed, they suggest prison bars as well as window blinds and the voyeurism that is a feature of the film, from opening scene to shower scene. Saul, who always struck me as having a strong sense of the dialectic, enjoyed designing with oppositions and referred to "unity of opposites" as an old Marxist term (SB/PK 1994 and OH, p. 36).

86 Saul's fee for designing the title sequence was $3,000 and his contract included up to $2,000 for production sketches (Hitchcock Collection, File 1003. Herbert Coleman to Herman Citron, September 9, 1959, AMPAS SC). The making of the sequence is discussed in Rebello (pp. 140–142). One of the most expensive Bass titles of the period, it cost $21,000. Filmed at National Screen Services, Harold Adler stated that the lines that went up and down were animated; those that moved sideways were "done under camera with black bars" (Rebello, pp. 140–141). Adler, who helped Saul translate his designs to screen graphics, told Stephen Rebello, "I don't think [Saul Bass] was too technically involved or oriented at that time. One of the reasons he came to us at National Screen Services was that we tried to contribute to that concept and not let him make any mistakes. The storyboards for the *Psycho* [title sequence] were very complete and precise, which was true of all Saul's work, but I had to interpret them"; animation director William Hurtz and Paul Stoleroff were also involved (p. 140).

Art Goodman, who is credited as production supervisor for the title sequence (Awards List) felt that Adler's claim to Rebello about his input was "overblown" but acknowledged my point that Saul would have listened very carefully indeed to any recommendations made by a specialist (AG to PK 2004). When discussing Adler's claims to authorship of some of the lettering related to films for which Saul provided titles and ad campaigns (Jill Bell, "Calligraphy's Role in Hollywood: A Look at Hand Lettering and Calligraphy in Particular in the Film Industry," *Association for the Calligraphic Arts Newsletter*, vol. 5, no. 4, Summer 2002, pp. 5–6), however, Goodman was adamant that Saul would never have handed over the design of lettering, an area in which Saul had specialized since his teenage years, to Adler. He stated, "I know everyone wants their 15 minutes but Saul was so adept at lettering that there was no reason why he wouldn't design it. I saw him work on lettering on every project from the late 1950s onwards" (AG to PK 2004).

Adler clearly played some role in translating designs for lettering into lettering on film but any involvement that related to design decisions about lettering would have been taken in full collaboration with Saul; at best Adler would have been a co-designer, with Saul as art director, and also co-designer. Adler, in discussion with Bell, however, claimed the lettering on *The Man with the Golden Arm* but Bell noted that there was evidence of Maury Nemoy (a friend of Adler's who had shared office space with Saul – see Chapter 1) working on it (Bell, pp. 5–6). Indeed, there seems to be no evidence of Adler working on it, whereas Nemoy featured it in ads for his work that he placed in *Western Advertising*, along with lettering executed for *Saint Joan* and *The Man with the Golden Arm* as well as for ads for Qantas and Pabco (Awards List and *Western Advertising*, vol. 70, no. 1, August 1957, p. 184). Credits related to awards in the Bass Archive include Nemoy for *The Man with the Golden Arm* and Adler for *Bonjour Tristesse* (Awards List). Although the precise roles Adler and Nemoy played vis-à-vis the lettering are not known, they were credited for their contributions at the time and later (note 97, Chapter 1).

87 Rebello, pp. 57–58. Although Hitchcock had a reputation for being tight with money, he insisted on hiring Saul as consultant at the then very high fee of $10,000 (he refused to go as high as that for the rights to the book on which the film was based). His financial advisers argued against paying so much because Hitchcock was using his own money to produce the film (the budget for the movie was just over $800,000), but Hitchcock vetoed suggestions that the fee be lowered. Saul's fee as a visual consultant was the same as that for supporting actor Vera Miles and, taken at a weekly rate, earned him three times as much as editor George Tomascini. The total paid to Saul for all three aspects of his work came to just under $17,000, just short of the $17,500 paid to Bernard Herrmann for scoring the entire movie and approximately $8,000 less than Janet Leigh's fee of $25,000 (see Hitchcock Collection. Herbert Coleman to Herman Citron, September 9, 1959 and folder 587, AMPAS SC; Rebello pp. 57–65 and 100–102; and Andreas Timmer, *Making the Ordinary Extraordinary: The Film-Related Work of Saul Bass*, unpublished PhD dissertation, New York: Columbia University, 1999, p. 103 and note 83, p. 138).

88 Ferren's internal sequence in *Vertigo* looks amateurish in comparison to Saul's opening sequence, a point presumably not lost on Hitchcock when deciding whom to hire for the shower scene in *Psycho*.

89 SB/PK 1994. See also Rebello, pp. 57–58 and 105. Given that the scene as filmed closely follows the storyboard and that Saul's image of a bloodstained hand pulling the shower curtain off the bar, which is in the storyboard but not the movie, appears in stills (Janet Leigh, with Christopher Nickens, *Psycho: Behind the Scenes of the Classic Thriller*, New York: Harmony, 1995, p. 71 and Timmer, p. 108), it seems likely that all the storyboard images were shot.

90 SB. Sidebar, BA. See also SB/PK 1994, and SB lecture, School of Visual Arts, New York, March 1996. Since Hitchcock mostly shot exactly to storyboard, and, according to Saul, was sitting immediately behind him, this was a spontaneous "token" gesture, one more akin to a rite of passage than any abrogation of directorial authority [SB/PK 1995, SB/JM and "Hitchcock's Shower Scene: Another View," *Cinefantastique*, vol. 16, no. 4/5, October 1986, p. 66]. Indeed, Hitchcock had been allowed to do much the same when he worked as a young assistant at Lasky (Timmer, p. 118). The shots involved were short and simple and therefore Hitchcock was not taking much of a risk, especially since he had already carefully inspected Saul's setting up of them. Both Hitchcock and Saul were extremely meticulous in terms of preparation. For further discussion of the shower scene see note 92 and Pat Kirkham, "Reassessing the Saul Bass and Alfred Hitchcock Collaboration," *West 86th: A Journal of Decorative Arts, Design History, and Material Culture*, vol. 18, no. 1 (2011), pp. 50–85.

The Fixer, poster, 1968

91 SE Sidebar, BA; SB/PK, 1994; and SB lecture, School of Visual Arts, 1996.

92 See François Truffaut (in collaboration with Helen Scott), *Le Cinema Selon Hitchcock*, Paris: Editions Robert Laffont, 1966, pp. 209–210 and New York: Simon and Schuster (English translation), 1967, pp. 207–208. When Truffaut asked Hitchcock about Saul's contribution to *Psycho* above and beyond the title sequence (for which Saul had a separate credit: his credit for the other work was "pictorial consultant") Hitchcock stated, "He did only one scene, but I didn't use his montage. He was supposed to do the titles, but since he was interested in the picture, I just let him lay out the sequence of the detective going up the stairs, just before he is stabbed." Truffaut did not press further. By 1966, when the statement was published, *Psycho* had become world-famous, and the shower scene even more so. Hitchcock's statement that Bass's only contribution was to advise on a quite different scene is a gross understatement at best. Although Hitchcock thereafter never publicly acknowledged Bass's contribution to the shower scene, others involved in the movie did, some on more than one occasion (see below and Kirkham, "Reassessing the Saul Bass and Alfred Hitchcock Collaboration," pp. 50–85).

Although Hitchcock often found it difficult to give credit to collaborators, from Ivor Montague in 1926, for helping Hitchcock re-edit and rework *The Lodger* between previews and final release, to Bernard Herrmann for his musical scores, he was a director who gave art directors and others considerable artistic leeway (Rebello, p. 68). That was certainly Saul's experience.

When asked about directors getting credit and him not at an AFI Seminar in 1979, Saul stated, "…that's not unfair. The director, it's his film, it's under his umbrella that all of this happens. It's all operating within the framework of his vision." When asked about the shower scene, he spoke of Hitchcock's generosity and giving him the "go-ahead" to shoot, before adding "Hitch didn't remember it that way when he talked to Truffaut… But that's the way it was" ("American Film Institute Seminar with Saul Bass, May 16, 1979," BA). Saul understood that Hitchcock found the scene difficult to deal with after it became so famous: "You make a film and you have somebody work on a sequence that turns out to be the one that everyone talks about" ("American Film Institute Seminar," BA). In 1986 Saul told *Cinefantastique*, "It was Hitch's decision to agree to do what I was proposing to do. So it's his baby. I don't feel uncomfortable with that notion. On the contrary, Hitch was so generous to me that I can only think of him as a benefactor." When pushed to comment on Hitchcock taking all the credit for the shower sequence, he replied, "It didn't matter that I happened to be the vehicle through which certain things occurred. *Psycho* is still Hitch's film. Many people make contributions to a film and I had the honor of being one of those people on *Psycho*…(Hitchcock's Shower Scene: Another View," *Cinefantastique*, 1986, p. 66).

Saul rarely voiced his disappointment at Hitchcock's reply to Truffaut but when I asked him about it he replied, "Was I disappointed? Of course I was. We had been close. Yes it hurt that he did not acknowledge my work; I was, and am, proud of that scene – of course I'd cut it faster today but that's another story. I don't like to dwell on it but I did imagine those images. I designed that scene. I storyboarded it, shot a rough and supervised the final shooting with him. I had too much respect for Hitch to make an issue of it; after all, it is his film. I'm grateful to him for all of the great things he's done for film and for what I learned from him. He was my mentor; my 101 in filmmaking. He's a man whose friendship I valued. A man who gave me opportunities. And, this issue aside, was always very generous to me" (SB to PK 1995).

It bears repeating that Hitchcock paid a large sum of money for Saul's services and continued to sing his praises after 1960. By 1966, however, Hitchcock had experienced not only seeing *Vertigo* flounder while Saul's titles for it were greatly praised but also the shower scene, which in 1960 was regarded as a significant scene in a "B" movie that few thought would make it at the box office, take on a stardom of its own.

In 1973 the Bass/Hitchcock "debate" took a new turn. The London *Sunday Times* published an article of approximately 700 words on Saul's work, of which only about 130 words were devoted to *Psycho* and the shower scene. Unfortunately they included comments that Saul considered "totally untrue" (SB to PK 1995), especially the journalist's bald claim that Saul had "wound up directing" the scene [Philip Oakes, "Bass Note," *Sunday Times* December 9, 1973, p. 36]. Thus stated, many people were upset because they felt it implied Saul was claiming Hitchcock's role. Positions polarized again in the 1980s after articles in *Variety* and *Cinefantastique* raised the question of Hitchcock allowing Saul to "direct" the scene, despite Saul answering a question from London journalist Jane Harbord about Hitchcock taking all the credit by emphasizing that Hitchcock was the director of the film ["Bass Takes the Credit – But Not for *Psycho*," *Broadcast*, April 18, 1986, p. 17. See also *Variety*, June 3, 1981]. In October 1986, Saul reiterated his position, stating, "It came time to shoot and Hitchcock benignly waved me on. It was spontaneous. Not something he planned, discussed or organized. At that time, nobody paid much attention. There were lots of people milling around, doing what everybody has to do on a set. And the fact is, Hitch was always there and his 'presence' naturally dominated the set. As far as everybody on the set was concerned, including me, he was in charge whether or not he said 'action' or 'cut' or not" ("Hitchcock's Shower Scene: Another View," *Cinefantastique*, 1986, p. 66).

My sense is that if those who were upset by claims that Saul "directed" the scene had ever heard his telling of the story, it would have been apparent that he was not claiming a great deal. Indeed, it says much about the reverence in which Hitchcock was, and is, held that "Hollywood" people with considerable experience of newspapers and magazines wildly misrepresenting their own remarks took those supposedly uttered by Saul at face value. As noted, Saul's film work was based on doing the best that he could within the parameters of the director's vision, but Janet Leigh was particularly upset, insisting that she was on set all the time (now known not to be the case) and therefore knew exactly what happened (Leigh with Nickens, pp. 67–69). She acknowledged that Saul was on the set but stated that he did not "direct" her (Rebello, p. 109). What she forgot but others working on the film recall, and the records confirm, was that she was not on set for shots involving a body double or for shots that did not involve a body at all and that two cameras were used (Bill Krohn, *Hitchcock at Work*, London: Phaidon, 2000, p. 230 and Timmer, p. 108; where production records exist, they confirm that Saul was doing what he said he was doing and where he said he was doing it at any particular point). Others who were on the set were also upset at "director" claims but no one who interviewed them seems to have asked them about a possible gesture between Hitchcock the mentor and his latest "student." Although Saul told the story about the "directing" on several

The Shining, poster, 1980

The Two of Us, poster, 1967

Schindler's List, posters, 1993

occasions, the basic account remained the same and it needs to be remembered that he always stressed how the work he did for directors was for them; for their movies. Ironically, he was auteurist in that sense (see p. 109).

The issue, as I see it, is not whether someone was on the set all the time but rather that the people who got, and get, upset about what Saul was supposed to have claimed had, and have, a very different understanding from Saul of what he meant when he spoke of his mentor Hitchcock offering him the courtesy of calling "Action!" For Saul, for courtesy was more than a fond memory; it was evidence of Hitchcock acknowledging the very substantial role he (Saul) played in the shower scene, a role that, in 1966, Hitchcock had so casually side-stepped in the Truffaut interview.

Such has been the power of "auteur" theory in film studies until recently that many of those who wrote about this scene gave Saul little or no credit, despite his actual credits in the title sequence itself and visual clues such as the transition from bath to victim's dead eye being reminiscent of Saul's title sequence for *Vertigo*. William Rothman, for example, went as far as stating "nothing that makes the sequence a summation of Hitchcock's art derives from Bass's designs" (William Rothman, *Hitchcock: The Murderous Gaze*, Cambridge, MA: Harvard University Press, 1982, p. 364). Indeed, as Timmer points out, features that Victor Perkins and others credited Hitchcock with bringing to the scene are all recognizable within the Bass oeuvre and one can simply substitute "Bass" for "Hitchcock" in their texts without losing any of the sense (p. 106). As a Hitchcock fan, it seems to me that it takes nothing away from Hitchcock to acknowledge Saul's contribution.

In the end, however, there is only Saul's word for the claim that Hitchcock allowed him to call "Action!" It is perfectly plausible that, during the production of this cheap film, made extremely quickly under circumstances far from ideal, what passed between Hitchcock and Saul was simply not noticed. It is also plausible that Hitchcock, during a period of well-documented frustration trying to shoot the shower scene according to Saul's storyboard (the set was often soaked and the skin coverings worn by Janet Leigh took hours to dry out, thus greatly slowing down filming – see Rebello, p. 109), was relieved to be pressing on with his movie and, happy with the efforts of his meticulous consultant, felt sufficiently confident in their joint planning to allow the younger man the thrill of calling "Action!," as he himself had been allowed to do many years before.

It is ironic that Saul of all people should have been involved in an issue over credit because, unlike many "big name" designers of the period, including Charles Eames and George Nelson, Saul went out of his way to credit associates. I have written elsewhere about collaboration and credit and throughout this project have been struck by how much more careful Saul was to give credit to "associates" than other designers of the period. Saul's generosity in terms of credit was noted at the time (AK/PK 2003; Danziger to PK 2009). For collaboration and credit see also Kirkham, *Charles and Ray Eames: Designers of the Twentieth Century*, Cambridge: MIT Press, 1995, esp. pp. 63–95, *Women Designers in the USA, 1900–2000: Diversity and Difference*, New Haven: Yale University Press, 2000, esp. pp. 68–81 and "The Personal, The Professional, and the Partner(ship)," in Beverly Skeggs, *Feminist Cultural Theory*, Manchester: Manchester University Press, 1995, pp. 207–226. Saul told me that, "As the office grew bigger and bigger in the 1970s, it became increasingly difficult to credit everyone and so more often the Saul Bass & Associates credit was used, and then Bass/Yager & Associates. Ideally, of course, everyone should be credited" (SB to PK 1994. See also Chapter 1, note 90).

93 See Krohn, pp. 224–230; Timmer, pp. 98–118; and Kirkham, "Reassessing the Saul Bass and Alfred Hitchcock Collaboration," pp. 80–85.

94 SB, Sidebar, BA.

95 SB. Sidebar, BA.

96 "*The Facts Of Life*," BA. Title sequence credits: Saul Bass, art director; Saul Bass, designer; Paula Powers and Art Goodman, illustrators (Awards List). The film was produced by Norman Panama, who sought out Saul's services as title designer and visual consultant when he directed *Not with My Wife You Don't*, 1966. The humor of the film hangs on two rival American pilots who meet a nurse during the Korean War. She marries one (Tony Curtis) after he convinces her that the other (George C. Scott) is dead. Fourteen years later, the rival returns ... Saul was responsible for the titles (simple lettering in gay colored chalks on a blackboard) and a delightful animated cartoon about the green-eyed monster of jealousy, as well as transitions between certain sections of the film.

97 "*Ocean's Eleven*," BA. Title sequence credits: Saul Bass, art director; Saul Bass, designer; Art Goodman, illustrator; William Hurtz and Dick Barlow, producers (National Screen Services) (Awards List). The commission probably came through Frank Sinatra, a long-standing admirer and patron of Saul (Chapter 2 and Awards List).

98 "Bullet holes" ad credits: SB&A, art direction; Saul Bass, designer; Saul Bass, artist, Art Goodman, artist; Dave Nagata, illustrator (Awards List).

99 Kirk Douglas, Statement, BA. Many people have commented to me that this symbol reminds them of later "Black Power" graphics. Both this and the symbol for *Exodus*, also released in 1960, drew upon a well-established vocabulary of Left graphics as well as contemporary reworkings of them (see note 48).

100 "Frames for the Title for *Spartacus* by Saul Bass," BA.

101 "Academy Presentation 10/4/82," BA and SB. Sidebar, BA. The version told me by Elaine, who directed the sequence when Saul was in Japan at the World Design Conference, was similar (EB/PK 20C3).

102 SB. Sidebar, BA and SB/PK 1994.

103 SB. Sidebar, BA and SB/PK 1994.

104 SB. Sidebar, BA. See also Badder, Baker and Salmi, p. 3.

105 EB/PK 2004.

106 "Frames from the Title by Saul Bass," BA and Gid "Saul Bass: New Film Titlings." Title sequence credits: Saul Bass, art director; Saul Bass, designer; SB&A, producer; Tom Miller and J. Tannenbaum, photographers; Dave Nagata and Don Sterling, production supervisors (Awards List). The trailer for this film makes considerable use of film from the title sequence.

107 For *West Side Story* see Gid, p. 151; "Storyboard drawings for the Prologue," BA; and "Academy presentation 10/4/82," BA.

108 SB/PK 1994.

109 Robert Wise. Letter to SB, 1996, BA. Wise replaced Robbins as director after about four scenes.

110 Bob Gill/PK 2003, New York. Many people assume that Saul designed the posters but he never claimed them and they are not signed by him. It is not known precisely what he contributed to the final ad campaign but there is something of a "Bass" look to it.

111 "Frames from the Title by Saul Bass," BA and Gid, p. 155.

112 SB. Sidebar, BA.

113 Steven Spielberg, Statement, "Celebration," BA.

114 "Cat Fight," BA.

115 "Morning Session of Bass Day," BA and Gid, p. 152.

116 SB. Sidebar, BA.

117 "Frames from the Title by Saul Bass," BA; Haskin, "Saul Can You?," p. 16; and *Saul Bass and Associates* (IDEA special issue), p. 107. The sequence that follows the titles was probably conceived, designed and directed by Saul and Elaine. It is not clear to what extent Saul was involved with the advertising for this film.

118 SB/PK 1994.

119 "Frames from the Title by Saul Bass," BA, "Academy Presentation 10/4/82," BA. Bob Allen detailed the work undertaken at Playhouse Pictures where approximately 5,000 separate drawings were created and photographed. Bill Melendez, who worked with Saul on earlier projects, developed the animation from Saul's drawings and stated that he helped on storyboards. Allen Childs, animation cameraman, devised and built special equipment for this major undertaking ("Designing and Producing the Credit Titles for *It's a Mad, Mad, Mad, Mad World*," *American Cinematographer*, vol. 44, no. 12, December 1963, p. 707).

120 SB/PK 1995.

121 John Frankenheimer, tribute, "Celebration," and EB/PK 2003. *Seconds* was released in October 1966 and *Grand Prix* in December but Saul was already working on *Grand Prix* (see notes 125 and 126) when he created the *Seconds* sequence.

122 SB/PK 1994 and *Saul Bass and Associates* (IDEA special issue), p. 106.

123 Wong Howe's cinematography, full of strange distorted angles and extreme close-ups, won him an Oscar.

124 Elaine remembers wrapping up Art Goodman's face, shooting stills and working with them for days in order to demonstrate to Saul her idea for projecting images onto sheets of thin aluminum that then could be made to move and thus distort the image (EB/PK 2003).

125 SB/PK 1994; Badder, Baker and Salmi, p. 5; and SB/JM, "Academy Presentation ... 1979," BA. Saul's work on the internal race montages was credited separately from the title sequence and visual consultancy. *Grand Prix* was released at the end of 1966, the year in which Hitchcock failed to acknowledge Saul's input into the shower scene in *Psycho* in an interview with François Truffaut. Although published in French, the contents were well known in the film world before the English language edition (1967) and Saul may have decided not to chance again being denied credit for a significant piece of work within a film (see notes 90–92).

126 SB. Sidebar, BA. Saul credited Frankenheimer with the idea of making the titles out of the preparations for the first race ("Academy Presentation 10/4/82," p. 4, BA). The use of split-screen and multiple images was novel in mainstream U.S. movies in 1966. Asked about them a few years later, Saul raised criticisms similar to those voiced by others who considered the excesses of multiple imagery in the late 1960s and early 1970s as representative of a trend to put "medium" before "message": "The point is, it's a device, and as far as I'm concerned I'll never use it again – if it actually cries out for it, I'll use it but as a device it's lost its currency, because, later on, it was, unfortunately, used meaninglessly. It's the kind of thing that grows up without ever having a youth and there's no opportunity to explore it. On *Grand Prix*, I took the multiple image ... and carried it down the line quite a way. I think it is terrific at expressing muchness, but I suspect it's not capable of expressing deep feeling or contemplative ... I tried to do that in the race I referred to, the romantic one. I think it partially worked, that's for others to judge..." (Badder, Baker and Salmi, p. 5). See also Everett Aison, "Saul Bass: The Designer as Filmmaker," *Print*, vol. 23, January 1969, p. 133.

127 SB. Sidebar, BA.

128 When, because of his recent operation and other commitments, Saul told Frankenheimer that he could not do as much as Frankenheimer had hoped, the latter asked production designer Richard Sylbert to shoot a race. Frankenheimer admired Sylbert as a production designer, but felt Saul could do better on this project and therefore again pressed Saul to direct the other races (SB/JM tapes).

129 SB. Sidebar, BA and Badder, Baker and Salmi, p. 5.

130 SB. Sidebar, BA. The last title sequence Saul and Elaine made before being "rediscovered" in the late 1980s (Chapter 5) was for *That's Entertainment, Part II* (1976, dir. Gene Kelly), MGM's second anthology of "old movies." They created an "affectionate spoof" on titles past. Saul recalled, "We wanted to create a nostalgic sequence by recreating mythic memories of early titles. We went back and looked at old titles but found our memories of them quite different in many instances, sometimes very different, from how we then experienced them. They seemed a little rough technically, sometimes visually too, by the standards of the late 1970s. After the initial disappointment and long discussions, we decided to go with flashes of "memories," after all that's how we remember them anyway. We aimed at capturing the tone and feeling of the older titles in our vignettes. But what genre to use? Normally, whatever technique you use to do a title, is the technique you use all the way through. Once you figure out how to do it, you keep doing that thing. You do two minutes or so of it, with variations as the case may be. Here we worried that a single genre would detract from the different moods we were trying to convey. So we shot each vignette in an appropriate genre. Every ten seconds we were into something different. It was very time-consuming but truer to the original conception of an homage."

Return from the River Kwai, poster, 1989

4

Beginnings, Middles & Ends

1 SB/PK 1993 and Pat Kirkham, "Looking for the Simple Idea," *Sight and Sound*, vol. 4 (February 1994), p. 16.

2 Everett Aison, "Saul Bass: The Designer as Filmmaker," *Print*, vol. 23 (January 1969), p. 94.

3 EB to PK 2003.

4 SB/PK 1994. This is not to suggest that input was equally shared in each instance or to deny that Saul was the main driving force behind most projects, but rather to emphasize the collaborative nature of the work. Elaine's name appears in most of the film credits but her involvement extended beyond those specific acknowledgements of it. See press release "Elaine Bass" (The Jack Solomen Agency, Studio City, California for Bass/Yager & Associates," nd.), BA. Art Goodman spoke very highly of Elaine's talents, as do Martin Scorsese and Thelma Schoonmaker. Goodman described her as "A very, very creative person. She thinks in metaphors. I've always been impressed by what she comes up with… She can think of visual solutions quickly and is tenacious in following ideas through (AG to PK 2005, telephone).

5 EB to PK 2003.

6 James Powers, "H'wood [sic] Mastery Marks Fair Films Friday," *Hollywood Reporter*, May 29, 1964.

7 For experimental films see David Curtis, *Experimental Cinema: A Fifty Year Evolution*, London: Studio Vista, 1971, pp. 49–133; Sheldon Renan, *An Introduction to the American Underground Film*, New York: Dutton, 1967; and Lewis Jacobs, *The Rise of the American Film*, New York: Harcourt Brace, 1939, pp. 119–168. Experimental filmmaking in the U.S. is usually taken as starting with *Manhatta* (1921, dir. Charles Sheeler and Paul Strand).

8 SB to PK (telephone conversation) 1995. Deren's name appears in a short list of people who influenced him that Saul compiled about 1995, BA. Saul also admired the caricatures and animation of early French filmmaker Émile Cohl (SB to PK and BW 1994).

9 For sponsored films see Kirkham, *Charles and Ray Eames*, pp. 309–320 and Rick Prelinger, *The Field Guide to Sponsored Films* (www.filmpreservation.org/dvds-and-books/the-field-guide-to-sponsored-film, viewed September 2009). Pre-World War II examples include Pare Lorentz's *The Plow that Broke the Plains* (1936) and *The River* (1938), made for the Resettlement Administration and Farm Security Administration respectively. Flaherty's *The Land* (1942), showing the devastation of agricultural land during the Great Depression, was sponsored by the U.S. Department of Agriculture, while Standard Oil's sponsorship of his *The Louisiana Story* (1948) is often considered to mark the entry of big business into sponsored filmmaking (Ralph Caplan, "Industry on the Screen," *Industrial Design*, vol. 7 (April 1960), p. 63.

10 Advertisement (Victor Animatograph Corporation) in *Business Screen*, vol. 1, no. 3, 1945 and Kirkham, *Charles and Ray Eames*, pp. 316–317 (for statistics).

11 Other 1950s examples include two public service documentaries directed by Hammid; *Angry Boy* (1950) for the National Association of Mental Health, and *Power Among Men* (1958) for the Public Information Services of United Artists. For Hammid and Thompson at the 1964 World's Fair see Caplan, "Industry on the Screen," p. 50. The Eameses' film for IBM, *The Information Machine: Creative Man and the Data Processor*, 1957, was shown at the 1958 World's Fair and their multiscreen *The House of Science*, for the United States Information Agency, at the 1962 World's Fair (Kirkham, *Charles and Ray Eames*, pp. 320–325).

12 EB/PK 2004.

13 For the Goldsholls see Rhodes Patterson, "Morton Goldsholl & Associates," *Communication Arts*, vol. 5, July–August 1963, pp. 36–46 and "Millie and Morton Goldsholl: Designs for Film," *Print*, vol. 16, no. 7, November 1962, pp. 34–38. The latter includes images from the film *Faces and Fortunes*, which featured "logos" of times past, other films for Kimberly-Clark and Karolton Envelopes, and a Standard Oil television program opener.

14 LD/PK 2004 (New York). See also Raymond Gid "Saul Bass: New Film Titlings and Promotional Films," *Graphis*, vol. 19 no. 106 (March 1963), pp. 150–159, and Bass/Yager & Associates promotional leaflet (nd., BA).

15 SB/PK 1994 and "Apples and Oranges – Food for Thought: How CBS 'Sells' A Concept," *Telefilm*, May 1963, pp. 30–31.

16 "Apples and Oranges," p. 30.

17 *From Here to There*: Conceived and Designed by Elaine & Saul Bass; Saul Bass (director); SB&A (producer); Larry Yust (associate producer); Sy Wexler (production consultant); Saul Bass & Albert Nalpas (editors); Jeff Alexander (music); Michael Murphy (photography); William Garnett (aerial photography); Fred Hudson, Ken Middleham, Jim Salter, Horst Seyfarth (additional photography). See Mina Hamilton, "Films at the Fair II: A Comparative Review," *Industrial Design*, vol. 12, May 1964, pp. 38–40; Will Lane, "Anatomy of an Image Maker," *Media Agencies Clients*, 877, December 7, 1964, p. 20; and SB, "Thoughts on Film," 1966, BA, "Press Comments," BA and Pyramid Film & Video publicity leaflet.

18 See Hamilton, p. 40, David A. Sohn, *Film: The Creative Eye*, Dayton, OH: G. A. Pfaum, 1970, pp. 40–41; Pyramid Film & Video publicity leaflet; and "Press Comments," BA.

19 Hamilton considered *The Searching Eye* the most experimental of the films at the Fair and stated that it came "close to integrating form and content" (p. 38). Conceived and Designed by Elaine & Saul Bass, Saul Bass (director); SB&A (producer); Larry Yust (associate producer); Sy Wexler (production consultant); Paul David (writer); Jeff Alexander (music); Albert Nalpas & Saul Bass (editors); Archer Goodwin, Ken Middleham; Ron Church, Bob Davison, William Garnett; Fred Hudson, Mike Murphy, Horst Seyfarth; Roger Barlow, Arthur Carter, Steven Craig, Claude Jendrusch, I. Manofsky, James Schaadt, David Shore (photography).

20 SB. Sidebar, BA.

21 SB. Sidebar, BA.

22 *Saul Bass and Associates* (IDEA), p. 116. By 1996 it had won over 30 awards and was one of the top grossing short films of the century. Art Goodman's major contributions to the film include "brainstorming" with Saul and Elaine and translating Saul's sketches and art direction into finished artwork. Mayo Simon (co-writer); Eric Daarstad (photgraphy); Kent MacKenzie, Albert Nalpas, Cliffe Oland (editors); Jeff Alexander (music); Art Goodman and Pantomime (animation); Robert Aller (associate producer).

23 I am grateful to Michael Sandberg for information about his father's role in promoting both the concept of creativity and this film. See also *Saul Bass and Associates* (IDEA special issue), p. 116.

24 SB. Sidebar and "London/Copenhagen – April 1995," BA.

25 SB/PK 1994 and SB/JM.

26 Publicity leaflet, BA. See also Bruce Kane and Joel Reisner, "A Conversation with Saul Bass," *Cinema*, vol. 4 (Fall 1968), p. 34.

27 SB. Sidebar, BA.

28 SB. Sidebar, BA.

29 SB. Sidebar, BA.

30 There is a Monty Pythonesque humor to this film, but *Why Man Creates* was completed in 1968; *Monty Python's Flying Circus* first aired on British television in October 1969. The whackier side of Saul's humor was well developed many years before the Python group developed their particular brand of comedy.

31 Frank Stanton to PK (telephone) 2004.

32 There are always interesting commentaries on the film on www.imdb.com. In 2003 they included: "the greatest movie they ever showed in school" [jeffballardman]; "This movie had a profound effect on me as a student of art in middle school and high school [realspace]; "one of the most thought-provoking films I have ever seen, plus it is a lot of fun to watch. The vast majority of my friends can quote lines with me; it's that good; [go_seaward]"; "It has been over twenty years, since I saw it, and I still talk about it to this day [Richard Stewart]"; and "This film deserves to be preserved and shared with each generation of young children so that their imaginations can be freed to soar with whimsy and joy" [lbcsrw].

33 Saul Bass (director); Stan Hart and Saul Bass (writers); Elaine Bass and Jim Rogers (producers). This film is a modified version of *Windows* (made as part of an identity program to help the company to define and promote itself as a broad-based organization, in the finance and business worlds as well as the wider community) [*Saul Bass and Associates* (IDEA special issue), p. 120].

34 SB. Sidebar, BA.

35 SB. Sidebar, BA.

36 "Robert Redford called us…" BA; "Solar Film Bkground [sic]," BA; and Stanley Mason, "Saul and Elaine Bass. A New Film on Solar Energy," *Graphis*, vol. 37, no. 232 (1984), pp. 156–159.

37 Press Statement and *Solar Film* file, BA and RR to PK, 2006. Stan Hart, Saul & Elaine Bass (writers); Robert Redford (executive producer); Saul Bass, Michael Britton (producers); Jeff Okun (editor); Michael Brown (cinematography); Larry Cansler (music); Art Goodman, Herb Klynn and Playhouse Pictures (animation).

38 EB /PK 1994.

39 SB/PK 1994.

40 "Press Comments." *Solar Film* file, BA.

41 *Solar Film* file, SB. Sidebar, BA, SB/PK 1995 and SB/JM.

42 *Solar Film* file, Press Statement, 1980, BA and Press Comments (solar file), BA.

43 EB/PK 2004 and "*Quest*" (single sheet), BA. MOA follows the teachings of the late Mokichi Okada. It sees the

household as the starting point for working through new attitudes towards others, as well as to life and work (www.moainter.org.ar/intro.html, viewed March 2, 2005).

44 EB/PK 2003. Other credits: Berrington Van Campen & Elaine Bass (music); Jeff Okun (editor); Chuck Colwell (cinematographer); Robert Bass (associate producer).

45 Ray Bradbury, Statement, BA. The Bergson book was *Creative Evolution*, 1907. See also Marsha Jeffer, *Guide to Quest*, Los Angeles, Pyramid Film & Video, 1983.

46 See Jeffer, *Guide to Quest*, p. 3 and "Reflections on Quest," BA.

47 SB. Sidebar, BA and SB/PK 1995.

48 EB/PK 2003 and "Reflections on *Quest*," BA.

49 EB/PK 2003 and "Reflections on *Quest*," BA.

50 SB to PK 1994 (shortly after George Lucas's 50th birthday party, at which the Basses were guests). Cited in Jeffer, *Guide to Quest*, p. 3. British design critic James Woudhuysen described *Quest* as "smacking a little of George Lucas" ["Bass Profundo," *Design Week*, September 22, 1989, p. 17] but it should be remembered that Lucas was taught by Saul at USC (Chapter 1).

51 Loose color page in English and Japanese. "Reflections on *Quest*," BA.

52 Loose color page in English and Japanese. "Reflections on *Quest*," BA.

53 SB/PK 1995.

54 SB. Sidebar, BA and SB/PK 1994. Writer Mayo Simon (Barry Malzberg novel);

100 Years of the Telephone, short film, 1976

Producer Paul Radin.

55 Badder, David, Bob Baker and Markku Salmi, "Saul Bass," *Film Dope* 3 (August 1973), p. 6 and "Cable Column: An Interview with Saul Bass," *Z Magazine*, vol. 2, no. 3, August–September 1975, p. 21.

56 Gaston Bachelard, *The Poetics of Space*, Boston: Beacon Press, 1992, p.155.

57 Saul was opposed to that war. In 1965 he was one of many cultural producers who signed an open letter criticizing U.S. foreign policy in Vietnam and the Dominican Republic ("End Your Silence," *New York Times*, June 27, 1965, X18). The *Los Angeles Times* described the film as "a thoroughly terrifying, bizarrely beautiful ecological parable … a stunningly effective warning that man must learn to live in harmony with nature – if it is not already too late" ("Press Comments" and *Phase IV* file, BA).

58 Dilys Powell, the *Sunday Times*, London, in "Press Comments," BA.

59 Jay Cocks, *Time*, New York, in "Press Comments," BA.

60 "American Film Institute Seminar," BA.

61 See www.imdb.com and Andreas Timmer, *Making the Ordinary Extraordinary: The Film-Related Work of Saul Bass*, unpublished PhD dissertation, New York: Columbia University, 1999, pp. 221–222.

62 SB. Sidebar, BA. See also "The Aim of this Film is," BA.

63 SB/PK 1994. See also EB/PK 2003 and letter from Saul to Peter Bankers, Paramount Pictures, New York, 1974, trying to resolve the ending (offered for sale on eBay, November 2004).

64 Saul rarely revisited this episode, partly, I think, because he felt that to complain about the studio withdrawing funding might sound like an excuse. And Saul never liked to make excuses. A 1974 *Time* review stated that *Phase IV* had originally ended with a montage of hallucinatory images suggesting man's destiny after the ants have had their way but that Saul deleted the sequence because he thought it too abstract ("Press comments," BA). This was not correct. Saul was very disappointed not to be able to complete this beautiful near-abstract sequence, which he was working on when the budget was cut.

5

The Wheel Comes Full Circle

1 Nicholas Pileggi to PK, 1994 (telephone conversation and fax) and Pat Kirkham, "Bright Lights, Big City: What is the Power of Elaine and Saul Bass's titles for *Casino*?," *Sight & Sound*, vol. 6, January 1996, pp. 18–19.

2 SB/PK, 1993 in preparation for Kirkham, "Looking for the Simple Idea," *Sight & Sound*, vol. 4, February 1994, p. 16. Exceptions were commissions for three Preminger films, *Such Good Friends* (1971), *Rosebud* (1975), *The Human Factor* (1979); and *That's Entertainment, Part II* (1976).

3 SB/PK 1993. Another factor was that some studios were not willing to invest in

NBC 50th Anniversary Special, opening sequence (the boy is Jeffrey Bass), 1976

either the high fees Saul and Elaine by then commanded or what could often be high productions costs for about three minutes of film (see notes to Chapter 3).

4 EB/PK 1993 and 2004.

5 Pamela Haskin, "Saul, Can You Make Me a Title?," *Film Quarterly*, vol. 50, no. 1, Fall 1996, p. 17.

6 Kirkham, "Looking for the Simple Idea," p. 17.

7 Kirkham, "Looking for the Simple Idea," p. 17. When I asked Saul about some people stating that the titles for *Broadcast News* and *Big* did not look like "Bass titles," he emphasized that the purpose was to serve the film and commented, "There are times when the appropriate communications should look acrobatic, and times when the perceiver does not have to understand the artifice bringing the message. As communicators we're trying to achieve a response, not necessarily astonish the onlooker with skills" (SB/PK 1993).

8 SB/PK 1993.

9 Chuck Ross, "Saul Bass Returns in *Big* Way," *San Francisco Chronicle*, June 18, 1988, C4.

10 "Saul Bass Returns in *Big* Way," C4.

11 SB/PK 1994.

12 Saul told the following story about this sequence. "We flew from Beijing to the end of the line in the westernmost part of China; traveled twelve hours by train through the Gobi; then four hours by car to the location. There we sat down and reviewed our storyboard with Junya.

We finished. We waited for his reaction. There was a long pause. He said, 'Which script were you working from?' Our hearts sank. We identified it. 'Oh!' he said, 'that's our second script. We are now shooting from our third script. I'm sorry to say your storyboard now doesn't make sense. Let me explain the shift.' He did – in Japanese (we listened, as we slowly sank into our chairs). Because of the long stretches of translation, there was time for Elaine and I to talk. We had to come up with something right then! We were in an intense interchange. Elaine recalled that we had been traveling through a landscape of beautiful desolate dunes. Periodically we encountered ancient half-buried ruins of what were once splendid cities. It came to us. Power, greed, control are indeed evanescent. After the dust of centuries has buried the cities, what is cherished is not the victories or defeats in battle or politics, but the contributions to the human spirit. We related our notion. There was a long silence. We waited. He nodded. Then said 'Ah … good!' We cleared out fast and began preparations for the shoot" (SB. Sidebar, BA).

13 EB/PK 2004 and "Frames from the Prologue by Elaine & Saul Bass from the Feature Film *Tonko*" (1988, Junya Sato), BA.

14 Elaine came up with the idea for an extended visual joke that related to the opening shot of the movie and held back its punchline until the very last moment (SB/PK 1993 and EB/PK 2004). The sequence is an example of what Saul called the tyranny of the title: "we would have preferred this to be two-thirds the length but we had to extend it to cover all the credits. It takes ingenuity to keep a concept alive over several minutes … but the longer you maintain it, the funnier the gag" (SB/PK 1993).

15 SB/PK 1993. See also "Frames from the opening title by Elaine & Saul Bass from the Feature Film *Mr. Saturday Night*" (1992), BA.

16 SB. Sidebar, BA. In the 1990s Saul and Elaine worked on two films for which the directors had already completed live-act on openings. For *Doc Hollywood* (1991, dir. Michael Caton Jones), a romantic comedy starring Michael J. Fox as a young plastic surgeon who, forced to undertake community service in a small town, reappraises his materialistic aspirations, Saul and Elaine had great fun thinking up amusing credits: they roll down the road taken by Michael J. Fox in his Porsche en route for Los Angeles, fame and fortune, while the *Doc Hollywood* credit flies off the Hollywood Hills in the form of the famous "Hollywood" sign that symbolizes the glamour of the life he could have there. The sequence for *Higher Learning* (1995, dir. John Singleton) was also restricted to lettering and the placing of the credits. Elegant capital letters rush on and off screen at oblique angles. White is used for names; gray for their contributions until the director credit. That comes in red.

17 Nicholas Pileggi to PK 1994.

18 Quentin Tarantino to PK (*Shots in the Dark* festival: Broadway, Nottingham, England, 1994).

19 Martin Scorsese, tribute, "Celebration."

20 SB/PK 1993 and Kirkham, "Looking for the Simple Idea," pp. 16–20.

21 SB/PK 1993 and Kirkham, "Looking for the Simple Idea," pp. 16–20.

22 SB/PK 1993 and Kirkham, "Looking for the Simple Idea," pp. 16–20.

23 SB/PK 1993 and Kirkham, "Looking for the Simple Idea," p. 18.

24 EB/PK 2004.

25 EB/PK 2004. Saul told the *New York Times*, "all the water, and the reflections and these threatening submerged images in the water – that signals the awfulness that is to come, we're very good at awfulness. No, really, we do some sweet titles too" (March 10, 1996, SM 21).

26 EB/PK 2004. Saul was already ill when this sequence was made and Elaine's role in it was quite considerable, as it was with *Casino*. Saul told the *New York Times* that the opening flowers were a metaphor for the film: "the Victorian veneer with the malevolence beneath it. We attempted to show that with flowers that start as sweet and then slowly become malevolent" (March 10, 1996, SM 21).

27 EB/PK 2004 and Kirkham, "Looking for the Simple Idea," pp. 16–20.

28 Scorsese, tribute, "Celebration."

29 SB. Sidebar, BA. See also Kirkham, "Bright Lights, Big City," pp. 12–13.

30 EB/PK 2004.

31 Nicholas Pileggi to PK (telephone conversation) 1994.

32 SB to PK (telephone conversation) 1994.

6

Corporate Identity

1 "Saul Bass on symbols," nd., BA. For "Design is Thinking Made Visible" see "Design Philosophy," nd., BA.

2 See also "Agenda: 1. The Corporate Identity Program: A Management Tool," March 1978, BA; "Saul Bass on Corporate Identity," *Step-by-Step Graphics*, September/October 1986, pp. 44–45; and notes on typed draft of "Saul Bass on Corporate Identity" (October 11, 1980,

Saul, 1966

interview with Philip Meggs, BA) published in *AIGA Journal of Graphic Design*, 1990, pp. 4–5 [reprinted in Steven Heller and Marie Finamore (eds.), *Design Culture: An Anthology of Writing from the AIGA Journal of Graphic Design*, New York: Allworth Press, 1997, pp. 71–76].

3 Barbara Baer Capitman, *American Trademark Designs*, New York: Dover Publications, 1976, pp. vii–viii.

4 Karen Moon, *George Walton: Designer and Architect*, Oxford: White Cockade Publishing, 1993, pp. 71–82.

5 Tilmann Buddensieg, *Industriekultur: Peter Behrens and the AEG, 1907–1914*, Cambridge, MA: MIT Press, 1984 and Alan Windsor, *Peter Behrens: Architect and Designer*, New York: Whitney Library of Design, 1981, pp. 77–93. Such breadth of design responsibility was rarely matched until the corporate imaging programs of the last quarter of the twentieth century, and even then architecture and product design were often left to specialists.

6 See Robert Maynard Hutchins, *Walter Paul Paepcke, 1896–1960*, Chicago:

Bell System, working session, 1969

Trustees of the University of Chicago, 1960; Herbert Bayer, "Walter Paepcke," *Print*, vol. 14, September 1960, pp. 34–36; and Egbert Jacobson, "Container Corporation of America: Good Design, an Important Function of Good Management," *Graphis*, vol. 6, 1950, pp. 136–47.

7 Writing in *Advertising Age* in 1959, Howard Gossage, of the Gossage Advertising Agency, urged company executives to "adopt clearer, more consistent, identities as a sound business strategy" (cited in Ellen Lupton, *Mixing Messages: Graphic Design in Contemporary Culture*, New York: Princeton Architectural Press, 1996, pp. 84–85). For post-World War II corporate identity graphics, see Wally Olins, *Corporate Identity: Making Business Strategy Visible Through Design*, London: Thames & Hudson, 1989; and Barbara Baer Capitman, passim.; and Ellen Lupton and J. Abbott Miller, "Corporate Design, Corporate Art" in Mildred Friedman et al., *Graphic Design in America: A Visual Language History*, New York: Abrams and Minneapolis: Walker Art Gallery, 1989, p. 47. Lester Beall's 1960 identity program for International Paper was one of the most extensive of that period. Saul considered Beall to be extremely influential in terms of large-scale "problem-solving" corporate graphics, more so than Rand (SB to PK 1995). For Rand see Steven Heller, *Paul Rand*, London: Phaidon, 1999, pp. 145–213 and for Beall, Roger Remington, *Lester Beall: Trailblazer of American Graphic Design*, New York: W. W. Norton, 1996.

8 Beall's manual for Connecticut General (1959) is regarded as the first of its type.

9 "Agenda: 1," BA.

10 SB to PK 1995.

11 LD/PK 2004 (New York).

12 SB to JM for proposed book.

13 SB/PK 1993.

14 LD/PK 2004 (New York).

15 AG/PK 2004.

16 SB. Sidebar, BA.

17 HW/PK 2003.

18 HW/PK 2003.

19 I am grateful to Joe Morgenstern for this information. See David Geffen, Statement, BA, for similar remarks about Saul.

20 SB. Sidebar, BA.

21 Richard N. Frank, *Lawry's Foods, Inc: A Blending of Dreams*, New York: Newcomen Society of the United States, 1987, p. 30. See also "Four Corporate Identity Programs," *IDEA*, vol. 84 (September 1967), pp. 98–108, "Lawry's Foods: Visibility as a Wedge of Distribution," in *Saul Bass and Associates* (*IDEA* special issue), pp. 66–67. Logo credits: Saul Bass, designer: Phyllis Tanner, artist; doggy bag credits: Saul Bass, designer; Art Goodman and Phyllis Tanner, artists (Awards List). See also E.W. Ted Poyser, "Art Directors Club of Los Angeles," *Graphis*, vol. 18, no. 101, May–June 1962, p. 307.

22 SB to PK 1995.

23 SB. Sidebar, BA. See also Frank, p. 30.

24 SB. Sidebar, BA and SB/PK 1995. See also "Saul Bass Recent Work," *Print*, vol. 15, May–June 1961, p. 35; "Four Corporate Identity Programs," pp. 77–85; "ALCOA: Separating Material Processor from Product Fabricator," *Saul Bass and Associates* (*IDEA* special issue), p. 65; Peter Bart "Advertising: Myth of Creative Shop," *New York Times*, January 17, 1963, p. 14; and George David Smith, *From Monopoly to Competition: The Transformations of Alcoa, 1888–1986*, Cambridge: Cambridge University Press, 1988.

25 The program took three years to complete and a design manual was compiled to ensure standards ("Four Corporate Identity Programs," p. 78). Logo credits: Saul Bass and Don Handel, designers (Edward Booth-Clibborn and Daniele Baroni, *The Language of Graphics*, New York: Abrams, 1973, p. 155).

26 SB. Sidebar, BA and SB/PK 1995.

27 See "Fuller Paints: Signaling

Lawry's dip mix packaging, early 1960s

Presence" in *Saul Bass and Associates* (*IDEA* special issue), p. 65 and "Four Corporate Identity Programs," pp. 106–111. For Bass and Rosenthal see Chapter 2 and the end of this chapter (Exxon). Artist Claire McMenamin worked on these sculpture projects with Saul and Rosenthal and also worked on the Ohio Blue Tip Matches project (p. 302–303), as did photographer Don Handel (Awards List). Dick Hastings, a designer who worked for Rosenthal, also worked on the Fuller sculptures (www.adac.org/events/newsletter/news-nov06.htm, viewed February 13, 2007; no longer accessible, but a copy of the article can be found at http://mehallo.com/blog/sacramentos-saul-bass-sculpture).

28 "Agenda," BA, p. 22. See also "Four Corporate Identity Programs," pp. 86–97 and "Celanese: From Synthetic Fibers to Chemicals, to Paint, to Plastics," *Saul Bass and Associates* (*IDEA* special issue), pp. 54–57.

29 SB and EB to PK 1994.

30 SB to PK 1994. See also "Continental Airlines: An Aggressive Medium-sized Airline Anticipating Expansion," *Saul Bass and Associates* (*IDEA* special issue), pp. 32–35.

31 "Continental Airlines: An Aggressive," p. 32.

32 Jack Altman, "Bye, Bye Birdie," *Chicago Sun Times*, January 7, 1968, p. 10.

33 "Continental Airlines: An Aggressive," p. 32.

34 "Continental Airlines: An Aggressive," p. 32.

35 "Continental Airlines: An Aggressive," p. 32. See also Altman, p. 14.

36 SB to PK 1995. For Rockwell see "Rockwell International: Visualizing the Marriage of High Technology and Consumer products," *Saul Bass and Associates* (*IDEA* special issue), pp. 46–49.

37 See "The Bell System: Bringing Image in Line with Reality," *Saul Bass and Associates* (*IDEA* special issue), pp. 14–21; George T. Finley, "Bass for Bell," *Industrial Design*, vol. 18, March 1971, pp. 50–53; "Saul Bass, Los Angeles: The Corporate Identities of United Airlines and Bell Telephone," *Novum Gebrauchsgraphik*, vol. 49, December 1978, pp. 45–48; "Presentation to Telephone Company," BA; and "Agenda: 1," BA.

38 SB/PK 1994 and "A New Ring to the Bell," *Pacific Telephone Magazine*, April 1970, p. 4.

39 "A New Ring to the Bell," p. 4 and "Agenda: 1," BA.

40 "A New Ring to the Bell," p. 4.

41 "Saul Bass, Los Angeles: The Corporate Identities of United Airlines and Bell Telephone," p. 48. Logo credits: Saul Bass, art director; Saul Bass, Yasaburo Kuwayama, designers; Don Handel, photography (Arthur Pulos, *The American Design Adventure, 1940–1975*, Cambridge: MIT Press, *1988*, p. 275).

42 SB. Sidebar, BA.

43 SB. Sidebar, BA, SB/PK 1994 and SB/JM.

44 "Quaker: From Oats to Grocery Products, to Chemicals, to Toys," *Saul Bass and Associates* (*IDEA* special issue), pp. 50–53. See also "Agenda: 1," BA and SB/Sidebar, BA.

45 SB. Sidebar, BA. See also "United Airlines: Dealing with Bigness, Unification, and Technology," *Saul Bass and Associates* (*IDEA* special issue), pp. 26–31 and "Agenda: 1," BA.

46 SB. Sidebar, BA.

47 SB. Sidebar, BA. See also "United Airlines: Dealing with Bigness, Unification, and Technology," pp. 22–26.

48 SB. Sidebar, BA.

49 SB. Sidebar, BA and "Visual Communication & Change," BA. Logo credits: [Saul Bass, art director]; Saul Bass, Art Goodman and Mamoru Shimokochi, designers (Takenobu Igarashi (ed.), *World Trademarks and Logotypes*, II, Tokyo: Graphic-sha Publishing Company, *1983*, p. 40).

50 SB/PK 1993 and "Visual Communication & Change," BA.

51 "Visual Communication & Change," BA. See also "United Way: Making Order Out of Confusion," *Saul Bass and Associates* (*IDEA* special issue), p. 60 and "United Way Set a Record With $910–Million in Year," *New York Times*, December 2, 1972, p. 19.

52 "Visual Communication & Change," BA. In a list of captions, Saul noted, "No words are needed to identify America's largest and best known charitable organization; just this familiar, and long-lasting symbol" ("5/3/88," BA).

53 "Warner Communications: Making Diversity Comprehensible," *Saul Bass and Associates* (*IDEA* special issue), p. 42.

54 Logo credits: [Saul Bass, art director]; Saul Bass, Art Goodman and B/Y&A, designers (Igarashi, I, p. 40).

55 See Chapter 4.

56 SB. Sidebar, BA, SB/PK 1995 and SB/JM.

57 SB/PK 1995 and SB/JM. Main logo credits: [Saul Bass, art director]; Saul Bass and G. Dean Smith, designers (Igarashi, II, p. 52).

58 SB. Sidebar, BA.

59 Edward Block, Statement, BA.

60 See "Burry's Girl Scout Cookies: Something for Kids. Something for Adults," *Saul Bass and Associates* (*IDEA* special issue), pp. 78–81.

61 Hesselbein Statement, BA. Logo credits: [Saul Bass, art director]; Saul Bass and Art Goodman, designers (Igarashi, II, p. 41).

62 SB to PK 1993.

63 Hesselbein to PK, March 2010 (New York).

64 SB. Sidebar, BA and www.bgca.org/whoweare/pages/history.aspx (viewed May 2, 2007).

65 SB/PK 1995.

66 HW/PK 2003.

67 HW/PK 2003. Logo credits: [Saul Bass, art director]; Saul Bass and G. Dean Smith, designers (Igarashi, II, p.56 and EB to PK 2003). Larry Brady also worked with Saul and Smith on the typeface. Logos for which Smith was also co-designer include General Foods, Geffen Records, Kibun, Museum of Art (MOA).

68 HW/PH 2003. See also "Recommended Design Criteria Getty Identity Design Program," BA.

69 HW/PH 2003. According to Williams, Getty staff found it difficult to agree on a common symbol, let alone a common background. The designs in the Bass Collection indicate that Saul spent a great deal of time on trying out different backgrounds – one for each department – against a common symbol but he always

Bell System, phone packaging, 1969

considered such an approach less satisfactory than the solution ultimately adopted. An alphabet was created to complement Richard Meier's architecture. John Guard worked closely with Saul on the alphabet as well as the signage program and its integration with its environment (The Getty Center website, www.thegetty.edu). N.B. The building review group of which Saul was part included Frank Gehry, Ada Louise Huxtable and Ricardo Legorreta. Saul also sat on a Getty working group exploring the relationship of art and film. At the time of his death, he was working on signage for the new site.

70 When Saul first told me the story about the Japanese flag, he joked that he sometimes wondered if he had been Japanese in another life (SB/PK 1995).

71 Although Japan was not part of "The Marshall Plan" (the European Recovery

Saul, Aspen Design Conference, 1983

Program), financial aid went along with military occupation. For U.S. aid and Japanese design see Penny Sparke, *Modern Japanese Design*, London: Michael Joseph, 1988, pp. 34–38. For wider issues see Yoneyuki Sugita, *Pitfall or Panacea: The Irony of US Power in Occupied Japan, 1945–1952*, London: Routledge, 2003; John Dower, *Embracing Defeat: Japan in the Wake of World War II*, New York: Norton, 1999; and Michael Schaller, *The American Occupation of Japan: The Origins of the Cold War in Asia*, New York: Oxford University Press, 1985.

72 Richard Warren Lewis, "Box-Office Bait by Bass," *Show Business Illustrated*, January 23, 1962, p. 50.

73 I am grateful to Yumiko Yamamori and Barbara Brookes for translating this and other Japanese documents.

74 For corporate identity in Japan seeking to reemphasize "value" and human issues in the new post-industrial age see Motoo Nakanishi, *Building a New Form of Corporate Identity: Japan's Corporate Identity Revolution*, Tokyo, 1993, "Corporate Identity in Japan" and Kazumasa Nagai, "Corporate Identity: The Challenges to Come" (undated and unreferenced offprints), BA and http://www.paos.net/english/aboutus/profile.html, viewed August 28, 2005.

75 *Saul Bass and Associates* (*IDEA* special issue), p. 132. Los Angeles-based Akiko Agishi also helped the company liaise with Japan in the 1980s and 1990s (EB/PK 2003).

76 SB/PK 1993.

77 SB/PK 1993.

78 SB. Sidebar, BA.

79 "Ajinomoto: Reinforcing Breadth of Line in the Japanese Market," *Saul Bass & Associates*, pp. 74–76.

80 Seiichi Wazumi, preface to *Minolta CI Story*, Tokyo: Seibundo Shinkokosha Publishing, 1984, p. 5. Logo credits: [Saul Bass, art director], Saul Bass and Art Goodman, designers (Igarashi, I, p. 37).

81 Wazumi, p. 5.

82 Wazumi, p. 5.

83 SB. Sidebar, BA.

84 Hideo Tashima (CEO Minolta), Statement, BA.

85 Hideo Tashima, Statement, BA and Seiichi Wazumi, p. 5.

86 "Kibun," BA. Logo credits: [Saul Bass, art director]; Saul Bass and G. Dean Smith, designers (Igarashi II, p. 54).

87 SB. Sidebar, BA.

88 SB. Sidebar, BA.

89 "Saul Bass – in Appreciation" (attached to letter from Kenji Maeda to SB, 1996), BA. For Saul and Minami see Akira Minami, Statement, BA.

90 "Saul's 'Vision' – Texaco, July 11, 1995" (notes for presentation: in file "Atlanta July 10, 11, 1995 (Saul, Herb)," BA. In December 1992 Nippon Mining Company merged with Kyodo Oil Company to form Nikko-Kyodo Oil Company. A year later it became JOMO (www.ods.co.jp/english/jomo.html, viewed March 3, 2006; see also www.noe.jx-group.co.jp/english/company/history/nmh.html).

91 SB. Sidebar, BA.

92 "Saul's 'Vision' – Texaco, July 11, 1995," BA and SB/JM. The original commission was won against Pentagram, Landor Associates, S & O Consultants and Anspach Grossman Portugal.

93 "Saul's 'Vision' – Texaco, July 11, 1995," BA.

94 "Saul's 'Vision' – Texaco, July 11, 1995," BA and "Modular Design Revamps Exxon Stations World-Wide as Markets Change," *Industrial Design*, vol. 28, no. 6, November–December, 1981, p. 26.

95 JB to PK, 2005 and SB/JM.

96 "Creating Good-Looking Objects That Work," *Time*, January 4, 1982, pp. 74–75.

97 "Modular Design Revamps Exxon Stations World-Wide as Markets Change," p. 26 and Paul Sargent Clark, "Ringing the Corporate Bell," *Design*, 436, April 1985, p. 25.

98 Sean O'Leary, "Change as a Constant. Sohio Oil's New Identity Program Becomes British Petroleum's," *Identity*, 2, Spring, 1989, p. 42.

99 Saul brought in a small architectural team headed by David Reidford but he (Saul) remained overall creative director and was responsible for everything other than structural issues and engineering (O'Leary, pp. 41–45).

100 O'Leary, pp. 43–45.

7

Personal Handwriting

1 Stuart Frolick, "Nothing Less Than A Legend: Saul Bass," *Graphis*, vol. 47, no. 276 (November–December 1991), p. 100.

2 SB/JM. See also "Saul Bass/Gertrude Snyder," BA (interview conducted for "Profiles: The Great Graphic Innovators," *U&lc* magazine).

3 Herb Yager, "Saul Bass: Questions, Answers, Evasions," *Saul Bass and Associates* (*IDEA* special issue). Tokyo: Seibundo and Shinkosha Publishing Company, 1979, p. 129.

4 "Interview with Saul Bass – 4/92." Typed sheet. nd, BA.

5 "Saul Bass Graphicinemagician by P. K. Thomajan" (notes), BA; SB/PK 1994.

6 "Saul Bass Graphicinemagician by P. K. Thomajan" (notes), BA.

7 David A. Sohn, *Film: The Creative Eye*, Dayton, OH, George A. Pflaum, 1970, p. 50.

8 SB/PK 1993. See also Richard Warren Lewis, "Box-Office Bait By Bass: A Designer Masters the Fine Art of Hooking an Audience," *Show Business Illustrated* (January 23, 1962), p. 50.

9 Laurel Harper, "Saul Bass: The Man with the Golden Designs," *How* magazine, vol. 11, no. 3, May–June 1996, p. 91.

10 Herb Yager, "Saul Bass: Questions, Answers, Evasions," p. 129.

11 "Morning Session of Bass Day II," (typed sheet), BA.

12 Sohn, p. 58.

13 Sohn, p. 58.

Environment, poster, 1971

14 *Saul Bass* (1989 videotaped interview with Archie Boston. Now on DVD in *20 Outstanding LA Designers* series); SB to PK, London, 1995.

15 SB/PK 1993. See also Will Lane, "Anatomy of an Image Maker," *Media Agencies Clients*, 877 (December 7, 1964), p. 20.

16 SB/PK 1993.

17 *Saul Bass* (1989 videotaped interview with Archie Boston); SB to PK, London, 1995.

18 *Saul Bass* (1989 videotaped interview with Archie Boston); Lane, p. 20; SB/PK 1995.

19 Richard Warren Lewis, p. 50.

20 "In an interview with *Designer* afterwards…" (with imprint: Society of Industrial Artists and Designers, Editorial Office), BA.

21 "Saul Bass/Gertrude Snyder," BA.

22 "Saul Bass Believes in Magic," BA (interview conducted with Saul in his office on July 15, 1994, for Nancy Hopkins Klein, "Saul Bass: On the Real Priorities," *Design Firm Management*, Evanston, Illinois, Wefler and Associates, Inc., 1994, pp. 1–6).

23 SB/PK 1993; See also "Saul Bass Graphicinemagician by P. K. Thomajan" (notes), BA.

24 "Interview for *Idea* magazine, January 24, 1991," BA.

25 "Saul Bass. Excerpts from a taped conversation" in Robert C. Niece, *Art: An Approach*, Dubuque, Iowa: Wm. C. Brown Company 1963, p. 106.

26 Frolick, p. 99.

27 Sohn, p. 53.

28 Typed sheet (no heading, nd.), BA.

29 Typed sheet (no heading, notes for a speech, nd.), BA.

30 Typed sheet (no heading, notes for a speech, nd.), BA.

31 Herb Yager, "Saul Bass: American Designer," *Graphis*, vol. 33, no. 193 (1977–78), p. 398.

32 Harper, p. 90; "Saul Bass Believes in Magic," BA.

33 Klein, p. 7.

34 "Interview with Saul Bass – 4/92," BA.

35 Sohn, p. 51. See also Lane, p. 25.

36 "Interview with Saul Bass – 4/92," BA.

37 "Saul Bass eminent designer and filmmaker says…," BA.

38 Sohn, p. 49; "Interview with Saul Bass – 4/92," BA.

39 Lane, p. 24; "Saul Bass Graphicinemagician by P. K. Thomajan," BA; SB/PK 1994.

40 "Interview with Saul Bass – 4/92," BA.

41 Klein, p. 5.

We the people, commemorating the bicentennial of the U.S. Constitution, 1987

42 "Interview with Saul Bass – 4/92," BA.

43 "Interview with Saul Bass – 4/92," BA.

44 Frolick, p. 99.

45 "Saul Bass. Strathmore advertisement (interview)," *Communication Arts*, vol. 31 (November 1989), p. 190.

46 Frolick, p. 97.

47 Typed sheet (no heading, nd.), BA.

48 Yager, "Saul Bass: Questions, Answers, Evasions," p. 129.

49 Herb Yager, "Saul Bass: American Designer," *Graphis*, vol. 33, no. 193 (1977–78), p. 398.

50 Yager, "Saul Bass: Questions, Answers, Evasions," pp. 128–129.

51 Yager, "Saul Bass: Questions, Answers, Evasions," p. 128.

52 "Saul Bass/Gertrude Snyder," BA.

53 "The AIGA Medalist 1981: Saul Bass," David R. Brown (ed.), *The Annual of the American Institute of Graphic Arts*, New York: Watson-Guptill, 1982, p. 3.

54 Herb Yager, "Saul Bass: American Designer," *Graphis*, vol. 33, no. 193 (1977–78), p. 398.

55 "Interview with Saul Bass – 4/92," BA.

56 *Saul Bass* (1989 videotaped interview with Archie Boston).

57 Frolick, p. 100.

58 Klein, pp. 5–6.

59 Klein, p. 6.

Bibliography

Abrams, Janet. "Beginnings, Endings, and the Stuff in Between," *Sight & Sound*, vol. 4 (December 1994), pp. 22–25.

"The AIGA Medalist 1981: Saul Bass" in David R. Brown, ed., *The Annual of the American Institute of Graphic Arts*, New York: Watson-Guptill, 1982.

Aison, Everett. "The Current Scene: Film Titles," *Print*, vol. 19 (July–August 1965), pp. 26–30.

———. "Saul Bass: The Designer as Filmmaker," *Print*, vol. 23 (January 1969), pp. 90–94, 129–130, 133–134.

Allen, Bob. "Designing and Producing the Credit Titles for *It's a Mad, Mad, Mad, Mad World*," *American Cinematographer*, vol. 44, no. 12 (December 1963), pp. 706–707, 728–730.

Allen, James Sloan. *The Romance of Commerce and Culture: Capitalism, Modernism, and the Chicago-Aspen Crusade for Cultural Reform*. Chicago: University of Chicago Press, 1983.

Altman, Jack. "Bye, Bye Birdie," *Chicago Sun Times* (January 7, 1968), pp. 10–14.

The American Poster. New York: The American Federation of Arts, 1967.

"Animal Hospital by Rochlin and Baran, Architects: Saul Bass, Project Manager," *Arts & Architecture* (June 1955), pp. 24–25.

Anobile, Richard J. *Psycho: The Film Classics Library*. New York: Avon, 1974.

"Apples and Oranges – Food for Thought. How CBS 'Sells' a Concept," *Telefilm* (May 1963), pp. 30–31, 38.

Armstrong, Elizabeth, ed. *Birth of the Cool: California Art, Design, and Culture at Midcentury*. New York: Prestel USA; and Newport Beach: Orange County Museum of Art, 2007.

Arnell, Gordon. *Grand Prix*. New York: National Publishers, 1966.

Arnold, Edwin T. and Eugene L. Miller. *The Films and Career of Robert Aldrich*. Knoxville: University of Tennessee Press, 1986.

Assayas, Olivier. "Hommage à Saul Bass," *Cahiers du Cinema*, vol. 426 (1981), p. 10.

Auiler, Dan. *Vertigo: The Making of a Hitchcock Classic*. New York: St. Martin's Press, 1998.

Aynsley, Jeremy. *A Century of Graphic Design*. Hauppauge, New York: Barron's, 2001.

———. *Graphic Design in Germany, 1890–1945*. Berkeley: University of California Press, 2000.

Badder, David, Bob Baker and Markku Salmi. "Saul Bass," *Film Dope* 3 (August 1973), pp. 1–6, 10.

Bärmich, Barbara. *USA-Plakate: Sean Adams, Walter Allner, Saul Bass*. Cottbus: Brandenburgische Kunstsammlungen Cottbus, 1994.

Barnicoat, John. *A Concise History of Posters*. London: Thames & Hudson, 1972.

Barthes, Roland. "Beim Verlassen des Kinos," *Filmkritik*, vol. 235 (1976), pp. 290–293.

Bass, Saul. "A Definition for Creativity," *Design: The Magazine of Creative Art*, vol. 60 (March–April 1959), pp. 144–145, 170.

———. "Creativity in Visual Communication" in Paul Smith, ed. *Creativity: An Examination of the Creative Process*. New York: Hastings House Publishers, 1959, pp. 121–130.

———. "Film Advertising," *Graphis*, vol. 9, no. 48 (1953), pp. 276–289.

———. "Film Titles: A New Field for the Graphic Designer," *Graphis*, vol. 16, no. 89 (May 1960), pp. 208–216.

———. "How I Got the Idea," in Beryl McAlhone and David Stuart, eds. *A Smile in the Mind: Witty Thinking in Graphic Design*. London: Phaidon Press, 1996, pp. 170–171.

———. "Movement, Film, Communication" in Gyorgy Kepes, ed. *Sign, Image, Symbol*. New York: George Brazillier, 1966, pp. 200–205.

———. "Some Thoughts on Motion Picture Film," in Laurence S. Sewell, *Design Forecast* 2. Pittsburgh, PA: Aluminum Company of America, 1960, pp. 20–26.

———. "Thoughts on Design," *The Journal of the Royal Arts Society for the Encouragement of Arts Manufactures and Commerce*, vol. 63 (November 1965), pp. 991–994. Reprinted in *Royal Designers on Design: A Selection of Royal Designs for Industry*. London: The Design Council, 1986.

———. Foreword to Stefan Kassel and Frank Jastfelder, eds., *The Album Cover Art of Soundtracks*. Boston, MA: Little Brown & Company, 1997.

Baxter, John. *George Lucas: A Biography*. New York: HarperCollins, 1999.

Bayer, Herbert. "Walter Paepcke," *Print*, vol. 14 (September 1960), pp. 34–36.

Beilenhoff, Wolfgang and Martin Heller, eds. *Das Filmplakat*. Zurich: Museum für Gestaltung, 1995.

Benayoun, R. "Le Phénix de l'Animation," *Positif*, vol. 54–55 (1963), pp. 10–11.

Bergan, Ronald. *The United Artists Story*. New York: Crown Publishers, 1986.

Billanti, Dean. "The Names Behind the Titles," *Film Comment*, vol. 18, no. 3 (May–June 1982), pp. 60–65.

Blackwell, Lewis. "Bass Instinct," *Creative Review*, vol. 15 (May 1995), pp. 48–49.

Blanchard, Gérard. "Saul Bass: Génériques et Films," *Communications et Languages*, vol. 40 (1978), pp. 76–96.

Bodger, Lonnel A. "Modern Approach to Film Titling," *American Cinematographer*, vol. 40 (August 1960), pp. 476–478.

Booth-Clibborn, Edward and Daniele Baroni. *The Language of Graphics*. New York: Abrams, 1979.

Borchert, Karlheinz. "Stars Versus Design. The Film Poster is 100," *Plakat Journal*, 4 (October/December 1995), pp. 12–15.

Bowser, Eileen. "Trademarks, Titles, Introductions," in Eileen Bowser. *Transformations of Cinema: 1907–1915*. Berkeley: University of California Press, 1994, pp. 137–147.

Burtin, Will, ed. *Variations on a Theme: Fifty Years of Graphic Arts in America*. Champion Papers, Inc., 1966.

"Cable Column: An Interview with Saul Bass," *Z Magazine*, vol. 2, no. 3 (August–September 1975), p. 21.

Calhoun, John Leroy. "Where Credit Is Due: The Heads and Tails of Title Design," *Theatre Crafts*, 21 (August–September 1987), pp. 79–82.

Camuffo, Giorgio, ed. *Pacific Wave: California Graphic Design*. Museo Fortuny. Udine: Magnus Edizioni, 1987.

Canham, Kingsley. "Phase IV," *Federation of Film Societies*, 2 (October 1974), p. 18.

Capitman, Barbara Baer. *American Trademark Designs*. New York: Dover Publications, 1976.

Capitman, William. "To What Extent Should Research Guide the Designer?," *Print*, vol. 13 (September 1959), pp. 47–51.

Caplan, Ralph. *Design in America*. New York: McGraw Hill, 1969.

———. "Designs by Saul Bass," *Industrial Design* (special issue), vol. 5, no. 10 (October 1958), pp. 88–95.

———. "Industry on the Screen," *Industrial Design*, vol. 7 (April 1960), pp. 48–65.

"Case Study House 20," *Arts & Architecture* 75 (September 1958), pp. 20–21, 28–29.

"Case Study House 20," *Arts & Architecture* 75 (November 1958), pp. 12–22.

Casey, Edward S. "The Memorability of the Filmic Image," *Quarterly Review of Film Studies* (Summer 1981), pp. 241–264.

Chaudoir, Mark. "A Figure with Personality," *Baseline*, 19 (September 1995), pp. 17–21.

Christie, Ian. "Martin Scorsese's Testament," *Sight & Sound*, vol. 6 (January 1996), pp. 7–11.

Clark, Paul Sargent. "Ringing the Corporate Bell," *Design*, 436 (April 1985), p. 25.

Clarke, Frederick S. "Hitchcock's Shower Scene: Another View," *Cinefantastique*, vol. 16, no. 4–5 (October 1986), pp. 64–67.

"The Compleat Designer" in *Design Forecast*, 2. Pittsburgh, PA: Aluminum Company of America (1960), pp. 27–28.

Connah, Roger. "Saul Bass, Arthur Guinness, Günter Grass: Part 2," *Graphis*, (April 1993), pp. 14–18.

Constantine, Mildred, ed. *Word and Image: Posters from the Collection of the Museum of Modern Art*. Text by Alan M. Fern. Greenwich, CT: New York Graphic Society, 1968.

Cort, Saloment. "The 'Compleat Film-Maker'–From Title to Features," *American Cinematographer*, vol. 58, no. 3 (March 1977), pp. 288–291, 315, 325–327.

Coupland, Ken. "Saul Bass: The Man Behind the Titles," *Graphis*, vol. 316 (July–August 1998), pp. 102–107.

Coyne, Richard S. "Saul Bass & Associates," *Communication Arts*, vol. 10 no. 4 (August–September 1968), pp. 14–31.

"Creativity is Indivisible for Saul Bass," *Print*, vol. 11, no. 6 (May–June 1958), pp. 17–37.

Crook, G. *The Changing Image: Television Graphics from Caption Card to Computer*. London: Robots Press, 1986.

Crouwel, Wim and Kurt Weidemann. *Packaging: An International Survey*. New York: Praeger, 1968.

Cumbow, Robert C. "Phase IV," *Movietone News*, 37 (November 1974), pp. 31–32.

D'Angelo, Aldo. "La Graphica nel Cinema e nella Television," *Blanco e Nero*, 29 (September–October 1968), pp. 112–117.

Dailey, Victoria, Natalie Shivers and Michael Dawson. *LA's Early Moderns: Art, Architecture, Photography*. Los Angeles: Balcony Press, 2003.

Davis, Mike. *City of Quartz: Excavating the Future in Los Angeles*. London: Verso, 1990.

Davis, Myrna. "The Keys to the Kingdom: Commercial Film Posters of the Last Two Decades," *Affiche*, 8 (December 1993), pp. 38–49.

de Harak, Rudolph, ed. *Posters by the Members of the Alliance Graphique Internationale, 1960–1985*. New York: Rizzoli, 1986.

"Design on the West Coast," *Industrial Design* (special issue), vol. 4, no. 10 (October 1957), pp. 43–137.

"Designs by Saul Bass," *Industrial Design*, 5 (October 1958), pp. 88–95.

Doll, Susan, Christopher Lyon and James Vinson, eds. *The International Dictionary of Films and Filmmakers*, vol. 4. London: St. James Press, 1991.

Dorfsman, Louis, "Film Titles and Captions," in Walter Herdeg (ed.), *Film and TV Graphics 2: An International Survey of the Art of Film Animation*, Zurich: The Graphis Press, 1976, pp. 172–195.

———. "Saul Bass, a Combination of Intellect and Emotion," in *Saul Bass*, Tokyo: ggg Books–10, Ginza Graphic Gallery, 1993, p. 5.

Dreyfuss, John. "Making a Mark: The Logotype is a Key Weapon in the Battle for Corporate Recognition," *Philadelphia Inquirer* (December 10, 1981), p. 9D.

Dunn, Linwood. "The Mad, Mad World of Special Effects," *American Cinematographer*, vol. 46, no. 2 (December 1961), p. 736.

Dynslaegher, Patrick. "De Vadar Van Het Voorspel," *Knack*, 16 (November 1994), pp. 85–91.

Ebenhöh, Ludwig. "Saul Bass, USA," *Gebrauchsgraphik*, vol. 27 no. 11 (November 1956), pp. 12–21.

"11th Annual Type Directors Club Awards," *Art Direction*, 23 (June 1971), pp. 73–95.

"Experimental Letterheads by Saul Bass: A Portfolio of Eight Exciting New Designs," *Print*, vol. 16 (September–October 1962), pp. 30–32.

Edwards, Gregory John. *International Film Poster Book: The Role of the Poster in Cinema Art, Advertising, History*. London: Columbus, 1985.

Finley, George T. "Bass for Bell," *Industrial Design*, vol. 18 (March 1971), pp. 50–53.

"First for Saul Bass: Illustrations from Henri's Walk to Paris," *Print*, vol. 16 (November–December 1962), p. 55.

Firstenberg, Jean. "Credit Where Credit is Due," *American Film*, 9 (April 1984), p. 80.

"Five Problems in Corporate Identity… And How They Were Solved," *Print*, vol. 16 (November–December 1962), pp. 14–29.

"Four Corporate Identity Programs," *Idea*, vol. 84 (September 1967), pp. 74–106.

Frank, Richard N. *Lawry's Foods, Inc.: A Blending of Dreams*. New York: Newcomen Society of the United States, 1987.

Friedman, Lawrence S. *The Films of Martin Scorsese*. New York: Continuum, 1997.

Friedman, Mildred, et al. *Graphic Design in America: A Visual Language History*. New York: Harry N. Abrams and Minneapolis: Walker Art Center, 1989.

Freidrich, Otto. *City of Nets: A Portrait of Hollywood in the 1940s*. New York: Harper & Row, 1986.

Friend, Leon and Joseph Hefter. *Graphic Design: A Library of Old and New Masters in the Graphic Arts*. New York: Whittlesey House, McGraw-Hill, 1936.

Frischauer, Willi. *Behind the Scenes of Otto Preminger*. London: Michael Joseph, 1973.

Frolick, Stuart. "Nothing Less than a Legend: Saul Bass," *Graphis*, vol. 47, no. 276 (November–December 1991), pp. 94–105.

Garland, Kenneth. "Structure and Substance," *The Penrose Annual*, vol. 54 (1960), pp. 1–10.

Geibel, Victoria. "Images in Motion," *Design Quarterly* 144 (1989), pp. 1–30.

Gid, Raymond. "Saul Bass: New Film Titlings and Promotional Films," *Graphis*, vol. 19, no. 106 (March 1963), pp. 150–159.

———. "Saul Bass," in Lewis Jacobs, ed., *The Emergence of Film Art: The Evolution and Development of the Motion Picture as an Art, from 1900 to the Present*. New York: Hopkinson and Blake, 1969, pp. 382–383.

Glucksman, Mary. "Due Credit," *Screen International* (May 13, 1994), pp. 27–28.

Goldsholl, Morton (with Yoshi Sekiguchi). *Inside Design: A Review, Forty Years of Work*. Tokyo: Graphic-sha Publishing Company, 1987.

Goldstein, Barbara, ed. *Arts & Architecture: The Entenza Years*. Cambridge, MA: MIT Press, 1990.

Golec, Michael. "A Natural History of a Disembodied Eye: The Structure of Gyorgy Kepes's Language of Vision," *Design Issues* vol. 18, no. 2 (Spring 2002), pp. 3–16.

Gomery, Douglas. *The Hollywood Studio System: A History*. London: BFI Publishing, 2005.

Goss, Tom. "On Air, On Screen, Type Over Time," *Print*, vol. 40 (November 1986), pp. 72–78.

Great Graphic Designers of the 20th Century: A Special Issue, *Print*, vol. 23, no. 1 (January–February 1969).

Griffith, Richard. *Anatomy of a Motion Picture*. New York: St. Martin's Press, 1959.

Halas, John and Roger Manvell. *Design in Motion*. New York: Visual Communications Books, 1962.

Halas, John. "Graphics In Motion," *Novum Gebrauchsgraphik* 9 (September 1982), pp. 14–19.

Hamilton, Mina. "N.Y. World's Fair Film Preview," *Industrial Design*, vol. 11 (April 1964), pp. 36–43.

———. "Films at the Fair II: A Comparative Review," *Industrial Design*, vol. 12 (May 1964), pp. 32–41.

Harbord, Jane. "Bass Takes the Credit – But Not for *Psycho*," *Broadcast* (April 18, 1986), p. 17.

Harper, Laurel. "The Man with the Golden Designs," *How*, vol. 11, no. 3 (May 1, 1996), pp. 901–995.

Harvey, Francis. "Type and the TV Screen," *Print*, vol. 8 (1954), pp. 91–116.

Harwood, J. "*Phase IV*," *Variety* 276 (October 9, 1974), p. 18.

Haskin, Pamela. "Saul, Can You Make Me a Title? – Interview with Saul Bass," *Film Quarterly*, vol. 50 (Fall 1996), pp. 101–117.

Heller, Steven. *German Modern: Graphic Design from Wilhelm to Weimar*. San Francisco: Chronicle Books, 1998.

———. *Paul Rand*. London: Phaidon, 1999.

———. "Saul Bass" in Mildred Friedman et al. *Graphic Design in America: A Visual Language History* (New York: Harry N. Abrams and Minneapolis: Walker Art Center, 1989), pp. 161–119.

Heller, Steven and Georgette Balance, eds. *Graphic Design History*. New York: Allworth Press, 2001.

Heller, Steven and Marie Finamore, eds. *Design Culture: An Anthology of Writing from the AIGA Journal*. New York: Allworth Press, 1997.

Heller, Steven, Roger Remington and Leslie Scherr. *Graphic Design USA*. New York: American Institute of Graphic Arts, 1993, p. 14.

Henning, Michael. "Der Vorspann im Film," Unpublished Diplomarbeit am FB Design, Köln: 1997.

Herdeg, Walter, ed. *Film and TV Graphics: An International Survey of Film and Television Graphics*. Zurich: Graphics Press, 1967.

"Hitchcock's Shower Scene: Another View," *Cinefantastique*, vol. 16, no. 4/5 (October 1986), pp. 64–67.

Hofmann, Greg. "Moving Images: Dance Lessons for Designers," *Step-by-Step Graphics*, vol. 10 (March–April 1994), pp. 159–163.

Hoffman, H.U. "Kimberly Clark," *Print*, vol. 14 (November–December 1960), pp. 36–40.

Hogenkamp, Maaike. "The Man with the Golden Arm," *Skrien*, 165 (1989), pp. 46–47, 68.

Horton, Richard. *Billy Wilder: Interviews*. Jackson: University Press of Mississippi, 2001.

Hosansky, Eugene A. "The Current Scene: Film Posters," *Print*, vol. 19, no. 4 (July–August 1965), pp. 20–25.

Hutchins, Robert Maynard. *Walter Paul Paepcke, 1896–1960*. Chicago: Trustees of the University of Chicago, 1960.

Hyman, Sidney. *The Aspen Idea*. Norman: University of Oklahoma Press, 1975.

Igarashi, Takenobu, ed. *World Trademarks and Logotypes I*. Tokyo: Graphic-sha Publishing Company, 1983.

———. *World Trademarks and Logotypes II*. Tokyo: Graphic-sha Publishing Company, 1987.

Jackson, Frank. "*Phase IV*: Individualists Are Likely to Find It a Disturbing Dream," *Cinefantastique*, 3 (1974), p. 31.

Jacobs, Lewis ed. *The Emergence of Film Art: The Evolution and Development of the Motion Picture as an Art, from 1900 to the Present*. New York: Norton, 1969.

Jacobson, E. "Container Corporation of America: Good Design, an Important Function of Good Management," *Graphis*, vol. 6, no. 30 (1950), pp. 136–147.

Jeffer, Marsha, and Pauline G. Weber. *Guide to Quest*. Pyramid Film and Video, 1983.

Kamekora, Yusako. "Graphics" in *Japanese Design: A Survey Since 1950* by Kathryn B. Hiesinger and Felice Fischer, pp. 39–41. New York: Harry N. Abrams and Philadelphia Museum of Art, 1994.

———. "Recent Works of Saul Bass, 1961–1963," *Graphic Design*, 13 (October 1963), pp. 27–40.

———. *Trademarks and Symbols of the World*. London: Studio Vista, 1966.

Kampel, Stewart. "Giving Credit Where It's Due – In Graphic Arts," *New York Times* (January 12, 1964), X19.

Kapsis, Robert R. *Hitchcock: The Making of a Reputation*. Chicago: University of Chicago Press, 1992.

Kane, Bruce, and Joel Reisner. "A Conversation with Saul Bass," *Cinema*, vol. 4 (Fall 1968), pp. 30–35.

Karlstrom, Paul J. *Turning the Tide: Early Los Angeles Modernists, 1920–1956*. Santa Barbara, CA: Santa Barbara Museum of Art, 1990.

Kassel, Stefan and Frank Jasfelder (eds). *The Album Cover Art of Soundtracks*. Boston, MA: Little Brown & Company, 1997.

Katz, Ephraim. *The Film Encyclopedia*. New York: Crowell, 1979.

Keeve, Meredith. "Saul Bass," *Zoom*, 82 (July–August 1988), pp. 74–77.

Kentgens-Craig, Margaret. *The Bauhaus and America: First Contacts, 1919–1936*. Cambridge, MA: MIT Press, 1999.

Kepes, Gyorgy. *Education of Vision*. New York: George Brazillier, 1965.

———. *Language of Vision*. Chicago: Paul Theobald, 1944.

———. *Sign, Image, Symbol*. New York: George Brazillier, 1966.

King, Emily. *Taking Credit: Film Title Sequences, 1955–1965*, unpublished MA thesis. London: RCA, 1993.

Kirkham, Pat. *Charles and Ray Eames: Designers of the Twentieth Century*. Cambridge, MA: MIT Press, 1995.

———. "Bright Lights, Big City: What is the Power of Elaine and Saul Bass's Titles for Casino?," *Sight & Sound*, vol. 6 (January 1996), pp. 12–13.

———. "Dots and Sickles," *Sight & Sound*, vol. 5 (December 1995), pp. 10–13.

———. "The Jeweller's Eye," *Sight & Sound*, vol. 7 (April 1997), pp. 18–19.

———. "Looking for the Simple Idea," *Sight & Sound*, vol. 4 (February 1994), pp. 16–20.

———. "The Man with the Golden Pencil," *Blueprint*, 129 (June 1996), p. 16.

———. "The Personal, The Professional, and the Partner(ship)" in Beverly Skeggs, *Feminist Cultural Theory*, Manchester: Manchester University Press, 1995, pp. 207–226.

———. "Reassessing the Saul Bass and Alfred Hitchcock Collaboration," *West 86th: A Journal of Decorative Arts, Design History, and Material Culture*, vol. 18, no. 1 (2011), pp. 50–85.

———. "Saul Bass and Billy Wilder: In Conversation," *Sight & Sound*, vol. 6 (June 1995), pp. 18–21.

———. "Saul Bass: A Life in Design and Film; Elaine Bass: A Collaboration in Film and Life," in Jeremy Aynsley and Harriet Atkinson, eds. *The Banham Lectures: Essays on Designing the Future*. Oxford: Berg Publishers, 2008, pp. 143–155.

Klein, Lenore. *Henri's Walk to Paris*. New York: W.R. Scott, 1962.

Klein, Nancy Hopkins. "Saul Bass: On the Real Priorities," *Design Firm Management*, 41. Evanston, Illinois: Wefler and Associates, Inc. (1994), pp. 1–6.

Kobal, John. *Fifty Years of Movie Posters*. London: Hamlyn, 1973.

Kothenschulte, Daniel. "Overtüren des Kinos. Saul Bass – Meister des Filmvorspanns," *Filmdienst* 48 (January 4, 1994), pp. 8–11.

Krag, Thomas and Tim Voldsted, eds. *Title Sequence Seminar: Saul and Elaine Bass*. Copenhagen: The National Film School of Denmark, 1995.

Kramer, Stanley and Thomas H. Coffey. *A Mad, Mad, Mad, Mad World: A Life in Hollywood*. New York: Harcourt Brace, 1997.

Krohn, Bill. *Hitchcock at Work*. London, Phaidon, 2000.

Lane, Will. "Anatomy of an Image Maker," *Media Agencies Clients*, 877 (December 7, 1964), pp. 18–27.

Leigh, Janet with Christopher Nickens. *Psycho: Behind the Scenes of the Classic Thriller*. New York: Harmony Books, 1995.

Lewis, Richard Warren. "Box-Office Bait by Bass: A Designer Masters the Fine Art of Hooking an Audience," *Show Business Illustrated* (January 23, 1962), pp. 48–51.

Lupton, Ellen. *Mixing Messages: Graphic Design in Contemporary Culture*. New York: Princeton Architectural Press, 1996.

"The Making of *Quest*," *Step-By-Step Graphics*, 2 (September–October 1986), pp. 36–47.

Mason, Stanley. "Saul and Elaine Bass: A New Film on Solar Energy," *Graphis*, vol. 37, no. 232 (1984), pp. 156–159.

The Master Series: Saul Bass (exhibition catalog). New York: Visual Arts Press,1996.

Matthews, Tom. "One Sheets: Their Design and Impact – Part I, The Lure of the Movie Poster," *Boxoffice*, 122 (1986), pp. 10–13.

McAsh, Iain F. "Saul Bass: One Black Rose Over a Crimson Flame," *Films Illustrated*, 2 (March 1973), pp. 22–23.

McCoy, Esther. *Case Study Houses, 1945–1962*. Los Angeles: Hennessey and Ingalls, 1977.

Meggs, Philip B. *A History of Graphic Design*. New York: Van Nostrand Reinhold, 1992.

———. "Saul Bass on Corporate Identity," *AIGA Journal of Graphic Design*, vol. 8, no. 1 (1990), pp. 4–5. Also in Steven Heller and Marie Finamore, eds. *Design Culture: An Anthology of Writing from the AIGA Journal of Graphic Design*, New York: Allworth Press, 1997, pp. 71–77.

———. *Six Chapters in Design: Bass, Chermayeff, Glaser, Rand, Tanaka, Tomaszewski*. San Francisco: Chronicle Books, 1997.

Metzl, Ervine. *The Poster: Its History and Its Art*. New York: Watson-Guptill, 1963.

Milton, Joyce. *The Tramp: The Life of Charlie Chaplin*. New York: Da Capo Press, 1998.

"Modular Design Revamps Exxon Stations World-wide as Markets Change," *Industrial Design*, vol. 28, no. 6 (November–December 1981), pp. 24–29.

Moholy-Nagy, László. *The New Vision: From Material to Architecture*, translated by Daphne M. Hoffman. New York: Brewer, Warren & Putnam, 1932.

Moore, Deborah Dash. "Defining American Jewish Ethnicity," *Prospects*, 6 (1981), pp. 387–409.

———. *At Home in America: Second Generation New York Jews*. New York: Columbia University Press, 1981.

Morella, Joe, Edward Z. Epstein and Eleanor Clark. *Those Great Movie Ads*. New Rochelle, NY: Arlington House, 1972.

Moritz, William. "Digital Harmony: The Life of John Whitney, Computer Animation Pioneer," *Animation World Magazine*, vol. 2, no. 5 (August 1997), pp. 29–31.

Nakanishi, Motoo. *Building A New Form of Corporate Identity: Japan's Corporate Identity Revolution Today*. Tokyo: PAOS, 1990.

Naremore, James. *Film Guide to "Psycho."* Bloomington: Indiana University Press, 1973.

———. *North by Northwest: Alfred Hitchcock, Director*. New Brunswick: Rutgers University Press, 1993.

"A New Look for Ma Bell," *Communication Arts*, vol. 12, no. 6 (1970), pp. 59–67.

Niece, Robert C. *Art: An Approach*. Dubuque, Iowa: Wm. C. Brown Company, 1963.

Oakes, Philip. "Bass Note," the *Sunday Times* (December 9, 1973), p. 36.

Obach, Robert. *Communication: The Art of Understanding and Being Understood*. New York: Hastings House, 1963.

Oeri, Georgine. "Container Corporation of America. Great Ideas of Western Man: Advertising by Inference," *Graphis*, vol. 13, no. 74 (November–December 1957), pp. 504–513.

———. "Saul Bass," *Graphis*, vol. 11, no. 59 (1955), pp. 258–265.

O'Leary, Sean. "Change as a Constant: Sohio Oil's New Identity Program Becomes British Petroleum's," *Identity*, 2 (Spring 1989), pp. 41–45, 74, 76.

Olins, Wally. *Corporate Identity: Making Business Strategy Visible through Design*. London: Thames & Hudson, 1989.

Packaging Perspective: An Exhibition of Imaginative Thinking by Six International Designers. London: Transparent Paper Limited, 1959.

Paepcke, Walter. "Art in Industry" in Paul Theobald, *Modern Art in Advertising: Designs for Container Corporation of America*. Chicago: Container Corporation of America, 1946.

Peters, David (director), *Die Titelmacher*, DVD (for Zweites Deutsches Fernsehen: producer Joachim Kreck), 1976.

"*Phase IV*," *Independent Film Journal*, 74 (18 September 1974), p. 8.

Pilditch, James. *The Silent Salesman: How to Develop Packaging that Sells*. London: Business Publications, 1961.

"Pioneers: Saul Bass," *Communication Arts*, vol. 41 (March–April 1999), pp. 164–165, 242.

Poyser, E.W. Ted. "Art Directors Club of Los Angeles," *Graphis*, vol. 18, no. 101 (May–June 1962), pp. 304–311.

Pratley, Gerald. *The Cinema of Otto Preminger*. New York: A.S. Barnes, 1971.

Preminger, Otto. *Preminger: An Autobiography*. Garden City, NY: Doubleday and Company, 1977.

"Print Personality: Saul Bass," *Print*, vol. 11, no. 6 (May–June 1958), p. 38.

Pulos, Arthur J. *The American Design Adventure, 1940–1975*. Cambridge, MA: MIT Press, 1988.

Racine, Robert W. "Short Films: Why Man Creates," *Mass Media Ministries*, 7 (August 10, 1970), pp. 1–2, 10.

Rand, Paul. *A Designer's Art*. New Haven and London: Yale University Press, 1985.

Rapaport, Brooke Kamin, and Kevin L. Stayton. *Vital Forms: American Art and Design in the Atomic Age, 1940–1960*. Brooklyn: Brooklyn Museum of Art in association with Henry N. Abrams, 2001.

Rebello, Stephen. *Alfred Hitchcock and the Making of Psycho*. New York: Dembner Books, 1990.

Rebello, Stephen and Richard Allen. *Reel Art: Great Posters from the Golden Age of the Silver Screen*. New York: Abbeville Press, 1988.

"Recreation and Playground Designs by Saul Bass," *Arts & Architecture*, 75 (October 1958), pp. 20–21.

Remington, Roger. *Lester Beall: Trailblazer of American Graphic Design*. New York: W.W. Norton, 1996.

———. *Nine Pioneers in American Graphic Design*. Cambridge, MA: MIT Press, 1989.

Remington, Roger and Robert Fripp. *Design and Science: The Life and Work of Will Burtin*. Aldershot, England; Lund Humphries, 2007.

Rischin, Moses. *The Promised City: New York's Jews, 1870–1914*. New York: Corinth, 1962.

Rose, David. "Los Angeles Advertising Art," *Graphis*, vol. 14, no. 75 (January–February 1958), pp. 58–65.

Rosen, Ben. *The Corporate Search for Visual Identity*. New York: Van Nostrand Reinhold, 1970.

Rosenbaum, J. "*Phase IV*," *Monthly Film Bulletin*, 41 (October 1974), p. 228.

Rosentsweig, Gerry. *Graphic Design: Los Angeles*. New York: Madison Square Press, 1988.

Ross, Chuck. "Saul Bass Returns in Big Way," *San Francisco Chronicle* (June 18, 1988), pp. C3–5.

Rosser, Ed. "Saul Bass," *Cinema Papers*, 11 (January 1977), pp. 238–239.

Rothman, William. *Hitchcock: The Murderous Gaze*. Cambridge, MA: Harvard University Press, 1982.

Ryan, Tom. *Otto Preminger Films "Exodus": A Report* by Tom Ryan, New York: Random House, 1960.

Saul Bass (exhibition catalog). Tokyo: Ginza Graphic Gallery, 1993.

Saul Bass and Associates (*IDEA* special issue). Tokyo: Seibundo Shinkosha Publishing Company, 1979.

"Saul Bass & Associates," *Communication Arts*, vol. 10, no. 4 (1968), pp. 14–31.

"Saul Bass," *Communication Arts*, vol. 11, no. 4 (August–September 1969), pp. 16–19.

"Saul Bass," *Communication Arts*, vol. 31 (November 1989), pp. 189–190.

"Saul Bass," *Communication Arts*, vol. 32 (March–April 1990), pp. 5–6.

"Saul Bass," *Graphis*, vol. 46 (May–June 1990), pp. 9–10.

"Saul Bass," *IDEA*, 18 (May 1970), pp. 76–77.

"Saul Bass," *IDEA*, 41 (September 1993), pp. 130–131.

"Saul Bass/Herb Yager & Associates," *IDEA*, 35 (November 1987), pp. 22–29.

"Saul Bass, Los Angeles: The Corporate Identities of United Airlines and Bell Telephone," *Novum Gebrauchsgraphik*, 49 (December 1978), pp. 45–52.

"Saul Bass: Portfolio of the Versatile Designer's Works," *Print*, vol. 15 (May–June 1961), pp. 35–46.

"Saul Bass: Recent Work," *Print*, vol. 15 (May–June 1961), pp. 35–46.

Schickel, Ricard and George Perry. *You Must Remember This: The Warner Bros. Story*. Philadelphia: Running Press, 2008.

Schwartzman, Arnold, "Saul Bass–Anatomy of a Mentor," *Baseline International Typographics Journal*, 22 (1996), pp. 17–24.

Scorsese, Martin, "Giving Credit to Saul Bass," *i-D*, 43 (September–October 1996), p. 28.

———. "Saul Bass: Anatomy of a Synthesist," *New York Times Magazine* (December 29, 1996), pp. 44–45.

Scott, Allen J. *On Hollywood: The Place, the Industry*. Princeton: Princeton University Press, 2005.

"Sculptured Tile," *Arts & Architecture*, 75 (September 1958), p. 5.

Serling, Robert J. *Maverick: The Story of Robert Six and Continental Airlines*. New York: Doubleday, 1974.

Silver, Alain and James Ursini. *What Ever Happened to Robert Aldrich?: His Life and Films*. New York: Limelight, 1995.

Skerry, Philip J. *The Shower Scene in Hitchcock's Psycho: Creating Cinematic Suspense And Terror*. Lewiston: Edwin Mellen Press, 2005.

Smith, Elizabeth A.T., et al. *Blueprints for Modern Living: History and Legacy of the Case Study Houses*. Cambridge, MA:

MIT Press and Los Angeles: Museum of Contemporary Art, 1989.

———. *Case Study Houses*. Köln: Taschen, 2002.

Smith, George David. *From Monopoly to Competition: The Transformations of Alcoa, 1888–1986*. Cambridge: Cambridge University Press, 1988.

Smith, Paul, ed. *Creativity: An Examination of the Creative Process*. New York: Hastings House Publishers, 1959.

Smith, Scott. *The Film 100: A Ranking of the Most Influential People on the History of Movies*. Seacaucus, NJ: Carol Publishers, 1998.

Snedaker, Kit. "The Image Dealers," *Los Angeles Herald-Examiner California Living* (August 29, 1971), pp. 18–24.

Sohn, David A. *Film: The Creative Eye*. Dayton, OH: George A. Pflaum, 1970.

Solana, Gemma and Antonio Boneu. *Uncredited: Graphic Design and Opening Titles in Movies*. Amsterdam: BIS Publishers, 2007.

Sommese, Lanny. "Saul Bass," *Novum Gebrauchsgraphik*, 59 (June 1988), pp. 4–11, 59.

Sparke, Penny. *Modern Japanese Design*. London: Michael Joseph, 1988.

Spigel, Lynn. *TV by Design: Modern Art and the Rise of Network Television*. Chicago: University of Chicago Press, 2008.

Spinrad, Leonard. "Titles: There's More to Them than Meets the Eye and Ear," *Films in Review*, 6 (April 1955), pp. 168–170.

Spoto, Donald. *The Art of Alfred Hitchcock*. New York: Doubleday, 1976.

———. *The Dark Side of Genius: The Life of Alfred Hitchcock*. Boston: Little Brown, 1983.

———. *Stanley Kramer: Film Maker*. New York: G.P. Putnam's Sons, 1978.

Staiger, Janet. "Announcing Wares, Winning Patrons, Voicing Ideals: Thinking about the History and Theory of Film Advertising," *Cinema Journal*, vol. 29, no. 3 (Spring 1990), pp. 3–31.

Stang, Janet. "Movie (Title) Mogul," *New York Times* (December 1, 1957), pp. 86–88.

Steen, Tom. "Checklist 60 – Saul Bass," *Monthly Film Bulletin*, vol. 35, no. 415 (August 1968), p. 128.

———. "Saul Bass Title Designer," *Skoop*, 4 (March 1968), pp. 37–48.

Sullivan, Catherine. "The Work of Saul Bass," *American Artist*, vol. 18 (October 1954), pp. 28–31, 67–68.

Supanick, Jim. "Saul Bass: '…To Hit the Ground Running…,'" *Film Comment*, vol. 33 (March–April 1977), pp. 72–78, 93.

"Survival Warnings: AIGA Show Offers Designers' Perspectives on Threats to Life on Earth," *Print*, 25 (March–April 1971), pp. 51–55.

Theobald, Paul. *Modern Art in Advertising: Designs for Container Corporation of America*. Chicago: Container Corporation of America, 1946.

Thomas, Tony. *Howard Hughes in Hollywood*. Secaucus, NJ: Citadel Press, 1985.

Thompson, David and Ian Christie, eds. *Scorsese on Scorsese*. London: Faber, 1996.

"Top Drawer. A 'first' for Saul Bass," *Print*, vol. 16, no. 6, November 1962, p. 55.

Timmer, Andreas. *Making the Ordinary Extraordinary: The Film-Related Work of Saul Bass*, unpublished PhD dissertation, New York: Columbia University, 1999.

Timmers, Margaret, ed. *The Power of the Poster*. London: V&A Publications, 1998.

Trasoff, Victor. "Art Directors Club of New York," *Graphis*, vol. 15, no. 81 (January–February 1959), pp. 36–51.

Truffaut, François, in collaboration with Helen Scott. *Hitchcock*. New York: Simon and Schuster, 1967. (*Le Cinema Selon Hitchcock*. Paris: Editions Robert Laffont, 1966.)

Tschichold, Jan. *The New Typography: A Handbook for Modern Designers*, translated by Ruari McLean. Berkeley: University of California Press, 1997. (First published 1928.)

Tuchman, Mitch. "Wayne Fitzgerald Interviewed by Mitch Tuchman," *Film Comment*, 18 (May–June 1982), pp. 66–69.

"Two Playgrounds by Saul Bass and Associates," *Arts & Architecture*, 77 (February 1960), pp. 14–15.

Ultan, Lloyd. *The Beautiful Bronx, 1920–1950*. New Rochelle, NY: Arlington House, 1979.

Ultan, Lloyd and Gary Hermalyn. *The Bronx: It was Only Yesterday, 1935–1965*. The Bronx, New York: The Bronx County Historical Society, 1992.

Van der Leun, Gerard. "That Old Bass Magic," *United Mainliner* (March 1981), pp. 61–64.

Wazumi, Seiichi. *Minolta CI Story*. Tokyo: Seibundo Shinkokosha Publishing, 1984.

Wees, William C. *Light Moving in Time: Studies in the Visual Aesthetics of Avant-Garde Film*, Berkeley: University of California Press, 1992.

Whitman, M. "*Phase IV*," *Films Illustrated*, vol. 4 (November 1974), p. 84.

Whitney, John. "Motion Control: An Overview," *American Cinema* 62 (December 1961), pp. 220–223.

Whitney, Michael. "The Whitney Archive: A Fulfillment of a Dream," *Animation World Magazine*, vol. 2, no. 5 (August 1, 1997), pp. 1–3.

"Wide Range of Saul Bass Work Shown," *Print*, vol. 11 (May 1958), pp. cover, 17–38.

Wild, Lorraine. "Europeans in America," in Mildred Friedman et al., pp. 152–169.

Wilk, Christopher, ed. *Modernism: Designing a New World, 1914–1939*. London: V&A Publications, 2006.

Williams, David E. "Initial Images," *American Cinematographer*, vol. 79 (May 1998), pp. 92–98.

Windsor, Alan. *Peter Behrens: Architect and Designer*. New York: Whitney Library of Design, 1981.

Wingler, Hans Maria. *The Bauhaus: Weimar, Dessau, Berlin*, Chicago, translated by Wolfgang Jabs and Basil Gilbert. Cambridge. MA: MIT Press, 1969.

Wolf, Henry. "Saul Bass," *Creation*, 18 (1993), pp. 34–57.

———. "Saul Bass," *Graphis*, vol. 41, no. 235 (January–February 1985), pp. 28–35.

Wollen, Peter. *Raiding the Icebox: Reflections on Twentieth-Century Culture*. London: Verso, 1993.

"World Design Conference in Japan: Excerpt," *Industrial Design*, vol. 47 no. 7 (July 1960), p. 48.

Woudhuysen, James. "Bass Profundo," *Design Week* (September 22, 1989), pp. 16–17.

"The World Masters 1: Saul Bass," *IDEA*, 38 (March 1990), pp. 1–31.

Yager, Herb. "Saul Bass: American Designer," *Graphis*, vol. 33, no. 193 (1977–78), pp. 392–407.

Yager, Herb and Saul Bass. "Questions, Answers, Evasions," in *Saul Bass and Associates* (*IDEA* special issue). Tokyo: Seibundo and Shinkosha Publishing Company, 1979, pp. 128–129.

A note on photographers:

Every effort has been made to give credit for specific photographs when known, but unfortunately complete records were not available. The following photographers are among those who worked with Saul and Elaine over the years:

Sid Avery
Ferenc Berko, p. 30
Morton Dimondstein
André Gobeli, p. 249
David Fredenthal
Don Handel
George M. Heneghan
Don Jim, pp. 23, 82, 89
Jay Maisel, p. 109
Tom Miller
Leonard Nadel, title page, pp. 28, 40
Marvin Rand, p. 21
J. Tannenbaum
Gerald Trafficanda
C. G. Walker
Todd Walker
Jerry White, pp. 323, 364
Bob Willoughby, pp. 64, 112, 113, 193, 202
Max Yavno

George Arakaki (staff photographer from 1956–1995) was responsible for most of the project documentation photography in the book.

Selected Client / Project List

Much more was designed than is noted here, but the following list provides a sense of the breadth of work undertaken. Work is arranged alphabetically by year and by type of work (film and television projects in bold type, all other design work in book weight). Corporate identity projects are indicated with a bullet at the date of implementation (though work usually began 1–3 years prior and often continued for many years afterward).

Tylon Cold Wave
(advertising)
1945

OWI / French Government
(exhibition, assisting Kepes)
1945

Arts & Architecture
(magazine cover)
1948

Western Air Lines
(brochure, poster)
1948

Champion
(trade ads)
1949

Home of the Brave
(trade ads)
1949

Archer School of Photography
(brochure, with Kahn students)
1949

Barber Shop Harmony
(album cover)
1949

Chopin
(album cover)
1949

Rexall drugstore
(advertising)
1949

Western Air Lines
(advertising)
1949

No Way Out
(poster, advertising)
1950

The Men
(trade ads)
1950

Cyrano De Bergerac
(album cover, trade ads)
1950

Rose Marie Reid
(packaging, retail display)
c. 1950

Western Advertising
(publication cover)
1950

Death of a Salesman
(trade ads)
1951

Decision Before Dawn
(trade ads)
1951

7th Annual Los Angeles Art Exhibition (catalog cover)
1951

The Laurence Puppets
(symbol, letterhead)
1951

Werner Gebauer
(brochure)
c. 1951

Androcles and the Lion
(trade ads)
1952

High Noon
(trade ads)
1952

My Six Convicts
(promotional material)
1952

The Four Poster
(trade ads, invitation)
1952

The Happy Time
(trade ads)
1952

The Lusty Men
(trade ads)
1952

The Member of the Wedding
(trade ads)
1952

The Sniper
(trade ads)
1952

• Lightcraft of California
(corporate identity, brochure)
1952–

Stanley Kramer Productions
(trade ads, promotional material)
1952

Return to Paradise
(trade ads)
1953

The Moon is Blue
(trade ads)
1953

Brett Lithographing Company
(brochure)
1953

Composers Guild of America
(logo)
1953

Flo Ball pens
(packaging, retail display)
c. 1953

General Pharmacal Corporation
(advertising)
1953

Jack Palance
(trade ads, promotional material)
1953

John Westley Associates
(promotional material)
c. 1953

Joseph Eger Ensemble
(program cover)
1953

Municipal Art Patrons of Los Angeles
(logo, letterhead)
1953

A Star is Born
(trade ads)
1954

Carmen Jones
(title sequence, symbol, trade ads, promotional material)
1954

Magnificent Obsession
(trade ads)
1954

Vera Cruz
(trade ads)
1954

Art Directors Studio News
(publication cover)
1954

Cleary, Strauss & Irwin
(trade ads)
1954

Cole of California
(retail display)
1954

Dick Danner
(trade ads, promotional material)
1954

Fiberboard Paper Products
(product advertising)
1954

• Frank Holmes Laboratories
(corporate identity, packaging)
1954–

Glide Window Company
(advertising)
1954

Golden State Mutual Insurance
(logo, print material)
1954

Marshall Field & Co., Suede Sorcery (retail display)
c. 1954

Max Yavno Photography
(symbol, stationery)
1954

Neville Brand
(trade ads, promotional material)
1954

New Dimensions in Sound
(exhibition)
1954

Panavision (trade ads)
1954

• Panaview
(corporate identity, brochure)
1954–

Paul Gregory Productions
(advertising)
1954

Pet Health Plan
(symbol, letterhead, documents)
1954

Robert Aldrich
(promotional material)
1954

Society of Illustrators
(logo, letterhead)
1954

Veterinary Research Center and Animal Hospital (architecture, signage – with Herb Rosenthal)
1954

Kiss Me Deadly
(trade ads)
1955

Mister Roberts
(trade ads)
1955

My Sister Eileen
(trade ads)
1955

Night of the Hunter
(trade ads)
1955

Not as a Stranger
(trade ads)
1955

Pearl of the South Pacific
(trade ads)
1955

The Big Knife
(title sequence, trade ads)
1955

The Desperate Hours
(trade ads)
1955

The Man with the Golden Arm
(title sequence, poster, advertising, trailer, promotional material)
1955

The Racers
(title sequence, trade ads)
1955

The Rose Tattoo
(trade ads)
1955

The Seven Year Itch
(title sequence)
1955

The Shrike
(title sequence, trade ads)
1955

The Virgin Queen
(trade ads)
1955

Trial
(trade ads)
1955

Gruen Lighting
(advertising)
1955

Hecht Lancaster Productions
(trade ads, promotional material)
1955

Madre Selva
(graphics, packaging)
1955

Qantas Empire Airways
(advertising)
1955

Richard Conte
(trade ads, promotional material)
1955

Robert Alexander, Architect
(logo, letterhead)
c. 1955

The Phoenix Corporation
(symbol, letterhead)
1955

William E. Phillips Co. beauty products (television commercial)
1955

Around the World in Eighty Days
(title sequence)
1956

Attack!
(title sequence, trade ads)
1956

On the Threshold of Space
(trade ads)
1956

Playhouse 90
(television opening sequence)
1956–60

Somebody Up There Likes Me
(trade ads)
1956

Storm Center
(title sequence, advertising, promotional material)
1956

The Conqueror
(trade ads)
1956

The Naked Eye
(trade ads)
1956

Anatole Robbins (packaging)
c. 1956

Elmer Bernstein, Blues & Brass
(album cover)
1956

Frank Sinatra, Tone Poems of Color
(album cover)
1956

General Controls Company
(advertising)
1956

Pabco Paint
(advertising)
1956

The Guggenheim Foundation, The Art of PreHistory (curator, exhibit design – not realized)
c. 1956

Edge of the City
(title sequence, poster, advertising, promotional material)
1957

Love in the Afternoon
(poster, trade ads)
1957

Saint Joan
(title sequence, poster, television spot, promotional material)
1957

The Frank Sinatra Show
(television promo sequence)
1957

The Pride and the Passion
(title sequence, trailer, promotional material)
1957

The Young Stranger
(title sequence, promotional material)
1957

Blitz Beer (advertising, television commercials)
1957

British European Airways
(advertising)
1957

California Test Bureau
(brochure)
1957

Case Study House no. 20
(architectural collaboration)
1957

Container Corporation of America, Great Ideas of Western Man
(poster, advertisement)
1957

Enfield Cables, UK
(advertising)
1957

International Paints
(calendar)
1957

• KLH
(corporate identity, advertising, packaging)
1957–

Mike Todd
(promotional material)
1957

National Bohemian Beer
(print advertising, television commercial)
1957

New York Central
(logo, train and station graphics)
1957

Pomona Tile Company, Distinguished Designer Series
(tile design)
1957–1958

Safeway Stores,
(product packaging)
1957

Scamper detergent
(packaging)
1957

Shell Oil, UK
(advertising)
1957

Silverlake Lithographers
(symbol, letterhead)
1957

Stephens TruSonic Hi-Fi
(modular cabinets, benches)
1957

Strathmore Paper Company
(brochure)
1957

The Bomb
(poster)
1957

ABC television, Fall Line Up:
Ozzie & Harriet, Walt Disney Presents, Wednesday Night Fights, Wyatt Earp, Sid Caesar etc.
(network promos)
1958

Bonjour Tristesse
(title sequence, poster, advertising promotional material)
1958

Cowboy
(title sequence, trade ads)
1958

The Big Country
(title sequence, trade ads, promotional material)
1958

The Defiant Ones
(trade ads)
1958

Vertigo
(title sequence, poster, advertising)
1958

2nd San Francisco International Film Festival (poster)
1958

Bel Air Pies (packaging)
1958

Capitol Towers, Sacramento
(play and recreation areas – with Herb Rosenthal)
1958

Chicken of the Sea Tuna
(packaging)
1958

Print, May/June
(magazine cover)
1958

Revell Toy Trains
(packaging, retail display)
1958

Reynolds Aluminum, Splendor Gift Wrap
(logo, wrapping paper, dispenser)
1958–59

Stan Freberg
(symbol, letterhead, promotional material)
1958–

Tee-Pee Nylons (packaging)
1958

This is Goggle, Broadway play
(poster, advertising)
1958

4 Just Men
(television opening sequence)
1959

Anatomy of a Murder
(title sequence, poster, advertising, television spot, promotional material)
1959

Faces and Fortunes
(short film – with Morton Goldsholl)
1959

North by Northwest
(title sequence)
1959

Olin Mathieson, Small World
(television opening sequences)
1959

Speedway
(television commercial, print advertising)
1959

3rd San Francisco International Film Festival (poster)
1959

Alcoa, Aluminum is Color
(brochure)
1959

Cumins Engine Company
(annual report)
1959

• Ducommun
(corporate identity)
1959

Dupont
(advertising)
1959

Hollywood Branch of the National Committee for a Sane Nuclear Policy
(poster, logo, invitation)
1959–60

• Lawry's
(corporate identity, packaging)
1959–96

Link Toys
(toy train play elements)
c.1959

Lightolier
(catalog covers)
c.1959–60

Speedway/Marathon
(advertising)
1959

Tavris Insurance
(logo, letterhead)
c.1959

White King
(television commercial)
1959

Exodus
(title sequence, poster, advertising promotional material)
1960

Ocean's Eleven
(title sequence)
1960

Psycho
(title sequence, pictorial consultant)
1960

Ranier Beer
(television commercials, packaging)
c.1960

Some Like It Hot
(trade ads)
1960

Spartacus
(title sequence, trade ads, design consultant)
1960

The Facts of Life
(title sequence)
1960

The Magnificent Seven
(trade ads – not realized)
1960

4th San Francisco International Film Festival (poster)
1960

Aspen Design Conference, Call to the Conference
(poster)
1960

Committee of Aluminum Producers
(logo, brochure)
1960

Cravings of Desire (book cover)
1960

Critics' Choice, Broadway play
(poster, advertising)
1960

FirstAmerica Corporation
(annual report)
1960

Kimberly-Clark
(packaging, promotional material)
1960–64

Manufacturers National Bank
(advertising)
1960–61

Oakbrook Terrace Shopping Center, Chicago (symbol)
c.1960

The Ranch Club, Malibu
(symbol, letterhead, brochure)
1960

Westinghouse (advertising)
c.1960

Wesson Oil
(bottle design, packaging)
1960

ABC, Stan Freberg Presents
(promotional material)
1961

Alcoa Premiere
(television opening sequence)
1961–63

One, Two, Three
(advertising, poster)
1961

Something Wild
(title sequence)
1961

The Sale of Manhattan
(sequence in television program)
1961

West Side Story
(prologue, title sequence, visual consultant)
1961

Westinghouse, PM East and PM West
(television opening sequences)
1961

Westinghouse, The Party
short film
1961

5th San Francisco International Film Festival (poster)
1961

Esquire (illustrations)
1961

Hunt Foods & Industries
(annual report)
1961

Saturday Evening Post
(illustrations)
1961–62

The Detroit News (advertising)
1961

The Plaintiffs Against the Blacklist (invitation)
1961

Advise and Consent
(title sequence, poster, advertising, promotional material)
1962

Best of Bolshoi
(television animated preludes)
1962

CBS, Apples and Oranges
(short film)
1962

IBM, History of Invention, Men Against Cancer, Orientation
(extended television commercials)
1962

Mennen, Baby Magic and Genteel Baby Bath
(television commercials)
1962

Walk on the Wild Side
(title sequence)
1962

Eastman Kodak
(World's Fair Pavilion – not realized)
1962

Great Issues Foundation
(logo, letterhead)
1962

Henri's Walk to Paris
(children's book illustration)
1962

Hunt Foods & Industries
(annual report)
1962

U.S. World's Fair Pavilion
(exhibit, ride, film – not realized)
1962

Bridgestone Tires, Japan
(television commercial in U.S.)
1963

It's a Mad, Mad, Mad, Mad World
(title sequence, advertising, promotional material)
1963

National Bohemian Beer
(television commercials, packaging)
1963–65

Nine Hours to Rama
(title sequence, trade ads)
1963

NBC, S&H Green Stamps intro, to The Andy Williams Show
(television opening sequence)
1963

The Cardinal
(title sequence, poster, advertising promotional materials)
1963

The Victors
(prologue, title sequence)
1963

7th San Francisco International Film Festival (poster)
1963

• Alcoa
(corporate identity)
1963–

• Fuller Paints
(corporate identity, packaging, signage, sculpture)
1963–

Ohio Blue Tip matches
(packaging)
c.1963–65

Transport-a-Child
(symbol, letterhead
1963

UNESCO, Human Rights Week
(poster, promotional material)
1963

From Here to There
(short film, promotional material)
1964

Hallmark Hall of Fame
(television opening sequence)
1964

Profiles in Courage
(television opening sequence)
1964

The Searching Eye
(short film, symbol)
1964

2nd New York Film Festival
(poster)
1964

8th San Francisco International Film Festival (poster)
1964

Golden Boy, Broadway play
(poster, advertising, album cover)
1964

• Hunt-Wesson
(corporate identity)
1964–

Keio Department Store, Japan
(wrapping paper, window display)
1964

Kleenex, table napkins
(easy open box joint patent, with Goldsholl & Altree)
1964

Pirelli magazine, Italy (covers)
1964, 1965

UNESCO, Mind Your World
(brochure cover)
1964

Wexler Film Productions
(logo, letterhead)
1964

Bunny Lake is Missing
(title sequence, poster, advertising promotional materials)
1965

In Harm's Way
(title sequence, poster, advertising promotional materials)
1965

• Celanese
(corporate identity)
1966–

Devoe Paint (packaging)
1966

Grand Prix
(title sequence, trade ads, visual consultant)
1966

Not with My Wife You Don't
(title sequence, visual consultant)
1966

Seconds
(title sequence, advertising, promotional material)
1966

• Security Pacific Bank
(corporate identity)
1966–

Variations on a Theme: 50 Years of American Graphic Design
(illustration)
1966

The Firemans Ball
(poster, promotional material)
1967

The Two of Us
(poster, book cover, promotional material)
1967

• Continental Airlines
(corporate identity)
1967–

Mattel, Baby Tenderlove
(television commercial)
1968

RCA, The Kid
(television commercial)
1968

The Dixie Cup Company
(television commercial)
1968

The Fixer
(trade ads, promotional material)
1968

Why Man Creates
(short film, poster)
1968

XIV Milan Triennale (exhibit)
1968

Ameryka
(publication cover)
1968

Laura Scudder's, Viko Chips, Pokitos Chips, Old Fashioned Peanut Butter and Dittos Chips
(packaging)
1968, 1972, 1975, 1978

Northern Tissue
(advertising, packaging)
1968–69

• Rockwell International
(corporate identity)
1968–

Stamp Out Smog (poster)
1968

Very Happy Alexander
(poster, promotional material)
1969

• Bell System
(corporate identity, packaging)
1969–

• Dixie
(corporate identity, packaging, product graphics)
1969–

Prayer for the 70s
(book cover, illustrations)
1969

• Quaker
(corporate identity, packaging)
1969–

Change
(short film – not realized)
1970

California Exposition
(symbol)
1970

National Reading Council
(symbol)
1970

UCLA Graduate School of Management (logo)
1970

United Nations 25th Anniversary
(poster)
1970

Such Good Friends
(poster, promotional material)
1971

Selected Client / Project List 419

Environment
(poster, cover)
1971

· United Way
(identity program)
1972–

10th Chicago International
Film Festival (poster)
1973

ACLU, Freedom of the Press
(pamphlet)
1973

· Ajinomoto, Japan
(corporate identity, packaging)
1973–

Burry, Girl Scout Cookies
(packaging)
1973–

Los Angeles Free Clinic
(logo)
1973

· Paul Harris
(corporate identity)
1973

Stomu Yamashta, Freedom is
Frightening and Sea & Sky
(album covers)
1973, 1985

· Ticor Title Insurance
(corporate identity)
1973

Phase IV
(feature film)
1974

AIGA Fiftieth Anniversary
(poster, book cover)
1974

Chicago International Film Festival
(poster)
1974, 1984, 1994

· United Airlines
(corporate identity)
1974–

· Warner Communications
(corporate identity)
1974–

Rosebud
(poster, promotional material)
1975

· Avery
(corporate identity, packaging)
1975–

La Folie restaurant (symbol)
1975

**AT&T, One Hundred Years
of the Telephone**
(short film)
1976

NBC, 50th Anniversary special
(television opening sequence)
1976

That's Entertainment, Part II
(title sequence)
1976

Fujiya, Japan
(packaging)
1976

Right to Read
(poster)
1976

Brothers
(poster, promotional material)
1977

Notes on the Popular Arts
(short film, poster)
1977

Bell System, Phone Center Store
(retail display, packaging)
1977–

Preminger: An Autobiography
(book jacket)
1977

Some of My Best Friends,
Broadway play
(poster)
1977

Bass on Titles
(short film, poster)
1978

CBS, 50th anniversary
(symbol, animated opener)
1978

Bi-Plane Films
(symbol)
1978

· Frontier Airlines
(corporate identity)
1978

· Girl Scouts of America
(corporate identity, packaging)
1978–

Rodeo Collection
(logo)
1978

· Wienerschnitzel
(corporate identity)
1978

Hanna-Barbera
(symbol, animated sequence)
1979

The Human Factor
(poster, promotional material)
1979

Frank Sinatra, Trilogy
(album cover)
1979

Music Center Unified Fund
(poster)
1979

· RTD, Los Angeles
(corporate identity)
1979–

The Shining
(poster, promotional material)
1980

The Solar Film
(short film, poster)
1980

· Boys Clubs of America
(identity program)
1980–

Exxon/Esso
(service stations)
1980–

Kaufman Astoria Studios
(symbol)
1980

Photoworks
(logo)
1980

President's Council for
Energy Efficiency (logo)
1980

AIGA Graphic Design USA 2
(book cover)
1981

Artwork, Germany
(magazine cover)
1981

LA 200, Los Angeles
Bicentennial 1781–1981
(poster)
1981

Filmex '81
(poster)
1981

· Geffen Records
(corporate identity)
1981

Los Angeles Museum
of Natural History, Treasures
of Columbia (poster)
1981

· Minolta
(corporate identity, packaging)
1981–

· J. Paul Getty Museum
(corporate identity, signage)
1981–

· Mokichi Okada Association, Japan
(corporate identity, packaging)
1982–

Morgenthaler, Rainbow Bass
Alphabet (font design)
1982

Quest
(short film, poster)
1983

· Real California Cheese
(corporate identity, packaging)
1983–

U.S. Postal Service,
Science & Industry
(postage stamp)
1983

20th Chicago International
Film Festival (poster)
1984

· AT&T
(corporate identity, packaging)
1984–

Games of the XXIIIrd Olympiad
(poster)
1984

· General Foods
(corporate identity)
1984–

· Kibun Foods, Japan
(corporate identity)
1984–

Tonio's (logo)
1984

Filmex '85 (poster)
1985

Honda Motorcycles
(advertising, signage)
1985

Los Angeles Music Center
Club 100 (symbol, poster)
1985

Directors Guild 50th Anniversary
(poster)
1986

Napoli, Italy (poster)
1986

· Wells Fargo Bank
(corporate identity)
1986

**Alexander Nevsky –
film restoration screening**
(poster, promotional material)
1987

Broadcast News
(title sequence)
1987

· Kerr Company
(corporate identity)
1987

· Pomona College Centennial
(identity program, poster,
promotional material)
1987

Sinfonia Varsovia, Warsaw
Symphony Orchestra (poster)
1987

UCLA extension catalog (cover)
1987

We the People… (poster)
1987

Big
(title sequence)
1988

Tonko/Dun Huang/The Silk Road
(title sequence, posters)
1988

5th Israel Film Festival
in the USA (poster)
1988

AT&T, sponsors of the USA
Olympic team (television tag)
1988

Human Rights Watch Film
Festival (poster)
1988

· Miles Bayer
(corporate identity program)
1988

Mitsukoshi, Japan
(catalog cover)
1988

· Republic Federal Bank
(corporate identity)
1988

Standard Oil/Sohio/Gulf/BP
(service stations)
1988

The United States Film Festival/
Sundance, Park City, Utah
(poster)
1988

· YWCA
(identity program)
1988

**National Film Registry,
Library of Congress**
(symbol, animated sequence)
1989

Return from the River Kwai
(poster)
1989

The War of the Roses
(title sequence)
1989

6th Israel Film Festival
in the USA (poster)
1989

Human Rights 1789–1989
(poster)
1989

New York Art Directors Club
Call for Entries (poster)
1989

· Special Olympics
(identity program, poster)
1989

Goodfellas
(title sequence)
1990

Matsushita, Japan
(television commercial)
1990

· David Geffen Company
(corporate identity)
1990

· Minami, Japan
(corporate identity)
1990

The Film Foundation
(logo)
1990

Uchida, Japan
(catalog cover)
1990

Cape Fear
(title sequence)
1991

Doc Hollywood
(title sequence)
1991

63rd Annual Academy Awards
(poster)
1991

· Kosé, Japan
(corporate identity)
1991

· Maeda, Japan
(corporate identity, signage)
1991

Maglite
(corporate identity)
1991

Motion Picture & Television Fund
(symbol)
1991

The George Lucas
Educational Foundation
(symbol)
1991

The Smithereens, Blow Up
(album/cd cover)
1991

Mr. Saturday Night
(title sequence)
1992

Motion Picture Centennial
(logo, poster)
1992

· Safelite
(corporate identity)
1992

Martin Scorsese Presents
(title graphic)
1993

Schindler's List
(posters, advertising)
1993

The Age of Innocence
(title sequence)
1993

65th Annual Academy Awards
(poster)
1993

Psychology (textbook cover,
chapter headings, posters)
1993

· JOMO, Japan
(corporate identity)
1994

· J. Paul Getty Trust
(corporate identity, signage)
1993–

UCLA extension, 75th Anniversary
course catalog, (cover)
1993

Under Suspicion
(television opening sequence)
1994

30th Chicago International
Film Festival (poster)
1994

66th Annual Academy Awards
(poster)
1994

Petersen Automotive Museum
(symbol)
1994

Society of Lyricists and Composers
(invitation)
1994

Casino
(title sequence)
1995

Higher Learning
(title sequence)
1995

**Martin Scorsese's Personal
Journey Through American Movies**
(television opening sequence)
1995

67th Annual Academy Awards
(poster)
1995

68th Annual Academy Awards
(poster)
1996

· Conservation International
(identity program)
1996

· East West Bank
(corporate identity)
1996

· NCR
(corporate identity)
1996

· Taiwan R.O.C. Farmers' Association
(identity program)
1996

· University of Southern California
(identity program)
1996

Selected Chronology

1920	**Born May 8, the Bronx, NY**	1948	Art Directors Club, LA Outstanding Contribution to Advertising Art Award	1967	Son Jeffrey born
1932	Saint Gauden's Medal for Fine Draughtsmanship School Art League, NY	1949	Los Angeles Society of Contemporary Designers, founding member	1968	**Academy Award for Best Documentary Short Subject, *Why Man Creates***
1934	Art in Trades Club Medal School Art League, NY	1950	Foote, Cone & Belding, art director	1970	Gold Medal, Moscow Film Festival *Why Man Creates*
	Paints signs for local fruit stalls and store windows	1952	**Establishes his own design office**	1975	Herb Yager joins the office (Bass / Yager & Associates in 1978)
1936	Graduates from James Monroe High School, the Bronx, NY	1953	International Design Conference in Aspen, Planning Committee Chair	1977	**New York Art Directors Club Hall of Fame**
	Wins scholarship to the Art Students League	1955	Profiled in *Graphis*	1980	Design Arts Policy Board, National Endowment for the Arts (NEA), Washington D.C.
	Howard Trafton's commercial art evening class		Board of Directors, International Design Conference in Aspen (IDCA)	1981	**Gold Medal, American Institute of Graphic Arts (AIGA)**
1937	John Wanamaker Award, Annual Drawing Competition		IDCA Conference Co-chair (with Will Burtin)		Founding Trustee, Sundance Film Institute
	Works in small studio specializing in trade ads for films	1956	**Elaine Makatura joins Saul as an assistant**	1984	Advisory Board, Program for Art & Film, Metropolitan Museum of Art and the J. Paul Getty Trust
1938	Warner Brothers, NY advertising department, lettering and paste-up man		New York Art Directors Club special award for *The Man with the Golden Arm*	1985	Founding member of AIGA / LA
1940	Marries Ruth Cooper		Work shown at the Alliance Graphique Internationale, London	1986	Guardian Lecturer, British Film Institute, London
1941	20th Century-Fox, NY, layout man and art director	1957	**Art Directors Club of New York, Art Director of the Year**		Regents Lecturer, University of California, Los Angeles
1942	Son Robert born		IDCA Conference, Program Chairman *Design and Human Values*		UCLA Retrospective Exhibition
1944	Blaine Thompson ad agency, NY, art director	1958	**Forms Saul Bass & Associates**	1987	**Board of Governors, Academy of Motion Picture Arts & Sciences**
	Gyorgy Kepes's evening class, Brooklyn College	1960	Art Goodman joins office full time	1993	Granddaughter Amanda born
1946	Distinctive Merit Award, Art Directors Club, NY		World Design Conference, Japan Co-chair of U.S. delegation	1994	Chicago International Film Festival Gold Hugo Lifetime Achievement Award and Retrospective Exhibition
	Moves to Los Angeles	1961	**Marries Elaine Makatura**		
	Buchanan and Company, LA, art director and designer	1964	Daughter Jennifer born	1996	The Master Series: Saul Bass, Award and Retrospective Exhibition, School of Visual Arts, NY
	Daughter Andrea born		**Honorary Royal Designer for Industry, Royal Society of Arts, London**		**Dies April 25, Los Angeles, CA**

Index

Page numbers in *italics* refer to illustrations

A

ABC Television 94, *94*, *95*, 101
Abstract Expressionism 34, 111
Advise & Consent 142–5, *397*
AEG 283
Age of Innocence
 262, 270, *276*, *277*, *402*
AIGA 374
Ajinomoto 287, 344–5, *344*, *344*, *346*, *346*, *347*, *416*
album cover design 52, 53, *53*, 107, *120*, 125, *126*, *131*, *136*
Alcoa 283, 294–7, *416*
Aldrich, Robert 36, 161
Algren, Nelson 116
Altadena House, Los Angeles
 see Case Study House No. 20
American Can Company 322, *323*
Ameryka magazine 375
Anatole Robbins 84
Anatomy of a Murder 107, 111, *111*, *112–13*, *130*, 131–7, *400*
Anderson, Michael 166
The Andromeda Strain 258
Anger, Kenneth 232
Annual Academy Awards (Oscars)
 posters *368*, *369*
Apples and Oranges (short film)
 232–3, *233*
Arakaki, George 24, *24*
architectural projects 29, 41, 82, 90–2
Around the World in Eighty Days
 108, 166, *166–7*, *399*
Arts & Architecture magazine 14, *15*, 90
Arts and Crafts Movement 7, 90
Asaba, Katsumi 111
AT&T 283, 288, 318, 330–3, *418*
Attack! 160, 161–3, *399*
Avery International 289, *289*, *417*

B

Baby Magic (Mennen) 96, *97*
Baby Tenderlove (Mattel) 96, *99*
Baker, Carroll 198
Ball, Lucille 188
Barber Shop Harmony 53
Bass, Andrea 8, *165*
Bass, Elaine (née Makatura)
 21, 22–3, 24, *24*, 96, 193, 198, *199*, *200*, 202, *204*, 205, 210–13
 film title collaborations 23, 107, 193–4, 264–5, 270, *270*, 278
 logo *396*
 short film collaborations
 23, 92, *93*, *228*, *229*, 230–3, *234*
Bass, Jeffrey 23, 231, *231*, 264, *388*, *389*, *408*
Bass, Jennifer 23, *23*, 96, 99, *388*, 231, *231*, 264, *388*, *389*
Bass, Robert 8, *394*
Bass, Saul
 art and design education 6, *7*, *9*
 awards 5, 11, 115, 230, 247, *255*, 258
 birth and childhood 2–5
 cat (Tippi-Tu) 23, 204
 collaborating with Elaine 21, 23, 107, 193, 231, 237, 264, *265*, 278, 382
 collecting artifacts 381, 388, *388*, *389*
 on creativity 16, 32, 34–5, 92, 241, 246, 382, 387
 doodles and sketches 7, *254*, 381, *382*, *384*, *385*, *386*, *392*
 employment 7, 8, 11, 12, 16–17, 20–1
 family 3, 8, 23, 96, 231, 237
 going freelance 21, 24–5, 29
 in Hollywood 12–20, 232
 on humor 231, 245, 246, 249, 382
 in Japan 32, *32*, *33*, 344–54, 355
 on narration 250
 photography 230, 309, 355, 381, *383*, *386*, *388*
 on presentations 285, 286–7, 288, 289, 337
 on psychology 9, 34, 217
 teaching art 6, *15*
Bass / Yager & Associates
 24, *24*, 25, *25*, 345, 348
Bauhaus 9, 283
Bayer, Herbert
 11, 30, 32, *33*, 34, 85, 283
Beall, Lester 34, 283
Bell System
 64, *281*, 283, *286*, 314, 314–19, 330, *334*, *409*, *416*
Benedek, Laszlo 17
Bernstein, Elmer
 xii, 53, 111, 116, 205, 272, 277
Bernstein, Leonard 199, 202
Best of Bolshoi 102, *103*
The Big Country
 108, 109, *174*, 174–7, *400*
Big 265, 271, *402*
billboards 18, 40–5, 111, *112–13*
Blaine Thompson Company 8, 11
Blitz Beer 40, *42*, 94, 101
Block, Edward 289, 331, 332
Blues & Brass (Bernstein) 52
Bonjour Tristesse
 108, *128*, 129, *129*, *397*, *399*
book design 58–9
Boys Clubs of America 338, *338*, *417*
Bradbury, Ray xii, 253
Brand, Neville 36, *36*
Bridgestone Tires *99*, 344
Bristol, George 233
British European Airways (BEA) 44, *44*
Broadcast News 265, *265*
Brodovitch, Alexey 8, 11, 34
Bronowski, Jacob 30
Brooklyn College 9, 11
Brooks, Jim 265
Brown, Charlie 331
Buchanan and Company 11, 16, 17
Buff, Straub & Hensman 90, *90*
Bunny Lake is Missing
 114, *152*, 153, *153*, *401*, *403*
Burtin, Will 11, 30, *31*, 34, 287

C

California Test Bureau 80–1
Cape Fear 262, 270, 272–5, *402*
The Cardinal 146–9, *401*
Carlson, Edward 324, *325*, 327
Carmen Jones
 106, 108, 114, 115, *115*, *399*
Carra, Vince *284*, 325
cartoons 107, 214, 233, 250, *397*
Cassavetes, John 169
Case Study House No. 20
 21, 88, 90, *90*, *91*

Casino 107, *262*, 265, 270, 278, *278–9*
CBS 30, 94, *95*, 232, 233, *233*, 259
Celanese 283, 304–7, *416*
ceramic tiles 82, 88, *89*
Champion 16, *17*, *17*, 18
Chaplin, Charlie 16
Chermayeff, Ivan xiv
Chicago International Film Festival
 364, *365*
Chicken of the Sea 82, *396*
Cocteau, Jean 232
Cole of California 85
Columbia Pictures Corporation 36
Committee of Aluminum Producers
 29, *395*, *415*
The Conqueror 36
Conservation International *418*
Container Corporation of America (CCA)
 30, 283, 48
Conte, Richard 189, 36, *36*
Continental Airlines 64, 283, *286*, *287*, *308*, 309–11, *416*
Cooper, Ruth 8
Copland, Aaron 198
corporate identity design
 54, 64, 102, *281*, 282–9
 see also named companies
Cowboy 173, *173*
Critic's Choice *397*
Crystal, Billy 268, *269*
Curtis, Tony 15, 245, *246*
Cyrano de Bergerac 17, 53

D

Dalí, Salvador 185
Dandridge, Dorothy 115
Danner, Dick 37
Danziger, Lou 12, *393*, *395*
Daves, Delmer 173
Davis, Bette 164
Davis Jr., Sammy 189
Death of a Salesman 16, 17
Decision Before Dawn 18, *19*
De Niro, Robert 272, 278
Deren, Maya 232
The Detroit News 41, *42*
DeVito, Danny 267
Dickinson, Angie 189
Directors Guild of America *361*
Disasters of War (Goya) 171, *171*
The Dixie Cup Company 322, *416*
Dmytryk, Edward 17, 205
Dorfsman, Louis xii, 233, 283, 287, 381
Doshi, Balkrishna 32
Douglas, Kirk 193, 197
Drury, Allen 142
Ducommun *415*

E

Eames, Ray and Charles
 13, 15, 30, 154, 185, 232, 396
Eastman Kodak Pavilion, World's Fair
 (1964–65) 92, *93*, 236, 287
Eastman Kodak sponsored film
 93, 234, 236, 239
Eckbo, Dean & Williams 21, 90
Edge of the City
 168, 169, *169*, *399*
Ellington, Duke 136
Enfield Cables 44
Environment 410

environmental projects 41, 82
Exodus 138–41, *398*, *400*
experimental films 230, 232–3, 236
Ewell, Tom 154
Exxon (Esso) 283, 355–7

F

Faces and Fortunes (short film) 232
The Facts of Life 188, *188*
Faust (Gounod) 277
Ferren, John 185, *404*
film advertising 7, 8, 11, 16–20, 29, 36, 107, 114, 115
film poster design 107, 111, 115, 125
film titles and credits
 23, 29, 106–11, 115, 264–5, 278
 see also named films
Filmex *362*, *366*
Firstamerica Corporation 78
Fischinger, Oskar 13, 232
Fitzgerald, Wayne 175
The Fixer 405
Fleischer, Richard 17
Flo Ball Pens 82, *87*
Follis, John 12
Foote, Cone & Belding 20, 21
Ford, Glenn 173
Ford, John 106
Foreman, Carl 17, 210
4 Just Men (ITV England) 101, *103*
The Four-Poster 17
Frank Holmes Laboratories, Inc.
 74–5, *415*
Frank, Melvyn 188
Frank, Richard 291, 292
The Frank Sinatra Show (ABC) 101, *101*
Frankenheimer, John 172, 217, 221, 225
Freberg, Stan, 64, *65*
Freedom of the Press 375
From Here to There (short film)
 234, *234*, *235*, 239
Frontier Airlines *417*
Fuller Paints 283, 300, *300*, *301*, *416*

G

Galentine, Wheaton 232
Garden of Allah, Los Angeles 12, *12*, *13*
Garfein, Jack 198
Garner, James 221
Gascoigne, Brian 257
Gavin, John 185
Geffen *334*, *417*
General Controls Company 51
General Foods 335, *417*
General Pharmacal Corporation 50, *51*
The Getty Center *418*
Gill, Bob xiv, 202
Girl Scouts of America 336–7, *417*
Glaser, Milton xii
Glass, George 17
Gold, Ernest 214
Golden, William 34, 283
Goldman, Ilene 250
Goldsholl, Morton and Millie 232, *404*
Goodfellas 270, 271, *271*, 278, *402*
Goodman, Art 24–5, *24*, 111, 178, 217, *242*, 264, *280*, *284*, 287, 392–410
Gordon, Michael 17
Grand Prix
 107, 108, *220*, 221–7, *401*, *403*
Graphis magazine 178

Griffiths, D.W. 106
Guidi, Robert 12, *403*

H

Halas, John 166
Hallmark Cards 94, *98*
Hammid, Alexander 232
Hanna-Barbera *334*, *417*
The Happy Time 17
Harak, Rudolph de xiv, 12
Harrington, Curtis 232
Hecht, Harold 36
Henri's Walk to Paris 58, *59*
Herrmann, Bernard 180, 183, 272
Hesselbein, Frances 337
High Noon 17
Higher Learning 402
History of Invention (IBM) 96, *97*
Hitchcock, Alfred
 xiii, 114, 178, 182, 183, 187, 403–6
Hollywood for SANE 54, *54*
Hoogenboom, Andy 110
Hope, Bob 188
Home of the Brave 17
Hudson, Rock 217
Hughes, Howard 20
The Human Factor 404
Human Rights 1789–1989 360, *373*
Human Rights Watch Film Festival *372*
Human Rights Week 54, *55*
Hunt-Wesson Foods
 79, 283, 288, *298*, *299*, 300, *416*

I

IBM 30, 232, 283 96, *97*
illustration 41, *56*, *57*, *392*
In Harm's Way
 150, 151, *151*, *398*, *401*, *403*
International Design Conferences in Aspen
 (IDCA) 21, *30*, 30–2, *31*, 232, 283
Intolerance 106
Israel Film Festival in the USA *367*
It's a Mad, Mad, Mad, Mad World
 108, 171, 214, *214–15*, *401*
Ivan Allen Co. 69

J

The J. Paul Getty Museum
 340, 340–1, *341*, *417*
Jacobson, Egbert 30, 283
Japan *see* Saul Bass in Japan
John Westley Associates 28
JOMO (Japan Energy Corporation)
 354, *354*, *418*
Joseph Eger Ensemble 29

K

Kahn, Louis 30, 32
Kaiser Aluminum sponsored film
 32, 241, 247
Kallis, Al 397–8, *403*
Kamekura, Yusaku 32
Kauffer, Edward McKnight 44
Keio Department Store
 33, 82, 344, *344*
Kelly, Gene 239
Kepes, Gyorgy
 9, *9*, 11, 12, 15, 30, 179, *393*
Kershner, Irving xii, 255

Kibun Foods 335, 350, *350*, 417
The Kid (RCA) 96, *96*
Kimberly-Clark Corporation 68, *86*, 232
Kleenex tissues/napkins 82, *86*
KLH *76–7*, 415
Kosé *351*, 418
Kramer, Stanley 17, 36, 171, 214
Kubrick, Stanley 193, 194, 258

L

La Folie 417
Lancaster, Burt 36, *38*, *39*
Lang, Walter 106
Language of Vision (Kepes) 9, 11
The Laurence Puppets 64, *65*
Lawford, Peter 189
Lawry's
 283, 288, *290*, 291–3, 409, 415
LeClerq, Sharon 284, *325*
Leigh, Janet 185, *187*, 404–5
Lemmon, Jack 156, 173
Lewis, Juliette 272
Liebes, Dorothy 88
Lightcraft of California *70–1*, 394, 415
Lightolier 396
Lionni, Leo 30, 34
Lissajous forms 179, 180
Litchfield, Lawrence 294, 296
Litvak, Anatole 18
Lonzo, Michael xiv
FILMEX 366
Love in the Afternoon 155, *155*
Lucas, George xiv, 255
Lustig, Alvin 12, 13, 15, 34, *48*

M

Maeda 345, *352*, 353, *353*, 418
magazine advertising 16, 17
Maglite 418
Magnificent Obsession 36
The Magnificent Seven 190, 191, *191*
Maldonado, Tomas 32
The Man with the Golden Arm
 53, *104*, 106, 107, 108, *110*, 110–11,
 116–23, 399
Mankiewicz, Joseph 18
Mann, Anthony 193
Manufacturers National Bank 47
Marsh, Morris 24, *24*
Marshall Field 85
Marshall, Penny 265
Masquers Club 12
Matter, Herbert 11, 13, 15, 34, *48*
Max Yavno 67, 415
McDonnell Aircraft Corporation 64, *68*
The Member of the Wedding 17
The Men 16, *17*
Meshes of the Afternoon 232
MGM 36
Milan Triennale (1968) 92, *92*
Miles Labs 418
Milestone, Lewis 189
Milton, John 261
Minami 418
Minolta 283, 345, *348*, 348–9, *349*, 417
Mister Roberts 36
Mitsukoshi Department Store 381, 384
Modernism 9, 11, 15, 18, 34, 90, 179, 283
Moholy-Nagy, László 9, 15, 283
Mokichi Okada Association 285, 417
 short film 253

Monroe, Marilyn 154
Monsieur Verdoux 16
Montand, Yves 221, 225
The Moon is Blue 115
Morton Goldsholl Associates 86
Moss, Jerome 146
Motion Picture & Television Fund 418
movies *see* film
Mr. Saturday Night 268, *269*, 402
Music Center Unified Fund 378
My Sister Eileen 36

N

Nagashima, Kazushige 354, 355
Nagata, Dave *24*, 406
National Bohemian Beer *100*, 101
National Film Registry 335
NBC 50th Anniversary Special 408
Nelson, George 30, 88, 92
Nemoy, Maury 394, 398, 404
The New Vision (Moholy-Nagy) 9
New York Art Directors Club
 10, 11, 12–13, 32, *48*, 85, 115
New York Film Festival 62
Nine Hours to Rama
 108, 208, *208–9*, 398, 401
Nitsche, Erik 18
No Way Out 8, 18, *18*, 393
Noguchi, Isamu 32, *33*
North by Northwest 178, 182, *182*
Northern Tissue 323
Norton Simon Inc. 250
Not with My Wife You Don't
 107, 245, 401
Notes on the Popular Arts (short film)
 229, 231, 248, 249, 329, 402
Novak, Kim 120, 178

O

Oakbrook Shopping Center 29, 415
Ocean's Eleven 189, *189*, 278, 400
Ohio Blue Tip Matches *302*, 303
Olin Matheson 98
Olympic Games, Los Angeles 370
On the Threshold of Space 36, 394
One, Two, Three 158, *158*, 159
One Hundred Years of the Telephone
 (short film) 102, 408
Osh Kosh B'gosh 69

P

Pabco Paint 40, *43*
packaging 82
Paepcke, Walter 30, *48*, 283
Palance, Jack 34, *35*, *37*
Panaview *72–3*, 415
Paramount Pictures
 11, 12, 36, 257, 258, 259
The Party (short film) 102
Peck, Gregory 175, 403
Peterson Automotive Museum 418
Phase IV (feature film)
 230, *256*, 257–61, 324
The Phoenix Corporation 66, 415
Pileggi, Nicholas 270, 271, 278
Pinzke, Herb *31*, 32
Playhouse 90 (CBS) 95
PM East / PM West (Westinghouse)
 102, *102*
Pomona Tile Company 88, *89*

A Portfolio of 8 Letterheads *68–9*
poster design
 54, 107, 111, 115, 125, 360
Preminger, Otto xiii, 106, 107, *114*,
 114–16, 120, 122, *122*, 129
The Pride and the Passion
 170, 171, *171*, 399
product design
 29, 82, 85, 88, *395*, 396
Profiles in Courage (ABC) *95*, 101
promotional advertising 34, 36
Prouvé, Jean 32
Psycho 107, 178, 183–7, 400
Psychology 376, 377

Q

Quaker 4, *320*, 320–1, *321*, 416
Quest (short film)
 231, *252*, 253–5, 402

R

The Racers 399
Rand, Paul 8, 9, 11, 18, 34, 48, 283
Rainier Beer *100*, 101
RCA 94, 96, *96*
Redford, Lola 250
Redford, Robert xiii, xiv, 250
Reis, Irving 17
retail display units 82, 85, 395
Return from the River Kwai 407
Return to Paradise 37
Reyner Banham, Peter 381
Reynold's Aluminum 64, 415
Riddle, Nelson 189
Ritt, Martin 169
RKO 20, 21
Robbins, Jerome 199
Roberts, Jack 12
Robson, Mark 17, 208, 209
Rockwell International 284, *312*, 313, 416
Rose, Judy 24
Rose Marie Reid 82, 85, *85*
The Rose Tattoo 36
Rosenfield, Jonas 8, 18
Rosenthal, Herb 92, 300, 409
Rosselli, Alberto 32
Rothman, Al 24
RTD 417
Rubens, Peter Paul 6, *6*, *7*
Rukov, Mogens 108
Rudolph, Paul 32

S

Saint, Eva Marie 221, 225, *225*
Saint Joan 107, *124*, 125–7
San Francisco International
 Film Festival 60, *61*, 63
SANE 54, *54*, 415
Sato, Junya 265, 266
Saturday Evening Post 56, *57*
Saul Bass & Associates (SB&A)
 24, 24–5, 64
Schindler's List 406
Schwartzman, Arnold xiv
Scorsese, Martin
 xiii, 111, 131, 270, *270*, 271, 277
The Searching Eye (short film)
 93, 229, 234, 236, *237*, 238,
 239, 401
Seberg, Jean 129

Seconds
 108, 216, 217–19, 272, 401
Security Pacific Bank 416
The Seven Year Itch 154, *154*, 399
Shankar, Ravi 209
Shell Oil 44, *45*
Shelley, Percy Bysshe 266
Shimokochi, Mamoru *280*, 409
The Shining 194, 405
short film design 23, 92, *93*, 94, 230–3
 see also named films
The Shrike 399
Shriner, Herb *69*
Shulman, Julius 15
Silverlake Lithographers 67
Sinatra, Frank 53, 101, *119*, 120, 189
Sinfonia Varsovia World Tour 379
Small World (Olin Matheson) 98
Smith, Dean 394, 409, 410
Smithson, Peter 32
The Sniper 17
Society of Contemporary Designers 12
Society of Illustrators 415
The Solar Film (short film)
 231, 250, *251*, 402
Some Like it Hot 156, *156*, 157
Somebody Up There Likes Me 36
Something Wild 198, *198*, 400
Soriano, Raphael 32
Spartacus
 23, *104*, 107, *192*, 193–7, 400
Special Olympics 360, 418, *380*
Speedway gasoline 41, *46*
Spellbound 185
Spielberg, Steven xii, 205
sponsored films
 93, 229, 232–44, 246–7, 296, *297*
A Star is Born 36
Stanton, Frank 30, 247, 259
Stefano, Joseph 185
Stephens TruSonic 88, *88*, 396
Stomu Yamashta 257, 360
Storm Center 164, *164*, *165*, 399
Strathmore Paper promotion
 self-portrait *358*, 387
Sturges, John 191
Sturges, Preston 12
Such Good Friends 404
Suede Sorcery 85, 395
Sundance Institute xiii, 250
Sutnar, Ladislav 34

T

Tange, Kenzo 32
Tanner, Phyllis *24*, 394, 395–6, 398
Taradash, Daniel xiv, 164
Tashima, Hideo 348
Tavernier, Bertrand 255
Tavris Insurance *66*, 415
Tee Pee Nylons 82, *83*
television commercials / show openers
 29, 41, 94, 96, 101–2
That's Entertainment, Part II 402
Thompson, Francis 232
Thompson, J. Lee 272
Timmer, Andreas 217, 404, 406
Todd, Mike 166
Tomasini, George 185
Tone Poems of Color (Sinatra)
 26, 53, *53*
Tonko / Dun Huang / The Silk Road
 265, 266, *266*, 402

Trafton, Howard 6, *6*, 9
Transparent Paper Limited 44, 82, *83*
Transport-a-Child Foundation 64, *65*, 415
Truffaut, François 185, 406
TWA 11
Twentieth Century-Fox 8, 36
The Two of Us 405
2001: A Space Odyssey 258
Tylon Cold Wave 10, 11

U

United Airlines *280*, 283, *284*, 324–7,
 342–3, 416
 sponsored film 234, 239
United Artists 7, 16, 115, 120
United States Film Festival 363
United Way 328, *328*, 416
Universal International 36, 193

V

Vera Cruz 38, *39*
Vertigo *104*, 107, 178–81, 185, 400
Very Happy Alexander 404
The Victors 108, 210–13, 401
Vignelli, Lella and Massimo 111
The Virgin Queen 36
von Lauderbach, Nancy 24

W

Walk on the Wild Side
 23, 108, *204*, 204–7, 400
The War of the Roses
 265, 267, *267*, 402
Warner Brothers
 8, 11, 36, 249, 250, 329, *329*, *329*
Watson, Tom 30
Watts, Charlie 111
We the People 410
Weinerschnitzel 417
Welles, Orson 250
West Side Story
 107, 108, 199–203, 400
Westinghouse Electric Corporation
 49, 102, *102*
Wharton, Edith 277
What Price Glory 106
Whitney, John 102, 179, 403–4
Why Man Creates (short film)
 92, 231, *240*, 241–7, 249, 401
Wilder, Billy 106, 114, 154–9, 185
Williams, Harold xii, xiv, 288, 340–41
Wise, Robert 199, 202, 258
With a Song in My Heart 106
Wong Howe, James 217
Wyler, William 109, 175
World Design Conference, Tokyo (1960)
 32, *32*, *33*, 344, *344*
World's Fair (New York, 1964–65)
 92, *93*, 230, 232, 234–7, 239, 287

Y

Yager, Herb 24, *25*, *285*, 331, 345, 348
The Young Stranger 172, *172*, 399
Youngstrom, Joe 21, *23*, 24, 82
YWCA 339, *339*, 418

Z

Zinnemann, Fred 17

Index **423**

Saul and Elaine Bass
1967

LAURENCE KING

Published in 2011
by Laurence King Publishing Ltd
361–373 City Road
London EC1V 1LR
United Kingdom
Tel: + 44 20 7841 6900
Fax: + 44 20 7841 6910
e-mail: enquiries@laurenceking.com
www.laurenceking.com
Reprinted 2012

Text copyright © Pat Kirkham 2011
Design copyright © Jennifer Bass 2011

All rights reserved. No part of this publication may be reproduced or transmitted in any form or by any means, electronic or mechanical, including photocopy, recording or any information storage and retrieval system, without prior permission in writing from the publisher.

A catalogue record for this book is available from the British Library.

Back jacket: Saul Bass, for an article in *Show Business Illustrated*, 1962. Photograph by Bob Willoughby.

ISBN: 978-1-85669-752-1

Color separations by Echelon, Los Angeles
Printed in China

MIX
Paper from responsible sources
FSC® C008047

Picture Credits:
Every effort has been made to trace and contact the copyright holders. Any images not listed below were deemed to be in the public domain. The publishers apologize for any unintentional omissions or errors and will be pleased to insert the appropriate acknowledgement to the companies or individuals in any subsequent edition of this book.

Sony Pictures Entertainment:
THE AGE OF INNOCENCE pp. 262, 276, 402
© 1993, Columbia Pictures Industries, Inc.
All rights reserved. Courtesy of Columbia Pictures
ANATOMY OF A MURDER pp. 111, 130–136, 137, 400
© 1959, renewed 1987 Otto Preminger Films, Ltd.
All rights reserved. Courtesy of Columbia Pictures
BONJOUR TRISTESSE pp. 129, 399
© 1958, renewed 1986 Columbia Pictures Industries, Inc. All rights reserved. Courtesy of Columbia Pictures
BUNNY LAKE IS MISSING pp. 152, 153, 401
© 1965, renewed 1993 Otto Preminger Films, Ltd.
All rights reserved. Courtesy of Columbia Pictures
COWBOY pp. 173, 399
© 1958, renewed 1986 Columbia Pictures Industries, Inc. All rights reserved. Courtesy of Columbia Pictures
STORM CENTER pp. 164, 165, 399
© 1956, renewed 1984 Columbia Pictures Industries, Inc. All rights reserved. Courtesy of Columbia Pictures
THE VICTORS pp. 210, 211, 401
© 1963, renewed 1991 Columbia Pictures Industries, Inc. All rights reserved. Courtesy of Columbia Pictures
WALK ON THE WILD SIDE pp. 207, 400
© 1962, renewed 1990 Columbia Pictures Industries, Inc. All rights reserved. Courtesy of Columbia Pictures

Metro-Goldwyn-Mayer:
ATTACK! pp. 160–162, 399
© 1956, Metro-Goldwyn-Mayer Studios Inc.
All rights reserved.
THE BIG COUNTRY pp. 174–177, 400
© 1958, Estate of Gregory Peck and the Estate of William Wyler.
All rights reserved.
THE BIG KNIFE p. 399
© 1955, Metro-Goldwyn-Mayer Studios Inc.
All rights reserved.
EXODUS pp. 138, 140, 141, 400
© 1960, Metro-Goldwyn-Mayer Studios Inc.
All rights reserved.
THE FACTS OF LIFE pp. 188, 400
© 1960, Metro-Goldwyn-Mayer Studios Inc.
All rights reserved.
IT'S A MAD, MAD, MAD, MAD WORLD pp. 214, 215, 401
© 1963, Metro-Goldwyn-Mayer Studios Inc.
All rights reserved.
ONE, TWO, THREE pp. 158, 159
© 1961, Metro-Goldwyn-Mayer Studios Inc.
All rights reserved.
THE PRIDE AND THE PASSION pp. 171, 399
© 1957, Metro-Goldwyn-Mayer Studios Inc.
All rights reserved.

SOME LIKE IT HOT pp. 156, 157
© 1959, Metro-Goldwyn-Mayer Studios Inc.
All rights reserved.
SOMETHING WILD pp. 198, 400
© 1961, Prometheus Enterprises Inc.
All rights reserved.
WEST SIDE STORY pp. 199–203, 400
© 1961, Metro-Goldwyn-Mayer Studios Inc.
All rights reserved.

Paramount Pictures:
IN HARM'S WAY pp. 150, 151, 401
© 1965, courtesy of Paramount Pictures.
PHASE IV pp. 256, 258–259, 401
© 1974, courtesy of Paramount Pictures.
SECONDS pp. 216, 218, 401
© 1966, courtesy of Paramount Pictures.

Twentieth Century-Fox:
BIG p. 402
© 1988, Twentieth Century-Fox.
All rights reserved.
BROADCAST NEWS pp. 265, 402
© 1987, Twentieth Century-Fox.
All rights reserved.
CARMEN JONES pp. 115, 399
© 1954, Twentieth Century-Fox.
All rights reserved.
NINE HOURS TO RAMA pp. 208, 209, 401
© 1963, Twentieth Century-Fox.
All rights reserved.
THE RACERS p. 399
© 1955, Twentieth Century-Fox.
All rights reserved.
THE SEVEN YEAR ITCH pp. 154, 399
© 1955, Twentieth Century-Fox.
All rights reserved.
THE WAR OF THE ROSES pp. 267, 402
© 1989, Twentieth Century-Fox.
All rights reserved.

Universal:
CAPE FEAR pp. 262, 273–275, 402
© 1991, Universal City Studios, Inc.
& Amblin Entertainment, Inc.
Courtesy of Universal Studios Licensing LLP.
CASINO pp. 262, 278–279, 402
© 1995, Universal City Studios, Inc.
& Syalis Droits Audiovisuals.
Courtesy of Universal Studios Licensing LLP.
PSYCHO pp. 183, 184, 187, 400
© 1960, Shamley Productions, Inc.
Courtesy of Universal Studios Licensing LLP.
SCHINDLER'S LIST p. 406
© 1993, Universal City Studios, Inc.
Courtesy of Universal Studios Licensing LLP.
THE SHRIKE p. 399
© 1955, Universal City Studios, Inc.
Courtesy of Universal Studios Licensing LLP.
SPARTACUS pp. 104, 192, 195, 400
© 1960, Universal Pictures Company, Inc.
& Bryns Productions, Inc.

Courtesy of Universal Studios Licensing LLP.
VERTIGO pp. 104, 180, 181, 400
© 1955, Universal City Studios, Inc. for Samuel Taylor & Patricia Hitchcock O'Connell.
Courtesy of Universal Studios Licensing LLP.

Turner Entertainment Co.:
EDGE OF THE CITY pp. 168, 169, 399
© 1956, Turner Entertainment Co., A Warner Bros. Entertainment Company. All rights reserved.
GRAND PRIX pp. 220, 222, 223, 401
© 1966, Turner Entertainment Co., A Warner Bros. Entertainment Company. All rights reserved.
NORTH BY NORTHWEST pp. 182, 400
© 1959, Turner Entertainment Co., A Warner Bros. Entertainment Company. All rights reserved.
THAT'S ENTERTAINMENT III p. 402
© 1994, Turner Entertainment Co., A Warner Bros. Entertainment Company. All rights reserved.
THE YOUNG STRANGER pp. 172, 399
© 1990, Turner Entertainment Co., A Warner Bros. Entertainment Company. All rights reserved.

Warner Bros.:
AROUND THE WORLD IN EIGHTY DAYS pp. 166, 167, 399
© 1956, Mike Todd Co., Inc.
All rights reserved.
DOC HOLLYWOOD p. 402
© 1991, Warner Bros. Inc.
All rights reserved.
GOODFELLAS pp. 271, 402
© 1990, Warner Bros. Inc.
All rights reserved.
MR. SATURDAY NIGHT pp. 268, 269, 402
© 1992, Warner Bros., Inc.
All rights reserved.
NOT WITH MY WIFE YOU DON'T p. 401
© 1966, Warner Bros.,
Fernwood Productions, Inc.
& Dorchester Productions, Inc.
All rights reserved.
OCEAN'S ELEVEN pp. 189, 400
© 1960, Dorchester Productions, Inc.
All rights reserved.

Publisher's Photography Credits:
p. viii Andy Hoogenboom; p. xvi Andreas Feininger, Collection of the New York Historical Society; p. 14 right Arts & Architecture®/David Travers; p. 12 right and p. 13 left © Bison Archives / Marc Wanamaker; pp. 90, 91 © J. Paul Getty Trust. Used with permission. Julius Shulman Photography Archive, Research Library at the Getty Research Institute (2004.R.10); pp. 114, 146 Photo by Sam Shaw © 2011 Sam Shaw, Inc., Licensed by Shaw Family Archives, Ltd.; p. 283 © John G. Zimmerman; p. 340 below © 2005 Richard Ross with the courtesy of the J. Paul Getty Trust; p. 341 below Mauritius Images/www.photolibrary.com; p. 359 Luca Vignelli.

Thanks to Tim Nicholson for studio permissions.